Signs Of Life

Bio Art and Beyond

Leonardo

Roger F. Malina, Executive Editor

Sean Cubitt, Editor-in-Chief

Signs Of Life

Bio Art and Beyond

Eduardo Kac, editor

The MIT Press
Cambridge, Massachusetts
London, England

MIT Press books may be purchased at special quantity discounts for business or sales promotional use. For information, please e-mail special_sales@mitpress.mit.edu or write to Special Sales Department, The MIT Press, 55 Hayward Street, Cambridge, MA 02142.

This book was set in Garamond 3 and Bell Gothic on 3B2 by Asco Typesetters, Hong Kong, and was printed and bound in the United States of America.

Library of Congress Cataloging-in-Publication Data

Signs of life : bio art and beyond / Eduardo Kac, editor.
 p. cm.—(Leonardo)
Includes bibliographical references and index.
ISBN 978-0-262-11293-2 (hardcover : alk. paper)
1. Biotechnology in art. 2. Art and science. 3. Art—Moral and ethical aspects. 4. Science—Moral and ethical aspects. I. Kac, Eduardo.
N72.B56S54 2007
700$'$.105—dc22 2006035537

10 9 8 7 6 5 4 3 2

Contents

Series Foreword

The arts, science, and technology are experiencing a period of profound change. Explosive challenges to the institutions and practices of engineering, art making, and scientific research raise urgent questions of ethics, craft, and care for the planet and its inhabitants. Unforeseen forms of beauty and understanding are possible, but so too are unexpected risks and threats. A newly global connectivity creates new arenas for interaction between science, art, and technology but also creates the preconditions for global crises. The Leonardo Book series, published by the MIT Press, aims to consider these opportunities, changes, and challenges in books that are both timely and of enduring value.

Leonardo books provide a public forum for research and debate; they contribute to the archive of art-science-technology interactions; they contribute to understandings of emergent historical processes; and they point toward future practices in creativity, research, scholarship, and enterprise.

To find more information about Leonardo/ISAST and to order our publications, go to Leonardo Online at ⟨http://lbs.mit.edu/⟩ or e-mail ⟨leonardobooks@mitpress.mit.edu⟩.

Sean Cubitt
Editor-in-Chief, Leonardo Book series

Leonardo Book Series Advisory Committee: Sean Cubitt, *Chair*; Michael Punt; Eugene Thacker; Anna Munster; Laura Marks; Sundar Sarrukai; Annick Bureaud

Doug Sery, Acquiring Editor
Joel Slayton, Editorial Consultant

Leonardo/International Society for the Arts, Sciences, and Technology (ISAST)

Leonardo, the International Society for the Arts, Sciences, and Technology, and the affiliated French organization Association Leonardo have two very simple goals:

1. to document and make known the work of artists, researchers, and scholars interested in the ways that the contemporary arts interact with science and technology and
2. to create a forum and meeting places where artists, scientists, and engineers can meet, exchange ideas, and, where appropriate, collaborate.

When the journal *Leonardo* was started some forty years ago, these creative disciplines existed in segregated institutional and social networks, a situation dramatized at that time by the "Two Cultures" debates initiated by C. P. Snow. Today we live in a different time of cross-disciplinary ferment, collaboration, and intellectual confrontation enabled by new hybrid organizations, new funding sponsors, and the shared tools of computers and the Internet. Above all, new generations of artist-researchers and researcher-artists are now at work individually and in collaborative teams bridging the art, science, and technology disciplines. Perhaps in our lifetime we will see the emergence of "new Leonardos," creative individuals or teams that will not only develop a meaningful art for our times but also drive new agendas in science and stimulate technological innovation that addresses today's human needs.

For more information on the activities of the Leonardo organizations and networks, please visit our Web sites at ⟨http://www.leonardo.info/⟩ and ⟨http://www.olats.org⟩.

Roger F. Malina
Chair, Leonardo/ISAST

Acknowledgments and Credits

I wish to thank George Gessert for countless stimulating conversations and his feedback; Roger Malina, Doug Sery, Annick Bureaud, and Joel Slayton for their support and patience through the editorial process; Edith Flusser for her generous permission to reprint Vilém Flusser's essay (first published in *Art Forum*, vol. 27, no. 2 [1988]); Jens Hauser for the sustained dialogue, for his curatorial vision, and for his generous permission to reproduce a revised version of Yves Michaud's text from *L'Art Biotech*, ed. J. Hauser (Paris: Filigrane, 2003); Dusan Bojic, from Incepta, Brisbane, for the fascinating conversations on Alexander Fleming's work; Melentie Pandilovski, director, The Experimental Art Foundation, Adelaide, who invited me to teach a workshop at the Foundation and thus made these conversations possible; Dr. Robert Fleming, for his permission to reproduce Alexander Fleming's 1936 paper on his "germ paintings"; Kevin Brown, Trust Archivist and Alexander Fleming Laboratory Museum Curator, London, for his assistance with my research and also for his permission to reproduce a "germ painting" by Alexander Fleming; and Ruth Kafensztok for her perceptive insights on various topics. I also extend many thanks to all whose contributions, in the form of text or pictures, helped make this book a reality. Ronald Gedrim's chapter was first published in *History of Photography*, vol. 17, no. 4 (Winter 1993) (reproduced with permission from Taylor & Francis Group). Translation credits are as follows: Louis Bec, "Life Art," translation: Julia Zarankin; Bernard Andrieu, "Embodying the Chimera: Biotechnology and Subjectivity," translation: Pascal Peytoureau; Dominique Lestel, "Liberating Life from Itself: Bioethics and Aesthetics of Animality," translation: Julia Zarankin; Yves Michaud, "Art and Biotechnology," translation: Joelle Rubion.

Introduction

Art that Looks You in the Eye: Hybrids, Clones, Mutants, Synthetics, and Transgenics

Eduardo Kac

As has been the case with every new medium, from radio to video, from computer to telecommunications, the tools and processes of biotechnology opened up unprecedented possibilities for art. Further, contemporary biotechnology has had the cultural effect of enhancing society's awareness of traditional biotechnology. The old method is quite plainly represented by bread, cheese, beer, wine, and vinegar, and by the hundreds of breeds of animals and hybrid plants commonly found worldwide, such as dogs and roses. The contemporary approach is rendered more or less obvious when countries reject, debate, partially accept, label, or silently embrace genetically modified foods, one of the most hotly contested topics brought to the fore by the biotech industry. It is not clear what are the benefits, if any, to the consumer and whether there can be serious environmental consequences. Likewise, developments in genomics, such as the Human Genome Project, and subsequent research in proteomics, to reveal and study the three-dimensional structure (and functionality) of proteins, bring with them the potential of important social benefits as well as the horrifying specter of what I call a genocracy, that is, a government that conducts social policy (privacy legislation, public health, labor regulations, law enforcement) based on the false belief that genes alone determine matters of life and death.

The general public does not need to have expertise in computer science, business administration, or genetic engineering to feel and understand the threat of bioinformatics, that is, the promotion of a dangerously reductive analogy between discrete binary data and the more complex, environment-related field of genetics. The extreme difficulty in dealing with very complex biological interactions leads to the simplified treatment of life processes as quantified data that exhibit statistical patterns. In turn, this can lead to an objectification of life and a disregard for the subjects and their rights. In reaction, citizens worldwide express their concerns about biopiracy, gene patenting, and genetic discrimination by insurance companies and employers. If a private company can legally own the

reproduces, as well as what new life forms should be created, the second delivers them worldwide overnight. Undoubtedly, contemporary corporate business plans, institutional research agendas, and individual initiatives of various kinds are collectively reshaping the Earth's evolutionary history.

For the first time, not only are humans fully aware of evolution at work but they witness it as it unfolds in novel ways and at accelerated speed. More important, they play a direct and conscious role in its development on a large physical scale. The most outstanding examples now dominating the North American landscape are species extinction and the corporate monocrops of selected transgenic varieties of plants. The latter have decreased biodiversity by pushing out local family farms and their unique cultivars, which are genetically various and are often locally adapted not only to weather and soil but also to a given region's economic and cultural needs. In the age of molecular biology, rather than operating at the glacial pace of geological time, evolution both annihilates a percentage of the extant flora and fauna and produces new life and new relationships (symbiosis, parasitism, assistance, predation, hybridization, infection, cooperation) within the life cycle of a single human being.

Life Continuum: Humans and Nonhumans

This compressed evolutionary speed is a new phenomenon, but our awareness of it at the level of ordinary experience is even more recent, from our surprise at a new colorful bell pepper suddenly found in the supermarket to newspaper headlines about beings created through genetic engineering. How did we get to our present state of consciousness about evolution?

Both life and our understanding of it have dramatically changed since Aristotle's first natural history studies. Aristotle did not believe in evolution. For him life was eternal; it was always already there and would continue to be. Writing in the golden age of Latin literature, centuries after Aristotle, the Roman lyric poet and satirist Horace (65–8 BCE) mused in his *Ars Poetica* (The Art of Poetry), published circa 10 BCE: "Supposing a painter chose to put a human head on a horse's neck or to spread feathers of various colors over the limbs of several different creatures, or to make what in the upper part is a beautiful woman tail off into a hideous fish, could you help laughing when he showed you his efforts?" Horace agreed that poetic license had to be respected but "not to the point of associating what is wild with what is tame, of pairing snakes with birds or lambs with tigers."[5]

Horace's commanding vision of coherence and unity, as well as categorical condemnation of incongruity, had long staying power beyond painting and literature. It is not until the materialism set forth unequivocally by Julien Offray de La Mettrie (1709–1751) that analogies between and among living and nonliving entities became seriously possible from both a scientific and philosophical point of view. Advancing notions first articulated by

Descartes, in two short books, *L'homme machine* (Man a Machine, 1747) and *L'homme plante* (Man a Plant, 1748), the experimentalist philosopher developed views that inevitably resonate as excessively reductionistic to twenty-first-century readers but that in his own time were extremely progressive, revolutionary, visionary. In *L'homme plante*, La Mettrie wrote that "the singular analogy between the plant and animal kingdoms has led me to the discovery that the principal parts of men and plants are the same."[6] The preliminary sequencing of the human genome and that of a plant from the mustard family have extended the philosopher's analogies beyond his wildest dreams, into the deepest recesses of the human and plant cells. Both have revealed homologies between human and plant genetic sequences.[7] For suggesting continuity among plants, human and nonhuman animals, as well as machines, La Mettrie was persecuted and had to leave France, only to find comfort under the protection of Frederick the Great in Berlin, where he stayed until his death in 1751.

La Mettrie did not degrade humankind; rather, he elevated the status of nonhuman animals. The philosopher undermined the hierarchy that posits human supremacy, suggesting a sense of continuity between humans and the family of life. He was the first to suggest that primates could acquire a human language and to propose how to achieve this: Teach young apes (who are more educable) and use gestural techniques already employed at the time to assist human deaf mutes. Our contemporary, the gorilla Koko, makes use of well over one thousand gestures of a modified form of American Sign Language and understands over two thousand words of spoken English. Equally significant, in the three decades she has worked with her human teacher, Koko has expressed the whole range of emotions also felt by humans, including happiness, sadness, love, and grief. The fact that primates in their wild habitats do not need to develop these interspecies communicative faculties is an altogether different matter—the important and novel event is the acknowledgement of this cognitive continuity between humans and nonhumans.

La Mettrie's intellectual bravery was both profound and profane, with far-reaching consequences. If, according to the Church, humans were created in the image of God, how could other, "lowly" creatures form a continuum with humans? Augustine of Hippo wrote plainly in his *Against Julian* (the book was left unfinished at his death in CE 430): "I see a great punishment for man, image of God, to be reduced to the condition of an animal."[8] In *Summa Theologiae* (1273),[9] Thomas Aquinas stated: "Now man excels all animals by his reason and intelligence; hence it is according to his intelligence and reason, which are incorporeal, that man is said to be according to the image of God." The thought that humans are much closer to other life-forms than previously known or accepted still resonates uncomfortably with most.[10] Likewise, the mixing of tissue or organs among humans, the combination of human and inanimate matter, or the integration of human and nonhuman life still evoke a negative feeling in the general public as dangerous both physically and intellectually. While the first two have become commonplace, as exemplified by blood transfusions and organ transplants, pacemakers and bone implants, the third,

known as xenotransplantation, is still very experimental. However, the global shortage of organs suggests that either xenotransplantation will prevail over its major technical obstacles and become standard, or tissue and organs will be routinely grown from stem cells, or possibly both.

We are now accustomed to the idea of manipulating the plasticity of life, but there were early signs of this malleability even before La Mettrie's birth. It is often suggested that the technique of grafting was first implemented thousands of years BCE in China. Already in 323 BCE the botanist Theophrastos suggested grafting as an important agricultural technique. References to grafting can be found in the New Testament: "For if thou wert cut out of the olive tree which is wild by nature, and wert grafted contrary to nature into a good olive tree: how much more shall these, which be the natural [branches], be grafted into their own olive tree?" (Rom. 11:24). The grafting technique alluded to in this passage is of a simple kind, but already by the late seventeenth century the complex being made of disparate parts was no longer mythology or distant fantasy. Intricate plant chimeras were being created through grafting techniques, as exemplified by the "Bizzaria" orange produced in 1644 by a Florentine gardener from orange stock and citron scion (a scion is a shoot or twig containing buds). These graft chimeras had fruits that were part orange and part citron, and new Bizzaria plants maintained their chimerical hybridity when propagated by cuttings. By the nineteenth century, the technique was so normalized and diffused that the artist Jean-François Millet pictured it in his painting *Peasant Grafting a Tree* (1855).

The Bizzaria orange is a curious but not frightening chimera, since it is a citrus fruit created from plants of the same genus (a taxonomic group containing similar species). However, the monster, "nature's error," or being made from unharmonious elements, has often evoked strong fears. The Italian naturalist Ulisse Aldrovandi (1522–1605) posthumously published in 1642 his book *Monstrorum Historia* (History of Monsters), which includes visual depictions of countless creatures, real or imagined, observed in person by him as well as narrated by others, such as a bearded young woman and a horned viper. Aldrovandi was an early proponent of the use of images in the analysis of the natural world, and he commissioned many artists to illustrate his object of study. The book stands as one of the most interesting documents of the period of transition from the old to the new life science, which took place in the sixteenth and seventeeth centuries.

Inasmuch as it is necessary to distinguish between the "living monster" (an actual being born with malformations) and the "fictional monster" (a mythological or artistic creation), it is also imperative to recognize the symbolic value attributed to both socially—emblematic as they are of the idea of uncontrollable natural forces gone astray. In their verbal, visual, or embodied forms, "monsters" have been used by society to project anxieties that reflect major cultural shifts taking place at different points in history. This is clear from the ancient Greek chimera to Shelley's post-Galvanian Frankenstein, from Bosch's allegorical and moralist medieval paintings to Wells's vivisection parable *The*

Island of Dr. Moreau. The concerns expressed through these and countless other creatures were essentially a sign of anxiety over nature, over shifting patterns of social organization, or over the fact that firmly held boundaries between traditional concepts such as "nature" and "artifice" were slowly starting to erode. These were fears of the unknown, emotional responses that continue to manifest themselves into the present.

In his *Manual de zoología fantástica* (Handbook of Fantastic Zoology), first published in Mexico in 1957, and since 1967 retitled *El libro de los seres imaginarios* (The Book of Imaginary Beings), Jorge Luis Borges stated that "we could evolve an endless variety of monsters—combinations of fish, birds, and reptiles, limited only by our own boredom or disgust. This, however, does not happen; our monsters would be stillborn, thank God."[11] Borges wrote his book in the pre-biotech era, when imaginary beings were firmly in the realm of legend and literature. The Argentinean writer, who died in 1986 at the age of eighty-six, lived long enough to have possibly heard of the ultimate living chimera of the late twentieth century, the amazing Geep (figure 0.1). A true mammalian chimera (which, in science, means animals with cells from two beings), mosaic of goat and sheep, the Geep adorned the cover of the journal *Nature* of February 16–22, 1984.[12] Only thirteen years later, scientists used tissue engineering to create an inoperative prosthetic human ear and graft it on the back of a mouse.[13] Although technically not a chimera, the ear-mouse effectively functioned like one in the public eye, eliciting vehement responses of fascination and rejection—a clear sign of inquietude about the biotech future.

Evolution, Teratology, and Art

The materialist and anti-theocentric project of the Enlightenment challenged the received Scholastic biologic, a synthesis of Greek logical thought and Christian medieval theology. In this sense, it must be noted that La Mettrie was not alone in his attack on old conceptions of life. The work of Pierre Louis Moreau de Maupertuis (1698–1759), for example, was a precursor of the modern theory of evolution centered on random mutation and natural selection. Going against a theocentric and teleological view of life, in his book *Essai de cosmologie* (Essay on Cosmology, 1750), he wrote: "Chance one might say, turned out a vast number of individuals; a small proportion of these were organized in such a manner that the animals' organs could satisfy their needs. A much greater number showed neither adaptation nor order; These last have all perished—thus the species which we see today are but a small part of all those that a blind destiny has produced."[14] The Scottish geologist James Hutton died in 1797, before he was able to publish his *Elements of Agriculture*, in which he advanced similar ideas about natural selection.

By the early nineteenth century, Jean-Baptiste Lamarck had published his book *Philosophie zoologique* (Zoological Philosophy, 1809) and coined the term "biology" to designate the science that studies what plants and animals have in common. Published the same year Darwin was born, his book defended the view that animals evolved from simpler forms.

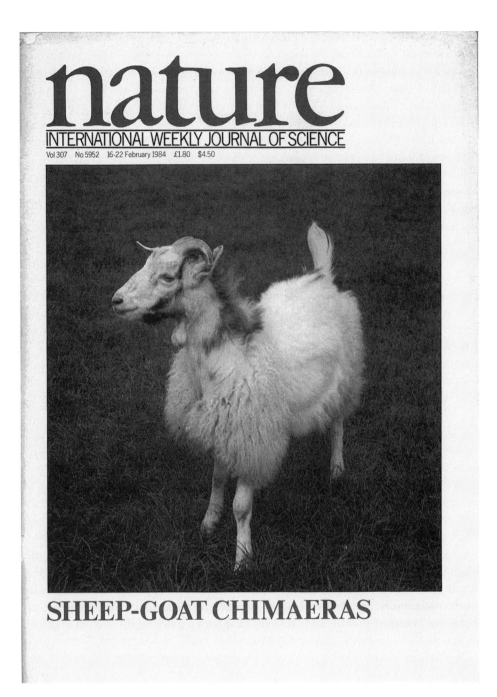

nature

INTERNATIONAL WEEKLY JOURNAL OF SCIENCE

Vol 307 No 5952 16-22 February 1984 £1.80 $4.50

SHEEP-GOAT CHIMAERAS

Figure 0.1

The Geep, a living chimera, a mosaic of goat and sheep, adorned the cover of the journal *Nature* of February 16–22, 1984. The Geep was created by Steen Willadsen and his group. Reproduced with permission from *Nature*.

Soon afterward, the literary and pictorial trope of monstrosity would engender the science of monstrosity, or teratology, founded by Etienne Geoffroy Saint-Hilaire with his 1822 book *Philosophie anatomique. Des Monstruosités humaines, ouvrage contenant une classification des monstres* (Anatomic philosophy. Human monstrosities, work containing a classification of monsters). Saint-Hilaire believed that organisms are ruled by a common organic law. His work was not devoted to folktales of fantastic beasts but to demonstrating that interruption in the development of the fetus provoked grave deformations. In so doing he founded a new discipline that eliminated superstitious conjectures, such as the idea that the imagination of a pregnant woman could generate monstrous offspring. Today teratology is an established field that studies the biological processes that lead to abnormal development and birth defects as well as their prevention.

When Darwin released *On the Origin of Species* (1859) and Mendel published his first genetic experiments (1865), the nineteenth century set in motion a groundbreaking shift in our understanding of life. A hallmark of this paradigm shift, which would help usher in the age of molecular biology, was the synthesis of physics and biology spurred by Erwin Schrödinger's *What Is Life?*, ironically first published in 1944 at the peak of modern human negative eugenics and the industrialization of death. From the visualization of the double helix to IVF, from the oncomouse to the rodent born from two mothers and no father, it is precisely the instrumentalization of life and its processes enabled by the atomism of classic science that has spawned the brave new world of human-produced hybrids, clones, mutants, synthetics, and transgenics.

In light of these developments, contemporary art cannot automatically relegate this new biota cornucopia to the traditional category of the "grotesque," since what once was exceptional (distorted and incongruous imagery) can now be said to either be the norm or at least be entirely integrated into mainstream art practice. Additionally, many new life-forms may be heterogeneous genetically but look and behave the same way as other members of their species. The "grotesque" as an epistemological category can only be operative in opposition to an assumed typicality. An extreme contrast would posit it against the vague property known as "beauty"—a precept constructed through social convention that changes according to geographic location and historical period. An idealized notion of "beauty" inherited from Greco-Roman art held sway in the West as an aesthetic guiding principle until the twentieth century, for the history of Western art can be seen as couched in the biologically normative representation of human and animals. In other words, traditionally, the representation of atypical life-forms was meant to reinforce the distinction between "normal" and "deviant," and not to underline the continuity among all life.

With his paintings that forge whimsical parallels among floral, vegetal, and human forms, Giuseppe Arcimboldo (1527–1593) meant to produce as much a formal tour de force as allegories for the seasons or the power of individuals, not quite yet the analogy and principle of continuity that would only start to be taken up seriously with La Mettrie's

Sonfist's *Time Landscape: Greenwich Village, New York* (1978), located between Houston and Bleecker Streets in Manhattan, is an 8,000-square-foot area with soil and indigenous plant life, ecologically restoring and commemorating the vanished natural habitat.

With the exceptions of Steichen and Gessert, creators of their own flowers, the works mentioned here are emblematic of strategies that progressively became pervasive in contemporary art. What they all have in common is the use of already existing living organisms or body fluids. Another strategy has been to transpose principles from the realm of genetics to conceptual art and electronic music. A forerunner of this approach is *La destruction de votre code génétique par drogues, toxins et irradiation* (The destruction of your genetic code by drugs, toxins and irradiation), created by the Swedish composer and text-sound artist Sten Hanson in 1968 and performed publicly for the first time in Stockholm in 1969 (figure 0.2). The piece, which exists as both an artist's book and a recorded performance, consists of an arbitrary sequence of 195 codons (e.g., ACT, GTG, TTG, ATA, CTG, AAT). Periodically the sequence undergoes a verbivocovisual mutation, resulting in bases (A, C, G, T) interspersed with empty spaces, left parentheses, overlapping letters, and invented signs meant to evoke the mutation, breakup, or ultimate destruction of nucleotides.[18] By contrast, the essential trait that distinguishes transgenic art in particular and bio art in general from these and other strategies and movements is the manipulation of biological materials at discrete levels (e.g., individual cells, proteins, genes, nucleotides) and the actual creation of new life.

Art Beyond Biology: This Book

The writers and artists whose work forms this anthology don't see their role as commentators chronicling or illustrating the burgeoning biotech culture. Rather, their work is engaged in shaping discourse and public policy, and in stimulating wide-ranging debate. The writers and artists in this collection also reveal an acute awareness of the ethical questions associated with biotechnology.

While the writers and artists herein explore the myriad thematic pathways of the biotech culture, all of the artists also engage with biotechnology on a material level. In this lies the specificity of the selected artists: For them biotechnology is not just a topic but their very medium. They understand that biotechnology produces new materials and processes, which historically have always been of interest to artists, from the collapsible tin tubes that extended the shelf life of oil paints and the metal ferrule flat brushes that helped shape impressionism to the industrial precision tools that gave minimalism its distinctive visual mark.

Furthermore, artists whose work involves the direct transformation of living organisms or the creation of new life ought to realize that their efforts no longer take place in the well defined domain of objecthood—but rather in the more complex and fluid zone of subject-

```
ACT   GTG   ATA   T G   CTG   AAT   G(G   AC'
GTG   TTG   CTG   ATA   AAT   ACT   T G   G(G
TTG   ATA   AAT   CTG   ACT   G(G   ATA   T G
ATA   CTG   ACT   AAT   G(G   T G   CTG   ATA
CTG   AAT   GTG   ACT   T G   ATA   AAT   CTG
AAT   ACT   T G   GTG   ATA   CTG   AC'   AAT
ACT   GTG   ATA   T G   CTG   AAT   G(G   AC'
GTG   TTG   CTG   ATA   AAT   ACT   T G   G(G
TTG   ATA   AAT   CTG   ACT   G(G   ATA   T G
ATA   CTG   ACT   AAT   G(G   T G   CTG   ATA
CTG   AAT   G(G   ACT   T G   ATA   AAT   CTG
AAT   ACT   T G   GTG   ATA   CTG   AC'   AAT
ACT   GTG   ATA   T G   CTG   AAT   G(G   AC'

T G   ATA   GTG   AT    AC'   G(G   T G
ATA   GTG   AT    AC'   G(G   T G   ATθ
GTG   AAT   AC'   G(G   T G   ATθ   GTG
AAT   AC'   G(G   T G   ATθ   GTG   AT
AC'   G(G   T G   ATA   GTG   AT    'C'
G(G   T G   ATA   GTG   AT    'C'   G(G
T G   ATA   GTG   AT    AC'   G(G   T G
ATA   GTG   AT    AC'   G(G   T G   ATθ
GTG   AAT   AC'   G(G   T G   ATθ   GTG
AAT   AC'   G(G   T G   ATθ   GTG   AT
AC'   G(G   T G   ATθ   GTG   AT    'C'
G(G   T G   ATA   GTG   AT    'C'   G(G
T G   ATA   GTG   AT    AC'   G(G   T G
```

Figure 0.2

Sten Hanson, *La destruction de votre code génétique par drogues, toxins et irradiation* [The destruction of your genetic code by drugs, toxins and irradiation], 1968. The piece, first performed publicly in Stockholm in 1969, consists of an arbitrary sequence of six codons (ACT, GTG, TTG, ATA, CTG, AAT) that undergoes mutation, resulting in bases (A, C, G, T) interspersed with empty spaces, left parentheses, overlapping letters and invented signs meant to evoke the mutation, breakup, or ultimate destruction of nucleotides. Reading orientation: Read first all eight blocks at the top from left to right; then move on to the seven bottom blocks from left to right.

hood. Subjects are alive, free, and autonomous. From bacteria to bunnies, from frogs to flowers, living organisms grown or bred in unique ways, modified or invented by artists, are the elements of a true art of evolution. It is necessary to articulate a new critical vocabulary to meet the intellectual challenge posed by the emerging bio art documented here.

Biotech Culture

Part I of the book, entitled "Biotech Culture," opens with an essay by Eugene Thacker (chapter 1) that explores the ever-increasing, nearly indistinguishable association between computer science and biology. Analogous to the democratic software movement known as "open source" are Thacker's reflections on the future of biological information (including the human genome). The Open Source Initiative assures that operating system software is designed, maintained, and freely shared by a worldwide group of volunteer programmers. How would this model manifest itself in the genomic and postgenomic worlds?

Gunalan Nadarajan (chapter 2) traces the historical and philosophical backgrounds of the notion of the "ornament" to suggest that biotechnology collapses the opposition between the natural and the ornamental. "What happens when the ornament is natural; when the ornament is the reference for the creation of the natural?" he asks. Nadarajan also addresses the use of contemporary biotechnology in the development of new ornamentals in Singapore. The country is the top exporter of ornamental fish in the world, dealing with five hundred varieties and species. Singapore is also a major exporter of cut orchids and ornamental plants (including aquatic plants). The island-state is the hub of a distributed biotech Galápagos in the Asia-Pacific market.

Bernard Andrieu (chapter 3) revisits the mythological and scientific notions of the "chimera" and of the "monster." He states that transgenics and chimeras "belong to the biological compatibilities allowed by nature even if not produced by nature itself along the course of its evolution." Andrieu's investigation of biotechnology and subjectivity leads him to engage both Francisco Varela's notion of the "embodied mind"[19] and Foucault's critique of self and sexuality linked to truth and nature (as in psychoanalysis or the religious confessional). Varela's work completely undermines the separation of cognition from the sensorimotor capacities of the body. For Foucault the subject is an effect of power; therefore, relations of biopower have a constitutive role in our understanding of subjectivity. Foucault connected the ethics of resisting the subordination of human life to the normalizing thrust of biology to an "aesthetics of existence," that is, the individual's self-stylization, an aesthetic behavior that gives precedence to a philosophy of life over scientific meaning. Foucault described "aesthetics of existence" as "a way of life whose moral value did not depend either on one's being in conformity with a code of behavior, or on an effort of purification, but on certain formal principles in the use of pleasures, in the way one distributed them, in the limits one observed, in the hierarchy one respected."[20]

Short of stating it explicitly, Andrieu implies a link between "aesthetics of existence" and Varela's situated cognition, suggesting that in the biotech age subjectivity is inscribed between power vectors and the phenomenology of a constantly transforming body.

Richard Doyle, author of a dissecting analysis of the rhetorical strategies of molecular biology,[21] contributes a chapter entitled "The Transgenic Involution" (chapter 4) in which he entangles taxonomy, traditional cross-breeding, hallucinogenics, art, biotechnology, and the Internet to reflect on new evolutionary practices predicated on human agency.

Concluding part I is a chapter by Louis Bec, a longtime advocate of a literal art of life, who is known in Europe as an artist and writer or, in his own words, as a "zoosystemician" and as the developer of "fabulatory epistemology." While the former encapsulates the notion of animal life as a system, and the work of the artist as creator of new ones—which Bec has pursued through drawings, diagrams, and digital media—the latter suggests the role of imagination in human pursuit of knowledge (thus readily undermining the traditional epistemological distinction between true and false knowledge). In 1987 Bec published with Vilém Flusser the book *Vampyrotheutis infernalis: eine Abhandlung samt befund des Institut Scientifique de Recherche Paranaturaliste* (Vampyrotheuthis Infernalis: Report of Findings from the Scientific Institute of Paranaturalist Research).[22] The book, an exercise in "fabulatory epistemology," consists of a text by Flusser (in which he describes the experience of a deep-sea squid from an anthropocentric point of view) and a series of images by Bec (through which he presents fanciful organisms of his own creation; figure 0.3). Uniting text and image is the authors' shared belief that humans should abandon the unproductive tendency to think of evolution hierarchically (with humans at the top) and proceed to study and construct phenomenologically a different nature. In chapter 5, Bec weaves insights drawn from many disciplines to articulate some of the aesthetic principles unique to an art of life.

Bioethics

Part II focuses on "bioethics," striking a balance between the normative framework of applied ethics and the theoretical inquiry into the very meaning of "ethics" in the context of contemporary biotechnology. In chapter 6, Cary Wolfe employs insights from Foucault, Derrida, and Wittgenstein to interpellate professional bioethicists on philosophical issues often bracketed for the sake of institutionalization of the field of bioethics: What is life? What is morality? How different or similar are humans from other animals? What is the role of ethics in ontology and vice versa? Molecular biology has indeed created this unprecedented phenomenon: Multinational companies, such as Dupont, for example, employ philosophers (bioethics is part of ethics, a branch of philosophy) in their biotechnology advisory panels. Even though Wolfe's text is theoretical in nature, the reader may infer that he alludes to a parallel question: Might the viability of a career in bioethics partially

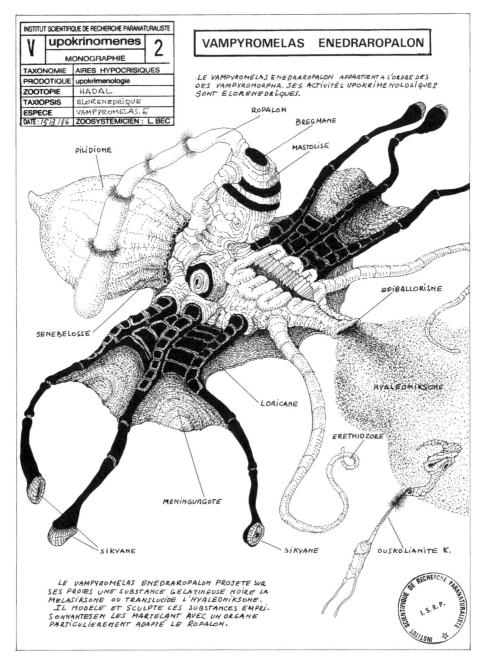

INSTITUT SCIENTIFIQUE DE RECHERCHE PARANATURALISTE		
V **upokrinomenes**		**2**
MONOGRAPHIE		
TAXONOMIE	AIRES HYPOCRISIQUES	
PRODOTIQUE	upokrimenologie	
ZOOTOPIE	HADAL	
TAXIOPSIS	ELORENEDRIQUE	
ESPECE	VAMPYROMELAS. E	
DATE: 15/3/86	ZOOSYSTEMICIEN : L. BEC	

VAMPYROMELAS ENEDRAROPALON

LE VAMPYROMELAS ENEDRAROPALON APPARTIENT A L'ORDRE DES DES VAMPYROMORPHA. SES ACTIVITÉS UPOKRIMENOLOGIQUES SONT ELORENEDRIQUES.

ROPALON
BREGMANE
MASTOLISE
PILIDIONE
EPIBALLORISME
SENEBELOSSE
HYALEONIKSONE
LORICANE
ERETHIDZORE
MENINGURGOTE
SIKYANE
SIKYANE
DUSKOLIANITE K.

LE VAMPYROMELAS ENEDRAROPALON PROJETE SUR SES PROIES UNE SUBSTANCE GELATINEUSE NOIRE LA MELASIKSONE OU TRANSLUCIDE L'HYALEONIKSONE. IL MODELE ET SCULPTE CES SUBSTANCES EMPRI-SONNANTES EN LES MARTELANT AVEC UN ORGANE PARTICULIEREMENT ADAPTE LE ROPALON.

INSTITUT SCIENTIFIQUE DE RECHERCHE PARANATURALISTE
I.S.R.P.

Figure 0.3

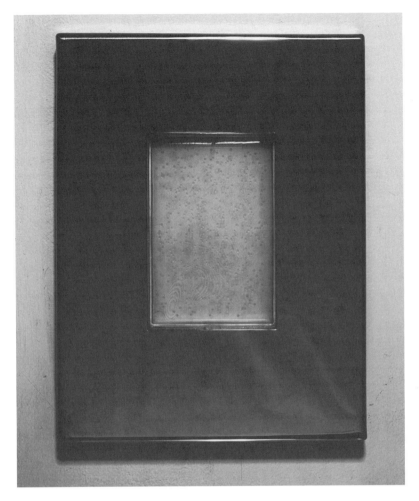

Figure 0.4
Marc Quinn, *Cloned DNA Self Portrait* (2nd perspective), 2001. Stainless steel, polycarbonate agar jelly, bacteria colonies, cloned human DNA, $10\frac{5}{16} \times 8\frac{1}{16} \times 1\frac{1}{16}$ in (26.2 × 20.5 × 2.7 cm). Photo: Stephen White. Courtesy Jay Jopling/White Cube (London).

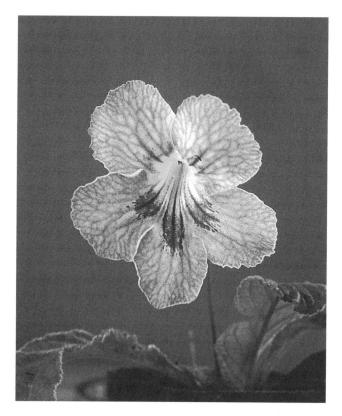

Figure 0.5

George Gessert, *Hybrid 1761*. Streptocarpus hybrid. Hybridized 2002. First bloomed 2003.

Moholy-Nagy's colleague at the Bauhaus). As we move into a world in which technology increasingly shapes cultural sensibility, Moholy-Nagy's true significance becomes progressively clearer to artists, art historians, and the general public. While Moholy-Nagy was committed to a relentless investigation of new technologies in art, he was also deeply dedicated to education and to biological harmony. Botar's research rejects the uninformed view that the artist was a rational formalist and promotes the necessary revision that accurately accounts for the complexity of Moholy-Nagy's vision in motion.

Alexander Fleming, who discovered penicillin in 1928—for which he received the 1945 Nobel Prize in Physiology or Medicine—was also the creator of what he called "germ paintings," that is, images drawn with invisible bacteria directly on paper, which was soaked in the culture medium and grown in an incubator. After growth, the invisible

bacteria became colored lines and surfaces and thus revealed the painted image, which was then fixed with methanol vapor or formalin for display. This is Fleming's palette: Micrococcus varians—white; Serratia marcescens—red; Micrococcus luteus—yellow; Bacillus sp.—orange; Micrococcus roseus—pink; Chromobacterium violaceum—purple. Fleming was also a member of the Chelsea Arts Club, which was founded in 1891 through the initiative of the painter James McNeil Whistler. The Chelsea Arts Club was a private club that accepted artists of all genres. There are no records of Fleming exhibiting his germ paintings at the Chelsea Arts Club, but he did show them in 1933 when George V and Queen Mary came to open new buildings at St Mary's Hospital Medical School in London. The small paintings were often circular because the paper was cut out and placed on the agar in a petri dish. Fleming's text (chapter 26) was originally presented at the Second International Congress for Microbiology, realized in London in 1936. While the paper is concerned with the more general question of producing cultures of microorganisms on paper for scientific audiences, the technique Fleming described was also the base for his germ paintings and is the only text he ever wrote on the subject of painting with bacteria. He did write, however, about the use of paper discs for the preparation of museum specimens of mould cultures and even gave mounted specimens as gifts—what he called "mould medallions."

Ronald J. Gedrim's essay (chapter 27) is a thorough examination of Edward Steichen's genetic art—its main goals, methods, and results, and also its reception in its own time.

Responding to rapid developments in molecular biology in the 1980s, including milestones such as the birth of the first human-conceived transgenic organisms and the creation of mammalian chimeras, Vilém Flusser wrote in "Curie's Children," his column for the magazine *Artforum*, in 1988: "Why is it that dogs aren't yet blue with red spots, and that horses don't yet radiate phosphorescent colors over the nocturnal meadows of the land? Why hasn't the breeding of animals, still principally an economic concern, moved into the field of aesthetics?" Flusser's essay (chapter 28) remains a visionary outlook into the possibilities of a biotech art.

Barbara Stafford (chapter 29) looks at biological metaphors in contemporary art but also sees how larger patterns of technological change (in networking, bioengineering, the physical sciences) can be used to understand aspects of the art created in the late twentieth century and early twenty-first century. She points to the spectacular and performative nature of molecular biology, with its stock market–driven and headline-generating research agendas. Ultimately, she shows how artists working with biomedia can create "an array of kingdom-defying ambiguities."

Last, Yves Michaud refocuses the debate on the specificity of the new art. In chapter 30, he starts by characterizing more traditional biological practices in comparison to contemporary biotechnology, to suggest the passage from an implicit method to the use of precise scientific systems. He sees biotechnological art following a similar path, and he states that

in spite of new media and materials the true accent of the art of today is not in the production of things but in the creation of experiences. Michaud sees biotech art, or bio art, as participating in a larger cultural and artistic trend that he refers to as the "aestheticization of life," a direct application to contemporary art of what Foucault previously called "aesthetics of existence." He states that although science has been directly employed in art before, there are indeed unique qualities to bio art. Michaud concludes with a word of caution regarding its transgressive dimension and its future.

Biofuture

Michaud's Faustian warning is welcome, for it is couched in his personal experience of the bio artworks themselves and springs from a nonalarmist rationality. The fine balance between engagement and critique that bio art crafts enables it to carve an autonomous space, that is, separate from the nearly indistinguishable domains of biotech research and industrial application. By the same token, as an art of evolution, an art of life or existence, it affects, or has the potential to affect, the world in unprecedented tangible ways. The Steichen Strain is still planted today. Will we find Gessert's irises in a catalogue seventy years from now, davidkremers's bacterial paintings evolving new forms, or Menezes's butterflies rendered in germ line variety? Will Symbiotica's synthetic but organic, semi-living stakes become a food industry standard? Will they become NASA's solution to nourishing Mars colonizers, as current space research suggests? Artists working with the tools of the biotechnology age grapple with the complexity of life, that is, the interaction among genetics, organism, and environment. They resist biological determinism and reductionism, and they demonstrate the fragility of the objective edifice of science. They also invent new entities and new relationships never seen before. This book offers itself both as map and terrain.

Notes

1. Michel Foucault, "The Birth of Biopolitics," in *Michel Foucault: Ethics, The Essential Works I*, ed. P. Rabinow, vol. 1 (London: Penguin, 1997), 73–79. In his essay on biopolitics at the end of *History of Sexuality, vol. 1*, Foucault argues in reference to the eighteenth century: "For the first time in history, no doubt, biological existence was reflected in political existence; the fact of living was no longer an inaccessible substrate that only emerged from time to time, amid the randomness of death and its fatality; part of it passed into knowledge's field of control and power's sphere of intervention." See Michel Foucault, *History of Sexuality, vol. 1* (New York: Random House, 1981), 142.

2. Peter Kropotkin, *Mutual Aid: A Factor of Evolution* (Montreal: Black Rose Books, 1989), xxxvii. First published in 1903.

3. Lynn Margulis, *Symbiotic Planet: A New Look at Evolution* (New York: Basic Books, 1998).

4. Richard C. Lewontin, *Biology as Ideology: The Doctrine of DNA* (New York: HarperPerennial, 1993), 10.

5. Horace, "The Art of Poetry," in *Classical Literary Criticism*, trans. Penelope Murray and T. S. Dorsch (London and New York: Penguin Books, 2000), 98.

6. Julien Offray de La Mettrie, *Man a Machine* and *Man a Plant* (Indianapolis: Hackett Pub. Co., 1994), 77.

7. The December 14, 2000, issue of the journal *Nature* featured the sequence and analysis of the completed genome of the flowering plant Arabidopsis thaliana. There are almost 150 genes in Arabidopsis thaliana, or thale cress, which are the counterparts of human disease genes. The sequence of two chromosomes had been published previously: Xiaoying Lin et al., "Sequence and Analysis of Chromosome 2 of the Plant Arabidopsis Thaliana," *Nature* 402, no. 6763 (December 16, 1999): 761; K. Klaus Mayer et al., "Sequence and Analysis of Chromosome 4 of the Plant Arabidopsis Thaliana," *Nature* 402, no. 6763 (December 16, 1999): 769. The December 14, 2000, issue of *Nature* republished both papers together with new ones about chromosomes 1, 3, and 5, and additional articles that explain human homology and the overall significance of this achievement.

8. Augustine of Hippo, *Against Julian*, trans. Matthew A. Schumacher (Washington, DC: Catholic University of America Press, 1992).

9. Part I, Question 3, Article 1, Reply to Objection 2. Aquinas went as far as stating that man has divine authority to kill or do as he pleases with "dumb animals": "Hereby is excluded the error of those who lay it down that it is a sin for man to kill dumb animals: for by the natural order of divine providence they are referred to the use of man: hence without injustice man uses them either by killing them or in any other way: wherefore God said to Noe: *As green herbs have I given you all flesh* (Gen. 9:3). Wherever in Holy Scripture there are found prohibitions of cruelty to dumb animals, as in the prohibition of killing the mother bird with the young (Deut. 22:6,7), the object of such prohibition is either to turn man's mind away from practising cruelty on his fellow-men, lest from practising cruelties on dumb animals one should go on further to do the like to men, or because harm done to animals turns to the temporal loss of man, either of the author of the harm or of some other; or for some ulterior meaning, as the Apostle (1 Cor. 9:9) expounds the precept of not muzzling the treading ox." See Saint Thomas Aquinas, *Of God and His Creatures; An Annotated Translation (With some Abridgement) {of the}* Summa Contra Gentiles *of Saint Thos. Aquinas* by Joseph Rickaby (London: Burns and Oates, 1905), Book 3, section entitled "That Rational Creatures are governed by Providence for their own sakes, and other Creatures in reference to them."

10. This is true mostly in the West, but some non-Western belief systems also espouse related views. In Buddhism, for example, not living a righteous life could result in being reincarnated into what is considered a "lower" life-form, such as a cat or dog.

11. Jorge Luis Borges with Margarita Guerrero, *The Book of Imaginary Beings* (New York: Dutton, 1969), 16.

12. C. B. Fehilly, S. M. Willadsen, and E. M. Tucker, "Interspecific Chimaerism Between Sheep and Goat," *Nature* 307 (February 16–22, 1984): 634.

13. Y. Cao, J. P. Vacanti, K. T. Paige, J. Upton, and C. A. Vacanti, "Transplantation of Chondrocytes Utilizing a Polymer-Cell Construct to Produce Tissue Engineered Cartilage in the Shape of a Human Ear," *Plastic and Reconstructive Surgery* 100, no. 2 (1997): 297–302.

14. Pierre Louis Moreau de Maupertuis, *Essai de Cosmologie; Systéme de la Nature; Reponse aux Objections de M. Diderot* (Paris: Librairie Philosophique J. Vrin, 1984), 11–12. Originally published in Lyon in 1768.

15. Fontana is believed to be one of the artists commissioned by Ulisse Aldrovandi. The young lady in question (whose name was Antonietta Gonsalus) was visited by the naturalist and is also represented in his Monstrorum historia.

16. Edward Steichen, "Delphinium, Delphinium and more Delphinium!," *The Garden* (March 1949).

17. Patrick O'Brian, *Picasso: A Biography* (New York: W. W. Norton, 1994), 143.

18. Personal interview with Sten Hanson in Stockholm on April 27, 2004. The artist's book was first published by Hanson in 1969; a second edition was produced by the artist in 1991. An excerpt of this work was published in the catalogue *Kontextsound*, published on the occasion of the Text in Sound Festival, Stedelijk Museum, Amsterdam, April/May 1977, p. 6. The sound version of the work is included in Sten Hanson, *Text-Sounds Gems & Trinkets* (CD), Firework Editions Records, Sweden, 2002.

19. Francisco Varela, Evan Thompson, and Eleanor Rosch, *The Embodied Mind: Cognitive Science and Human Experience* (Cambridge, MA: MIT Press, 1991).

20. Michel Foucault, *The History of Sexuality, vol. 2: The Use of Pleasure*, trans. R. Hurley (New York: Vintage Books, 1984), 89. Foucault first coined the phrase to suggest that ancient Greeks were more concerned with a general principal of sexual moderation than with the determination of what constitutes proper or perverse sexual behavior.

21. Richard Doyle, *On Beyond Living: Rhetorical Transformations of the Life Sciences* (Palo Alto, CA: Stanford University Press, 1997).

22. Vilém Flusser and Louis Bec, *Vampyrotheuthis Infernalis: Eine Abhandlung samt befund des Institut Scientifique de Recherche Paranaturaliste* (Göttingen, Germany: European Photography, 1987).

23. Humberto Maturana and Francisco Varela, *Tree of Knowledge: The Biological Roots of Human Understanding* (Boston, MA: Shambhala Publications, 1992), 94–117. Originally published as *El Árbol del Conocimiento* (Santiago, Chile: Editorial Universitaria, 1984). See also Francisco Varela, Evan Thompson, and Eleanor Rosch, *The Embodied Mind*, 200–205.

24. "Ready-made" is an art form invented by Marcel Duchamp that consists, essentially, in the appropriation of an existing object and its placement in the context of art (e.g., an art gallery) so as to enable the object to be experienced in novel ways, separate from its original functional context. A classic example is Duchamp's *Fountain* (1917), which is a urinal displayed on a pedestal. Conceptual art is an art form that gives precedence to ideas over objects, to concepts over form, to process over product. A classic example is Joseph Kosuth's *First Investigations* (subtitled *Art As Idea As Idea*) (1966), a series that includes photostats of dictionary definitions of words such as "meaning" and

"idea." Situationism is an art movement that emerged in 1957 in Paris and in other European cities that defended the political and experiential dimension of art, to the point of proposing to surpass art and cause actual social and personal change. The best known example of situationist work is Guy Debord's book *The Society of the Spectacle* (1967). Social sculpture is a concept proposed by Joseph Beuys in 1979 that, like the situationists before him, inflects art politically by stating that "everyone is an artist," and, therefore, everyone should participate in the process of molding and shaping the world.

I

Biotech Culture

Open Source DNA and Bioinformatic Bodies

Eugene Thacker

OS

The high-profile role of computational biology—or "bioinformatics"—in the mapping of the human genome has increasingly meant that biology is becoming indissociable from computer science. In addition, the so-called post-genomic fields, such as proteomics, structural genomics, and pharmacogenomics, are all contingent upon the latest developments in computer hardware and software.[1] Though there are a great number of free, online software tools available to researchers, there are an equal number of software packages, database tools, and hardware components created and marketed exclusively for molecular biotechnology research, creating a new niche market for the computer industry. A familiar illustration of this tension was played out in the mapping of the human genome, in which an international "public" effort, under the acronym IHGSC (International Human Genome Sequencing Consortium—the UN of biotechnology), was pitted against Celera Genomics, a private corporation whose stated challenge to the public project grabbed many headlines.[2] As we know, the "race" to map the human genome ended in a draw, with government and corporation shaking hands at a national press conference. In this way, the real "winner" of the race to map the human genome was not federally-funded life science research, nor was it the entrepreneurialism of a biotech company. The real winner was an IT company, such as Perkin-Elmer, whose automated genome sequencing computers—used by both teams—were instrumental in enabling the genome to be sequenced at such a rapid rate.

This is a high-profile portrait of the role computers are playing in the biotech industry. But computer technology also manifests itself in a lower-profile manner, in direct contrast to the Big Science projects like the human genome. A popularized example of this was revealed in the post-September 11 events surrounding bioterrorism and anthrax. News

reports expressed a new anxiety surrounding the human genome project: biotech terrorism. The worry was (and is) that the freely available information from the human genome project, along with a range of accessible computer tools and simple lab biology techniques, might lead to a new kind of bioterrorist. This bioterrorist would theoretically be able to utilize software tools on a standard PC and genetically target potentially thousands of individuals by engineering novel strands of anthrax-derived viruses. Although the anthrax attacks that followed September 11 showed no verifiable sign of being genetically engineered through computers (though one investigation revealed that the biological specimens were ordered online), what remains relevant is the way in which such events heightened tensions surrounding the status of the human genome as being either public or private. In the context of such anxieties, the increasing ubiquity of computers in biotech research has prompted government-sponsored organizations in the United States and United Kingdom to explicitly state their concern over the possible use of the human genome for what amounts to low-intensity bioterrorism.[3]

We begin by noting a simple trend: computers in biology. We note that, in this trend of associating computers with biology (bioinformatics), there are both high-profile and low-profile instances. But we end by raising questions that have as much to do with politics as they do with computer science or molecular biology. Should the data generated by research on the human genome be made public or private? If the human genome is considered to be in the "public domain," how do we insure that that information is not used to harm others? Moreover, who are the individuals or groups best prepared to make such decisions?

These political questions are, upon further inspection, inseparable from ontological questions. What is the relation, exactly, between files of As, Ts, Cs, and Gs in an online database, and my living body? How could a computer affect my DNA? Here bioinformatics implicitly philosophizes. On the one hand, a genome database is nothing but a series of files, those files storing, among other things, long strings of data (bits representing A, T, C, G—the molecular building blocks of DNA). From this perspective—computers as representation—the genome database is a little like an anatomical map or encyclopedia: It tells you about the general rules, but little about the exceptions to the rule. On the other hand, a genome database does not exist in a vacuum. It is created for a range of specific applications, from gene targeting in drug development, to genetic diagnostics for disease predispositions, to serving as a reference for genetic engineering research. The areas of agriculture, "pharming," health insurance, and health care are already being slowly transformed by such databases. From this perspective—computers as materialization—the genome database is not just a map or encyclopedia, it is more like a body hammer.

Beneath the political questions—should the human genome be public or private?—are a set of ontological questions that have to do with how "life" is being constituted and reconstituted at the molecular-informatic level. The question, then, is not whether or not the human genome should be in the public domain. The question is rather how the practice of genomics—both federally and corporate-funded—is implicitly redefining the

terms in which we are made to understand biological "life." The question isn't whether patenting genes is morally reprehensible, it is how our notions of property, subjectivity, and embodiment have been transferred to the domain of codes, databases, and patterns.

Such questions are daunting, but nevertheless worth thinking through. Note that I am not claiming to make any statements about the scientific validity or technical accuracy of biotech research itself. Nor am I interested in applying any overarching moral categories to the biotech industry. I am, however, interested in understanding the logic of what goes under the umbrella term "biotechnology." In pursuit of this, I want to consider biotechnology research as a set of practices or, better, as a set of gestures and articulations, which strategically recontextualize biological components and processes in novel (non-natural, artificial, instrumental) ways. Such gestures, practices, and material articulations are also, I want to suggest, statements about biological "life." What exactly is put forth about biological life differs, of course, from context to context, from subfield to subfield. We need not limit ourselves to press releases, interviews with scientists, or pop science books to grasp the articulations of biotech research. We can see implicit or explicit concepts forming concerning biological life in the very artifacts of biotech research: genome databases, gene discovery software, DNA chips, protein modeling software, and novel genetic drugs.

Bio-Logics

Let us take the example of bioinformatics. The field of bioinformatics has had a deep impact on progress made in genomics and post-genomic fields. However bioinformatics— simply defined as the integration of computer science into molecular biology research—is unthinkable without a complex history of viewing the basic units of biological life as "information."[4] The common notions of a genetic "code" derive from a tradition in molecular biology (indeed, a tradition that is molecular biology) of appropriating concepts from cybernetics and information theory into the biological sciences. Bioinformatics software can be seen to extend this tradition, culminating in an informatic view of biological life. As a number of cultural theorists have pointed out, this combination of informatics and biology is itself noteworthy because the technical term "information" has traditionally been conceived of as disembodied and immaterial.[5] But bioinformatics does more than repeat the borrowing of informatic and computational metaphors for biology; it creates databases, it models potential compounds based on data analysis, it synthesizes molecules and identifies key pathways through computational work. Data in (e.g., your blood sample) is recoded into data out (e.g., a disease profile based on your DNA and medical history). Data out is decoded and linked to your body (e.g., prescription of pharmaceuticals or gene-based therapies derived from your disease profile).

It appears that the well-worn divide between the digital and the material, between the technological and the biological, has been complicated by research fields such as bioinformatics. It is one thing to borrow informatic concepts from other fields in order to help

explain the results of biology research; it is quite another to materialize modes of working upon biological components and processes based on a computational, informatic paradigm. Though one implies the other, it appears that bioinformatics takes the notion of a genetic "code" quite literally—as something that can be digitized, ported to other platforms, and modeled in a variety of ways. What does a consideration of bioinformatics show us? That, like the earlier paradigms of molecular biology, it too utilizes informatic concepts, thereby assuming the separation of form and content (DNA is a code, and can thus be encoded into a database). However bioinformatics also reserves the right to modulate that DNA-as-code (a re-coding procedure), as well as to define the material output of that code (a decoding procedure). From an ontological standpoint, bioinformatics wants it both ways: It wants the "portability" that comes with conceptualizing DNA-as-code, and it wants the benefits of conceiving of code as material, able to beneficially affect "real" bodies of patients. Information is both immaterial (we can create an online database), and material (the database will help your body heal).

If one were to make generalizations based on fields such as bioinformatics, one could say that contemporary research in molecular biotechnology can be characterized by the following ontological assumptions: First, there is an ambivalent commitment to a residual "genetic reductionism." This genetic reductionism places a great deal of emphasis on DNA, genomes, and specifically "genes" as key components of molecular biotech research. Such an emphasis can be linked to the emergence of what Lily Kay calls "scriptural" metaphors of the organism during the 1950s, when molecular biology's "central dogma" was articulated by Francis Crick and others.[6] As I've mentioned, part of what characterizes this shift is the importing of concepts from informatics, rendering the organism as a molecular code. It might be better to call this not a scriptural but a scripting metaphor, in the sense of a computer scripting language such as Perl. The contemporary fields of genomics, proteomics, and pharmacogenomics—even stem cell research—all emphasize the centrality of genes as a foundation or reference point without which research cannot take place. To do proteomics without some reference to genomes and genes is thus unthinkable, even though the issues of protein-protein interactions, for instance, are qualitatively different from those of gene regulation. Despite the de-emphasis in current research on genes and genecentric theories, the gene, genome, and DNA still occupy a central place in molecular biology. Has the gene become "decentralized" in molecular biology? Is there room for it to become "distributed"? This is a tension that has not been fully addressed.

This tension is connected to a second assumption, which regards the role of technology in research. The cycles of technological development and scientific progress pose a question of origins: Does technology propel science research (and if so, does it determine it?), or does science research provide the occasion for technology development? On the one hand, Big Science projects like the human genome project generate a flood of data, data to be assembled, annotated, analyzed, modeled, and so on. The rise of bioinformatics as an industry is unmistakably linked to the proliferation of data from various genome projects.

On the other hand, what has enabled genome projects to generate all that data has been the integration of computer technology into the molecular biology lab, a gradual process that is still taking place (it is now difficult to find a molecular biology lab without at least one PC). Perhaps the question is less about origins, and more about understanding the dual mediation between technology development and biology research. In-lab computer technologies can be seen to enable networked bioinformatics software via the intermediary of "wet" genomes. Likewise, "wet" human genomes can be seen to enable genetically designed pharmaceuticals via the intermediary of computer and information technologies such as the Internet. The larger question here is whether are we seeing a complexification of our understanding of biological life, or a series of technical solutions to biological problems.

I have perhaps been too general here, characterizing the human genome project or biotech "industry" as a single entity. This brings up a third point, which is that, far from being a homogenous "Big Science," biotechnology is highly diversified and heterogeneous. "The" human genome is not a single database, but a cluster of semi-autonomous databases housed at universities, biotech companies, and independent research institutes. In fact, because any computer user can, if he or she so wishes, download the entire genome, "the" human genome is probably more distributed than we can guess. In addition, the human genome efforts have been accompanied by the recording of a number of population-specific genomes, genomes of various organisms, and even databases of genome anomalies such as repeat sequences and other "polymorphisms." This diversification has both bioscientific and bio-economical benefits. From the scientific perspective, a network of interlinked databases creates a more adaptive, flexible environment which can make possible a greater "customization" of the biomedical use of the genetic data (for diagnosis, prescription, designing clinical trials). Diversification also enhances the industry of biotechnology, making for a wide range of services for both researchers and potential patients. To borrow Michael Hardt and Antonio Negri's terms, the "informatization" of biology thus leads to a unique kind of "immaterial labor" that is characterized by the bioinformatic analysis, modeling, and materialization of genetic data.[7]

To reiterate: The purpose of pointing out the foregoing assumptions is not to show that "the body" is rendered immaterial nor that biotech companies have privatized genetic data. The point is to understand the thread or threads that connect one to the other, that connect ontological statements about the bioinformatic body with the regulation and control of genetic data, the connections between ontological statements about what a body can do (it can be encoded, databased) and the political attributes of those bodies in relation to notions of property (our clones, our selves), value (medical and/or economic value), and power (biology as technology). A number of theorists working in science studies have emphasized the importance of thinking at both ontological and political levels when addressing biotechnology. For instance, Cathy Waldby's notion of "biovalue" points out the ways in which unique modes of biological and medical-economic potentiality are accorded to "natural" entities such as stem cells.[8] Similarly, Adrian Mackenzie's notion

of "transduction" points out the ways in which information technologies in bioinformatics provide instances of materialization between property and corporeality.[9] What these studies suggest is that the headline topics concerning human cloning, stem cell research policy, and gene discoveries are issues which take place at the terminal ends of the discourse. If we backtrack a little, we see that the general questions ("should we allow experiments on human embryos?") are tied to specific scientific, institutional, and political-economic contexts (e.g., engineering of human embryonic stem cell lines for research in regenerative medicine), and those contexts are connected to philosophical issues (e.g., is the instrumentalization of organic matter the instrumentalization of "life"?).

From Biotech to Biosystems

I have by no means covered the whole of molecular biotechnology research in this discussion. While the foregoing assumptions—residual reductionism, informatic instrumentality, diversification—do characterize much of biotech research, there is a significant amount of research which explicitly counters such assumptions. Independent research groups, such as the Institute for Systems Biology, the Alliance for Cellular Signaling, and the Biopathways Consortium, as well as many research labs at universities, have each in their own way been exploring a systems approach to genomic and post-genomic science. Along with new types of databases of molecular interactions, such as the EMP (Enzymatic and Metabolic Pathways) and BIND (Biomolecular Interaction Network Database), this "systems biology" proposes an alternative way of understanding the organism at the molecular level, without over-emphasis on individual genes or genomes.[10]

Such systems biology approaches display a commitment to a nonreductive, nongenecentric view of the organism, while not foregoing the scientific traditions of molecular biology, genetics, and biochemistry. This means that, while the study of genomes and the identification of individual genes is part of the systems biology approach, there is equal emphasis on gene regulation, protein-protein interactions, and multi-component networks in cellular metabolism and cell signaling. In other words, process and interaction become the starting points for research, rather than identification of individual, discrete genes. Such a focus on process and interaction implies a wider view of the living cell and, indeed, the organism. This is, therefore, a holism, yet one which begins and ends at the molecular level. The primary interest in systems biology research is not whether a particular gene is "responsible" for the synthesis of a particular protein, but how a given phenotype can be understood as the outcome of a set of heterogeneous molecular processes and interactions. Instead of the targeting of individual, quasi-agential genes, systems biology attempts to identify possible "pathways" that culminate in the production of a protein or a given molecular event (such as coordinated expression of a region of a genetic network, enzymatic reactions in cellular metabolism, or protein receptor interactions in membrane signaling).[11]

While these aspects of biological regulation—gene expression, cell metabolism, signaling—are common to any molecular biology textbook, what makes the systems biology approach unique are two things: It begins from a consideration of systems-wide processes, and from there considers individual genes or proteins (not vice versa); and, this research is mobilized by the use of computer and information technologies. These two characteristics are interconnected. The use of genome sequencing computers, DNA microarrays, computerized sequencing, online data mining, and a host of other techniques enables systems biology research to integrate what would normally be widely divergent data sets. Instead of adapting information technologies to the terms of molecular biology (which is itself built upon informatic concepts), the systems biology approach re-adapts biology to the terms of information processing and networking. In a sense, we can see systems biology approaches as an effect produced by the layering of computing and networking technologies onto processes and interactions of biomolecular regulation. Indeed, complexity researchers such as Stuart Kauffman have long noted the networking features of gene expression (or "Boolean genetic networks").[12] Systems biology therefore combines and integrates the technologies of biotech research into a means of re-articulating the organism as a system: not just gene expression, but a genetic network; not just protein synthesis, but transcription pathways.

Systems biology approaches are equally influenced by the informatic heritage of postwar molecular biology, but in a different way. If, as we saw above, mainstream biotech research realizes DNA-as-data, then systems biology may be seen as an actualizing of genetic information as process and interaction. Mainstream biotech research, in its practices of cataloguing the genome and searching for novel genes, conceives of information first as a static entity, and second as an entity that can be transmitted. It thus linearizes information, somewhat along the lines of information transmission and circulation in information theory and cybernetics. Systems biology, on the other hand, in its effort to identify pathways and interaction networks, conceives of information first as an action, and only secondarily as a static entity. For mainstream biotech, a molecule first exists, and then it does something; for systems biology, a molecule is first a process or interaction, and its static existence is only a secondary effect of its dynamic nature.

While this seems to be a more interesting approach in theory, we should note again that both mainstream biotech and systems biology research re-articulate the organism via informatics and information technologies (though in differing ways). The question here is whether systems biology really does provide a more "complex" view of the organism, or whether it is simply offering technological solutions to biological and biophilosophical problems. That is, in the integration of heterogeneous technical systems (genome sequencing computer, microarray analysis, etc.), and in the reliance on advances in computing technology (including supercomputing initiatives), does systems biology conflate the "complex" with the "complicated"?

An answer to this question might be found by highlighting another problematic. Systems biology approaches state that what will be of central importance to them in their research is not genes, but processes and interactions, pathways and networks. But the emphasis on genes as both discrete entities and as targetable entities is precisely what the biotech industry is founded upon. The primary output of the mainstream biotech industry is heavily genecentric, despite the public relations rhetoric to the contrary. Gene-based therapies, genetically designed pharmaceuticals, and DNA diagnostics form the three central areas of economic concentration in the biotech industry (excluding laboratory technologies).[13] The systems biology approach seems to harbor within itself a tension: on the one hand, a more nuanced emphasis on systems-wide views, processes and interactions, and, on the other hand, the ability to offer products and services for research and clinical trials in medical applications.

The tension arises in how systems biology will articulate "information" and "complexity." From a medical-therapeutic standpoint, the systems biology approach amounts to attempting to administer the butterfly effect as a therapy, a kind of medicine-as-chaos approach. However, chaos is not complexity, and the systems biology approach has attempted to straddle this line between genecentrism and complexity by favoring experiments which perform "systematic perturbations" to a given pathway or network (e.g., local interventions, global effects—in theory . . .). But even this middle-ground approach still confronts the medical-economic issues of how such research can be turned into therapy, and whether such quasi-entities as interaction networks and pathways can be patented and/or put into a pill.

From Biosystems to Bio Art

As we've seen thus far, mainstream biotech research and research based on systems biology adopt different approaches to the study of biological life. But they are also united in their view toward high technology, and the necessary link between technological development and bio-knowledge. It is this reliance on technical solutions to biological problems that I want to focus on here, for it can lead to the problematic instance of rendering our knowledge of the body as being indissociable from an instrumental approach (specifically, an informatic instrumentality). While the systems biology approaches provide a possible alternative to more conventional genecentric theories, the perhaps undue reliance on high technology raises a set of questions that belong more to the domain of political philosophy: If the genome is a system, a network, a set of pathways, does this topological organization extend to the organism? Does it extend to the "self"? If "action" (we could even say "degrees of freedom") within the genome is highly distributed and highly coordinated, does this notion of agency extend to the subject? Finally, if the genome is indeed a "complex" system, how do we situate ourselves as panoptic observers of this system?

Such questions are not only highly abstract and theoretical, but also very far removed from the immediate concerns of life-science research. Perhaps what is needed is a means of taking up such questions from within the concerns of the lab, but in a way that is immanently ethical, philosophical, and political. It is for this reason that the notion of "bio art" may be helpful in addressing and problematizing issues that are traditionally seen to lie outside the domain of empirical life-science research. The term "bio art" has been used in a number of contexts, broadly referring to art projects which involve some intersection between art and biology.[14] Such intersections can be as simple as traditional art forms which take up issues in biology; they can involve collaboration between artists and scientists; or they can involve the incorporation of the tools and techniques of biology research. In general, bio art usually refers to art works which take the biological as their medium (instead of paint, clay, or video).

Certainly, bio art projects can do a great deal to contribute to the discourse on biotechnology. From a theoretical standpoint, bio art can create contexts in which provocative, controversial issues can be raised. From a pedagogical standpoint, bio art can do much to increase awareness of key ethical and political issues in biotechnology by making science accessible to a non-specialist public. From a political standpoint, bio art can also play a role in fostering a critical attitude toward biotechnology. Finally, from the institutional standpoint, bio art can participate in the more general art-science trend of breaking down the divisions between the "two cultures."

But it is also important to acknowledge that the notion of bio art is equally fraught with problems and inconsistencies. Too often bio art is assumed to be either reflection or commentary; that is, bio art either serves as science's mirror, reflecting and reduplicating two versions of the same idea, or it serves as commentary, coming after the fact of science. If bio art is to be truly interdisciplinary, then the context in which it is seen is crucial. The setting of the art gallery is simply a shift from one specialist environment to another. Making science accessible to "the public" may have good intentions, but the project of making contemporary art accessible to the public is controversial. In this sense, a reconsideration of the kinds of publics involved, and what counts as "specialist," is worthwhile. The problematizing of context is crucial, because without it, bio art risks replaying the tired narrative of recuperation of the avant-garde.

This question of context is already at stake in the institutional-corporate nexus of art and science. A number of pharmaceutical companies and life-science research institutes are aware of the benefits of cultural outreach programs, and are sponsoring art exhibits, public debates, and science fairs.[15] This is not necessarily a problem in itself, but bio art risks becoming public relation for corporate science in such venues. Or vice versa: What is often understood as "art" from within the sciences tends toward pure visual aesthetics when enabled by technology. Science becomes PR for art in the coffee table microscopy book—a kind of representational notion of art that is really only one part of the heterogeneity of contemporary art.

Technophilia is both seductive and myopic, and biotechnologies are no exception. Because so many of the technologies used in biotech research are expensive and nonubiquitous, gaining access to such tools and techniques can be very difficult. As with any set of learned skills associated with tools, biotechnologies effect a kind of privileged "membership" status upon their users, a status that can overwhelm the intellectual labor involved in conceptualizing a project. Too often we have seen art-technology projects which have done something simply because it could be done technically. This is not a Warholian gesture; in fact it is the opposite. Perhaps there is something to learn from the examples of video, installation, computers, robotics. If bio art's content is also its medium, then a critical view of technophilia is as important as an engagement with the tools and techniques of biotechnology.

Toward Post-Media

If there is a tendency for biotech research to offer technical solutions to biological problems, then we can say that bio art can similarly risk offering technical solutions to social and cultural problems.

In such situations, it might be helpful to consider another, not unrelated, example, in which an emerging technology interfaces with a range of users. Though most histories of the personal computer include accounts of the home-grown beginnings of Apple and Microsoft, a thorough sociological account of the "computer hobbyist" movement has yet to be written. When mentioned, this movement is often seen simply as a predecessor to the eventual formalization of the personal computer and software industries.[16] The stereotypes associated with the computer hobbyism of the early and mid-1970s—mostly male, white, middle-class, computer and electronics geeks—are themselves indicators of the problems of considering hobbyism as a social movement. In addition, while computer hobbyism did occasionally cross over into the post-hippie "computer lib" movement, hobbyism was, from the beginning, a niche market. Despite the rhetoric of DIY "kits" and inexpensive high technology, computer hobbyism was a specialized market that was able to grow—with the aid of Apple, Commodore, Tandy, IBM, and others—into a market for the "general purpose computer." Most histories relate the transformation of the computer from room-sized military mainframe (ENIAC) to office-sized business machine (IBM) to personal home fixture ("PC").

My question—a question with which I will end—is this: Will the PC happen to biotech? If so, what would such a technology be like? The question, "Will the PC happen to biotech" seems almost impossible, if not at least strange, to consider: What use could a personal genome sequencing computer, PCR, or gel electrophoresis have for the average person? Or perhaps the biotech PC will not be silicon-based at all, but a biomolecular modification in vitro, or in vivo? Perhaps the first biotech "killer app" will not be in the domain of medicine or agriculture, but in consumer biometrics or even video games?

Eugene Thacker

An argument can be made here concerning technological development (an art-for-art's sake for computers) as preceding its application. Things are built, and uses (or needs, or markets) can always be created for them. A genome project which generates endless amounts of data necessitates further technological development to analyze that data, which necessitates advances in modeling and simulation to transform that data into viable drugs and therapies, and so on. Computer hobbyism is worth a cautious consideration in this context, because, while it was certainly a niche market, its primary interest lay not in use or need but in development, a kind of participatory development. And we know what later happened to computer hobbyism: Apple, Microsoft, and the general acceptance of black box technologies.

Perhaps there are ephemeral instances of Félix Guattari's "post-media" here that we can learn from. Recall that, for Guattari, new technologies afford a range of new "existential territories" which are amenable to canalization (as objects, tools, commodities, and black boxes).[17] As opposed to the consensus of technological instrumentality, Guattari asks how a "dissensual" post-media might occasion that ontological zone we've been speaking of, in which the indissociability of ontology, ethics, and politics is taken as a starting point. "Complex" approaches to the study of biological life may be a starting point, as are bio art and a critical approach to knowledge-production, though these are not without their difficulties. In a context such as ours, in which genomes are databases, patients are disease profiles, and "life" is property, a zone in which questioning is facilitated is crucial. In such terms, what would it mean to conceive of a "biotech hobbyism" and of DNA as open source?

Notes

1. For more on bioinformatics see Diane Gershon, "Bioinformatics in a Post-Genomics Age," *Nature* 389 (September 27, 1997): 417–418; Ken Howard, "The Bioinformatics Gold Rush," *Scientific American* (July 2000): 58–63; Aris Persidis, "Bioinformatics," *Nature Biotechnology* 17 (August 1999): 828–830.

2. For popular accounts see Matt Ridley, *Genome* (New York: Perennial, 1999), and Jeremy Rifkin, *The Biotech Century* (New York: Tarcher/Putnam, 1998).

3. This has been a stated concern of U.S. and U.K. governments prior to September 11; see British Medical Association, *Biotechnology Weapons and Humanity* (Amsterdam: Harwood Academic Publishers, 1999); U.S. Department of Defense, *21st Century Bioterrorism and Germ Weapons* (New York: Progressive Management, 2001).

4. This is illustrated in the technical literature dealing with bioinformatics. See Pierre Baldi and Soren Brunak, *Bioinformatics: The Machine-Learning Approach* (Cambridge, MA: MIT Press, 1998); and Andreas Baxevanis et al., eds., *Bioinformatics: A Practical Guide to the Analysis of Genes and Proteins* (New York: Wiley-Liss, 2001).

5. See Richard Doyle, *On Beyond Living* (Stanford, CA: Stanford University, 1997); Katherine Hayles, *How We Became Posthuman* (Chicago: University of Chicago, 1999); Eugene Thacker, "Data Made Flesh: Biotechnology and the Discourse of the Posthuman," *Cultural Critique* 53 (Winter 2003): 72–97.

6. See Lily Kay, "Cybernetics, Information, Life: The Emergence of Scriptural Representations of Heredity," *Configurations* 5, no. 1 (1997): 23–91.

7. Michael Hardt and Antonio Negri, *Empire* (Cambridge, MA: Harvard University Press, 2000), 280–300.

8. Cathy Waldby, "Stem Cells, Tissue Cultures and the Production of Biovalue," *Health* 6, no. 3 (2002): 305–323.

9. Adrian MacKenzie, *Transductions: Bodies and Machines in Speed* (London: Continuum, 2002).

10. On systems biology see Leroy Hood, "The Human Genome Project and the Future of Biology" (1999), http://www.biospace.com; and Hiroaki Kitano, ed., *Foundations of Systems Biology* (Cambridge, MA: MIT Press, 2001). Also see the Web site for the Institute for Systems Biology (http://www.systemsbiology.org).

11. For a proof-of-concept paper on systems biology, see Troy Ideker et al., "Integrated Genomic and Proteomic Analyses of a Systematically Perturbed Metabolic Network," *Science* 292 (May 4, 2001): 929–934.

12. See Stuart Kauffman, *The Origins of Order: Self-Organization and Selection in Evolution* (New York: Oxford University Press, 1993), 411–440.

13. For current news on the biotech industry see Bioinform (http://www.bioinform.com), Biospace (http://www.biospace.com), and Recap (http://www.recap.com).

14. For a diverse range of approaches to bio art, see Oron Catts and Ionat Zurr, "Growing Semi-Living Sculptures: The Tissue Culture & Art Project," *Leonardo* 35, no. 4 (2002): 365–370; Critical Art Ensemble, *Molecular Invasion* (Brooklyn: Autonomedia, 2002); Natalie Jeremijenko, "OneTree: Complexity and Complex Representations," artist's homepage (1999), http://cat.nyu.edu/natalie/OneTree/OneTreeDescription.html; Eduardo Kac, "Transgenic Art," *Leonardo Electronic Almanac* 6, no. 11 (1998), http://mitpress.mit.edu/e-journals/LEA.

15. Such programs have been sponsored by companies such as Novartis (http://www.novartis.co.uk/visions_of_science.shtml), as well as public relations organizations such as the Gene Media Forum (http://www.genemedia.org), and research institutes such as the Wellcome Trust (http://www.sciart.org).

16. Computer hobbyism is briefly mentioned in William Aspray and Martin Campbell-Kelly's *Computer: A History of the Information Machine* (New York: Basic Books, 1996), and Paul Ceruzzi's *A History of Modern Computing* (Cambridge, MA: MIT Press, 1998). Ceruzzi points to the loose affiliations between hard-core geeks and the West Coast "computer lib" ideologies.

17. See Félix Guattari, "Regimes, Pathways, Subjects," in *Chaosophy: Soft Subversions*, ed. Sylvère Lotringer (New York: Semiotext(e), 1996), 112–130.

Ornamental Biotechnology and Parergonal Aesthetics

Gunalan Nadarajan

Weep not. Behold the true greatness of our age, that it can no longer bring forth ornament. We have vanquished decoration and broken through into an ornamentless world.

—Adolf Loos, "Ornament and Crime"

It is fascinating to note that what Adolf Loos announced so triumphantly in the beginning of last century seems to have become somewhat obsolete in this century, for the ornament has made successful returns in architecture and contemporary art practices. This essay seeks to show how the very same discourses and practices that undermined the notion of the ornament in modernist art and architecture have been renovated today to operate as ethical neutralizers within contemporary biotechnological research and development of ornament in nature. After a brief overview of the modernist position against ornament, especially in relation to color, I will deliberate on how the relationship between the natural and the ornamental provides a platform for examining the return of the ornament in what could be called ornamental biotechnology, which is the research into, manipulation of, and genetic engineering of life forms for ornamental purposes. The essay will conclude with an analysis of how artists working with biotechnological manipulations of animals provide a critical evaluation of ornamental biotechnology.

Ornament, Modernism, and Color

The foundational argument for what has come to characterize the modernist tendency to deemphasize the aesthetic value of ornamentation seems to derive from Immanuel Kant in his "Critique of Judgment." Kant argues that an aesthetic judgment, just like a logical one, is usually complicated by the presence of what he calls "judgments of sense," where

one's assessment of an object of beauty is affected by questions of whether that thing is agreeable or disagreeable. Kant proposes that a genuine "judgment of taste," however, should not be based on such issues as agreeableness since they are incidental and not fundamental to such assessments. He claims, "a judgment of taste ... is only pure so far as its determining ground [*Bestimmungsgrunde*] is tainted with no merely empirical delight [*Wohlgefallen*]. But such a taint is always present where charm and emotion have a share in the judgment by which something is to be described as beautiful." According to him, qualities such as color and tonalities are elements that are *added* [*hinzukommen*] to the object of beauty but the design and composition of these qualities are what constitute "the proper object of the pure judgment of taste." These qualities are considered to be secondary to what comes to be perceived as beautiful since their contribution is to make the form more "intuitable [*anschaulich machen*] and ... stimulate the representation by their charm, as they excite and sustain the attention directed to the object itself." As an exemplification of this secondary logic of that which adds to without constituting the fundamental form, Kant proposes the role of the ornament. He states that ornamentation [*Zierathen*] is "only an adjunct, and not an intrinsic constituent in the complete representation of the object" since the latter affects our judgment of taste "only by means of its form" (Kant 1911, 65–68).

Derrida, in an excellent assessment of Kant's notion of aesthetic judgment, identifies in Kant one more instance in the long history of attempts to distinguish between what constitutes the proper referent for aesthetic judgment and what does not. Derrida says that this drive to "distinguish between the internal or proper sense and the circumstance of the object being talked about—organizes all philosophical discourses on art, the meaning of art and meaning as such, from Plato to Hegel" (Derrida 1987, 45). He suggests however that such attempts presuppose and are sustained by what he calls "a discourse on the limit between the inside and outside of the art object" (Derrida 1987, 45). This secondary operation that holds a tenuous link with the art object without quite becoming it Derrida refers to as *"parergon"*; that which works alongside the work [*ergon*] while remaining separate and fundamentally different from it. Derrida argues that for Kant the parergon is "that which is not internal or intrinsic, as an integral part [*als Bestandstuck*], to the total representation of the object but which belongs to it only in an extrinsic way as a surplus, an addition, an adjunct, a supplement" (Derrida 1987, 57). Derrida points to the fact that Kant, despite his anxiety to excise the parergonal from that which constitutes the ergon of the work so as to facilitate pure aesthetic judgment, also had a conception of what could be called a good or successful parergon. Derrida notes that for Kant, "the parergon can augment the pleasure of taste, contribute to the proper and intrinsically aesthetic representation if it intervenes *by its form* and only by its form." However, if "it is not beautiful, purely beautiful, i.e., of a formal beauty, it lapses into adornment [*Schmuck*] and harms the beauty of the work" (Derrida 1987, 64). But it is important to note that Derrida identifies in the parergon a capacity for deconstructive operations insofar as it promises to dis-

rupt and frustrate efforts at separation of what constitutes the work from what it is not, even as it issues from the anxiety to undertake such demarcations. He characterizes its liminal status thus: "[A] parergon comes against, beside, and in addition to the *ergon*, the work done [*fait*], the fact [*le fait*], the work, but it is does not fall to one side, it touches and cooperates within the operation, from a certain outside. Neither simply outside nor simply inside" (Derrida 1987, 54). This deconstructive potential of the parergon is invoked to unsettle some of the problematic implications of contemporary invocations of the ornament in biotechnological research later in this essay.

It is now useful to see how the ornament figured within modernist discourses and practices. The modernist diatribe against the ornament has been led by many theorists and practitioners. I will highlight Adolf Loos and Le Corbusier, who have been most influential. Adolf Loos is considered by many to have written one of the most damaging statements against ornament in art and architecture in his 1908 essay, "Ornament and Crime." In this essay, Loos bemoans that while architects and designers at the turn of the century had a tremendous range of material and structural possibilities opened up by technological advancements, their creative practices were still paying reverence to historical genres of ornamentation. Loos hypothesizes that "the evolution of culture is synonymous with the removal of ornament from objects of daily use" (Loos [1908] 1985, 101). It is noteworthy, however, that his argument was not so much against ornament as such but against ornamentation that obfuscated the functionality of the object and/or covered over the complexity of the supporting structure.

Le Corbusier, whose own notion of ornamentation was informed by that of Loos, identified color as one primary enunciation of ornamentation to be systematically exorcised from art and architecture. Le Corbusier stages his argument against ornament thus: "Law of Ripolin, Coat of Whitewash: elimination of the equivocal. Concentration of intention on its proper object. Attention concentrated on the object. An object is made out of only necessity, for a specific purpose, and to be made with perfection" (Le Corbusier 1987, 188). Ripolin is a French paint company, very well known in France, that started production in 1881. The argument is clearly informed by the Kantian notion of what constitutes the proper object of aesthetic attention and judgment. The *Law of Ripolin* that calls for the removal of color in favor of whites is clearly an economizing gesture that sought to excise from and minimize in the proper object of architecture all that merely embellishes without contributing to its functionality.

Amedee Ozenfant and Le Corbusier first propounded their framework for a genre of painting called Purism in a 1920 essay, in which they argued that color is not entirely useful for the proper appreciation of other formal qualities, especially since it "strikes the eye" earlier than other formal elements. They proposed that some colors are inherently more amenable to the construction of volume in painting—they even classified colors according to how far they disrupt the formal qualities of painting. The Purists divided color in terms of a hierarchy of sensations—specifically with reference to scale—as *major,*

dynamic, and transitory. They claimed that "painting is a question of architecture and volume is its means. In the expression of volume, color is a perilous agent" (Jeanneret and Ozenfant 2002, 239). As such they believed that the use of certain colors could upset the volumetric architecture in painting. They classified colors therefore in relation to the degree to which they could upset volume. They suggested, and themselves constantly used, what they termed colors of the major scale—ochre yellows, reds, earths, white, black, and ultramarine blue—since they "keep one another in balance." The dynamic scale consisting of citron yellows, oranges, vermilions, Veronese greens, and light cobalt blues were advised against as they give "a sensation of a perpetual change of plane" thus constituting "disturbing elements." It is noteworthy here that the perpetual change provoked by these colors was thought to introduce too much variability, which was considered detrimental to the Purist search for the universal and therefore invariable. It is interesting that these notions of color-denied architecture gained currency not only in the theory of architecture but in actual practice (Ozenfant 1952, 38–42).

Ornament and Nature

> No matter how divorced from nature a freely invented decorative form may seem, the natural model is always discernible in its individual details.
> —Alois Reigl, *Problems of Style: Foundations for a History of Ornament*

It is necessary now to reflect on how the ornamental relates to the "natural" so as to better prepare for the transition to the subject matter of this essay: ornamental biotechnology. There has been a historical tendency to develop ornamentation that simulates and/or abstracts from natural objects and processes. The history of the discourses and practices of ornamentation has been constant witness to the debates on how the ornamental should relate to the natural—whether ornaments should faithfully represent the wondrous creations of nature ipso facto or if a more humble response to the incredible beauty and sophistication of natural things could be arrived at by simply abstracting them. In this section of the essay, the specific notions of nature articulated with reference and contraposition to ornament will be examined in the context of a brief overview of the discourses and practices of ornamentation from the mid-eighteenth century through the modernist era.

While the association between ornamentation (which served for many centuries as the principal referent of the artistic impulse) and nature has been embodied and deliberated on by thinkers and artists before, the most intense debates on the ornament per se proliferated during the eighteenth through early twentieth centuries. William Dyce, one of the first people to systematically teach about the relationship between nature and the ornament in the 1840s, described ornamental design as "a kind of practical science which investigates the phenomena of nature for the purposes of applying natural principles and results to show some new end" (qtd. in Durant 1986, 26). The works of A. W. Pugin and of

Owen Jones, two other advocates of the natural ornament, suggested that while ornamentation references nature it should seek to develop conventionalized means of representing nature rather than mimic it. John Ruskin, however, condemned conventionalization of nature through ornament as disrespectful of the divine order and beauty of God-created nature. He claimed, "The proper material of ornament will be whatever God has created; and its proper treatment, that which seems in accordance with or symbolical of His laws" (qtd. in Durant 1986, 27).

While the debates as to what constituted the proper relationship between ornament and its natural referent remained somewhat undecided throughout these times, the relevance of nature as a reference for ornamentation was taken for granted. Thus, where the ornament survived it did so by way of it serving, even if tenuously, as an embodiment of nature. This *ornamentalization of nature* seems to be related to several factors, namely, a scientific rationalism that permeated the natural sciences, thereby converting nature from divine mystery to a set of scientifically verifiable phenomena; the systematic exploitation of natural resources facilitated by its demystification through science and necessitated by a rapidly developing industrialization; and, finally, the proliferation of industrialization and technologies of mass production that deemphasized the object handcrafted from natural materials. It is no surprise to note that most ornaments that reference nature have gone through conventionalization as geometric forms abstracted from nature; the very nature that an ornamentation derives from is seldom if ever readily apparent in the final form.

As noted earlier, the Industrial Revolution, saw a simultaneous proliferation of ornamentation and of the celebration of nature. The ornament, which had until then been the most conspicuous marker of social and economic status, became more accessible to a larger segment of society. The mass production techniques promoted by industrialization also made possible the mass manufacture of ornamented goods. It is noteworthy that in many of these industrially made products the ornament has a striking presence. Some of the earliest designs for technologically novel objects from the Industrial Revolution are ornamented. Adrian Forty, in his groundbreaking analysis of the socio-cultural concomitants of design, *Objects of Desire*, notes that in an effort to engender greater acceptance of the then novel sewing machines, manufacturers resorted to "incorporating animals or cherubs" as ornamental finishes to these machines, which were thus "intended to appeal through their idiosyncrasy" (Forty 1995, 99). Ornamentation seems to have become strategically employed in facilitating the psychological transition from handcrafted objects (that were necessarily ornamental) to industrially manufactured and relatively novel objects. It is interesting also that animals have served a similar function of enabling the transition to new technological objects by being metaphorically associated with them; sometimes the association being enunciated by or as ornamentation. This *animalization of technology*, where the increasing proliferation of instrumental technologies is domesticated by the trope of the animal, is also noted by Lippit who claims, "The idioms and histories of numerous technological innovations from the steam engine to quantum mechanics bear

the traces of an incorporated animality...Cinema, communication, transportation and electricity drew from the actual and fantasmatic resources of dead animals" (Lippit 2000, 187). It is possible thus to speculate that the animal and the ornament (and therefore also the "animal ornament") have historically sustained a semblance of the "natural" within environments that have come to be increasingly marked out in counterposition as "artificial." However, what happens when the ornament is natural? *What happens when the ornament is the reference for the creation of the natural?*

Ornamental Biotechnology

> What flashes red, yellow and green, stops people in their tracks, but is not a traffic light? Answer: The zebrafish at the Underwater World Singapore, of course! The genetically-modified creatures have taken a research team from the National University of Singapore (NUS) four years of breeding to show off their three shades. They are now going with the swim of things exclusively at the Underwater World, the first aquarium in the world to exhibit transgenic fish created with genes from another organism—in this case, the fluorescent protein genes of the jellyfish and the sea anemone. And its creators at NUS are getting ready to splash more colors to *the zebrafish palette*. But *apart from presenting a pretty picture*, these mutant fishes are potential detectors of cancer-causing agents or environmental pollution.
> —Sylvia Low, "GM Glow-fish a Transgenic Coup for NUS"

The preceding quotation from the main newspaper in Singapore symptomizes some of the most important aspects of the discourses of ornamental biotechnology. Singapore is one of the world's largest producers and exporters of ornamental fish and ornamental orchids. For a land-scarce, tiny island like Singapore, tropical aquaculture and ornamental horticulture are not the most obvious economic strategies. However, historically this city-state in Southeast Asia has played an active role in tropical fish and orchid breeding programs in the region and thus developed key infrastructure and expertise in them. It is especially interesting that in recent years the government has identified biotechnology as a key economic activity and has invested billions of dollars in developing strategic industries in this field, including biomedical industries, bioinformatics, ornamental fish breeding, and ornamental horticulture. The article cited here notes that the transgenic zebrafish are not merely for "presenting a pretty picture" but also useful as biosensors for carcinogenic agents and environmental pollution. There seems to be an underlying anxiety that the ornamental qualities alone are not adequate to justify such transgenic experiments. The biomedical and environmental uses of the transgenic fish are presented almost as if they were redeeming features of what could potentially be construed as an ethically problematic action given its trivial pursuit of a "pretty picture." In this section of the essay, the primary discourses and practices of ornamental biotechnology are introduced using the example of the ornamental animal.

Ornamental life forms have been historically created by selective breeding of varieties to cultivate qualities that have appealed to us for some aesthetic dispositions and values (e.g., bushy tails, drooping ears, large eyes, colorful skin, slender body). It is fascinating that through a variety of discourses and practices, too many and too complex to be enumerated here, cultures have historically maintained distinctions between those animals bred for ornamental purposes and those bred for instrumental reasons such as for food and labor. While certain aesthetic qualities may be noted in the instrumentally bred animals, their distinction with regard to animals kept for ornamental and/or social reasons are seldom compromised. There are the occasional instances of animals bred for food being reclassified and maintained as pets (most delightfully presented in the hugely successful film *Babe*), but there is little evidence that animals are allowed to belong to both categories of ornamentation and instrumentality simultaneously. In some sense then, pets and potted plants are the most distinctive and common of the ornamental life forms (e.g., toy dogs and roses) inhabiting our own contemporary lives.

Biotechnological research into and development of ornamental life forms are relatively new phenomena compared to the long history of selective breeding. While there are many who problematically argue that there is no real difference between these practices insofar as both are manipulations of the genetic make-up of animals and plants, it is useful to note that there are several differences between them, the principal ones being the time it takes for a desired genetic expression to take effect; the accuracy and extent of genetic transfer; and, finally, the dangers of the accelerated shrinking and contamination of the existing gene pool. Biotechnological research in ornamental plants, especially for cut flowers, is usually focused on developing new techniques for transformation and regeneration, and on the introduction of selected foreign genes or changing endogenous gene expression by some form of genetic engineering. While some of such research has focused on selectively engineering aesthetic characteristics such as flower color, shape as well as more instrumental characteristics of longevity, plant habit, and resistance to diseases and insects, the majority of biotechnological research on ornamental plants is still on altering flower color and shape. In Singapore, biotechnological research on flowers is most heavily focused on orchids and involves more tissue culture engineering than genetic manipulation.

In terms of ornamental animals, the specific subject of this essay, it is noteworthy that almost all selection criteria employed are phenotypical and therefore readily apparent physical features. For example, in the conventional breeding of guppies (*Poecilia Reticulata*) in Singapore, males are selected for the following: vigor; large size; presence of vivid and uniform colors; absence of deformities like odd shaped fins, hunched back, etc.; streamlined shape; specific tail shapes like fan, delta, swordtail, round, etc. Females are selected for large size and appearance of some coloration on fins. The typical broodstock management of guppies involves several processes. Adult fish from stocking tanks, aged between four to six months, are selected and employed in broodstock to produce about four to six broods before they are replaced by a new batch of breeders. A typical brood size is about

thirty to eighty offspring, depending on the age and physiological condition of the mother. From the broodstock, careful and intensive selection of traits favored by the markets for these guppies, for example, color and fast growth, is made. Such selection means, of course, that there is a culling process in every broodstock where some are selected to be put out for sale or killed, while the best ones are selected to become breeders for more of their kind.

The ongoing biotechnological research in ornamental fish (though not necessarily on guppies) in Singapore, as seen in the article cited in the beginning of this section, tends to center on the selective propagation and engineering of certain aesthetic features such as colors and fin shapes in a variety of fish. The ornamental fish industry in Singapore, a major portion of its production being for export worldwide, is growing at a rapid pace, and there is a constant need to create new varieties of fish with sufficiently distinguishable aesthetic features. The designation, *zebrafish palette*, referred to in the news article cited above, signals this conflation of the discourses of aesthetics and economics by representing the supposedly infinite permutations possible and necessary with the same basic genetic material. The growing global market demand for ornamental fish is bound to lead to more genetic manipulation of ornamental fish in order to deliver the greatest variety in the least amount of time. The future proliferation of greater varieties of all such ornamental animals seems inevitable. It is interesting, though, that such research is presenting itself as ethically neutral or nonproblematic because the genetic manipulation is considered to be nonintrusive and superficial. The phenotypical transformations of these creatures are framed as not fundamental to their genetic constitution insofar as they do not cause any major complications to or affect the "essential functions" of the animals. In fact, some breeders have even suggested that the increased color varieties of the ornamental fish would improve their chances of breeding due to them becoming more attractive to their mates. This, however, is a problematic argument since it assumes that the color ranges that have been selectively bred for human pleasure would appeal to the fish, which have entirely different perceptual apparatus. It is noteworthy, though, that this positing of color as an ornamental feature that is secondary and not fundamental to the formal constitution and functionality of the object it is adhered to is similar to that of the modernist discourses presented earlier. The very same discourses that established the nonessentiality of ornament in order to relegate it in modernism are being used to ethically justify the creation of ornamental animals. And insofar as the nonessential quality of ornamentation has been retained in this new articulation in ornamental biotechnology, it is still fundamentally modern.

Parergonal Aesthetics

In conclusion, the essay presents the possibility of critically positioning oneself within and with reference to ornamental biotechnology through the works of artists Marta de Menezes

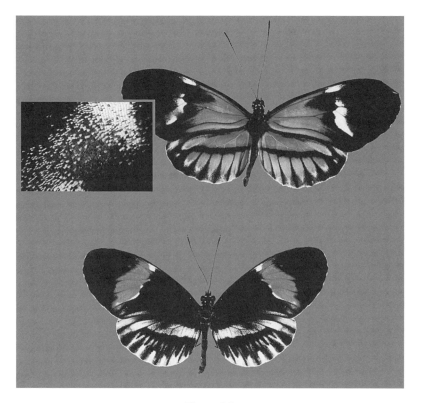

Figure 2.1

Marta de Menezes, manipulated *Heliconiu* butterfly left wing patterns, 1999. The artist sought to create butterflies that had the qualities of the natural and the human-made in one single entity.

and Eduardo Kac, who employ various biotechnologies to intervene in the ornamental constitution of animals. It is argued here that these artists enunciate *parergonal aesthetics*, where the ornament is deployed in order to unsettle notions of essentiality and functionality with reference to natural entities.

Marta de Menezes, a Portuguese artist, as one of her art works, manipulated the patterns on the wings of certain butterflies. She purposefully modified the natural patterns on one wing each of the *Bicyclus* and *Heliconius* butterflies (figure 2.1). By this gesture she sought to create butterflies that had the qualities of the natural and the man-made in one single entity. Her manipulations involved "adding, changing or deleting eyespots and color patches" as well as "highlighting of particular aspects of the natural wing—for example, the removal of the outer rings of an eyespot to show simply the white centre of it."

In sum, all her manipulations were phenotypical and ornamental in the modernist sense of the term. She claims,

> [I] simply aim to explore the possibilities and constraints of the biological system, creating (inasmuch as it is possible) different patterns that are not the result of an evolutionary process. It has also been my intention to create unique butterflies. The changes are not at the genetic level, and the germline is left untouched. As a consequence, the induced modifications are not transmitted to the offspring. Each modified butterfly is different from any other. (Menezes 2000)

Menezes's work enunciates the ornamental logic by opting for phenotypical changes that do not affect the germline and thus the genotype of these and subsequent generations of butterflies. However, she does not do it in an attempt to ethically neutralize her aesthetic manipulation of the butterflies' wings. Her work enacts a complication of the natural and the artificial through the parergonality of her manipulations, which simultaneously mimic and deviate from natural patterns.

Eduardo Kac's work, *GFP Bunny*, also named *Alba* (figure 2.2), has become one of the most important icons of the transgenic animal created through genetic engineering. Kac worked with a team of genetic engineers to create a transgenic fluorescent rabbit containing *green fluorescent protein* (GFP) extracted from a jellyfish. It is noteworthy that his work was not the mere creation of the transgenic rabbit but also encompassed

> 1) an ongoing dialogue between professionals of several disciplines (art, science, philosophy, law, communications, literature, social sciences) and the public on cultural and ethical implications of genetic engineering; 2) contestation of the alleged supremacy of DNA in life creation in favor of a more complex understanding of the intertwined relationship between genetics, organism and environment; 3) extension of the concepts of biodiversity and evolution to incorporate precise work at the genomic level; 4) interspecies communication between humans and a transgenic animal; 5) integration and presentation of "GFP Bunny" in a social and interactive context; 6) examination of the notions of normalcy, heterogeneity, purity, hybridity and otherness; 7) consideration of a non-semiotic notion of communication as the sharing of genetic material across traditional species barriers; 8) public respect and appreciation for the emotional and cognitive life of transgenic animals; 9) expansion of the present practical and conceptual boundaries of artmaking to incorporate life invention to be carried out over three phases. (Kac, qtd. in Dobrila and Kostic 2000, 101–102)

It is fascinating to consider the broad aims and implications of the work when the primary gesture and the most readily apparent aspect of the work is its fluorescence—an ornamental feature. The fact that *GFP Bunny*, the most talked about artwork of recent times, derives its primary aesthetics from a surface phenomenon is surely worthy of note. Kac

Figure 2.2

Eduardo Kac, *GFP Bunny—Paris Intervention*, 2000. Posters, 11 × 17 in (43 × 28 cm) each. In 2000 Kac scattered these posters all over Paris as part of a public campaign in the city.

has provided through this work a complex example of the parergonal aesthetics referred to earlier. The parergonal feature of color has, in fact, in the GFP Bunny, become the central feature of the work.

The discourses and practices involving the biotechnological manipulation and generation of life forms has been commonly justified by an ethics of consequentialism, where the means are justified by the ends being good and justifiable. By way of this ethical reasoning, scientific research into manipulation and creation of life forms is justified by the fact that the ends this research serves is noble—that is, it ultimately saves lives and contributes to the betterment of life. However, such arguments are based on assumptions of what is properly fundamental to life and what is not—curing a person's illness is just and therefore biotechnological research that furthers this cause is justified, while making a beautiful creature as a result of such research is not entirely justified (unless of course if the aims are not only to create a pretty picture and therefore potentially useful for other *more important* aspects of life). The works of artists such as Kac and Menezes complicate such distinctions between the fundamental and the secondary, the natural and the created, as well as of the scientific and the artistic, through a parergonal aesthetic that suspends and obfuscates such categories.

References

Derrida, Jacques. *The Truth in Painting*. Translated by Geoff Bennington and Ian McLeod. Chicago: The University of Chicago Press, 1987.

Dobrila, Peter Tomaz, and Kostic, Aleksandra, eds. *Eduardo Kac: Telepresence, Biotelematics, Transgenic Art*. Maribor, Slovenia: Association for Culture and Education, Kibla Multimedia Center, 2000.

Durant, Stuart. *Ornament: From the Industrial Revolution to Today*. New York: Overlook Press, 1986.

Forty, Adrian. *Objects of Desire: Design and Society since 1750*. New York and London: Thames and Hudson, 1995.

Jeanneret, Charles-Edouard (Le Corbusier), and Amédée Ozenfant. "Purism." In *Art in Theory 1900–2000: An Anthology of Changing Ideas*, 2nd ed., edited by Charles Harrison and Paul Wood, 239–242. Malden, MA: Blackwell Publishers, 2002.

Kant, Immanuel. *Critique of Aesthetic Judgment*. Translated by James C. Meredith. Oxford: Clarendon Press, 1911.

Le Corbusier. *The Decorative Art of Today*. Translated by James Dunnet. Cambridge, MA: MIT Press, 1987.

Lippit, Akira Mizuta. *Electric Animal: Toward a Rhetoric of Wildlife*. Minneapolis: University of Minnesota Press, 2000.

Loos, Adolf. "Ornament and Crime." In *The Architecture of Adolf Loos*, edited by Yehuda Safran and Wilfred Wang, 100–103. London: The Arts Council, [1908] 1985.

Low, Sylvia. "GM Glow-Fish a Transgenic Coup for NUS." *Straits Times Singapore*, http://straitstimes.asial.com.sg, May 25, 2001.

Menezes, Marta. "Nature?" http://www.aec.at/festival2000/texte/nature_e.htm, 2000.

Ozenfant, Amedee. *Foundations of Modern Art*. Translated by John Rodker. Mineola, NY: Dover Publications, 1952.

Reigl, Alois. *Problems of Style: Foundations for a History of Ornament*. Translated by Evelyn Kain. Princeton, NJ: Princeton University Press, [1891] 1992.

3

Embodying the Chimera: Biotechnology and Subjectivity

Bernard Andrieu

"Chacun d'eux portait sur son dos une énorme Chimère" [Each one of them carried on his back an enormous Chimera].
—Baudelaire, *Le Spleen de Paris*, bk. VI

Until the end of the seventeenth century, the monstrous body had a mythological function: A sign from irate gods, the monster (Kapler 1980) is not malformed like Oedipus's twisted foot/fate, it is a prodigious creature whose corporeal formation endows it with superior power. However, one must differentiate between fabulous monsters, whose corporeal hybridization remains paradoxical, and biological monsters studied as early as Hippocrates in *Of Generation*, X-I, and Aristotle in *Of the Generation of Animals*, Book IV. Greek mythology includes fabulous monsters, human bodies that have been recomposed with animal attributes such as wings, serpents, and boar tusks for Steno and Euryale (transformed by Athena owing to Medusa's jealousy), and Medusa, lover of Poseidon and expecting his child also transformed by Athena). Losing or disfiguring its human body defines the fabulous monster as a fall. On the other hand, the chimera is born with a triple animal body, a sort of multiform and polycephalous beast uniting multiple forms in one body (Plato, *The Republic*, bk. IX): lion-headed and dragon-tailed on the body of a goat. Yet specific unity is not maintained, as in the embodiment of Cerberus, the dog with three heads and a tail of snakes (figure 3.1). Cerberus remains a dog when a chimera represents three juxtaposed species. The chimera is a malefic creature whose next of kin are Echidna (half snake, half nymph), Geryon, the three-bodied giant, Medusa (serpent-haired and stony-eyed), Scylla (six claws, mouths and heads, and the roar of a lion) as well as the Sphynx endowed with a maiden's head and breasts, lion claws, and a dragon tail on a dog's body.

Bellerophon, queen Stheneboea's would-be lover, was exposed to her husband as he spurned her. The king then ordered him to rid the country of Chimera, a fabulous creature

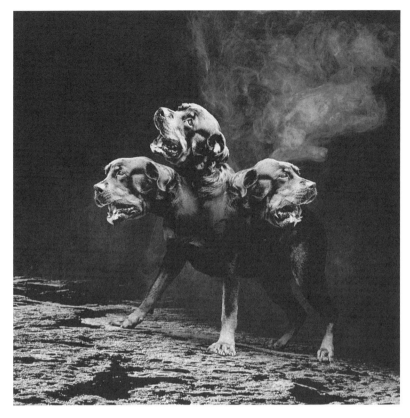

Figure 3.1
Milton Montenegro, *Cerberus*, 1999. QuadBlack inkjet print on Arches paper, 16.3 × 16.3 in (41.5 × 41.5 cm) edition of 10. © Milton Montenegro. Courtesy of Tepper Taka-yama Fine Arts.

born from the monstrous giant Typhon and the viper-bodied nymph Echidna, and who was, according to Homer (*The Iliad*, bk. VI), lion from up front, dragon from the back and goat in the middle. The breach of the laws of hospitality here rests on the adulterous desire felt by the queen for Bellerophon who, in her eyes, had the bad taste of refusing her. The queen was scared by this representation of an object of desire refusing itself to whom desires it. Bellerophon owes his confrontation to Chimera's body to this impossible hand-to-hand combat. All hold his death as certain, but the fabulous creature gives him the opportunity of an initiatic trial. Bellerophon is the child of Poseidon and the queen of Ephyra; he owes his name to his murder of Belleros, tyrant of Corynth, which freed the town. With the help of a gift from the goddess Athena, he manages to tame the winged

horse Pegasus. Then, zeroing in on the monster, he makes a nosedive: Chimera spews flames in defense, but Bellerophon seals its mouth with a leaden ball that melts under the heat, and stifles it to death.

Admittedly, the chimera can be used as a scapegoat as opposed to the unicorn, an emblem of purity and virginity in the Middle Ages. Yet the unicorn is a fabulous animal whose corporeal coherence makes it appealing, the equine body not being too remote from the deerhead bearing its sole horn. The chimera is a mixture of species—lion, goat, and dragon, that inverts the natural order by producing a paradoxical being. It is not an internal metamorphosis of the body, but a complex body. It is not a denigration of the corporeal form as much as an interrogation, through its presence, of the constitution and origin of corporeal identity. The chimera is not a hybrid in the sense that a mule is the hybrid of a donkey and a mare.

In ridding Corynth of Chimera, the mythical body of the semi-god triumphs over the chimerical body through the mastery of fire. Sexuality lies at the heart of the chimerical body insofar as Echidna may be Typhon's sister. The body of the semi-god (armed, it must be said, by Athena, daughter of Zeus whose limbs were temporarily bound by a triumphant Typhon before his destruction by the king of gods) refuses adultery and slays the incestuous daughter Chimera. Morals end up untainted, but the paradigm is set. As Françoise Duvignaud stresses: "The beast always lies close, reminder of a former order. Witness Typhon, monster amongst monsters, whom Gaia to no avail summons as a final attempt of mind perversion. Zeus, ever the bright spark, eventually destroys Typhon, but not before the latter, in a monstrous mating with Echidna, has begotten a progeny that will become the scourge of the centuries to come: Chimera, the Sphynx, Medusa and Scylla" (Duvignaud 1981, 21).

By adopting this technique given by Zeus, the sublunar world can hope to hold sway over the impurity and the malignancy of the chimerical body which cannot last or reproduce, not only because of its incestuous origin, but also because its make-up is heterogeneous.

According to the science historian Jean-Louis Fischer, it is as late as "1830 that Geoffroy Saint-Hilaire gives the science of monsters its name of teratology. As an object of science, the monster becomes an object of comparison, of reflection in the field of embryology as well as in the elaboration of the transformist theories that preceded the theories of evolution" (Fischer 1991, 38). Bellerophon's victory soon is a prodigy no more; it sets the study of chimeras at the heart of the technical domination without which a human being cannot be held as the peer of a God. The chimera is a trial to initiate humans to the dark side of creation: There is no creation without anomaly, there are no creatures without monsters, no whole bodies without mixed bodies.

The chimerical body raises the problem of identity. How can one be such a body, at the same time a lion, a dragon, and a goat? The harpy is part woman and part bird (figure 3.2). A monster is its body flaw, which is to say it sends us back to natural anomalies.

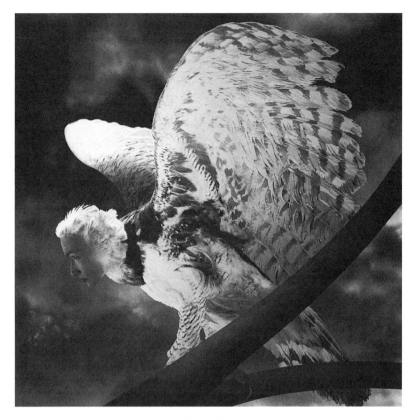

Figure 3.2

Milton Montenegro, *Harpy*, 1997. QuadBlack inkjet print on Arches paper, 16.3 × 16.3 in (41.5 × 41.5 cm) edition of 10. © Milton Montenegro. Courtesy of Tepper Takayama Fine Arts.

From Mythical to Scientific Chimera

In science, a chimera is an organism composed of two sorts of cells with different genetic origins, stemming from two different zygotes. Nature generates some chimeras without human intervention. Vegetal chimeras are made of interlocking tissues with genetically different structures, such as the apple tree, the maple, or the sansevieria (an agave-related species). Human chimeras are the result of chromosomal anomalies: Thus the dizygotic twin, whose sibling is usually stillborn, is transfused with hematopoietic tissue (bone-marrow) from the latter, harboring in this way two blood populations from different groups. The human chimera therefore is not the intermediate body of a Prometheus, a Faust, or a Frankenstein.

Bernard Andrieu

The imaginary relations that biological sciences have with the nature of the human body put a cast of evil on the changed body. Science may have sold its soul to the devil by preferring genetic immortality to the human condition. Unlike the chimera's body, metamorphosis does not uphold the double biological way, it only transforms the corporeal form, even if the hero's soul is damned: Prometheus is gnawed by his fault, Faust is sold to the devil, and Frankenstein is haunted by his origins. The metamorphosis is not a metanoia, which is to say, a conversion enabling the soul to turn away forever from the shadows in the cave in order to follow the stages of a dialectic ascending toward Truth. The changed body, as opposed to the chimerical body, claims to have done away with otherness whereas it remains inside it to give it identity. Metamorphosis is a failed chimera. The chimera upholds the Same and the Other within a unique double body, for the chimera is double—not a Doctor Jekyll and Mister Hyde, but a biological being whose double identity is always identifiable whenever identity alternation is necessary in the case of a split personality.

Jacqueline Carroy (1993) has illuminated the many historical affinities shared by the myth of split personality and the science vs. occultism schism that motivated many scientists at the end of the nineteenth century. The biological chimera rests upon what Olivier Pourquié calls, in his presentation of Nicole Le Douarin's works, a "substitution of homologous territories" rather than upon the parallelism of complementary identities. The chimerical body contains both quail cells and chicken cells; "the embryo chimera obtained in this way develops normally and the quail cells that compose the neural tube as well as the derivatives of the neural ridge that migrate from the neural folds can be identified through Feulgen-Rosszenbeck's nuclear coloring" (Pourquié 1995, 42). Identifying the cells stemming from the transplant can be done regardless of the state of differentiation of the cells. Fusion is incomplete for the chimera as it maintains the Different within the Same. One needs to follow the migration of the different within a unit without the latter disappearing: each is telltale of the other.

Yet the model of the chimerical body belongs to a contemporary fantasy, that of developmental biology. Winkler created the first vegetal chimeras in 1907: These heteroplastic grafts consisted of the paired cells from two different species without their respective hereditary potentials being modified. The chimera can not transmit its somatic state as long as one does not tinker with germinal cells.

The Chimera's Transplanted Body

At the beginning of the twentieth century, the scientific model of the chimerical body showed the transplanted body as the representation of the modern subject. Through transplants, the subject was able to step into the technical possibility of building a body while giving it an identity.

Chimerical biology was born when Mathieu Jaboulay (1860–1913) and Alexis Carrel (1873–1944) attempted their first grafts, respectively in 1906 and 1908. For any patient receiving a transplant, there remains the problem of the tolerance of the chimerical body. In this respect, Christian Cabrol prophesied:

> By 2015, it would be good for this tolerance to be obtained in all cases, in the wake of the transplant, for the receiving organism to accept two sorts of organs, its own and those transplanted.—But that's what was formerly called chimerism!—Indeed! In Ancient Greece the chimera was a fabulous animal showing the characteristics of different species, e.g., a human torso on a horse's body for centaurs [figure 3.3]. Understanding the mechanisms of tolerance would be an undeniable breakthrough on the way to the complete success of transplants, sparing the host the drawbacks of an immunodepressing treatment and the liability of chronic rejection leading to the progressive destruction of the transplant. (Cabrol 1995, 148)

The host must incorporate the Other into his own identity in order to live on. He never wholly becomes a chimera because of the technological contribution of an organ alien to the body per se. This technological contribution keeps the transplant within the frame of the mechanical body. As David Le Breton, the body sociologist, makes it clear: "Whenever symbolism deserts the body, there indeed remains of the latter but a set of wheels, a technical organization of interchangeable functions" (Le Breton 1993, 274–275). If this objectification of the body does have a part in ending the incarnate man of Christianity, it also points to a new relation of the subject to living matter. The transfiguration of the body defines a mode of incarnation that is subjective and not metaphysical anymore: Only the subject now wants to go beyond his body by defining it as a complex network of elements grafted together.

In biologist and philosopher Michel Tibon-Cornillot's eyes,

> chimerical animals, plants or bacteria herald the engineering of a new biological nature in which one can decipher anew an order of purposes which, in some way, have replaced the old providential ends that had carefully been expelled from the world. The emergence of these new beings, transgenics and chimeras, is set within such violent anthropocentrism that their presence really would not be a problem. (Tibon-Cornillot 1992, 232)

For all that, these new "rational-imaginary" objects are not virtual objects. They belong to the biological compatibilities allowed by nature even if not produced by nature itself along the course of its evolution. Even if chimeras depend mostly on scientific production, they stem from human understanding of life's mechanisms.

The legitimacy of this production should not be questioned. Like philosopher Max Marcuzzi, one can, of course, see "artificial bodies" in these productions, and assert that

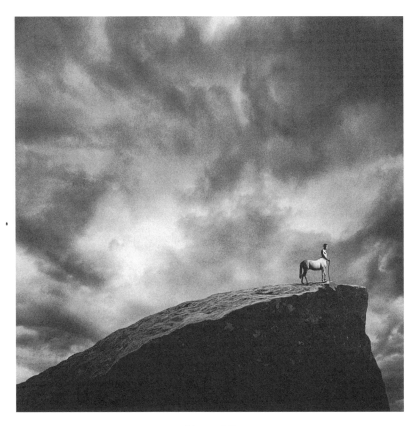

Figure 3.3

Milton Montenegro, *Centaur*, 1998. QuadBlack inkjet print on Arches paper, 16.3 × 16.3 in (41.5 × 41.5 cm) edition of 10. © Milton Montenegro. Courtesy of Tepper Takayama Fine Arts.

Teratology is biology in its widest form, and ontology in its strictest form; but above all, the lack of an absolute reference or harmony, whether divine or natural, that could be held as an objective and constant norm, there is no other norm left but the individual from which to decide what is or is not an aberration, and thus also to decide what makes the body, and what form it can have. (Marcuzzi 1996, 176–177)

Chromosomal aberrations and anomalies are, however, an essential dimension of living matter. The life sciences have always studied these countermodels in order to understand the reverse effect of nature's mirror through the two-way mirror of experience and experiment. What makes the chimera topical is not fashion as much as the definition of a new

world, in which the natural human being's essence is material to the point of coercing the body, fitting it with prostheses and grafts.

Transgenic Chimeras and Biopower

The use of biotechnologies feeds the illusion of an uncastrated body, a body within which we could be both one and the other, masculine and feminine. Patrick Baudry, a sociologist, understands the yearning to abolish all limitations as a figure of the "body extreme" (Baudry 1991, 1996) in that stepping over these limitations would entail the body's disappearance. Yet from the point of view of the life sciences, this extreme relation to the self accomplishes itself through mutation. Individual use of one's body resulting from an ideological conjunction of liberalism and biology empowers the subject of our time to transform not only the state but also the nature of his body.

To be sure, bioethical laws in several countries do now put a ban on human transgenesis because of the immorality of fiddling with our hereditary genetic patrimony, but for how long? All in vitro interventions should create nothing other than mosaic chimeras in order to ensure life through a therapeutic modification of the somatic cells with no definitive intervention on the germinal cells. Positive eugenism is thus proscribed, returning the human transgenic chimera to the position of literary object; yet negative eugenism does surround us: Anyone will admit that eliminating genetic diseases when selecting embryos for in vitro fecundation is very convenient to avoid necessitating abortion or having to raise a seriously handicapped child. Anomalies are eliminated from the start, thus recomposing the human chimera through the purification of the quality of its patrimony. At the beginning of our century, metamorphosis turns into a mode and a fashion of change of appearance, all too often confused with a change of being. Truism triumphs but the analogy with the human body remains dominant. By betting on all possibilities one does loosen the notion of being without asking the fundamental questions on the implementation of transgenesis. Discarding the human body is less an ecstasy than a final parting from one's initial genetic patrimony. Is not the wish to end the castration imposed by our genetic identity an acknowledgement of our species' self-loathing, or the evidence of our forgetfulness of the genetic mutations inflicted on the children of Chernobyl or Hiroshima? The human body will become a genetic chimera when, like animals and plants, humans have finally replaced the myth of Genesis and the Fall by that of transgenesis. In the 1946 second preface to his 1931 novel *Brave New World*, Aldovs Huxley described this revolution in the following terms: "The truly revolutionary revolution will take place, not in the outside world, but in the soul and flesh of human beings" (Huxley 1946, 12). Individual corporeal change is not enough anymore; a change of species would be in order.

If the eighteenth century was the century of the transvestite, and the end of the nineteenth century that of the hermaphrodite, as Michel Foucault stated in 1980, we still need

to find out what the theme of the chimera heralds in its pervasion of the beginning of the twenty-first century. Under the conditions described by Foucault, the human chimera would not leave the choice of his sex to the individual. It would be the logical consequence of the ideological link instituted by biopower between sex and truth: Having a real sex is not understood by the human chimera as the reduction of social sex to biological sex. Truth reaches here its biological acme by merging both sexes into one, the couple incarnated into a sole genetic unit. Having become transgenic, humans will have no more choice: Science will decide upon the validity of the body, health or economy once more being used as alibis. By committing itself to transgenesis, transgenetic research has become a French national priority, which comes down to asking Foucault's initial question: "Do we really need a real sex?" (Foucault [1980] 1994, bk. IV, 116). The chimera may be the last figure of a real sex, biotechnologically engineered as a whole, providing at last the negation of castration through the demiurgic integrity of creation.

To Everyone Their Chimera

The body has become a sign of identity where it once was but a modality of social appearance and surface (Le Breton 2002). Appearance is out, embodiment is in. The refusal of dualism is not as much expressed by a wish to bid the natural body goodbye as by the creation of a body of one's own. Through a body of his own, the subject can model form, but also matter itself: Marking the body is the first mode of this subjectification of the body, and genetic manipulation offers the possibility of shaping a humanized matter. Identity is building itself a cultural form through technological means. The cult of the body not only develops freedom of the self, it has also become self-cultivation and self-culture. If the capitalist system carries on maintaining subjectivity within the indefinite dividuation of the body by renewing its commodification, the consumer is tempted to consume himself in this circulation.

Within this mainstream liberal ideology, a body of one's own is held as an individual body in which we should only delight. Such consumerist hedonism satisfies the human body up to the excesses of obesity and high-risk behaviors. Once the body has become itself, the individual can also subjectify it by personalizing it rather than withdrawing into individualism. Corporal decoration fits into the pattern of expression when subjectification attempts to incarnate the subject in the very matter of the body. Being is not an essence, either exterior or transcendental to the subject. Sartre managed to reduce human essence as a whole to existence: I am, I am but my actions. Existentialism was to find privileged modes in feminism and worldly embodiment. The gender and the modes of their incarnation drew every man and woman into an identity struggle for the acknowledgement of corporeal existence. Being carnal consisted in directly incarnating one's existence through identity intensification as well as cultural exaltation. The cult of the body has been superseded by its culture and cultivation. The latter create their corporeal values in the subject's

very matter: his or her sex and sexuality, his or her actions, his or her genes or brain. Liberation of the body has led to an intense yearning for the incarnation of a chimerical body.

By using both biology and phenomenology, my notion of the incarnation of the subject or that of the embodied mind is similar to Francisco Varela's founding work. By suggesting to start from the "lived body" to account for cognition, the notion of incarnation (or embodiment) no longer has the dualistic meaning of Christian tradition. Spirit (the mind) is now present through the body that produces it. According to Varela, a compromise should now be reached, studying cognition neither as the reconstitution of a preordained exterior world (realism), nor as the projection of a preordained interior world (idealism), but as embodied action: "By using the term *embodied* we mean to highlight two points: first, that cognition depends upon the kinds of experience that come from having a body with various sensorimotor capacities, and, second, that these individual sensorimotor capacities are themselves embedded in a more encompassing biological, psychological, and cultural context" (Varela, Thompson, and Rosch [1991] 1993, 234).

Let us find the link between biology and phenomenology that Maurice Merleau-Ponty long looked for: *enaction* shows how cognitive structures emerge from the recurring sensorimotor schemes that guide action through perception. The phenobiotechnology of subjectivity is not the new unified science, but an interknowledge: Everyone wants an incarnate body.

A Phenobiotechnological Subject

The wish for a chimerical body is now only limited by biotechnological fantasy. Deciding that a wholly bio-artificial body might not be compatible with bioethical norms and laws would be to forget the biosubjectivity ensured by the progress of technological medicine. The individual interest of one human being invoking his right to live in a dignified body would legitimize research on artificial life. Supposing we could shape our bodies according to our wishes: Would that be enough to abolish this object/subject relation, to embody the subject fully? For the body, as a living subjectivity, is of such temporality and spatiality that no content can ever reduce it. By changing his or her body and making it as close to his or her wishes as possible, the biotechnological being would in effect change biological time, not to stop or stretch it but to live our biological time intensely as a biosubjective movement. By shaping the matter of his or her body, the subject not only forms him- or herself, the subject also gets information about the movement of his or her flesh. By changing the body, the subject finds itself to be moving. Rather than to construct him- or herself in order to reach some functional or aesthetic ideal, the moving subject would like, in the extreme, to modify him- or herself endlessly.

Given that the body is no more natural, or at least that the individual and social representation of the body defines it as entirely cultural and technical, we can deconstruct and reconstruct the body endlessly. The body as a whole is already replaceable, like parts in a biotechnological Meccano. Mechanization of the living must nonetheless be functional in its artificiality, as in Jean-Luc Nancy's 1999 text *The Intruder* about his transplant. Our mental attachment to subjectivity maintains us in this imaginary unity of the self, of the body proper that produces the illusion of mental independence from our biological state. We all find out that our given body gets worn, falls ill, changes with age, and is degraded by time. By changing the body, we could stop this biological temporality either by slowing down the aging process, or by making up for the problems of time with a spatial renewal of the body.

Conclusion

Through the creation of new species and within the human species, bioselected individuals such as Baby Adam—born in 2000, genetically screened and selected to save his ill sister—demonstrate that changing the body is now less virtual than feasible using biotechnology. There remains for a specific alibi to be found. These changes not only imply biological consequences, but also social ones. The changes in family relations, sexual intercourse, and the relation to one's body are now given legitimacy by the genomic sciences.

References

Baudry, P. *Le corps extrême: Approche sociologique des conduites à risques.* Paris: L'Harmattan, 1991.

Cabrol, C. *Le don de soi.* Paris: Hachette/Carrère, 1995.

Carroy, J. *Les personnalités doubles et multiples (Entre science et fiction).* Paris: Presses Universitaires de France, 1993.

Chatelet, N. *La tête en bas.* Paris: Grasset, 2002.

Duvignaud, F. *Le corps de l'effroi.* Paris: Le Sycomore, 1981.

Fischer, J.-L. *Monstres: Histoire du corps et de ses défauts.* Paris: Syros-Alternatives, 1991.

Foucault, M. "Le vrai sexe," introduction to *Herculine Barbin: Being the Recently Discovered Memoirs of a Nineteenth-Century French Hermaphrodite* (New York: Pantheon Books, 1980), in *Dits et écrits*, bk. IV, 115–123. Paris: Gallimard, 1994.

Huxley, A. Preface to *Le meilleur des mondes.* Paris: Presse Pocket, 1946.

Kapler, C. *Monstres, Démons et merveilles à la fin du Moyen-Age.* Paris: Payot, 1980.

Le Breton, D. *Signes d'identité: Tatouages, piercing et autres marques corporelles.* Paris: Métailié, 2002.

Marcuzzi, M. *Les corps artificiels. Peurs et responsabilités*. Paris: Aubier, 1996.

Nancy, J.-L. *L'intrus*. Paris: Galilée, 1999.

Pourquié, O. *Biologie du développement: La construction du système nerveux*. Paris: Nathan, 1995.

Tibon-Cornillot, M. *Les corps transfigurés: Mécanisation du vivant et imaginaire de la biologie*. Paris: Le Seuil, 1992.

Varela, F. J., E. Thompson, and E. Rosch. *L'inscription corporelle de l'esprit: Sciences cognitives et expérience humaine*. Paris: Le Seuil, [1991] 1993.

The Transgenic Involution

Richard Doyle

a consideration of a non-semiotic notion of communication as the sharing of genetic
material across traditional species barriers . . .
—Eduardo Kac, *GFP Bunny*

Falling into a Whole with a Rabbit

It may seem perverse to suggest that if you want to understand the telos of contemporary
biotechnology, then you ought to sample some hydroponic White Widow and look at art-
ist Eduardo Kac's transgenic bunny Alba. And indeed I would suggest no such thing.

Waiting to Inhale or, Bugging Out

Inhaling White Widow, a potent and recently evolved hybrid of Cannabis indica and Can-
nabis sativa, titrates a taboo, a legal infraction, an act of cognitive liberty, and a relation-
ship to a newly biotechnological plant. Since the massive surveillence and law enforcement
campaigns of the drug wars have forced its cultivation to become both domestic and in-
door, the quality, variety, and potency of cannabis has, er, *grown* at seemingly fantasmatic
rates. In response to an intensified prohibition and subsequent deterritorialization—"I
hear choppers, let's get these plants inside, quick"—cannabis underwent a technical trans-
formation that should be the envy of more mainstream biotechnological enterprises. And
although it is the THC levels that get the most attention—some estimate that levels of
this psychoactive and even psychedelic compound in high-end cannabis have increased
nearly fourfold since the 1980s—it is the new genetic diversity of cannabis that is truly
dizzying, a diversity that can itself only be encountered through the smoke or vapor of
inhaled cannabis.

True, one can sample the cannaboid porn to be found in such publications as *The Big Book of Buds* and see that hybrids like White Widow differ not only in biochemistry but in phenotypic presentation: The low shrubby Afghani type asks only to be grown in a closet and subjected to a high pressure sodium lamp, while the fractal and filigreed crystals of a Haze arrest the gaze as expertly and incessantly as an orchid summons a wasp. The massive proliferation of these spectacular images of cannabis on the Internet and in magazines such as *High Times*, *Cannabis Culture*, or *Heads* hardly supports the claim made by best-selling horticultural writer Michael Pollan that "no one would ever claim marijuana is a great beauty.... no one is going to grow cannabis for the prettiness of its flowers, those hairy, sweaty-smelling, dandruffed clumps.... The buds are homely, turdlike things, spangly with resin."[1]

Spangly?[2] While I can agree with Pollan that the flowering tops of a female cannabis plant do not charm the eye with the classic beauty of an orchid, it is difficult to explain the rampant dissemination of these new images of glistening green colas without grappling with the effects of cannabis porn on the viewer. It becomes tautological but vital to recognize that these images act as attractors on viewers, that many cannabis users spend time looking at, and not just inhaling, cannabis.

While the enthusiasm that growers and users might have for their favorite intoxicant might seem to need little explanation, it is worth noting that the Internet has not yet become home to photo galleries of home brew liquor or beer.[3] There is a function to images of cannabis in the community of growers and users that is absent in many other demographics of intoxication. Googling and oogling images of green buds such as those at www.hightimes.com teaches one immediately that the rhetoric of cannaboid porn is as diverse as cannabis itself: Here are images of an accursed share of buds, heaped harvests that contest the creeping sense of scarcity that always haunts a criminalized habit. Then there are spectacles of health perhaps most appreciated by growers, medium range shots of plants in full bloom. Their exuberant vitality images regimes of water, light, phosphorus, potassium, nitrogen, trace elements, and carbon dioxide that are absolutely precise and thoroughly supple in relation to the always shifting needs of the plant. But easily the most ubiquitous image of sinsemilla (literally, "without seeds") is the close-up of a ripe green cola enmeshed with and refracted by shimmering crystals of THC. Here one looks not at a crystal ball but into a crystalled bud for the glistening evidence of cannaboid production, as if the future effects of the plant were made achingly and vertiginously visible. But the crystals, in arresting the eye, also solicit it further, leading the viewer inside the flowering female: "Some of the pictures almost take you inside the bud."

Given the demographics of the viewers of such images, these veritable entries into the flower do resonate with the sexual gaze of a dominator culture (McKenna), a gaze that transforms the enveloping imbricated surfaces of calyxes and trichromes into yet another (seedless) receptacle for male passion. And yet it must also be recalled that if this is a pornography drawing on tropes found most frequently in *Penthouse* rather than in

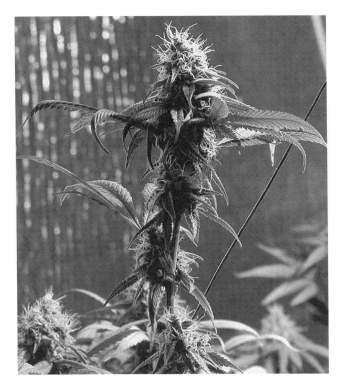

Figure 4.1

eighteenth-century botanical prints, then it is a pornography of *plants*. Is it not striking that this familiar but fantastic entry should map not only a metonymy of the eye and the phallus, but a veritable becoming insect? Catching a buzz indeed: The perspective hailed by the spangled buds is less inseminator than pollinator, more enflowering than deflowering (figure 4.1).

Hence another parallel and bugged out reading of cannaboid porn presents itself here: Spectacular close-ups of flowering cannabis, spangled with resin, work to blur the very boundary between human and plant. In soliciting a more or less sexualized gaze at a plant, such "bud shots" articulate an assemblage of plant, machine, and human that has driven THC levels through the roof. The flower/pollinator relation mapped by a *High Times* centerfold marks the tangled but hardly dominating relation of users and growers of these plants. Here viewers are as charmed by the plants as they are the radical differentiation of the plant genomes. Some writers have indeed looked at the (un)canny differentiation of cannabis and suggested that the relation between cultivator and cultivated has itself become blurred, that it is cannabis that is perhaps an agent of its own proliferation. As the appropriately named Pollan puts it, "So who is really domesticating whom?[4]

Traveling Stoner Problem

Still, if the ubiquitous glossy shots of cannabis teach us that for users and growers of cannabis, appearance matters, it seems equally clear that appearance itself is but one trait selected for by contemporary cannabis breeders. Flavor, aroma, ease of cultivation, and a remarkable variety of qualitatively different highs are all the object of selective pressure, and it is here that the biodiversity of cannabis becomes at once obvious and inaccessible. The diversity is obvious as the Sensei Seed Bank catalogue or *Cannabis Culture* or just plain Google teem with hundreds of different strains (and possibly two different species) of psychoactive plants. The spectrum of names—Big Freeze, Jack Kush, Northern Widow, California Orange, K2, Millenium, Flo, Master Kush—speaks to diaspora, the sudden differentiation of the cannabis genome transmitted via a sprawling list that would defeat any rhetorical urge toward taxonomy, or at least excessively divert it. If one looks to the naming practices of the cannabis ecology as a way of assaying its diversity, as I am, then the researcher buzzes with a veritable contact high. As mnemonic devices, the crowd of cannabis names primarily testify to a joyful and often synesthetic disarray: Purple High, Mazar, Oasis, Shaman, Nebula, Voodoo, Free Tibet . . . One looks hilariously but in vain for a structuralist algorithm that would reveal a secretly referential character to cannabis nominalizations, what we might call "ganjanyms."

But the diversity is also essentially inaccessible. Surely this rhetorical disarray is of a different kind than that famously and yet cryptically induced by cannabis sativa and indica? Only one way to find out. . . . Like other psychedelic allies, cannabis requires a human assay for its diversity as an organism to be evaluated.

And yet where to begin? Marc Emery's Seed Bank, an online Canadian vendor of high-end cannabis seeds, offers 611 different strains. How is the would-be cannabis biotechnologist to proceed? The evaluation of each individual strain, not to mention the combination of strains that is the province of contemporary cannabis breeders, presents an unfathomable and incalculable enterprise, available only partially to those willing to self experiment. Mapping the diversity of cannabis requires not only a quantitative and/or molecular genetic description—its lineage, preference, and habitat—but requires an active and paradoxically stoned deliberation.

An example from contemporary mathematics helps to situate just how confused the (necessarily, intermittently, stoned) cannabis biotechnologist must be. It is a cause of much fascination and embarrassment to mathematics that the seemingly simple computation known as the Traveling Salesman Problem presents so much difficulty to modern day Pythagoreans. The problem is as follows: Imagine you are a traveling salesman with responsibilities for fifty different towns in northern California, Oregon, Washington, and British Columbia. Given the knowledge of the distances (and/or costs) between the towns, what is the shortest (or cheapest) route to take as you make your rounds, distributing, showing, and selling your wares?

Richard Doyle

Despite the simplicity and ubiquity of this type of problem, its solution is nontrivial. It turns out that there is no general procedure for determining the shortest route other than the measurement and comparison of the different routes. And it gets worse: if there are fifty different towns, the number of different possible routes approaches the estimated number of particles in the universe.

By analogy, even the determination of the sequence of assays—first smoke Haze, then Widow, then . . .—becomes a highly dubious enterprise when dealing with combinations of 611 strains. Less a question of "distance" than "difference," the combinatorial practice of cannabis genetics, if it is to proceed from a deliberative logic, finds itself faced with an enormous calculation. And more strains are being developed all the time.

Dude, Where's My Car?

Yet, like my ability to arrive at work this morning despite the testimony of Zeno's paradox to the contrary, cannabis biotechnologists all over the globe do precisely calibrate, combine, and integrate the differences between different strains. We might be tempted, therefore, to suppose that cannabis breeding involves a slovenly departure from deliberation, less a practice than a passing out: the so called "couch lock" associated with certain strains of indica-influenced cannabis. And yet if contemporary cannabis genomics cannot, a priori, operate through a careful calculation or deliberation of the usual algorithmic sort, it nonetheless involves a set of heuristics that bring the fundamentally interactive nature of cannabis breeding into relief.

DJ Short is one of a number of emerging cannabis breeders who have achieved a measure of (paradoxically anonymous) celebrity through their innovations in cannabis breeding. Blueberry—a sativa/indica mix with, yes, the flavor of blueberries—exemplifies the innovative effects of DJ Short's breeding methodology. Aptly named, this DJ treats the cannabis genome as an immense mix to be sampled, recombined, and *scratched*. Like the conceptual artist and sonic shaman DJ Spooky, DJ Short highlights the fundamentally interactive and entangling processes of creative production.

First and foremost, of course, is the sampling of the plant itself to determine which plants to breed together. But DJ Short's sampling procedure involves more than the casual twist of bud into a bowl or joint. Instead, DJ Short carries out a veritable dance with the plant under consideration, pausing even to briefly rub up against it: "A sort of scratch and sniff technique is first employed. With clean, odor free fingers gently rub one plant at a time, on the stem where it is well developed and pliable . . . The newer leaves at their halfway point of development may also be rubbed and sniffed."[5]

These strange antics give both a topological and a biological spin to the boundary-blurring introduced by Pollan above. The transformation and combination of cannabis genetic information—that is, cannabis sex[6]—takes place here through a veritable mixing of bodily fluids, as DJ Short and a cannabis plant momentarily but undeniably share a

territory. The question of where the plant ends and DJ Short begins momentarily, but unmistakably, means nothing.

This human/plant alliance suggests that in DJ Short's methodology, selection favors those plants that *excel at dissolving boundaries.* In this case, the incredible array of flavinoids coaxed out of the plant must be present but also mobile: The gentle strokes of the breeder, over multiple generations, render an amplified flow of flavor.

And of course it is not only physical boundaries that must become fluid in this selection. As with Pollan's question—"Who is growing whom?"—cannabis seems almost uniquely capable of inducing the collapse of figure and ground that questions the agency of grower and grown. Indeed, in *On Being Stoned*, a quantitative and qualitative study of the effects of marijuana on human subjects, psychologist Charles Tart notes that "figure-ground shifts become more frequent and easier to control when stoned."[7]

Alba and Biotechnological Enlightenment

In a role reversal for a sometime model organism, Alba too, requires a human assay. Kac's biotechnological rabbit glows with the green fluorescent protein when, like so many 1970s psychonautic basements, it is bathed in the proper spectrum of light. In glowing, it involves the passage of an increasingly plastic taboo structure—*What is an animal? How ought we treat them?* Hence Alba's glow provokes questioning and debates, as if discourse were the real output for which bioluminescence is a catalyst. In contact with a human audience, Alba becomes an imaging device for the solicitation and registration of a rhetoric of genomics.[8]

But if Alba (who was quite white) and White Widow (who is not at all) are linked through their need for a human host, the entanglement speaks to their status as recently evolved familiars, border creatures who both extend and hack strangely into our agency as humans. How do a rabbit and a plant hack human agency in the context of biotechnology? Surely biotechnology is nothing if not the intensified application of human consciousness to evolution and its ecosystems. Homo sapiens' recently amplified capacity to manipulate genomes would be, in this light, a qualitative as well as a quantitative increase in human control over the living environment. Cloning technology, for example, promises to end the alleged nightmare of human reproductive difference as early as 2003, as humans become asexual as well as sexual reproducers.[9]

But both the cannabis hybrid and the transgenic rabbit expose us to a rather more liminal agency than the conjunction of consciousness and genomes might suggest. If the promise of genomics was a "triumph over death" (Jacob) or a revelation of "what life is" (Watson), then its delivery has been rendered more in anxiety than gnosis. While Alba glows, her light does not signal an epistemological enlightenment but the sudden arrival of an affect: In bioluminescence, Alba lights up a habitat whose fundamental output is interconnectivity. Alba is, er, *living proof* that machines, signs, and organisms, in their

Figure 4.2

newest promiscuities, no longer dwell in definable, taxonomical domains, but are instead differentials of intensity: networks. Alba's glow indicates that organisms are now indeed online, logged into the evolutionary network and turning Darwin's "tree" of life into a fabulous mesh of interconnection. An interaction with Alba solicits not merely due to novelty and surprise, but to a sudden sense of implication, a linkage between humans and Alba no less actual than her relation to the *Aequorea Victoria* jellyfish that is the source of the GFP gene. Hence if discourse is Alba's output, so too does she solicit a practice of affective connection. As an icon, Alba tends to indeed function as a sort of neon sign for transgenesis, but she is a sign who does much more than signify (figure 4.2). In a less replicated but no less revelatory image, Kac the artist is seen to be practically entwined with Alba. Selected, cropped, and zoomed, the image reveals a hospitable but entangled grapple (figure 4.3).

Kac writes of his first encounter with Alba: "As I cradled her, she playfully tucked her head between my body and my left arm, finding at last a comfortable position to rest and enjoy my gentle strokes. She immediately awoke in me a strong and urgent sense of responsibility for her well-being."[10]

While one may hear prolepsis in Kac's testimony—a preemptive response to the objection that he somehow abuses Alba by making her glow with the status of "art"—Kac's account also highlights an essential effect of the bunny. If the "big blue marble" shots of Earth from space provoked a sense of global unity and interconnection among many otherwise isolated viewers, Alba seems to provoke an outburst of hospitality, an urge to

Figure 4.3

loosen the boundaries that otherwise divide any particular human and animal. "Between my body," Alba provokes a multitude.

Darwinian Complication

> It is interesting to contemplate an entangled bank, clothed with many plants of many kinds, with birds singing on the bushes, with various insects flitting about, and with worms crawling through the damp earth, and to reflect that these elaborately constructed forms, so different from each other, and dependent on each other in so complex a manner, have all been produced by laws acting around us.
> —Charles Darwin, 1859

As recently evolved familiars, both White Widow and Alba are Darwinian to the core. There can be no question that selection is responsible for the emergence of these novel life forms. But when it comes to responding to the glow of Alba or the buzz of White Widow,

it is not natural or even artificial selection that is constitutive of these organisms and their peculiar traits. It is perhaps obvious that it is not fitness in any usual sense that is the metier of either the rabbit or the plant: Glowing under 488 nm light does nothing to help the lagomorph in its ongoing struggle for survival, and the sheer surplus of cannabinoids produced by White Widow goes beyond any utilitarian project of chemical, albeit, natural, warfare. And yet surely both are poster creatures for Darwin's analysis of variation under domestication, as wrought by human deliberation as the bulldog?

Of course it is the case that humans have cultivated these organisms, and that cannabis evolution has hinged on human preferences and choices. Yet in what sense are the selection procedures of DJ Short or Eduardo Kac *choices*? DJ Short, besides the scratch and sniff implication with his plants, also enters into states in which the distinct categories proper to deliberation and choice are themselves incessantly scrambled and recombined.

So, for example, when DJ Short teaches us how to select males for breeding, he asks us to cease scratching and sniffing and begin smoking: It is possible to test males by smoking or otherwise consuming them. This practice may be somewhat beneficial to beginners as it does involve a sort of obvious discretion . . . one must make sure this test smoke is the first smoke one consumes in a day in order to best discern its qualities, or lack thereof.[11]

It may seem obvious that in order to test the quality of a spliff, one must smoke it. And yet male cannabis plants present difficulties to the would-be biotechnologist because of their relative lack of THC vis-à-vis the females. Besides learning the timely and accurate sexing of plants—the ability to read the signs of maleness from a seedling so that those signs might be removed from the environs, a skill necessary to the production of buds— cannabis biotechnologists must also learn to read the signs of quality from male plants. In other words, *one must learn to "get high" from low potency marijuana*. The would-be grower must therefore learn to become less an athlete of the bong than a sensitive to her plants, capable of being affected by even trace elements of THC.

Thus stoned, however, the grower is taught by the plant: Even a beginner can learn to select a good plant for breeding in this fashion. While cannabis is notorious for its (prized) ability to *impair* judgment, in this context it becomes the very agency of judgment itself. The practice of becoming a sensitive involves an increased capacity to respond, less an act of agency than the arrival of a feeling: I'm stoned. Like an attempt at sleep (or enlightenment), one must learn less what to do than how to let go.

Still, even if the choice to become affected by another is a paradoxical one, an act of agency that undoes or stones identity, a sense of choice remains. The experience of this recipe of selection may itself not *feel* deliberate or even precise—"Uh oh, smoked too much"—but its procedure nonetheless constitutes an algorithm. While the successful assay necessarily scrambles the human/plant boundary, smoking a male demands an absolute sobriety that would bring its difference into relief: "Make sure this test smoke is the first smoke one consumes in a day."[12]

Figure 4.4

Yet if this assay depends upon the integrity of the category sober/stoned, DJ Short seems to argue that one knows the plant only as a mixture. Indeed, DJ Short ends his discussion of selection with less sobriety than ecstasy. While the smoking of males seeks to assay the difference cannabis might make to ordinary, baseline consciousness (whatever that is), DJ Short's final test for selection involves a modulation of extraordinary consciousness: He suggests that the best test for the character of a plant is to use it in conjunction with another psychedelic such as psilocybin or LSD-25: "Ideally, the psychedelic substance will further the range of noticeable subtleties by one's psyche . . . if the herb is truly blissful it will become readily apparent under such psychedelic examination."[13]

Again, a choice is made, but *its mechanism is the departure of agency itself*. Psychedelics are sought out precisely because they put the control of an ego into disarray, a manifestation of mind or psyche not amenable to the usual strategies of control.

Darwin noticed that sexual selection—that abjected, other vector of evolution that has spurred everything from peacock feathers (figure 4.4) to bioluminescence—seemed to rely on a similar sort of breakdown. Writing of the effect of male bird song and plumage on females during courtship (a.k.a. selection), Darwin said:

Are we not justified in believing that the female exerts a choice, and that she receives the addresses of the male who pleases her most? It is not probable that she consciously deliberates; but she is most excited or attracted by the most beautiful, or melodious, or gallant males. Nor need it be supposed that the female studies each stripe or spot of colour; that the peahen, for instance, admires each detail in the gorgeous train of the peacock—she is probably struck only by the general effect.[14]

While feminist researchers have rightly noted that Darwin was both attracted to and troubled by female choice precisely because it was *female*, this and other passages also emphasize the problematic nature of what Darwin called "charm" in evolution. "Struck by the general effect," females are both agents of selection and the charmed subjects of the feather, sufficiently seduced that the very boundaries of male and female break down into those zones of indiscernibility necessary to reproduction.[15]

It was sickeningly obvious to Darwin that the feather train of a peacock was hardly the result of any struggle for fitness of the usual sort: "Nor can we doubt that the long train of the peacock and the long tail and wing-feathers of the Argus pheasant must render them an easier prey to any prowling tiger-cat than would otherwise be the case."[16]

Yet strategies suited to courtship rather than survival abound in nature: birdsong, colorful plumage, insect stridulation, perhaps language itself.[17] Darwin's intense and exquisite study of the mechanisms of sexual selection—studies barely noted by contemporary researchers on the subject—continually focused on tactics for inducing the dissolution of boundaries, a sudden fluctuation of figure and ground.

Consider, for example, Darwin's analysis of ocelli, eyespots that adorn the feathers of said peacock. If Darwin is convinced that indeed an array of said eyespots charm the peahen, how exactly do they do so? Darwin puzzled over the effect, and was at first disappointed by the peacock's charm, little appreciating the perspective of the peahen:

When I looked at the specimen in the British Museum, which is mounted with the wings expanded and trailing downwards, I was however greatly disappointed, for the ocelli appeared flat, or even concave. But Mr. Gould soon made the case clear to me, for he held the feathers erect, in the position in which they would naturally be displayed, and now, from the light shining on them from above, each ocellus at once resembled the ornament called a ball and socket.[18]

What so impresses Darwin in this remarkable event of sexual selection—he himself plays the role of peahen, subject to the charms of a certain bespangled Mr. Gould—is not only the precision of the ocelli,[19] but their capacity to render three dimensions in a two-dimensional medium. The flat eyespots are practically an ornithological cinema, throwing images of depth and clarity through the deployment of an iterated but flat surface. This remarkable performance of trompe l'oeil captures not the peahen but her

attention. Much "struck" by the display, both Darwin and the peahen are persuaded by the charms of the peacock.

What images were thrown? These "ball and socket" images achieve not only three but n dimensions: Uncanny, they present nothing other to the eye than an eyeball itself, instilling a momentary but actual dissolution of the boundary between viewer and viewed.

Hence the importance of both a language of choice and the experience of seduction when attending to the mechanisms of sexual selection. Provoking not fitness but entanglement, sexual selection excels at the momentary breakdown of inside/outside topologies.

Back to the Whole, or The Earth, Aglow

The firefly is, of course, a poster creature for both bioluminescence and sexual selection, and recent research has even sought to study the reproductive success of transgenic zebrafish in competition with their less spangled competitors.[20] And if a bunny is considered to be a sign of a most semiotic sort, it is, of course, a sign of reproduction. If Alba, in her bioluminescence, charms us, she does so by revealing and even inducing our mutual entanglement in practices of evolution. So too does cannabis seem to remind us of our co-implication, producing the effect of a strangely distributed and sexually articulated agency. These familiars are thus exemplars of contemporary biotechnology whose methods are citational and recombinant: Biotech vectors us toward distribution and involution, a weaving together of life forms whose name is best understood as a verb: Gaia. Such a technology is essentially psychedelic, as we leave the world of reference whereby the narrating "I" can maintain any reliable differentiation from its object of knowledge or love.[21] As with certain peacock feathers, if we look properly at Alba and White Widow, a new dimension of experience and even consciousness suddenly unfolds, as the earth becomes less a globe than a network. Fade to bioluminescence: the earth, aglow . . .

Notes

1. Michael Pollan, *The Botany of Desire: A Plant's-Eye View of the World* (New York: Random House, 2001), 122, 137, 138.

2. Charles Darwin writes of the effects of "spangles" in the courtship of birds, discussed here and in note 7: "In this attitude the ocelli over the whole body are exposed at the same time before the eyes of the admiring female in one grand bespangled expanse." Complete text of *The Descent of Man* can be found at http://www.wildlifewebsite.com/descent/darwin0.shtml.

3. Indeed, not even hops, whose leaves bear more than a passing resemblance to cannabis, get much visual attention. See http://groups.msn.com/NorthTexasHomeBrewAssociationHomePage/yourwebpage1.msnw.

4. Pollan, *The Botany of Desire* (from back cover).

5. *cannabis Culture* (February 2003): 92.

6. cannabis is a dioecious plant—it has at least two sexes. If isolated from pollen, the female buds continue to grow and ripen, the sticky THC-laden trichromes grow larger and larger in the solicitation and attempted attraction of pollen. If allowed to seed, females more or less cease THC production and the potency of the crop is much diminished. Males produce early pollen-laden flowers, so the trick in the cultivation of sinsemilla is to "rogue out the males" as early as possible if one is growing from seed. Cloning methods help the grower avoid this sometimes tricky and urgent process of sexual selection: Cuttings are taken from a select female and grown repeatedly, giving the plant an almost Raelian quality of immortality. For more on the importance of sexual selection, see note 15.

7. Charles T. Tart, *On Being Stoned* (Palo Alto, CA: Science and Behavior Books, 1971), http://www.psychedelic-library.org/tart6.htm.

8. In this regard—her need for a kind of "activation" by an audience and light—Alba is kin to the vain peacock as described by Darwin in *The Descent of Man*: "this latter bird, however, evidently wishes for a spectator of some kind, and, as I have often seen, will shew off his finery before poultry, or even pigs." Charles Darwin, *The Descent of Man and Selection in Relation to Sex*, 2nd ed. (London: John Murray, 1882), 394.

9. See http://www.washtimes.com/national/20021128-78954640.htm.

10. See http://www.ekac.org/gfpbunny.html.

11. *cannabis Culture* (February 2003): 94.

12. DJ Short's formulation here seems to highlight the uncertainty of such a proposition and the scarcity of windows for such an assay. Given cannabis's notorious (albeit contestable) effects on short-term memory, one looks in vain for a heuristic whereby one could indeed "make certain" that this was the first ingestion.

13. *cannabis Culture* (February 2003): 96. Short's locution of "psyche" here is instructive, as it harkens to a more expansive undertanding of self than that ego whose death so famously occurs under the influence of LSD. See discussion of "psychedelic" in note 21.

14. See http://www.wildlifewebsite.com/descent/darwin1259.shtml.

15. It might be worth noting that in the opening paragraph of *On the Origin of Species*, Darwin describes himself as similarly "struck": "When on board H.M.S. Beagle, as naturalist, I was much struck with certain facts in the distribution of the inhabitants of South America, and in the geological relations of the present to the past inhabitants of that continent." See http://www.literature.org/authors/darwin-charles/the-origin-of-species/introduction.html.

16. Indeed, Darwin noted that charm was sometimes a more crucial evolutionary ally than the much-vaunted "battle": "We shall further see, and it could never have been anticipated, that the power to charm the female has sometimes been more important than the power to conquer other males in battle." Darwin, *The Descent of Man*, 227.

17. "The impassioned orator, bard, or musician, when with his varied tones and cadences he excites the strongest emotions in his hearers, little suspects that he uses the same means by which

his half-human ancestors long ago aroused each other's ardent passions, during their courtship and rivalry." Darwin, *The Descent of Man*, 573.

18. Darwin, *The Descent of Man*, 398.

19. "These feathers have been shown to several artists, and all have expressed their admiration at the perfect shading. It may well be asked, could such artistically shaded ornaments have been formed by means of sexual selection?" Darwin, *The Descent of Man*, 398.

20. See http://www.science.nus.edu.sg/Research/News/DEC2001/LiDaiQin/right.html. For a remarkable resource on bioluminescence (and the difficulties of imaging it), see C. E. Mills, "Bioluminescence of Aequorea, a Hydromedusa," http://faculty.washington.edu/cemills/Aequorea.html. Published by the author, Web site established June 1999, last updated (at the time of this writing) December 5, 2002.

21. Here I follow the coinage of "psychedelic" (Humphrey Osmond) as a "mind manifesting." This marks less the fantastic character of the effects of these compounds than the dissolution of the boundary between mind and nature. Both Alba and cannabis thus are psychedelic in the sense that they are indeed manifestations or exfoliations of human consciousness.

5

Life Art

Louis Bec

We are not speaking in terms of multiple possible alternatives to a single actual world but of multiple actual worlds.
—Nelson Goodman, *Ways of Worldmaking*

The living is.

The living communicates.

It transforms and reinvents itself in, and through, its own language. The genetic code becomes flesh. Artifacts that represent the living let its presence—both exacting and evident—take over.

This reversal enables the living to be formed of wholly expressive matter. It finds itself liberated from excessive constraints dictated by abstract physico-chemical logic, modes of representation, substitution, and a ponderous metaphysical heritage.

A "bio-logic"[1] then becomes possible.

The makeup of this bio-logic does not consist solely of scientific knowledge or of biological or genetic research, concepts, measures, methods, and models. This bio-logic is formed because the living imposes itself as a material subject that deals with itself, even beyond representation and current artistic and scientific categories. Therefore, all research construes itself as expression, and all expression construes itself as research by means of heterogeneous methods and hybrid achievements.

This bio-logic is conceivable because the discourse of the living—as long as it defines itself as an activity rendered autonomous by its internal regulatory system and its interactive and cognitive relations with the surrounding sphere—reveals it to be an acting entity with an experimental intentionality that is distinct from an inert artificial one.

If this bio-logic is to become real, one can assume that it will generate heuristic, concrete, and declarative practices. It will also supply the living with an effective tool for transgression, exploration, and auto-transformation: the art of manipulating processes.

This is why affirming this new condition of the living is explosive, especially when artistic and biological practices converge to create new conditions for the living as it is or as it could be. Biotechnologies, genetics, transgenesis, cloning, organ cultures, tissues, xenografts, and biological machines enable the living to redefine itself. The process of redefinition uncovers an unknown and dangerous terrain where each of these productions becomes a vertiginous and terrifying sign.

These productions—although only aimed at a complaisant and narrow audience—call the "suitability" of modern art into question: They manage to reveal the fears governing society as a whole, as well as its future, by illuminating its aesthetic, epistemological, technological, ethical, juridical, economic, and industrial problems.

Modes of "representation," "expression," "knowledge," and "modeling" are literally exploding. They are symptoms of the fundamental upheaval that shakes the normative models of contemporary societies.

Though still in its nascent stages, a truly democratic debate about technological culture and biotechnology has caught the public eye: The status of scientific research, the nature and consequences of the impact of technology and biotechnology, the changing role of art, the scientist and the creator's status and responsibility, and the limits of scientific progress are called into question. Attempts to reveal the biological, genetic, and biosemiotic[2] roots of culture—though still diffuse—are forcing societies to reevaluate their cultural foundations.

"Life art"[3] brings a patient and latent societal enterprise up to date: Its development dates from the age-old practice of breeding and domestication. The latter practice, based on intentional modification of certain animal species, already ushered in the initial stages of human-guided evolution.

This event joined forces with modern behaviors that appeared in human groups and which, according to Richard G. Klein,[4] a professor of anthropology at Stanford University, were the result of a genetic mutation, a biological accident that may have favored the neurological apparatus of the Homo sapiens in its abilities to innovate and elaborate superior symbolic forms, and may have also radically and suddenly altered social and technological organization.

This life art is the product of all the activities that constitute hominization, ranging from ritual and symbolic representations of the living to age-old practical knowledge, tools, and techniques linked to treating living matter, and the most advanced current biotechnologies.

Life art is characterized by a "monomaniacal" activity that consists of "fashioning" the living and assuming that its makeup consists of wholly expressive matter.

In fact, animal art is the art of domestication: The art of the body extends itself through corporeal art, piercing, and plastic surgery; transgenic art and the art of technofacturing the living shake the foundations of biotechnology; artificial life is the art of biomimetic

stimulation of the living. The art of communication and technozoosemiotic practice[5] examines animal and human cognition through linguistic, paralinguistic, and kinetic[6] activities in order to create a technological animal/machine/human language, and thereby to further our understanding of the roots of present-day expressions.

This is how, over time, an activity developed in tandem with the construction of material artifacts and became the most meaningful place for art and applied science. The appropriation of the living by the living developed a vast crucible of inventions—technical, symbolic, and artistic innovations that link realms of cognition, industry, economics, community, and utilitarian practices. Curiously, this appropriation has been glossed over for much time.

We can now say that life art has a place thanks to the development of biotechnological arts practiced by researchers in both genetics and art. They are primarily concerned with granting expression to living matter by breaking taboos and by widening the conventional categories of "experimental artistic" activities associated with the living.

The foundations of "animal art" rest largely on domestication and breeding, dressage and taming, and zootechnique. Its boundaries have now been extended to include gene transfer, cloning, genetic therapy, somatic hybridization, and genetic engineering.

Domestication has gradually introduced reproductive manipulation of species and the possibility of improvement by crossbreeding, and, finally, by artificial insemination. It has demonstrated that intervention in the metabolic processes of the living can be considered an act that generates new forms,[7] new species, and new behaviors. The art of manipulation has behaved and continues to behave just like any type of artistic production: Its activities range from piloting natural processes, to intentional manipulation of hereditary transmission mechanisms, to playing on morphological, chromatic, and behavioral aspects and aiming for variety in variation. It should therefore "naturally" inscribe itself in a wider cultural field.

If representations of animal nature hold a determining and fantasy place in the art and culture of all civilizations, manipulations striving for "harmonious" transformation and adaptation of the living are currently visible in the field of agriculture, but not culture. However, over the past few years, certain modern art movements[8] did not hesitate to include animals in installations, choreographies, theater productions, and, most recently, in interactive technological machines. These productions grant aleatoric liberties of intervention to animals or craft artistic creations from their behaviors. Many artistic activities find creative inspiration and new modes of expression through certain forms of animal/machine interactions discovered in the realms of zoology, botany, ecology, ethology, behavioral robotics, artificial life, and bio-computer science.

By intervening directly with the genomic syntax of the living, biotechnological art aspires to produce—with the help of geneticists—"constructs":[9] genetically transformed living organisms that respond to specific tasks and to ambitious poetic objectives.[10]

A decisive step is being taken: The technofacturing of the living, transgenesis, and bio-technological arts is introduced into the cultural sphere and into authenticating artistic realms.

This excursion of transgenic activity beyond the confines of the laboratory and toward a greater audience raises true ethical and aesthetic questions that reach the realm of artistic censorship and scientific taboos[11] and introduce a set of questions about the future development of human society. Media powers seizing upon these questions often deform their meaning and content with sensationalist remarks, amplifying latent worries.

The German philosopher Peter Sloterdjick was violently attacked in 1999 for his book *Rules for a Human Park*,[12] in which he claims that domesticating human beings is a reality, and calls it a "great unthinkable thing which humanism has ignored since Antiquity." He maintains that "in contemporary culture a titanic combat exists between impulses that tame and those that render brutish," and he pushes his deterministic model to examine the consequences of cloning and procreative eugenics: "However, in the long run, will evolution usher in a genetic reform to the properties of species? Will a future anthropo-technology reach a level where it could explicitly plan characteristics? Will humanity be able to accomplish, for all its species, a changeover from birth fatalism to optional births, and finally to prenatal selection?"[13]

The pioneering work of Eduardo Kac has opened up new horizons for transgenic art. If the existence of natural mutations is a well-known fact,[14] the creative space where transgenic art could develop is located in the space of induced mutations and is in keeping with the constructivist epistemological framework "of mutations of art and of the art of mutations." Although the technique of transgenesis seems simple at first glance—one needs to add a foreign gene to a living organism's genome or, conversely, to replace a specifically endogenous gene with another one—This procedure is sufficiently complex that it can be performed only in laboratories.

Transgenic art has provoked, and continues to provoke, serious discussions about the status of artistic production within the field of art and its relations with the world of laboratories and geneticists. The relationship with the public, the role of the artist, the various forms of mediatization, and exhibit locations are inherently problematic for all facets of artistic production, and generate conflicts. In the relatively new disciplines of media and communication studies, the term *mediatization* describes the object of these disciplines. It signifies the phenomenon of proliferating, intensifying, diversifying, and converging media, within complex internal relations of multimodality, intermediality, and self-reflexivity. In short, this signifies the twentieth-century media explosion.

However, a new form of biocryptographic aesthetics appears to be one of the fascinating particularities of these studies. Apparently nothing distinguishes a transgenetic "construct" from a living organism generated by natural procreation, contrary to the fanciful makeup and teratology that engender deviant morphologeneses. Calling this construct *transgenic* gives it a dimension of endogenous abnormality, a hidden dimension that

divulges the underlying pressure of degrading and impure procedures that engendered it. Originally buried in totipotent cells and in embryonic development procedures, the intractable gene is responsible for deviations; it generates gaps and sacrilegious violations that will never be revealed, and that cower—insidiously cryptographed—in a genetic code kept forever secret.

Life art is also of interest to technological modes of communication between animals and humans. Research activities range from animal cognition, to language acquisition by gestures, to graphic symbols, to lexigrams, and deal with different animal species including chimpanzees, dolphins, and octopuses, to name a few. The use of adequate technological interfaces indicates the fundamental interest in a communication system linking animal and human worlds. These projects are carried out by researchers in ethology, linguistics, and computer science, but are also the sources of diverse artistic works. The field of research that contributes to the developments of biosemiotics and zoosemiotics is that of technozoosemiotics or, put differently, of paralinguistic and kinetic modes of communication through digital interfaces and genetics.

Technozoosemiotics is at the crossroads of semiotics, ethology, cognitive science, technology, computer science, and artistic practice. Though it remains an integral aspect of zoosemiotics—the study of signs elaborated by living species in order to facilitate intra- or extraspecies communication—technozoosemiotics contributes, through technological and instrumentological means, to the construction of numerical interfaces, spaces of transduction, and transcoding between kinetic and paralinguistic systems and between syntactic and semantic forms of language. The basic hypothesis of technozoosemiotics affirms that all living beings are social beings and that they have to solve a characteristic set of communication problems that fit into a panoply of stimuli and common or approximate responses. Technozoosemiotics conducts experiments and makes hitherto unexplored connections to produce possibly intelligible signs among different living and artificial species. Technozoosemiotics presents itself as one of the cornerstones of the animal/machine/human relationship. It postulates that a logic of the living exists that strives to establish long-term interspecies communication—broadened to all the living organisms of the biomass—where human species could be but one of the operators. This transversal interspecific communication that operates diffusely and permanently could be considered one of the privileged areas of artistic practices. It led to, among other things, certain artistic quests for a real practice of interspecific animal communication or for finding paths proposed by artificial life as intermediary relays for life-forms such as they could be.[15]

The foundations of life art also lie in the important role played by corporeal arts in aboriginal societies: Their diversity and fundamental contributions have been revealed to anthropologists and ethnologists through rituals, tattoos, makeup, and scars. Thus, biological and corporeal memory questions cultural and technological memory and lets Western societies catch a glimpse of the underlying foundations of our symbolic, kinetic, and paralinguistic forms, and how these endure and structure most of our current, quotidian

behaviors.[16] Corporeal art that uses the body or flesh as a prop or an artistic means introduced extremely intense performances where pain, mutilation, wounds, and scatological provocations express the very limits of the human body. These experiments continue in the form of technological performances[17] whose range extends from capturing motion to electrophysiology. They engage the living in the ubiquity of telepresence: from automatized, distant enslavement on the Internet to actual experiments of piercing and cyborgs.

Now that the time of artisan workshops and industrial manufacturers are matters of the past, we have entered the age of *biotechnofacturers*—laboratories that hold the keys to manipulation arts and the instruments to develop proposed biological processes.

Rendering the living artificial now extends to all realms: cultivating skin and tissue, making bones, regenerating nerves, cultivating embryos, organs, conceiving and raising factory-animals, xenografting of temporary bionic implants, creating biological machines, putting in place captors and regulators for the living, etc.

New hybrid beings have suddenly appeared: technoteratogens.[18] Emerge from the convergences established between genetic and numerical codes and between neuronal and microelectronic ones. Thus, parts of the living are chimerically transformed into interactive technological machines, yet still conserve the viability criteria of living organisms. Technoteratogens recently made an appearance in art as well as numerous research laboratories. For example, the collective SymbioticA, where artists and research scientists collaborate, is a biology lab that carries out experimental artistic activities focused on manipulating living matter and living tissue culture.

"Half Fish/Half Robot," a research project presented by scientist Ferdinando Mussa-Ivaldi[19] of Northwestern University in Chicago and scientists from the University of Genoa, features a lamprey alevin swimming in a nourishing liquid. Electrodes connected to a Khepera robot are implanted on the vestibular parts of the fish's brain. The lamprey alevin is phototropic (sensitive to light) and can choose to follow light or not. A hybrid system forges bidirectional communication between the lamprey's brain and the mobile robot. The robot moves according to the information received from the alevin, and acts like an artificial body that delivers sensory information to, and receives command signals from, the neural tissues. The comparison between the various behaviors produced by a neural model is a determining tool for examining the role of synaptic plasticity in the sensory study of motor functions. Direct interaction of neural systems and artificial machines can provide new ways of evaluating supporting neurobiological structures of behaviors.

Neurologists from the SUNY Medical Center created a radio-controlled animal—a RATBOT—by wiring a chip directly into a living rat's brain. The rat carries a little antenna and a device that translates a radio signal into electric impulses that are then applied to the brain. A scientist can then pilot and guide this combine through a complex three-dimensional labyrinth. When the rat accomplishes a given task, it receives a "reward" or "pleasure" impulse.

Axel Michelsen[20] and Wolfgang H. Kirchner[21] demonstrated the presence of sounds emitted by a dancing bee. They constructed a bee robot to artificially recreate the bee's dance. This robot enabled them to isolate the precise moments when wriggling occured in the dance. Axel Michelsen noted that the emitted sounds contribute as much as the wriggling part of the dance to indicating distance. These signals are therefore redundant, and this limits errors during the transmission of a message.

Wolfgang H. Kircher and William F. Towne of the University of Kutztown in Pennsylvania discovered the auditory capacity of bees, and demonstrated the existence of Johnston organs situated in the second segment of the bees' antennae. The combination of these technozoosemiotic activities enables a swarm of bees to pilot toward a specific goal.

These examples demonstrate that different treatments of living matter simultaneously provoke epistemological streamlining on the living and a broadening of its expressive dimensions. Contrary to the biological and genetic enterprises that attempt to elaborate an objective discourse when dealing with the living, new technoteratogenic forms break the confines of these very limits. After defining itself as an integrating totality, the living lets itself expand into an integrating entity.

The reversal operated by developmental robotics compellingly illustrates this new orientation. Where it was once a question of transferring the biological dimension of cognition into an interactive technological machine, it is now the interactive technological machine that boards the cognitive living organism, and then connects to it. The living could first be genetically modified so as to be able to adapt its behaviors to desired functional ends.

It is clear that integrating technological systems with living systems provides new angles for measuring their future levels of hybridity. If artificialization can be considered a procedure of abstraction, it can launch a materialization by means of its symbiotic functions with the living and thereby grant itself a coherent and successive continuum constitutive of the almost-living. The living can be matched with a machine without needing to establish a hierarchy between them. Instead, it can be an entity that acts as an equal participant in its regulation. It can also be enslaved by granting specificity of its matter to the machine or it can pilot the machine as an integrated entity. However, this almost-living begins to really "exist" when, endogenously, a coding executes the laws of convertibility that would enable the two operators to bio-integrate effectively.

The question of functioning is controlled by the role and the potentialities of the cognitive apparatuses of the living coupled with the sensorimotor apparatuses of the machine. Unlike the technical object, the living being is equipped with memory that enables it to process received information and to reorganize it in codes: This process facilitates new acquisitions and reactivations. The technological machine has a finite memory bank where content and code remain separate.

Mediation between the living and the technological machine is carried out by means of a complex mnemo-transmitter space that contributes to rendering a singular form of

biotechnological autoregulation permanent and adaptive. This mediation becomes a world in and of itself that gives rise to an aesthetic of complex systems. It resembles a principle of insertion and unexpected processes that define the aesthetic object and not the biomimetic imitation. This aesthetic takes into account the significant emergence of coherence and the robustness of the integrated functioning of the living and the constructed machine.

The mediation is also accountable for the modes of expression of the totality of variable relations in a heterogeneous set, the behaviors of the living and the technological that develop there, and the metabolic and technological functions that are combined and trained using information that comes from the environment and that is subsequently interpreted by captors, biointegrators, and sensorial and cognitive apparatuses.

A symptom of this mediation highlights the successive states of adaptive changes of almost-living organisms, whose behavioral marks conform to alternate worlds that constitute them and that impose themselves within "natural" environments. To a certain extent, it turns into a salvaging aesthetic, an emersion of a buried revelation, of an ontological airtight receptacle that implodes.

The mediation is original because it expresses a resurgence of the states of biotechnology through signals. It also raises the question of stowage through phylogenesis of the living and of technological objects. The differences seem to erase themselves gradually in the welding of the living with the artificial, and the artificial environment with the natural environment through the constitution of associated or integrated environments. Strangely, this highlights the antagonistic parallelism between Darwinian theory of selection and the idea of telefinalist progress closely resembling Lamarckian theory.

In certain situations, the living can provoke, for itself, a programmed mutilation to serve the ends of avoidance, deception, regeneration, or organ re-implantation in order to amplify and strengthen its survival or domination. Certain animals practice autotomy,[22] spontaneous or voluntary amputation. This phenomenon of an amputation reflex is quite common in certain insects and crustaceans, and also exists among sea invertebrates such as cephalopods, or vertebrates such as lizards.

During the organizational process that associates objects of the living with those of the artificial realm, the living demonstrates degrees of inventive adaptation that require amputating certain functions or certain components of living matter. The technological machine does not have a surplus since it is deterministically constructed, while the living, though biomanufactured, is presented in the complex totality that assures its viability. The living will need to make choices hierarchically and amputate parts of itself that do not participate in basic activities, while preserving the limits of its vital functions.

These objects of the almost-living are *amputates*. Their functioning, or even the disappearance of some of their properties, corresponds to an aesthetic of subtraction, ablation, a part of the whole, a fragment, as in the case of Mussa-Ivaldi's alevin that had part of its flesh amputated in order to make the movement of a robot toward the light possible. As a

general rule, the technological machine always preserves its integrality, and the living sacrifices it in order to serve exploratory ends.

How can these activities develop particular epistemologies or aesthetics? What are the actual conditions in which the almost-living can become the object of aesthetic categories while the cultural and social context excludes any questioning of its fundamental, ethical, epistemological, and theological values? What conditions are necessary for technological objects of the almost-living to become a part of our reality, beyond virtual special effects?

It is obvious that the logic of the living remains incompatible with human logic, and that artistic activities find themselves forced to abandon the psychosociological terrain of art and its idealistic consumer and media armholes, in order to inscribe themselves in the logic of the living so as to better understand its dynamic of proliferation and inventive adaptation, and in order to attempt to test the limits of its mental and physiological viability.

The living constructs its living and constructs living.

The question is now what the limits of such productions will be. Will we witness the advent of criteria of viability such as epistemological, aesthetic, and regulatory truth, muzzled by obscurantist positions or (as I wrote in 1987, in a text devoted to the science of the living and visual art), will people performing cloning operations become the sculptors of tomorrow?[23]

Notes

1. *Bio/logos* is the discourse used by the living about the living.

2. Thomas Seboek is the founder of zoosemiotics—the study of signs that animal nature produces in order to communicate.

3. *Life art* is a generic term linking artistic practice with scientific practices that use living matter to artistic ends. This means there exists an art specific to the living and it is composed of living matter.

4. Richard G. Klein, *The Human Career: Human and Cultural Origins*, 2nd ed. (Chicago: University of Chicago Press, 1999).

5. *Technozoosemiotics* are scientific concepts and artistic practices created by Louis Bec, a zoosystemician. He works on chromatophoric languages of the cephalopods (loligo vulgaris) and on communication among electric fish (gnathonemus petersii).

6. Gregory Bateson, professor at the University of Palo Alto, was a biologist, anthropologist, psychiatrist, epistemologist, and cybernetician who specialized in the evolution of communication among mammals. After the Second World War, he became an intellectual model for a generation of young researchers. His two most influential books are *Steps to an Ecology of Mind: Collected Essays in Anthropology, Psychiatry, Evolution and Epistemology* (Chicago: University of Chicago Press, 2000) and *Mind and Nature: A Necessary Unity* (New York: Bantam Books, 1980). See the following chapters in

Steps to an Ecology of Mind: "Forms and Pathology of Relations," "Biology and Evolution," and "Epistemology and Ecology."

7. These new forms include plants and animals that populate space and create biodiversity.

8. Kounelis was one of the first artists, along with Joseph Beuys, to exhibit living forms in a gallery. The exhibit in Graz called *Animal Art Steirischer Herbst* included eighty-seven artists, among them Marina Abramovic, Terry Allen, Joseph Beuys, Ian Breakwell, Helen Chadwick, Kate Graig, Hubert Duprat, Valie Export, Werner Fenz, Lili Fischer, Terry Fox, Felix Hess, Jannis Kounellis, Tony Labat, and Mark Thompson.

9. *Technoteratogens* is a name given to transgenic animals that are genetically constructed according to an experimental program.

10. Poetics comes from the Greek; it means to do, make, act, construct.

11. Alba is the transgenic bunny created by Eduardo Kac with Louis Marie Houdebin for the art festival AVIGNONumerique (June 2000), whose appearance was censored for many reasons that included, perhaps, lobbying by rabbit farmers.

12. Peter Sloterdijk wrote *Rules for a Human Park* [Règles pour le parc humain] in 1999 (Paris: Mille et une nuits, 2000) and *The Domestication of Being* [La domestication de l'être] in 2000 (Paris: Mille et une nuits, 2000). His conversations with Carlos Oliveira are published in *Essay on Voluntary Intoxication* [Essai d'intoxication volontaire] (Paris: Calman-Levy, 1999).

13. Sloterdijk, *Rules for a Human Park*, 43.

14. *Mutations* refer to somatic mutations that act on an organic level, under the shock of tumors and other degenerate processes. Environmental mutations eventually result in environmental change. External mutations are caused by a rise in temperature, ultra-violet rays, and ionizing rays (cosmic rays, X-rays, radioactivity). Chemical mutations are caused by compounds such as nitrites and yperites.

15. One of the exobiological tenets of artificial life is to imagine that the construction of artificial intelligence is a possible way to relate to non-terrestrial life forms.

16. For a discussion of human ethology, see chapter 18 in Irenaüs Eibl-Eibesfeld, *Ethologie, biologiedu comportement* [Ethology, biology of behavior] (Paris: Naturalia et Biologia, 1984), esp. p. 84.

17. Stelarc is an Australian artist known for his technological performances with a robotic arm.

18. Technoteratogens (from the French neologism *technoteratogénes*) are monsters engendered through hybridization of genetic life forms with digital and electronic technologies.

19. Ferdinando Mussa-Ivaldi is a physiology professor at Northwestern University, Chicago.

20. Axel Michelsen is a biology professor at the University of Southern Denmark, Denmark.

21. Wolfgang H. Kirchner is a behavioral biology professor at the University of Konstanz, Germany.

22. *Autotomy* refers to the mutilation reflex of a body part in certain animals.

23. Louis Bec, "Sciences du vivant et arts plastiques" [Visual arts and the life sciences], *Mars*, no. 20 (Winter 1988): pp. 15–18.

II

Bioethics

6

Bioethics and the Posthumanist Imperative

Cary Wolfe

But who, me?
—Jacques Derrida, *Limited Inc.*

Bio-, Ethics

To ask the question, "What can bioethics be thinking?" is to raise the question not only of its institutional norms, which are powerfully vested indeed, but also of its philosophical norms. In that light, I will make the case that bioethics in its dominant mode of practice needs to undertake what philosopher Cora Diamond (following Wittgenstein) calls a "grammatical redescription"[1] of its chosen domain if it is to more fully and responsibly address the "bio-" of "bioethics"—the question of what Jacques Derrida calls simply (but not so simply, of course) "the living in general."[2]

Within the constraints of this essay, I can only provide a snapshot of contemporary bioethics with reference to one or two of its most well-known practitioners. In that light—to glance ahead for a moment—the first point I'd like to make is that contemporary bioethics in its most institutionally powerful form is largely if not exclusively within the purview of *policy studies* and, within that, in policies in healthcare and medicine, with all of the strings attached that one might expect. Indeed, contemporary bioethics is best understood not as ethics at all, but rather as the apotheosis of what Michel Foucault has analyzed as the rise of "bio-power" during the modern period, within which the areas of "health" and what will come to be called the "biomedical" take on new, politically central roles directly linked to the reproduction of both the state and capitalist relations.[3] In this context, Foucault argues, "the emergence of the health and physical well-being of the population in general" becomes "one of the essential objectives of political power."[4]

In light of Foucault's analysis of "bio-power" and its manifestation in the "medico-administrative" edifice, the root problem with contemporary bioethics is this: Bioethics presumes to serve as the self-designated conscience for those contemporary biotechnical apparatuses and institutions that exert power over life and death, but the obvious problem here is that the functions of "conscience" and those of establishing policies palatable to both state and economic power do not always or even often go hand in hand. Moreover, while there may be precious few compulsions on the side of conscience for the field of bioethics, there is no shortage of them on the side of policy, so that the tail does indeed wag the dog in an arrangement that critic David Shenk calls *Real Ethik*: "To simply declare certain procedures [such as human cloning] immoral and call for an immediate and permanent ban," he writes, "is to ignore brazenly the history of technology, one lesson of which might fairly be summarized as 'If it can be done, it will be done.'"[5]

Of course, such a position is cause for concern, and some of it has come from within the community of bioethicists themselves. Carl Elliott, who hopes to make the field more philosophically and ethically responsive to the real complexities it faces, puts it this way:

> [I]f the occupational hazard of philosophy is uselessness, that of medicine is an unthinking pragmatism. . . . Constrained by the demand for immediately useful answers, clinical ethics (at its worst, at any rate) comes dangerously close to being a purely technical enterprise carried out in isolation from any kind of deep reflection about the examined life.[6]

From this vantage, it is not surprising that, as Elliott puts it,

> the law is the *lingua franca* of bioethics. The language in which bioethics is discussed revolves around largely quasi-legal notions such as consent, competence, rights to refuse treatment, to have an abortion and so on. . . . [B]ut I also think that the law's influence on bioethics has been much deeper and more subtle. It has given us a picture of morality as somehow like the law in *structure*.[7]

Elliott continues,

> This way of reasoning says: we can figure out what to do in this case if we can just get straight about what a person is. That is, we know how to treat a person, so if we decide that this marginal being is a person—a fetus, an anencephalic or a neurologically damaged adult—or, say, a primate used in biomedical research—then a conclusion about how we should morally treat that marginal being will logically follow.[8]

But the problem here, from Elliott's point of view, is "the notion that we can somehow define what a person is apart from our *moral attitudes* towards persons,"[9] a procedure that

ignores the fact that "this is not the way our moral grammar works, in fact, just the opposite. Our moral attitudes are not *grounded* by a theory of persons; they are *built into our language*. Part of what we mean by the word 'person' entails a certain moral attitude."[10]

Trying to derive moral precepts from legalistic hair-splitting about the definition of the word "person" gets things backward, in other words, and when Elliott says "moral grammar" here, he means it in a specifically Wittgensteinian sense, as in Wittgenstein's well-known statement that "to imagine a language is to imagine a form of life."[11] And equally Wittgensteinian is his contention that "bioethics generally, if implicitly, assumes its subject matter to be questions of conduct and (sometimes) character." But it almost never confronts head-on

> questions about the sense or meaning of life, and it considers only in very awkward constructions (such as "quality of life") those questions about what makes life worth living. These are ultimate questions about the framework against which our judgments of value get their sense, but they are for the most part absent, or at least hidden, in mainstream bioethics.[12]

To put it another way, we may well agree with the pragmatism of *Real Ethik* in bioethics that dictates shifting "from policies of stark authorization/prohibition to a web of regulation and incentives, from ultimatums to real diplomacy, from grandstanding to nuance and compromise"[13]—but in the name of *what*, exactly, against what "background," to use the Wittgensteinian term? The answer typically given by bioethics is "to maximize the general social welfare and to minimize harm,"[14] but such a reply, of course, begs all sorts of questions, not the least of which is how it can be distinguished from a simple appeal to ethnocentric prejudice and pragmatic expediency in the service of the various vested interests already noted by Foucault. And on this point, nothing is more symptomatic of the current state of bioethics than its inability or unwillingness to address the ethical issues raised by dramatic changes over the past thirty years in our knowledge about the lives, communication, emotions, and consciousness of a number of nonhuman species.[15] This is entirely to the point for the field of contemporary bioethics, of course, simply because millions of animals are "used" in biomedical research each year.[16]

This problem is perfectly exemplified, it seems to me, by bioethicist Arthur Caplan's attempt to address the question of our obligations to non-human animals, especially those used in biomedical research, in a recent essay on the ethical complexities of xenotransplantation (transplanting animal organs in humans). I choose Caplan here not because he is an easy mark, a retrograde figure in the field; quite the contrary, he is in some ways one of its more progressive voices. And he is certainly one of its most visible; in addition to running the University of Pennsylvania Center for Bioethics, he is a regular columnist for MSNBC and appears regularly in the major media as the designated "expert" in contemporary bioethics.

Caplan's essay, "Is the Use of Animal Organs for Transplants Immoral?" displays exactly the kind of confusion to which Elliott objects, and on every page evinces the kind of contamination of ethical rigor by pragmatic expediency and ethnocentrism that is the hallmark of the *Real Ethik* of contemporary bioethics.[17] At the core of the essay, Caplan argues that it is acceptable to use some animals, even primates, to "demonstrate the feasibility of xenografting in human beings," and that this is so for a familiar set of reasons. First, he argues that the differences "in the capacities and abilities" of humans and primates—he lists the familiar litany: language, tool use, rationality, intentionality, and so on—justify a different moral status. He concedes that all of these are found in nonhuman species, but asserts that "Humans are capable of a much broader range of behavior and intellectual functioning than is any other primate species," and that therefore humans and non-human animals are not "moral equivalents."[18]

One might well begin by observing that there is a fundamental slippage here that needs to be clarified before we can make any real headway on this question. As even the most famous animal rights philosopher on the planet, Peter Singer, has argued, the question is not and has never been whether humans and nonhuman animals are "the same" morally. As Singer puts it, the issue

> is *not* saying that all lives are of equal worth or that all interests of humans and other animals are to be given equal weight, no matter what those interests may be. It *is* saying that where animals and humans have similar interests—we might take the interest in avoiding physical pain as an example, for it is an interest that humans clearly share with other animals—those interests are to be counted equally, with no automatic discount just because one of the beings is not human.[19]

A further problem with Caplan's position is that it is open to objection by means of what is often called "the argument from marginal cases." As philosopher Paola Cavalieri puts it,

> Concretely it is not true that all human beings possess the attributes that allegedly mark the difference between us and the other animals. It is undeniable that there exist within our species individuals who, on account of structural problems due to genetic or developmental anomalies, or of contingent problems due to diseases or accidents, will never acquire, or have forever lost, the characteristics—autonomy, rationality, self-consciousness, and the like—that we consider as typically human.[20]

This objection undermines as well Caplan's second point: "Human beings can be ethical," he writes. "They may act this way only rarely and some may never do so, but we are creatures capable of moral activity and moral responsibility. Humans can be moral agents, while animals, even other primates, are moral subjects."[21] As we have just seen, however,

even if this assertion is true of nonhuman animals, it is certainly not true of all human beings—namely, those "marginal cases" just referenced. And yet we refrain from using them to "harvest" organs while we do so with other animals who are demonstrably superior in relevant moral characteristics.

Moreover, as Cavalieri points out, a position such as Caplan's rests on a fundamental slippage between the question of "moral agents" and "moral patients." "This view may appear plausible," she writes, "but is in fact ambiguous. It can indeed mean two different things: (a) that only rational and autonomous beings can be morally responsible, or (b) that only what is done to rational and autonomous beings has moral weight."[22] As Cavalieri puts it, "If the moral agent is a being whose *behavior* may be subject to moral evaluation, the moral patient is a being whose *treatment* may be subject to moral evaluation."[23] From this vantage, it is irrelevant, as Caplan puts it, that "animals are incapable of being held to account for what they do," since the fundamental issue here is not *their* behavior but rather *our* treatment of them. (One might say the same, after all, of a human being suffering from severe schizophrenia, or a small child, or an elderly person suffering from Alzheimer's disease, and so on.)

Caplan's final line of defense in response to the marginal cases problem is perhaps the most telling and disturbing of all. The reason that even the severely retarded or permanently comatose person should not be used in the same research in which we use a more fully endowed great ape

> has nothing to do with the properties, capacities, and abilities of children or infants who lack and have always lacked significant degrees of intellectual and cognitive function. The reason they should not be used is because of the impact using them would have upon other human beings. . . . The assessment of the morals of how we treat each other and animals does not hinge simply on the properties that each possess [*sic*]. Relationships must enter into the equation as well, and when they do the balance begins to tip toward human rather than animal interests when there is a conflict.[24]

The problem with *this* position, of course, is at least twofold. Ethically speaking, it is a not even thinly disguised appeal to ethnocentrism and prejudice under the cover term "relations"—in this case, prejudice on the basis of species membership; and logically speaking, it is utterly circular.

As for the first, this appeal to "relational" rather than individual characteristics, though it seems commonsensical and clear-headed enough, is in fact ethically pernicious, and just *how* pernicious is revealed by a little experiment that Cavalieri conducts with it in her book *The Animal Question*. First, she quotes exactly the same "relational" position held by Caplan—this time from the work of Robert Nozick. "Perhaps it will turn out," Nozick contends,

that the bare species characteristic of simply being human...will command special respect only from other humans—this is an instance of the general principle that the members of any species may legitimately give their fellows more weight than they give members of other species (or at least more weight than a neutral view would grant them). Lions, too, if they were moral agents, could not then be criticized for putting other lions first.[25]

But what is revealed about this position, Cavalieri asks, if we plug in other terms instead:

Perhaps it will turn out that the bare racial characteristic of simply being white...will command special respect only from other whites—this is an instance of the general principle that the members of any race may legitimately give their fellows more weight than they give members of other races (or at least more weight than a neutral view would grant them). Blacks, too...could not then be criticized for putting other blacks first.[26]

Caplan may want to reject the view that says "that we are powerful and the primates are less so; therefore they must yield to human purposes"—"this line of response," he contends, "is far removed from the kinds of arguments that should be mustered in the name of morality."[27] But the point here, of course, is that this *is* the kind of argument Caplan is making. Moreover—to return to my second point above—it is not just that Caplan's position is ethnocentric; it is also circular, to wit: "we care about being X because we think of them as 'persons,'" and "we think of them as 'persons' because we care about them." What is needed here, of course, is a *disarticulation* of the question of "persons" from the question of membership in the species *Homo sapiens*. Here, it is important to note that the Wittgensteinian point about moral attitudes being "built into our language" is not some sort of positivism (though it is sometimes understood that way)[28] that holds that we should simply take for granted what "we" mean by "persons." On the contrary, it suggests that we should be extraordinarily, indeed philosophically, attuned to how our "forms of language"—what we say, what we write, how we ask philosophical questions—open up certain lines of thought, and indeed the ability to imagine entire worlds (as Wittgenstein puts it), and severely foreclose others.

So when Caplan asks if it is ethical to use animals to study the feasibility of cross-species xenografting, and he responds that "in part, the answer to this question pivots on whether or not there are plausible alternative models to the use of animals,"[29] we can see, in light of what I have just said, that the question ostensibly being asked has already been decided, since the question is really not "can we consider using them?" but rather, simply, "under what pragmatic circumstances?" Here—as Wittgenstein might put it—animals can't be persons because they already aren't.

Cary Wolfe

Beyond "Rights"

So far, I have been responding to the shortcomings of bioethics in its own terms—that is to say, the terms of analytical philosophy and what is sometimes called its "justice tradition." As I hope I have shown (far too hastily, I'm afraid), even in its own terms it is woefully inadequate—both ethically and philosophically—for confronting the complex questions of life, death, and our relations to other living beings that far exceed what "bioethics" currently constitutes as its unified field. At this juncture, we might move in one of two directions. Along one tack, we might remain within the purview of the analytical tradition and work more diligently to apply it consistently and dispassionately to the questions just raised—which is essentially what we find in the work of animal rights philosophers such as Cavalieri, Regan, and Singer. Or conversely, we might shift to another way of doing philosophy altogether, one that has a very different notion of the relationship between the practice of philosophy and the kinds of questions that animate, or ought to animate, bioethics. I want to now explore this second option, partly because the first has already been done so well by Cavalieri and others, and partly because the second will help us to tease out the limitations of the analytical tradition (which are, I believe, severe) for addressing questions of bioethics in the broadest sense.

We can begin to get a sense of what I mean by taking seriously Cora Diamond's contention—an essentially Wittgensteinian contention—that the "grammatical description" of a set of problems or questions is absolutely crucial to, and in some sense determinative of, our ability to do justice to the ethical challenges they pose.[30] For Diamond, the fundamental question of *justice* takes place in an essentially different conceptual register than the question of "rights." As she argues, "when genuine issues of justice and injustice are framed in terms of rights, they are thereby distorted and trivialized," in part because the language of rights still bears the imprint of the context in which it was shaped: Roman law and its codification of *property* rights—not least, of course, property rights over slaves.[31] But the question of justice cannot be reduced to the question of the fairness or unfairness of a share. "The attempt to give voice to real injustice in the language of rights," Diamond argues, "falters because of the underlying tie between rights and a system of entitlement that is concerned, not with evil done to a person, but with how much he or she gets compared to other participants in the system."[32] And so it is, she argues, that "the *character* of our conflicts is made obscure when two sides of a conflict involving very different elements of human life are expressed in the same terms," as, for example, when Irish victims of famine are allowed to starve to death because distributing food cheaply would undermine the rights of traders to make a profit.[33]

There are two different levels of value here, in other words,[34] and this is what is missed by *both* "sides" of what Diamond bemusedly calls "that great arena of dissociated thought, contemporary debate about animals' rights."[35] The problem with *both* sides of the debate

is that they are locked into a model of justice in which a being does or does not have rights on the basis of its possession of empirically determinable, morally significant characteristics (Singer's "interests," Regan's "inherent value," Caplan's "moral agency," and so on). *Both* sides argue "that what is involved in moral thought is knowledge of empirical similarities and differences, and the testing and application of general principles of evaluation," so that "if a Moral Agent believes it is wrong to torment a cat, this must depend on his having some such general principle as that The Suffering of a Sentient Being is a Bad Thing and that one ought therefore to prevent such bad states of affairs from existing."[36]

But what such accounts leave out for Diamond is "what human beings have *made of* the difference between human beings and animals."[37] What is interesting about Diamond's assertion is that it cuts both ways. For her, proponents of animal rights in the analytical tradition—she has in mind primarily Singer and Regan—are wrong when they insist that the distinction between human and animal is not ethically fundamental. At the same time, however, those who *oppose* animal rights in that same analytical tradition—not least, of course, the overwhelming majority of professional bioethicists—are wrong about how that difference between humans and animals *is* relevant. "The notion 'human being' is of the greatest significance in moral thought,"[38] she argues, but not because it is a "biological notion."[39] The difference between human and nonhuman animals "may indeed start out as a biological difference, but it becomes something for human thought through being taken up and made something *of*—by generations of human beings, in their practices, their art, their literature, their religion."[40] "Grasping a concept," she continues, "is not a matter just of knowing how to group things under that concept; it is being able to participate in life-with-the-concept. . . . To be able to use the concept 'human being' is to be able to think about human life and what happens in it; it is not to be able to pick human beings out from other things or recommend that certain things be done to them or by them."[41]

But it is not at all obvious at first glance how Diamond's insistence on the priority of "human being" as an ethical concept might be enabling for those interested in deepening and extending our ability to think about the question of our relations to the living in general, including nonhuman animals. She insists, however, that the specificity of the concept of "human being" "is a main source of that moral sensibility which we may *then* be able to extend to animals. We can come to think of killing an animal as in some circumstances at least similar to homicide," she continues, "but the significance of doing so depends on our already having an idea of what it is to kill a man; and for us (as opposed to abstract Moral Agents) the idea of what it is to kill a man does depend on the sense of human life as special, as something set apart from what else happens on the planet."[42]

For Diamond, in other words, it is not by denying the special status of "human being" but rather by intensifying and extending it that we can come to think of nonhuman animals not as bearers of "interests" or as "rights holders," but rather as something much

more important and compelling: "fellow creatures." That phrase "does not mean, biologically, an animal, something with *biological* life," but rather our "response to animals as our fellows in mortality, in life on this earth."[43] As Diamond might say, there is the *biological* fact of the mortality we share with animals, and then there is the *ethical* import of what human beings have *made* of that fact. She writes:

> If we appeal to people to prevent suffering, and we, in our appeal, try to obliterate the distinction between human beings and animals and just get people to speak or think of "different species of animals," there is no footing left from which to tell us what we ought to do. . . . The moral expectations of other human beings demand something of me as other than an animal; and we do something like imaginatively read into animals something like such expectations when we think of vegetarianism as enabling us to meet a cow's eyes. There is nothing wrong with that; there *is* something wrong with trying to keep that response and destroy its foundation.[44]

We can get a sense of the implications of this view for the grain and texture of ethical thinking and the question of the living by following Diamond's very interesting discussion of a highly publicized case several years ago. In a videotape smuggled out of the University of Pennsylvania's Head Injury Laboratory, researchers and lab workers are shown making fun of a baboon who has been subjected to massive injuries in their experiments, as one of the lab workers poses with the animal while the rest of the staff laughs at what one calls the "punk look" of the its massive cranial sutures.[45] Viewers, almost without exception, find this tape deeply disturbing—but not, Diamond argues, in a way accountable (or defensible) by either side of the animal rights debate.

For Diamond—and here she is extending remarks on ethics by Simone Weil—the nub of the issue is that "the animal's body, which is all it has, as a poor man's body may be all he has, is turned into the mere butt of your jokes"; the animal "lacks the power to get away, or to resist," and what is morally repugnant is to make this disempowerment, this abjection, the occasion for sport. But this repugnance is not easily accounted for by the rights framework, fixated as it is on the dependence of rights on interests, and interests in turn on a more or less naturalistic conception of the good of the animal. "Not being a butt of humor is not taken to be part of its good," Diamond writes; "we cannot owe it to animals that they not be treated in some way, unless they would *suffer* from such treatment; and the idea would be that an animal cannot suffer from being ridiculed if it is not even aware that it is being ridiculed."[46]

For Diamond, this example helps to illustrate two crucial points. The first, captured by the notion of "fellow creature," is that what generates our moral response to animals and their treatment is our sense of the mortality and vulnerability that we share with them, of which the brute subjection of the body—in the treatment of animals as mere research tools, say, or the torture of human beings as political prisoners—is perhaps the most

poignant testament. For Diamond, the "horror at the conceptualizing of animals as putting nothing in the way of their use as mere stuff" is dependent upon "a comparable horror at human relentlessness and pitiliness in the exercise of power" toward other humans.[47] And this leads in turn to a second point that Diamond wants to make about ethics in relation to the question of the living, one that has to do with how we *relate* to that vulnerability. Here, what the rights tradition misses, in her view, is that the "capacity to respond to injustice as injustice" depends not on working out (from a safe ontological distance, as it were) who should have a fair share of this or that abstract "good," but rather on "a recognition of *our own* vulnerability"—a recognition not demanded and in some sense actively avoided by rights-oriented thinking.[48]

More specifically—and here we find the full resonance of the Head Injury Lab example discussed earlier for ethics as such—"there is something wrong with the contrast, taken to be exhaustive, between demanding one's rights and begging for kindness—begging for what is *merely* kindness. The idea that *those* are the only possibilities is . . . one of the main props of the idea that doing injustice *is* failing to respect rights."[49] Contemporary moral theory "pushes apart justice, on the one hand, and compassion, love, pity, tenderness, on the other,"[50] but Diamond's understanding of the question "has at its center the idea that a kind of loving attention to another being, a possible victim of injustice, is essential to any understanding of the evil of injustice."[51] On this understanding, as Weil suggests, "rights can work for justice or for injustice," and the concept of rights itself possesses "a kind of moral noncommitment to the good";[52] it is, strictly speaking, *beside the point* of justice as such.

It may come as something of a surprise, then, that Diamond finds in the contemporary animal *rights* movement a profundity not available in the idea of mere animal *welfare*. "The welfarist view," she writes, "is essentially that we should ease the burdens we impose on animals . . . without ceasing to impose burdens on them, burdens that we impose because we *can*, because they are in general helpless" to resist us;[53] and "the force of the animal rights movement comes from the sense of the profound injustice of this." If we reject the opposition, all too dominant in contemporary moral theory, of justice and compassion, rights and pity, what is revealed, in fact, is "a kind of pitilessness at the heart of welfarism, a willingness to go ahead with what we do to the vulnerable, a willingness to go on subjecting them to our power because we can," that is different not in kind but only in degree from what goes on in the animal research labs. "'Willingness' is indeed too weak a word," she writes; "we *will* not give up a form of life resting on the oppression of others; and the will to continue exercising power in such ways . . . is inseparable from the 'compassion' we express in welfarism." What the idea of "animal rights" points toward but cannot articulate is that what is needed is attention to "how deeply attached we are to the institutions that make possible all sorts of goods for ourselves at terrible costs to others, an attachment entirely compatible with attempts to make those costs a little less burdensome."[54]

Cary Wolfe

Taking Bioethics Off "Auto"-Pilot

The originality and subtlety of Diamond's position lies in no small part, as we have seen, in her separation of the question of justice from the discourse of rights—and beyond that, in her insistence that vulnerability and compassion reside at the very heart of justice. But my interest in her work also concerns its attempt "to show how philosophical misconceptions about language are connected with blindness to what our conceptual life is like."[55] It is here, I think, that Diamond's approach runs aground, and for a very specific reason. She is certainly right in her Wittgensteinian suggestion that our ability to think about questions of bioethics depends on the language—and the understanding of language—that we bring to it. But what we find in her work, I believe, is a view of how language operates in a philosophical context—a view directly linked to her notion of "human being"—that undermines her attempt to open the question of justice beyond the human sphere alone.

The problem is hinted at, for example, by how easily the terms "language" and "conceptual life" drift apart in the formulation of Diamond's I just quoted, and I want to bring out what is at stake here for ethics by way of contrast with the work of Jacques Derrida. I choose Derrida not so much because of—or at least not *first* because of—his concept of language (though "concept" is not how he would put it, of course), but rather because we find in his recent work a gathering of terms around questions of justice and the living that is strikingly similar to what we have just seen in Diamond.

It will come as a surprise to any reader, I think, that in his recent work on ethics and the question of nonhuman others, Derrida returns to what serves in *Singer's* animal rights philosophy as the very benchmark for the ethical consideration of animals: namely, the utilitarian philosopher Jeremy Bentham's contention that the relevant question here is not "can they talk," or "can they reason," but "can they *suffer?*" For Derrida, putting the question in this way "changes everything," because in the philosophical lineage that runs from Aristotle through Descartes and Heidegger to Lacan, posing the question of the animal in terms of either the capacity for thought or language "determines so many others concerning *power* or *capability* [*pouvoirs*], and *attributes* [*avoirs*]: being able, having the power to give, to die, to bury one's dead, to dress, to work, to invent a technique."[56] What makes Bentham's reframing of the problem so powerful is that now, "The question is disturbed by a certain *passivity*. It . . . testifies to sufferance, a passion, a not-being-able." "What of the vulnerability felt on the basis of this inability?" he continues; "what is this non-power at the heart of power? . . . What right should be accorded it? To what extent does it concern us?" It concerns us very directly, in fact, for "mortality resides there, as the most radical means of thinking the finitude that we share with animals, the mortality that belongs to the very finitude of life, to the experience of compassion, to the possibility of sharing the possibility of this non-power . . . the anguish of this vulnerability."[57]

In Derrida as in Diamond, the vulnerability and, ultimately, mortality that we share with nonhuman animals, and the compassion that they elicit are at the very core of the

question of ethics: not just "mere" kindness, but *justice*. And for Derrida as for Diamond, the force of "what is still presented in such a problematic way as *animal rights*" is that it "involves a new experience of this compassion," one that has opened anew for ethics the question of "suffering, pity and compassion," "the sharing of this suffering among the living," and "the law, ethics, and politics that must be brought to bear upon this experience of compassion."[58] For Derrida as for Diamond, then, the force of the animal rights movement outstrips its own ability to articulate the questions it addresses, questions that require a different conception of ethics. For Singer, as we have already suggested, ethics means the application of what Derrida will elsewhere characterize as a "calculable process," in this case quite literally: the utilitarian calculus that tallies up the "interests" of the particular beings in question in a given situation, regardless of their species, and determines what counts as a just act by calculating which action maximizes the greatest good for the greatest number.[59] In doing so, however, Singer would reduce ethics to the very antithesis of ethics in Derrida's terms because it would overleap what Derrida calls "the ordeal of the undecidable," which "must be gone through by any decision worthy of the name." For Derrida, "A decision that didn't go through the ordeal of the undecidable would not be a free decision, it would only be the programmable application or unfolding of a calculable process. It might be legal; it would not be just."[60]

Moreover, such a "calculation," in its derivation of the shared "interests" of human and nonhuman animals, would confuse what Diamond calls "biological concepts" with the concepts proper to *ethical* thought. This is exactly what Derrida has in mind, I think, in his criticism of "geneticism" and what he calls a "biological continuism, whose sinister connotations we are well aware of." "I have thus never believed in some homogeneous continuity between what calls *itself* man and what *he* calls the animal," which relies upon "a naïve misapprehension of this abyssal rupture."[61] Here we might well ask why Derrida's appeal to the shared mortality of human and nonhuman animals is not itself a form of this very continuism,[62] were it not for the fact that Derrida provides an answer in insistence on the "abyssal rupture" between the human and animal—his version, with a very different inflection (as we are about to see), of Diamond's insistence on the importance of "what we humans have *made* of the difference" between humans and animals.

At this juncture, however—and it is marked quite precisely by Derrida's emphasis on "what calls *itself* man and what *he* calls the animal"—some fundamental differences between Derrida and Diamond begin to come into view, not least of all in the articulation of this peculiar thing called "the human." We can begin to get a sense of this difference by returning to the crucial role that vulnerability, passivity, and, ultimately, mortality play for both Diamond and Derrida. Let us recall Diamond's contention that "We can come to think of killing an animal as in some circumstances at least similar to homicide, but the significance of doing so depends on our already having an idea of what it is to kill a man."[63] Such an idea depends, however, on precisely the kind of relation to our own mortality that is rejected in Derrida's work; for with Derrida, contra Diamond, we *never* have

an idea of what death is *for us*—indeed, death is precisely that which can never be *for us*—and if we did, then the ethical relation to the other would be immediately foreclosed.

This is clearest, perhaps, in Derrida's reading of Heidegger and his concept of "being-toward-death," a concept that appears—but only appears—to do justice to the passivity and finitude in which the ethical resides. As Richard Beardsworth characterizes it, for Derrida, Heidegger *appropriates* the limit of death "rather than returning it to *the other* of time. The existential of 'being-toward-death' is consequently a 'being-able' (*pouvoir-être*), not the impossibility of all power" whose passivity and vulnerability ties the self to the other in an ethical bond. For Derrida, on the other hand,

> the "impossibility" of death for the ego confirms that the experience of finitude is one of radical passivity. That the "I" cannot experience its "own" death means, firstly, that death is an immanence *without* horizon, and secondly, that time is that which exceeds my death, that time is the generation which precedes and follows me.... Death is not a limit or horizon which, re-cognized, allows the ego to assume the "there" [as in Heidegger's "being-toward-death"]; it is something that never arrives in the ego's time, a "not-yet" which confirms the priority of time over the ego, marking, accordingly, the precedence of the other over the ego.[64]

Because the ego cannot experience its own death, "The recognition of the limit of death is always through another and is, therefore, at the same time the recognition of the other."[65] And since the same is true *of* the other in relation to its *own* death, what this means is that death—as an absolute horizon that nevertheless never appears *as such, for me*—"*im*possibilizes existence," and does so both for me *and* for the other, since death is no more "for" the other than it is for me.[66] But it is, paradoxically, in just this impossibility that the possibility of justice resides, the (as it were) permanent call of the other in the face of which the subject always arrives "too late."

Such is the full resonance, I think, of Derrida's recent contention with regard to Bentham: "The word *can* [*pouvoir*] changes sense and sign here once one asks 'can they suffer?' The word wavers henceforth. As soon as such a question is posed what counts is not only the idea of a transitivity or activity (being able to speak, to reason, and so on); *the important thing is rather what impels it towards self-contradiction, something we will later relate back to auto-biography.*"[67] What Derrida has in mind by the "auto-" of "auto-biography" here is exemplified, I think, in Diamond's picture of the human in relation to ethics, a picture in which, as in Heidegger, vulnerability, passivity, and finitude are recuperated as a "being-able" and a "transitivity," thus ontologizing the split between the human and the other, across which the human then reaches, so to speak, in an act of benevolence toward an other we "imagine" is enough like us to warrant ethical treatment. And in Diamond, this "human being" is an essentially homogeneous and undifferentiated creature that is capable of a more or less transparent relationship to its own nature, a relationship that it

then expresses in and through language in a second-order operation, and which it may *then* extend benevolently (or not) to the nonhuman other.

This seems clear enough, for example, in Diamond's contention that the "basis for justice" lies in the human being's "unreasoned expectation of good,"[68] or her contention that "we do something like imaginatively read into animals something like such expectations when we think of vegetarianism as enabling us to meet a cow's eyes."[69] In both of these examples, what the language of "unreasoned good," "moral expectations," and "imaginatively read into" attempts to paper over (unsuccessfully, I think) is just how undifferentiated in relation to itself the "human" is in this account, and how hypostatized its relations to the nonhuman other have become. And matters are not helped any by her contention that "Our *hearing* the moral appeal of an animal is our hearing it speak—as it were—the language of our fellow human beings."[70]

There are two distinct issues here that we need to treat in turn. The first is who, exactly, these "fellow human beings" are, particularly if we have ruled out recourse to "a biological concept," as Diamond insists we should. The second—and I will return to this in a moment—is that even if we know who those "fellows" are, what does it mean to say that there is "a language" proper to them, and that the animal must speak it if it is to be heard morally?

As for the first of these, perhaps the most succinct way to make my point is simply to note the question of ethnocentrism that it begs. For example, Diamond writes in "Experimenting on Animals" that if we want to know whether it is a good thing to treat dogs differently from other animals, or cows differently from other animals,

> it is absurd to think these are questions you should try to answer in some sort of totally general terms, quite independently of seeing what particular human sense people have *actually* made out of the differences or similarities you are concerned with. And this is not predictable. If the Nuer, for example, had not actually made something humanly remarkable out of giving cows a treatment quite different from that accorded other animals, one could not know that "singling cows out for special treatment" could come to that.[71]

The first half of Diamond's contention may be right but the problem is that there is nothing to prevent us from carrying out exactly the same sort of thought experiment here that we saw Cavalieri carry out with Nozick's "relational" view of ethics. (To wit: "if the Germans, for example, had not actually made something humanly remarkable out of giving Aryans a treatment quite different from that accorded Jews," and so on).

We seem to be faced, then, with a double bind: How can we agree with Diamond's rejection of basing ethical questions on empirical data and "biological concepts," and at the same time distance her view from the pernicious ethnocentrism harbored by a completely "relational" view of ethics? And at this juncture, we suspect that an altogether

different way of thinking about these problems may be necessary, a way that is invoked, for Derrida, by the name of "Nietzsche." From that vantage—the vantage staked out, say, in Nietzsche's "Truth and Lie in the Ultra-Moral Sense"—we might say that we find in Diamond the same problem we see in Richard Rorty's concept of "belief."[72] The question here is not so much the opening of the self-enclosed *ethnos* to an equally hypostatized outside named by "the biological" or "science," but rather that there is nothing *in the relation of the* ethnos *to itself*—the relation of the "auto-" to its "autobiography," to use Derrida's terms—that necessitates an ethical opening to the other by means of an alterity installed not *outside* the *ethnos* (who may then benevolently recognize—or not—such difference from a safe ontological distance), but rather at its very core, as the truth of the subject itself. And here, it is useful to remember the specific sense of Nietzsche's phrase "human, all too human," in which, as Diana Fuss puts it, "the 'all too' syntactically locates at the center of the human some unnamed surplus—some residue, overabundance, or excess. The doubling of the human that embraces the 'all too' suggests that this excess may be internal to the very definition of the human, an exteriority embedded inside the human as its condition of possibility. If humanness constitutes itself through its own superfluity, then to be human is already to be, in some profound sense, nonhuman."[73]

For Derrida, of course, that nonhuman alterity at the very core of the human is language itself, understood in his specific sense as an "arche-writing" constituted in and through *"différance."* I cannot revisit here the contours of Derrida's theory of language (which are in any case well known), but instead want only to emphasize how that view of language opens up our ability to think the ethical question of our relation to the living. For Derrida, "all the concepts of metaphysics"—including, of course, self-presence, the transparent presence of the self to itself of the sort we saw in Diamond—function to *"cover up* the strange 'movement' of this difference. But this pure difference, which constitutes the self-presence of the living present, introduces into self-presence from the beginning all the impurity putatively excluded from it. The living present springs forth out of its nonidentity with itself and from the possibility of a retentional trace. It is always already a trace." And what this means, in turn, is that "the trace is the intimate relation of the living present to its outside, the opening to exteriority in general."[74]

The ethical implications of this view are captured well, I think, by Vicki Kirby, and they form a stark contrast to Diamond's contention that the ethical call of the nonhuman animal depends upon our "hearing it speak *our* language." As Kirby puts it, if one places difference and alterity outside the subject and its means of representation, then "this division actually severs the possibility of an ethical relation with the Other.... [E]thical responsibility to the Other therefore becomes an act of conscious humility and benevolent obligation to an Other who is not me, an Other whose difference is so foreign that it cannot be known." A Derridean reading, on the other hand, would surely discover that alterity and difference within the subject itself, as "a constitutive breaching, a recalling and

differentiating within the subject, that hails it into presence. As impossible as it may seem, the ethical relation to radical alterity is to an other that is, also, me.[75]

This is what Derrida has in mind, I think, when he contends in the interview "Eating Well" that

> the idea according to which man is the only speaking being, in its traditional form or in its Heideggerian form, seems to me at once undisplaceable and highly problematic. Of course, if one defines language in such a way that it is reserved for what we call man, what is there to say? But if one reinscribes language in a network of possibilities that do not merely encompass it but mark it irreducibly from the inside, everything changes. I am thinking in particular of the mark in general, of the trace, of iterability, of *différance*. These possibilities or necessities, without which there would be no language, *are themselves not only human....* And what I am proposing here should allow us to take into account scientific knowledge about the complexity of 'animal languages,' genetic coding, all forms of marking within which so-called human language, as original as it might be, does not allow us to 'cut' once and for all where we would in general like to cut.[76]

At this juncture, we can feel the full force of the difference between Derrida's posthumanist position and how Diamond's humanism formulates the relation between language, ethics, and the human/animal divide. In "Injustice and Animals," Diamond suggests that applying the concept of justice to nonhuman animals is "a response to communicative pressure"; "the ways of speaking we find in response to activities and experiences may accommodate a merely superficial kind of 'meaning it'; or we may be able to find words that more fully render experiences or activities, *words that can be meant more fully*."[77] But it ought to be clear by now that the distinction between superficially "meaning it" and *really* "meaning it" reinstates—like J. L. Austin's distinction between "serious" and "non-serious" performatives that Derrida critiques in "Signature Event Context"—the subject as "auto-," "a free consciousness present to the totality of the operation, and of absolutely meaningful speech [*vouloir-dire*], master of itself: the teleological jurisdiction of an entire field whose organizing center remains *intention*."[78]

Over and against this recovery of humanism by what one might think of as the "Analytical-with-Apologies" tradition, Derrida counterposes what he characterizes as the "corrupting" and "contaminating" work of "iterability,"[79] which "does not signify simply...repeatability of the same, but rather alterability of this same idealized in the singularity of the event."[80] As such, it names a form of ethical responsibility that entails vigilant attention to each specific, interfolded iteration of "rule and event," to *this particular* undecidable" that "opens the field of decision or decidability,"[81] one that "is always a *determinate* oscillation between possibilities" that takes place "in strictly *defined* situations" that are "*pragmatically* determined."[82] Here, we find a sense of ethics obviously opposed to

the discourse of "(animal) rights," one quite congenial, or so it would seem, to Diamond. But Derrida's point of course is that the question "What is to be done?" can only be addressed in light of a prior one that in some sense determines the entire ethical field: "By whom?"

Notes

1. Cora Diamond, "Injustice and Animals," in *Slow Cures and Bad Philosophers: Essays on Wittgenstein, Medicine, and Bioethics*, ed. Carl Elliott (Durham, NC: Duke University Press, 2001), 123.

2. Derrida uses this phrase in many places, but the salient context for my purposes is his essay, "The Animal that Therefore I Am (More to Follow)," trans. David Wills, *Critical Inquiry* 28 (Winter 2002): 395.

3. Michel Foucault, "Right of Death and Power Over Life," in *The Foucault Reader*, ed. Paul Rabinow (New York: Pantheon, 1984), 263.

4. Michel Foucault, "The Politics of Health in the Eighteenth Century," in *The Foucault Reader*, ed. Paul Rabinow (New York: Pantheon, 1984), 277.

5. David Shenk, "Biocapitalism: What Price Genetic Revolution?," *Harper's* (December 1997): 44.

6. Carl Elliott, *A Philosophical Disease: Bioethics, Culture, and Identity* (New York: Routledge, 1999), xxii.

7. Ibid., xxviii.

8. Ibid., 159.

9. Ibid.

10. Ibid., 160.

11. Quoted in Carl Elliott, "Introduction: Treating Bioethics," in *Slow Cures and Bad Philosophers*, 12. It is beyond the scope of this essay to take up Wittgenstein's work in any detail, but I have investigated this question elsewhere, in my essay "In the Shadow of Wittgenstein's Lion: Language, Ethics, and the Question of the Animal," in *Zoontologies: The Question of the Animal* (Minneapolis: University of Minnesota Press, 2003), 1–57; it is also available as a chapter of my *Animal Rites: American Culture, the Discourse of Species, and Posthumanist Theory* (Chicago: University of Chicago Press, 2003), 44–94.

12. Elliott, *A Philosophical Disease*, xxxi.

13. Shenk, "Biocapitalism," 44.

14. Ibid.

15. These developments are not hard to come by; they have been widely popularized on cable television venues such as The Animal Planet station, and in series such as PBS's *The Animal Mind*, hosted by George Page. But the reader should also consult, among many others, *The Great Ape Project: Equality Beyond Humanity*, ed. Paola Cavalieri and Peter Singer (New York: St. Martin's Press, 1993); *Anthropomorphism, Anecdotes, and Animals*, ed. Robert W. Mitchell, Nicholas S. Thompson,

and H. Lyn Miles (Albany: State University of New York Press, 1997); and, especially, *Interpretation and Explanation in the Study of Animal Behavior*, eds. Marc Bekoff and Dale Jamieson (Boulder, CO: Westview Press, 1990).

16. Reliable figures on the exact number of animals used for research in the United States are hard to come by, for one simple reason: Mice, rats, and birds account for upwards of eighty percent of all animals used, but because they are not covered by the United States Animal Welfare Act, laboratories are not required to report their numbers. Estimates for total number of animals used range from seventeen to seventy million. See F. Barbara Orlans, "Data on Animal Experimentation in the United States: What They Do and Do Not Show," *Perspectives in Biology and Medicine* 37, no. 2 (Winter 1994). Readers interested in pursuing these questions should consult, among others, Orlans's *In the Name of Science: Issues in Responsible Animal Experimentation* (New York: Oxford University Press, 1993), and Hugh LaFollette and Niall Shanks, *Brute Science: Dilemmas of Animal Experimentation* (New York: Routledge, 1996).

17. Arthur L. Caplan, *Am I My Brother's Keeper?: The Ethical Frontiers of Biomedicine* (Bloomington, IN: Indiana University Press, 1997), 101–114.

18. Ibid., 108.

19. Peter Singer, "Prologue: Ethics and the New Animal Liberation Movement," in *In Defense of Animals*, ed. Peter Singer (New York: Harper and Row, 1985), 9.

20. Paola Cavalieri, *The Animal Question: Why Nonhuman Animals Deserve Human Rights*, trans. Catherine Woollard (New York: Oxford University Press, 2001), 76.

21. Caplan, *Am I My Brother's Keeper?*, 109.

22. Cavalieri, *The Animal Question*, 28.

23. Ibid., 29.

24. Caplan, *Am I My Brother's Keeper?*, 111.

25. Quoted in Cavalieri, *The Animal Question*, 80.

26. Ibid., 80.

27. Caplan, *Am I My Brother's Keeper?*, 110.

28. As Vicki Hearne writes of "thinkers who like to say that a cat cannot be said to be 'really' playing with a ball because a cat does not seem to know our grammar of what 'playing with' and 'ball' are" (a position that is sometimes attributed to Wittgenstein): "This more or less positivist position requires a fundamental assumption that 'meaning' is a homogeneous, quantifiable thing, and that the universe is dualistic in that there are only two states of meaning in it—significant and insignificant, and further that 'significant' means only 'significant to me'. . . . Such positivism of meaning looks often enough like an injunction against the pathetic fallacy, but seems to me to be quite the opposite" Hearne, *Adam's Task: Calling Animals By Name* (New York: Pantheon, 1986), 238.

29. Caplan, *Am I My Brother's Keeper?*, 107–108.

30. Diamond, "Injustice and Animals," 123.

31. Ibid., 120.

32. Ibid., 121.

33. Ibid., 124.

34. Ibid., 121.

35. Cora Diamond, "Losing Your Concepts," *Ethics* 98, no. 2 (January 1998): 276.

36. Cora Diamond, "Experimenting on Animals: A Problem in Ethics," in *The Realistic Spirit: Wittgenstein, Philosophy, and the Mind* (Cambridge, MA: MIT Press, 1991), 350.

37. Ibid., 351.

38. Ibid., 264.

39. Ibid.

40. Ibid., 351.

41. Diamond, "Losing Your Concepts," 266.

42. Diamond, "Experimenting on Animals," 353.

43. Cora Diamond, "Eating Meat and Eating People," in *The Realistic Spirit*, 329.

44. Ibid., 333.

45. Diamond, "Injustice and Animals," 148n.41.

46. Ibid., 137–138.

47. Ibid., 136.

48. Ibid., 121.

49. Ibid., 129.

50. Ibid., 131.

51. Ibid., 131–132.

52. Ibid., 128.

53. Ibid., 141.

54. Ibid., 141–142.

55. Diamond, "Losing Your Concepts," 263.

56. Derrida, "The Animal that Therefore I Am (More to Follow)," 386, 395.

57. Ibid., 396.

58. Ibid., 395.

59. Jacques Derrida, "Force of Law": The 'Mystical Foundation of Authority,'" trans. Mary Quaintance, in *Deconstruction and the Possibility of Justice*, eds. Drucilla Cornell, Michael Rosenfeld, and David Gray Carlson (London: Routledge, 1992), 24.

60. Ibid.

61. Derrida, "The Animal that Therefore I Am (More to Follow)," 45, 46.

62. As Derrida has suggested in his reading of Heidegger and the animal in *Of Spirit: Heidegger and the Question*, trans. Geoffrey Bennington and Rachel Bowlby (Chicago: University of Chicago Press, 1989), those "sinister connotations" of "continuism"—which Heidegger's humanist separation of human and animal is dead set against—include racism, the use of naturalism to countenance xenophobia, and much else besides, all of which are important in understanding Heidegger's complex relationship to Nazi ideology (56).

63. Diamond, "Experimenting on Animals," 353.

64. Richard Beardsworth, *Derrida and the Political* (London: Routledge, 1996), 130–131.

65. Ibid., 118.

66. Ibid., 132.

67. Derrida, "The Animal that Therefore I Am (More to Follow)," 396, emphasis mine.

68. Diamond, "Injustice and Animals," 131.

69. Diamond, "Eating Meat and Eating People," 333.

70. Ibid., 333–334.

71. Diamond, "Experimenting on Animals," 351.

72. See in this connection my discussion of Rorty in *Critical Environments: Postmodern Theory and the Pragmatics of the "Outside"* (Minneapolis, MN: University of Minnesota Press, 1998), 20–22, 140–141, 144–145.

73. Diana Fuss, Introduction in *Human, All Too Human*, ed. Diana Fuss (New York: Routledge, 1996), 4.

74. Jacques Derrida, "From *Speech and Phenomena*," in *A Derrida Reader: Between the Blinds*, ed. Peggy Kamuf (New York: Columbia University Press, 1991), 26–27.

75. Vicki Kirby, *Telling Flesh: The Substance of the Corporeal* (New York: Routledge, 1997), 95.

76. Jacques Derrida, "'Eating Well,' or The Calculation of the Subject: An Interview with Jacques Derrida," in *Who Comes After the Subject?*, ed. Eduardo Cadava, Peter Connor, and Jean-Luc Nancy (New York: Routledge, 1991), 116–117. See also Derrida's *Limited Inc.*, ed. Gerald Graff (Evanston, IL: Northwestern University Press, 1988), 134, 136.

77. Diamond, "Injustice and Animals," 134, emphasis mine.

78. Derrida, *Limited Inc.*, 15.

79. Ibid., 70.

80. Ibid., 119.

81. Ibid., 116.

82. Ibid., 148.

Blood and Bioethics in the Biotechnology Age

Dorothy Nelkin

In 1991, conceptual artist Mark Quinn created *Self*, a model of his head, using nine liters of his own frozen congealed blood. Every five years he creates a new *Self* using fresh blood. Quinn's head was one of the controversial pieces at *Sensation*, a 1999 exhibition at the Brooklyn Museum of Art.

Quinn is one of many contemporary artists who use blood as one of their media. Ana Mendieta used blood in her performances. Jana Sterbak draws with a pen filled with HIV-seropositive blood and anticoagulants. Some people have regarded the use of blood in art as shocking, pathological, profane. But blood is valued as material for art because of its rich symbolic associations.

The symbolic associations of this body substance are shaping the ethical responses to the growing use of blood for research and commercial purposes. Blood in the biotechnology age is a source of genetic information. The blood we all provide for diagnostic and clinical purposes is also useful for the study of biological processes and the genetic basis of disease. Indeed, blood has become one of the most valuable commodities in the world. While refined petroleum sells for forty dollars a barrel, an equivalent quantity of blood products is worth $67,000.

> Just as Quinn's use of blood in sculpture was shocking to many people, so the commercial use of blood seems ethically dubious and discomforting. But why should blood, a constantly regenerated substance, *not* be considered as a useful and exploitable resource? Why not use blood for art, research, and even commerce? What is this substance anyhow? And what is its cultural meaning?[1]

Blood, writes Piero Camporesi in *Juice of Life*, is a substance "thick with magical significance, mystical claims, pharmacological prodigies, alchemistical dreams."[2] In earlier

centuries, blood was a daily reality, far more visible than it is today: "From birth to death, the sight and smell of blood were part of the human and social pilgrimage of each and all . . . as barbers, phlebotomists, pork butchers, midwives, brothers hospitalers opened, closed, cauterized veins."[3] Today, blood is more a virtual reality, enjoyed by the viewers of grizzly gangster films, observed by the voyeurs of televised massacres, and managed by the remote control. It is a substance, not of daily experience, but of accidents, illnesses, battles, or orgies—a substance to be avoided "in the flesh." Writes Umberto Eco in his forword to Camporesi's book, "We who use the Internet think blood of interest only to surgeons and the scholars of the new planetary pestilences."[4] Yet, he observes, there is remarkable rapport between the cultural myths of the time when blood was a daily reality and the impulses of the present day.

Blood is obviously a biological substance: At the technical level, scientists understand its physical attributes. But more than a biological substance, it is also a cultural entity with social and political meanings. In the nineteenth century, Herbert Spencer drew a direct analogy between "the blood of the living body and the consumable and circulating commodities of the body politic."[5] Mary Douglas described the physical body as a metaphor for society—a "symbolic medium," a "visible expression of social relationships."[6] Similar assumptions—that perceptions of the body reflect historical associations, political circumstances, and social relationships—will frame my analysis of the cultural meanings of blood and how they bear on bio-ethical concerns in the genetic age.

Blood metaphors, collected from historical and contemporary sources, cluster around four themes: First, blood is defined as an essentialist substance, the essence of personhood, a basic life force; second, blood is a symbol of community and social solidarity; third, blood evokes references to race and social class; and, finally, blood is an exploitable resource associated with power and control.

Blood as an Essentialist Substance

An essentialist substance, blood is equated with life itself. In *Juice of Life*, Camporesi described blood as "the seat of the soul—that invisible, elusive principle that was deemed to ebb and flow in hiding, swelling and diffusing in the oily liquid of life."[7] Blood in the Eucharist doctrine of Roman Catholicism, where bread and wine are transubstantiated into the body and blood of Christ, is a sacred substance: The symbol of blood denotes the "real presence" of Christ in the Church.

As a life-sustaining fluid, blood has been associated with vital rejuvenating powers. The ancient Egyptians bathed in blood to regain the powers of youth. Witches in the middle ages were believed to drink the blood of youth to keep their magical powers. And Nicolae Ceausescu, the infamous and hypochondriac Romanian dictator, was suspected of harboring little boys in his castle so as to periodically draw their blood for his own rejuvenation.

Dorothy Nelkin

For many people in Japan, blood type is more than a biological indicator: It is a template of identity. The Japanese press publishes blood type analyses as a way to predict the personality and behavior of political candidates. A Japanese company sells condoms that indicate blood type. Dating services use blood analysis to make matches, and mismatched blood types have been grounds for divorce.

In American popular culture, "blood" is a word for "genes," implying that it holds meaning for the heritability of essential traits. For eugenicists, during the early years of the twentieth century, blood represented "lineage" or "bloodlines."[8] The language of eugenics faded from public discourse after World War II. But today, when the importance of heritability is again a prevalent theme in science, the popular culture metaphor for genes is still the "blood." A TV film called *Tainted Blood* is a story about a pair of teenage twins who had been adopted as infants into separate "good" families. They both ended up murdering their parents as their biological mother had done. They had inherited violent (tainted) predispositions. Criminal behavior was "in their blood."[9]

The forensic use of blood for identification reinforces its essentialist meanings. Blood samples have served as a means of identification since the discovery of the inheritance of blood groups in 1910. Blood-matching techniques, understood to reveal the invisible biochemical properties that define biological relationships, were first applied in the 1920s to establish relationships between parents and children, for example, in cases of infants switched at birth. Today, blood, as the source of DNA, is a tool of investigation in cases of disputed paternity, inheritance claims, and criminal identification.

To scientists, blood is replenishable material. But in its social meaning, blood is more than material—it is the essence of personhood, an inviolable substance. Conflicts between scientific and essentialist meanings of blood underlie the questions raised by bioethicists when blood is drawn for commercial purposes. Who owns blood? Is blood an inalienable part of the body, the property of an individual, a commodity, or a communal resource? Body organs are regarded as inalienable and many of the ethical questions about ownership and use have been resolved through legislation. But blood as a replenishible substance is exempt from this classification. Blood products that are manufactured from the blood of many persons are generally defined as a commodity. Whole blood, donated by an individual, becomes a "good" or a product only when parted from the body, and the individual has no control of its disposition.

Differences between scientific and essentialist meanings shaped a dispute over the Human Genome Diversity Project (HGDP), a scientific plan to collect and store blood from individuals from indigenous populations around the world. The HGDP had several goals: to trace patterns of immigration, to develop a history of world populations, and to salvage the DNA of indigenous groups that seem headed for extinction. (Interestingly, scientists from the HGDP themselves use essentialist language when they talk about their plans to "immortalize" these populations by banking their blood to preserve their DNA.) Some of

the DNA collected from indigenous populations is useful in the search for disease genes. But to many people, tampering with this essential fluid was a desecration of the body. While blood to scientists reveals serological truth, its social meaning is conditional on broader values.

Blood as a Symbol of Community

Beyond its essentialist meaning, blood has come to represent community spirit, altruism, and social cohesion. This social meaning of blood is expressed in common sayings that extend relationships of blood beyond the bonds of kinship—we refer to "blood brothers" or "blood ties." As a symbol of social solidarity, blood has been a critical substance in collective rituals. Anthropologist Mary Douglas suggests that rituals "work upon the body politic through the symbolic medium of the physical body." To Douglas, blood rituals are a way to address points of tension in a society. Premodern societies, for example, celebrate salvation anxieties in rites of violence and blood: Blood is spilled in "dramatic presentation of collective mortification."[10]

Anthropologist Victor Turner describes the Ndembu practice of carving the mukula tree during circumcision and childbirth rituals.[11] The tree secretes a red, blood-like gum that represents menstrual blood and the blood that accompanies the birth of a child. The ostensible purpose of the ritual is to coagulate the blood, but the mukulu tree also represents the woman's matrilineage and the principle of matriliny itself. The purpose of the ritual, writes Turner, is to make the woman accept her lot in life and thus to maintain tribal continuity and community by reinforcing rules that govern appropriate behavior.

Blood is also a symbol of community in contemporary art. In 1997, Eduardo Kac created a blood-based artwork entitled *A-Positive*.[12] He connects the human body to a robot via an intravenous needle and donates blood to the robot, which extracts oxygen from it to maintain a small flame burning inside its body. The "biobot" donates dextrose to the artist. This exchange is a way to probe the emerging relationship between human bodies and biomachines.

A common supply of available blood is associated with ideas of justice and fairness. The strength of such associations is reflected in blood donation systems. Donation of blood for the public benefit reinforces the sense of belonging to a community. In his analysis of HIV blood contamination and the deep meaning of "poisoned" blood, bio-ethicist Thomas Murray describes how the gift of blood—a form of altruism—has served to bind and affirm social connectedness and community by linking the donor to strangers and the donation to the public good.[13] More than the illness of individuals was at stake in the incidents of blood contamination.

Because blood is identified as a communal substance, the commercialization of blood donation has been suspect. To place economic value on blood through the payment of

donors threatens the value of the altruism underlying its distribution. The United States formally maintains a dual system, but paying individuals for donating whole blood is rare.[14] Ambivalence about paying donors, however, is apparent in language; we still talk of "donation" and "giving" even when "donors" are paid. We would scarcely be comfortable with a label of "blood vendor", or a description of a "blood market." And "donations" that are based on economic interests rather than altruism tend to be devalued and stigmatized. Donation—as the word implies—is supposed to be an altruistic act.

Profiting from blood is widely considered to be unethical and exploitative. Common phrases such as "bloodmoney" or "bloodsuckers" suggest the pejorative implications of connecting blood with money. Turning blood into an economic product seems to violate beliefs about its importance as a public good. The commercial interests involved in the banking of blood and the manufacturing and selling of blood products maintain a fragile credibility. Similarly, the commercial interests involved in the use and commercialization of blood as a source of DNA are suspect.

Tensions over the social meaning of blood in the biotechnology age are explicit in an ongoing debate over the privatization of cord blood. Placental blood can be harvested from the umbilical cord immediately after birth, and banked for the future as a substitute for bone marrow transplantation. Cord blood was once considered waste and thrown away, but biotechniques have turned this material into a valued commercial product and, inevitably, a focus of property disputes. Who owns cord blood—the infant, the parents, or the society? Is placental blood the private property of an individual or a public resource—a common good? The original plan was to use the cord blood as a communal resource available for those in need of a bone marrow transplant. But commercial interests now store cord blood in special private "banks" and urge pregnant women to bank their children's cord blood, of course at a cost, as a kind of insurance against future medical needs.

In light of the possibility for DNA analysis, the problems of privatizing cord blood extend beyond the conflict between public and private interests. Blood banks are a source of genetic information. Even a drop of blood can be genetically analyzed to reveal a great deal about an individual's health and predispositions.

Blood, Race, and Class

Until the seventeenth-century work of William Harvey, the biological properties of blood were believed to vary with the social position of the person. Nobles enjoyed superior social status because of the purity of their blood and the integrity of their bloodlines.[15] The scientific world view equalized the properties of blood, which became, in effect, an exchangeable commodity. Yet the old association of race categories with blood, and the myth that races have unique blood characteristics and that these can be correlated with both physical appearance and social behavior persisted. In Nazi Germany "the ideology of blood purity

spilled rivers of blood."[16] Despite the urgent need for blood during World War II and the scientific understanding of blood types, the United States Congress pressured the Red Cross to exclude black donors from the national blood donation program. As the need for plasma increased, the Red Cross accepted their blood, but still segregated it. Critics accused those who tried to accept the blood of black donors of trying to "mongrelize" the nation.[17]

Race categories in America were long based on ideas about "blood quanta." American Indians were identified through "blood quantum" rulings that required individuals to prove they have a specific percentage of Indian blood to qualify for land allotments and services. But this also subjected them to discrimination. African Americans were also identified by the "one drop of blood rule" that defined a person with even a drop of "black blood" as black. Blood became a metaphor for pedigree or ancestry in the American South where miscegenation laws used the metaphor of "black blood" to separate the legal concept of race from skin color. The skin could lie, allowing a person to pass, but the blood represented "serological truth;" it defined and identified race.[18] Southern judges, called upon to determine the race of individuals, expressed concern about "purity and defilement" from interbreeding.[19]

Beliefs about blood have also been used to stereotype women in descriptions of menstruation.[20] Menstruation has been categorized in medical text books as a disease and associated with defilement, dirt, disorder, and danger. Reformers of the Victorian age wrote of women "harboring polluted blood." A physican described the uterus as "the sewer of all the excrements existing in the body."[21] And even contemporary physicians have referred in medical journals to menstruation as "endocrinopathy," in effect a blood disease.[22] As a source of putrefaction, menstrual blood was a symbol of danger. And, related to emotion, it was associated with hysteria, believed to be a women's disease that must exclude her from occupational opportunities.

In the biotechnology age, similar associations appear in the popular and policy discourse about genetic predispositions. Just as pure blood was associated with social status, so today is DNA the basis of genetic distinctions and associated with social classifications. For example, notions of genetic purity appear in the nativist rhetoric in immigration debates. Blood language has long been a way to express political anxieties about the threat of foreigners to national borders. In the early part of the twentieth century, concerns about growing immigration in the United States were expressed in the language of blood pollution, resulting in the restrictive immigration laws in 1926. A similar set of metaphors have reappeared today. Using blood as a word for genes, nativists believe that "mixing blood" will lead to race suicide. Peter Brimelow writes that "a link by blood" is essential to the successful functioning of a nation.[23] Nativists worry that boundary transgressions— the mixing of genes—are threatening the social order. They draw on metaphors of blood purity that have long been invoked as a way to protect societies against the dangers of foreign intrusion.[24]

Dorothy Nelkin

Blood as an Exploitable Resource

The association of blood with danger appears in stories and myths about the violent history of colonial exploitation. A Guatemalan myth dwells on a practice, purportedly prevalent among the Spanish conquistadors who invaded the highlands. According to the story, these pale-skinned people took the blood of brown-skinned babies to cure their anemia.[25] Anthropologist Luise White, collecting oral histories in Uganda documented similar rumors about white people who captured Africans and extracted their blood.[26] These stories suggest that between 1918 and 1925, vampires appeared and used needles to suck the blood of Africans which they then sold or drank. The victims, drained of blood, would collapse. So powerful were these rumors that in the 1950s a white doctor in Kampala could not get people to donate blood because the Africans believed that he drank the blood himself.

The vampire stories were a colonial phenomena that disclosed anxieties about Western medical practice and experimentation. White's informant believed that "Europeans wandered around the country seeking human blood for purposes of making medicine." In 1972, a letter to the editor in a Tanzanian newspaper reported the mysterious disappearance of people whose "blood was used to treat the white man only."[27]

Variations of the vampire myth are found in the blood libel stories about Jews who purportedly killed Christian boys and used their blood to make matzoh during the Passover holidays. These powerful stories, equating the taking of blood with political and economic exploitation, were myths of danger, employed to reinforce stereotypes and used to support the pogroms. Today, efforts to draw blood for genetic research still evoke vampire metaphors, as in the response to the HGDP, which has often been called the "vampire project" and a form of "biopiracy."

Vampire myths are enjoying a revival in this genetic age. They appear in popular culture narratives that associate blood with fear of predators or "bloodsuckers" who threaten the integrity of the person. In the classic vampire myth, common in Slavic countries, the soul of a dead man quits his body to suck the blood of living persons. The story is about the power and danger of the dead. In recent vampire films, blood is used for spectacular effects suggesting danger and risk. A trashy film called *Hellraiser: Blood Line* manages to associate blood with both violence and heredity. Drenched in blood, this film, specializing in torture and decapitation—all to the tune of bloodcurdling screams—is about a man who carries demonic spirits in his blood. He inherited his violence through his "bloodline."

The meaning of blood reflects prevailing social tensions, for example over race, gender, and social class—and even anxieties about our ability to contain terrorism. A revealing scenario depicting possible forms of biological terrorism appeared in the *Journal of the American Medical Association* in 1996, well before the World Trade Center event. A disgruntled supervisor of a large blood bank introduces the Ebola virus into blood products,

exposing thousands of people to deadly infection.[28] Such stories suggest how the special anxieties or vulnerabilities of a society are expressed through metaphors of blood.

The cultural depictions of blood draw on powerful associations: Blood is the essence of life, the symbol of community, the basis of both purity and danger. But my examples also suggest its often contradictory connotations. Blood is a source of life and energy, but also a symbol of violence and danger. It is a metaphor for social solidarity, representing the connection between the individual and society, but it also represents the biological distinctions between peoples and is linked to the politics of race and social class. Purity of blood is a clinical concept associated with physical health, but also a racist construct used to define ethnicity and to justify exclusion. Blood is a social fluid that calls for altruistic relationships, but also an economic product that can be competitively bought and sold. In its social meanings, blood can stand at once for purity and contamination, vitality and death, community and corruption, altruism and greed.

Perhaps the most salient contradiction today follows from the instrumental value of this substance. As blood becomes an increasingly valuable resource in the age of genetics, its use is inevitably a source of strain; its value for science or commerce conflicts with its social and symbolic meanings.

The history of blood—the equation of blood with purity and danger, entitlement or exclusion, social difference and discrimination—helps to explain the ethical questions raised about the increased genetic understanding of the body—an understanding brought about, after all, by analysis of blood. Will analysis of blood reveal too much about the essence of a person? Will genetic understanding be used to reinforce social biases by providing purportedly scientific—blood-based—data for discriminatory classifications? Will the increased value of blood as a source of information reinforce old patterns of exploitation?

Though blood is still more a virtual than a visible reality in modern society, concepts of blood remain embedded in symbolic associations, shaping our fears and guiding our intuitions about the uses of this valued substance. We are still preoccupied with blood as the essence of the person, a symbol of community, and a basis for race and social class. And we still worry about its exploitation whether in art or in science. Little wonder that this substance, as it acquires greater value as a source of genetic information, has become a focus for the ethical dilemmas of the biotechnology age.

Notes

1. Some of the following examples are drawn from my essay "Cultural Perspectives on Blood," in *Blood Feuds*, ed. Eric Feldman and Ronald Bayer (New York: Oxford University Press, 1999), 273–293.

2. Piero Camporesi, *Juice of Life: The Symbolic and Magic Significance of Blood* (New York: Continuum, 1995), 54.

3. Ibid., 27.

4. Umberto Eco, "Foreword," in Piero Camporesi, *Juice of Life: The Symbolic and Magic Significance of Blood*, trans. Robert R. Barr (New York: Continuum, 1955), 7–11.

5. Herbert Spencer, *Social Statistics* (London: Chapman, 1851), 323–324.

6. Mary Douglas, *Purity and Danger* (New York: Routledge, 1966), introduction and chap. 7.

7. Camporesi, *Juice of Life*, 32.

8. Daniel Kevles, *In the Name of Eugenics* (New York: Knopf, 1985).

9. *Tainted Blood*, USA Channel, March 3, 1993.

10. Douglas, *Purity and Danger*, 153.

11. Victor Turner, *The Forest of Symbols* (Ithaca, NY: Cornell University Press, 1967).

12. This work was created in collaboration with Ed Bennett.

13. Thomas Murray, "The Poisoned Gift," in *A Disease of Society, Cultural and Institutional Responses to AIDS*, ed. Dorothy Nelkin, David Willis, and Scott Parris (New York: Cambridge University Press, 1991), 217.

14. Alvin Drake, Stan Finkelstein, and Harvey Sapolsky, *The American Blood Supply* (Cambridge, MA: MIT Press, 1982).

15. Davydd Greenwood, *The Taming of Evolution* (Ithaca, NY: Cornell University Press, 1984), chap. 4.

16. Anthony Synnott, *The Body Social* (New York: Routledge, 1993), 32.

17. Spencie Love, *One Blood* (Chapel Hill, University of North Carolina Press, 1996), 195.

18. Eva Saks, "Representing Miscegenation Law," *Raritan* (Fall 1988): 29–41.

19. Kenneth L. Karst, "Myths of Identity," *UCLA Law Review*, 43 (December 1995): 263ff.

20. Margaret Lock, *Encounters with Aging* (Berkeley, CA: University of California Press, 1993), 220.

21. Sally Shuttleworth, "Female Circulation," in *Body/Politics*, ed. Mary Jacobus, Evelyn Fox Keller, and Sally Shuttleworth (New York: Routledge, 1990), 56.

22. I. H. Thorneycroft, "The Role of ERT in Prevention of Osteoporosis," *Journal of Obstetrics and Gynecology*, 160 (1989): 1306–1310.

23. Peter Brimelow, *Alien Nation* (New York: Random House, 1995), 203.

24. Dorothy Nelkin and Mark Michaels, "Biological Categories and Border Controls," *International Journal of Sociology and Social Policy* 18, no. 5/6 (January 1998): 35–63.

25. Stuart J. Younger, Renee Fox, and Laurence O'Connell, eds., *Organ Transplantation* (Madison, WI: University of Wisconsin Press, 1996), 8.

26. Luise White, "Cars Out of Place: Vampires, Technology and Labor in Eastern and Central Africa," *Representations* 43 (Summer 1993): 27–50.

27. Ibid., 31.

28. Joan Stephenson, "Confronting a Biological Armageddon," *JAMA* 296 (August 7, 1996): 349.

Art as a Public Policy Medium

Lori B. Andrews

In 1998, a new boutique opened in a trendy shopping area in Pasadena, California.[1] Just two hours north of the Repository for Germinal Choice (a sperm bank selling the seed of Nobel Laureates and top athletes), the boutique, Gene Genies Worldwide, offered "the key to the biotech revolution's ultimate consumer playground." It sold new genetic traits to people who wanted to modify their personalities and other characteristics.

The boutique was filled with the vestiges of biotechnology—petri dishes and a ten-foot model of the ladder-like structure of DNA. Brochures highlighted traits that studies had shown to be genetic: creativity, conformity, extroversion, introversion, novelty seeking, addiction, criminality, and dozens more.

Shoppers initially requested one particular trait they wanted changed, but once they got into it, their shopping lists grew. Since Gene Genies offered people not only human genes, but ones from animals and plants, one man surprised everyone by asking for the survivability of a cockroach.

The co-owners were thrilled at the success of their endeavor, particularly since none of the products they were advertising were actually yet available. Despite their lab coats, Karl Mihail and Tran Kim-Trang were not scientists, but artists attempting to make a point, striving to serve as our moral conscience. "We're generating the future now in our art and giving people the chance to make decisions before the services actually become available," said Karl Mihail.

I very much identify with that quest. For the past twenty years, I've been a lawyer analyzing the policy issues raised by reproductive and genetic technologies. I took the bar exam the day Louise Brown, the first test-tube baby, was born. My phone rings constantly with calls from scientists, venture capitalists, government officials, priests, and reporters asking me about the legal and ethical implications of cutting-edge biology.

A few days after the announcement of the birth of Dolly, the cloned sheep, President Clinton's newly formed National Bioethics Advisory Commission called me for a legal opinion on human cloning. I rapidly began to think of this as the Bill Gates problem. If a wealthy individual like Gates wanted to clone himself—perhaps creating Bill Gates 5.0, 5.1, and 6.0—would any existing law stop him?

As I reviewed existing laws, I saw that there was nothing to stop the truly rich from cloning themselves, their departed loved ones, or celebrities. Nor are there any clear laws to prevent Bill Gates from being cloned against his will. What if Gates' barber used DNA from hair follicles to create a Gates clone—and then sued Gates for child support? Under current law, people have little right to their body tissue and genes once these materials leave their body. In *Moore v. Regents of the University of California*,[2] a patient's doctor, allegedly without his knowledge or consent, used the patient's unique tissue to develop a cell line worth an estimated three billion dollars. The doctor actually patented the patient's cells! The court found that the patient, John Moore, had no property rights to his tissue and no right to a share of the proceeds, which could lead to a snip-and-run industry of cloning from stolen bits of celebrity hair.[3] (Already, Nobel laureate Kary Mullis proposed marketing jewelry with celebrity DNA in it—why not a human replica?).

Some scientists suggest modifying people with the gene to photosynthesize so that we could get our energy from the sun, like plants, and not waste money or time getting food. Law review articles are already raising questions about how to treat these new creations. If an individual had half-animal and half-human genes, would he or she be protected by the U.S. Constitution? When I asked my law students that question, one replied, "If it walks like a man, quacks like a man, and photosynthesizes like a man, it's a man."

I view my work as similar to writing science fiction. I ask myself what society would look like if we chose one path as opposed to another. I often think of Dame Mary Warnock's admonition when her British committee was making recommendations about reproductive technologies: that we try to create a society that we can praise and admire, even if in individual detail we may wish it were different.

I very much feel a kinship with artists in this quest—and there is much I learn from them.[4] I appreciate artists whose work is influenced by the biological sciences because beyond its aesthetic value, the work can help society to:

- confront the social implications of its biological choices;
- understand the limitations of the much hyped biotechnologies;
- develop policies for dealing with biotechnologies; and
- confront larger issues of the role of science and the role of art in our society.

Art can also challenge the legitimacy and goals of science. As Dominique Lestel asks in *Art Press*, "What happens to the utilitarian legitimacy of the researcher if the artist can carry out the same manipulations, but while giving them a different interpretation?"[5]

The Techniques of Life-Science Artists

A prestigious art journal recently pointed out, "Genetic manipulation, cloning, GMO—these are some of the new words and realities to have become part of our everyday life and the life of art."[6] Some of the art that is influenced by genetics and the other biological sciences is representational—using paints, prints, sculpture, and photography as its media. On the representational level, geneticist Hunter O'Reilly[7] paints biological themes. In her *Anthrax Clock* portrait, O'Reilly shows four photos of her face superimposed on a clock. In each quadrant, anthrax cells and spores multiply beneath the face of the artist. As the anthrax increases, Hunter's face changes from happy to traumatized.

Other art uses biological phenomena as an artistic medium. Al Wunderlich, for example, in *Living Paintings*, created paintings visible only under a microscope, using bacteria that had been genetically engineered with fluorescent proteins.[8] Similarly, davidkremers creates paintings from growing bacteria, which have been genetically engineered to produce different colors in response to different compounds, on clear plates of acrylic.[9] These plates are placed in temperature-controlled rooms and incubated for eighteen hours before being cooled and sealed in synthetic resin.[10] This leaves the bacteria in a state of suspended animation.[11] The bacteria cells continue to grow once the resin is removed.[12] In one of his series, the bacteria were encouraged to grow into shapes that resembled the embryonic states of development.[13]

Artists' efforts in this area are evolving parallel to scientific developments. After learning that scientists were attempting to create artificial organs in culture, Oron Catts, Ionat Zurr, and Guy Ben-Ary of SymbioticA in Perth, Australia, used that same technology in 2000 to create *The Worry Dolls*. The artists created biodegradable polymers in the shape of small dolls, seeded them with endothelial, muscle, and osteoblast cells and put them in culture in a bioreactor. In this way they created seven dolls of living tissue to mimic the Guatemalan worry dolls to which children confess their worries. Among the dolls created were ones representing fear of biotechnology, fear of capitalism, and fear of eugenics.

Some of the art could lead to greater acceptance of biotechnology, because it makes it seem like the technology is attractive, safe, or valued. O'Reilly's painting, *Madonna con Clone* is seemingly intended (judging by both its title and appearance) to promote cloning. On her Web site, O'Reilly states that she supports human cloning. The Web site includes a photo of her with Randolfe Wicker, the founder of Clones Rights United Front, an organization designed to promote human reproductive cloning.[14]

Other artists use their work to critically assess the technologies or criticize the manner in which they are being integrated into society. At SymbioticA, Catts and Zurr grew living pig tissue in the shape of wings (*If Pigs Could Fly*). This demonstrated the possibilities of biotechnology but also showed its limits. One of the goals of the exhibit was to show people that their expectations about biotechnology are excessive. People came into the gallery expecting to see pigs that could fly—instead they saw tiny sculptures of tissue.

Thus, artists have addressed both the positives and negatives of biotechnologies. In *The Jefferson Suites* at the Santa Barbara Museum of Art, Carrie Mae Weems focused on the genetic findings purportedly proving Thomas Jefferson's sexual link to his slave Sally Hemings. "In this case, Weems seems to point out, genetic research can be a positive force, resolving historic controversies," notes Barbara Pollack in *ARTnews*. "Still other parts of her installation comment on more dubious applications of this knowledge, including harvesting 'genius' genes from university students and Wall Street's latest stock promotion of the genetics-research industry."[15]

The long-term impact of life science art on social conceptions of biotechnologies and the ethical and legal norms that govern them remains to be seen. In the meantime, some critics have raised concerns that much of their funding in these endeavors comes from large companies that want to promote the technologies.[16] Writing for *Art Press*, Dominique Lestel suggests, "We must also take into account the less glorious possibilities that these artists are being manipulated—and not necessarily consciously either—by technicians and multinationals; that they are serving to legitimize practices that our cultures otherwise find it hard to accept."[17]

Whether life science art will become a new school of art, a lobbying effort, a means of social criticism, or perhaps all three, remains to be seen. There is no question, though, that it is shaping the public discourse about genetics and reproductive technologies.

Art and the Body

Artists today are creating works that use body tissue—flesh and blood and DNA—in place of paint and clay. And some are using this media to comment on the changing meaning of the body in the biotechnology age.

Conceptual artist Orlan, for example, manipulates her own body by having repeated plastic surgeries in art galleries, shaping her features to resemble a composite likeness of historical and mythical figures. Her art questions the limits of the body's boundaries and the limits of science. Biology, for Orlan, is no longer destiny.[18]

Other contemporary artists use blood, tissue, and body wastes in their creations. Jana Sterbak draws with a pen filled with HIV-seropositive blood and anticoagulants.[19] Jack Kevorkian, a pathologist in the United States, became famous for his Thanatron, a machine that allows patients to kill themselves under his supervision. He is a painter as well. For his painting on the theme of genocide, he used blood from his own arm and also expired blood samples that he obtained from the hospital where he worked.[20]

In 1991, Marc Quinn created *Self*, in which he sculpted a model of his head using nine liters of his own frozen congealed blood.[21] The head is kept refrigerated in a glass cabinet.[22] Every five years he creates a new *Self* using fresh blood and a new cast. Without refrigeration, his work would melt. This is significant for Quinn, representing the fragility of the body and the ephemerality of life.

Susan Robb built a tower of urine, which she collected from artists from around the world.[23] The sixteen columns of urine jars rise to a height of eight feet.[24] Robb sees the tower as a performance piece in which the artists are performing for each other by donating their urine.[25]

Hair is a medium through which many artists such as Mona Hatoum explore the integrity of the body. The wide appeal of hair as a medium for artists lies in its ambiguous status; it is both outside the body, and still a part of it—not quite the body, but not really waste.[26] Artists are attracted to the ambiguity of such body materials as they explore ways to define the fragile boundaries of self.

Using the body in art is also a way for artists to comment on science. Quinn is critical of "the overdetermined factuality" of biological research. "Do we only think we know what the natural is because of what we've found through science?"[27] Yet artists are nevertheless seizing upon scientific techniques to extend the boundaries of their art. Biotechnologies have opened the way to new artistic visions of the body, resulting in a growing convergence between science and art.

Genetic Analysis

Biotechnologies have created new ways for artists to use the body in art. The techniques of emerging life-science art help bring to social consciousness issues related to individual rights, genetic manipulation, commodification, and the dearth of regulation of biotechnologies.

Genetic technologies have spawned a new genre of art. Photographer Gary Schneider provided hair, blood, sperm, and cheek-cell samples to Dr. Dorothy Warburton, director of Babies and Children's Hospital at Columbia University, to produce his *Genetic Self-Portrait*. The result was a range of photos ranging from his fingerprints to the nucleus of one of his cells.[28] Along the way he even underwent a frightening genetic analysis to determine whether he'd inherited a propensity to a particular cancer from his mother.

Kevin Clarke is a portrait photographer who uses a person's specific genetic code to represent his posers.[29] He believes that this allows him to perceive them freely without defining them socially.[30] Dui Seid is a Chinese-American artist who believes that a person's DNA is a portrait of his ancestry and probably even his descendents.[31] In *Bloodlines*, he displayed frosted test tubes of blood with the digital images of his DNA and his parents' images. His family portrait dissolves into his own image then into a myriad of all ethnically diverse people before finally dissolving into his own DNA.[32]

Iñigo Manglano-Ovalle is another artist who uses DNA as a basis in his work. When the wife of a patron of arts wanted to give her husband a surprise portrait for his birthday, Manglano-Ovalle conspired with the patron's barber to pluck some hair from the man's head. Manglano-Ovalle sent it to a forensic laboratory which extracted DNA. The result, *Clandestine Portrait*, was described in a catalogue of Manglano-Ovalle's work: "The bands,

now an infinitesimal measure of the patron's genetic semblance . . . were scanned into the artist's computer where he proceeded, much like a barber would, to trim, tidy and embellish the patron's likeness."[33]

For his 1998 exhibition called *Garden of Delights*,[34] Ovalle asked sixteen people to provide their own DNA and that of two other people. He sent the DNA to the Wake Forest University School of Medicine Genetics Laboratory in Winston-Salem, North Carolina, to develop DNA prints. Some of the prints are arranged as triptychs, reminiscent of a nineteenth-century Spanish colonial art genre called caste paintings, in which portraits of a mother, father, and child were used to illustrate the intermingling of the blood of Indians, Spaniards, and Africans. Manglano-Ovalle's DNA triptychs use gene profiles from blood to show people who are connected socially (such as by friendship) rather than by blood. In a DNA self-portrait, Manglano-Ovalle defined himself as mestizo—the product of Spanish and Indian blood. He paired his own DNA with that of his brother. The DNA prints are similar, although one brother has darker skin than the other. To Manglano-Ovalle, their DNA reveals that the old categorizations based on the color of skin have no meaning—that real identity lies beneath the skin—in the DNA.

Artists such as Schneider, Clarke, and Manglano-Ovalle convey a message of genetic determinism, underscoring the common perception in our culture that people can be reduced to their genes. Clarke sees DNA as a way to express identity, individuality, the essential, underlying self.[35]

In contrast, Paul Vanouse used live DNA to show the potential for eugenics. In his *Relative Velocity Inscription Device*, he created a multimedia installation to question the veracity of DNA sequencing.[36] Vanouse is of Jamaican descent and used his own multiracial family's DNA in the live scientific experiment.[37] He placed the DNA of four family members into a genetic sequencing gel and postioned them to race through the gel.[38] The DNA samples from his mother, father, sister, and himself were raced in the gel with the winner of the race changing depending on the particular region of DNA that was used.[39] The races last from two to three days and can be seen when the gel is bathed with ultraviolet light.[40] The results of each race are stored in a computer and can be accessed through a touchscreen monitor.[41]

These artists provide a social commentary about genetic analysis at the same time that their methodology itself raises social concerns. Vanouse's work illustrates the ease of judging people based on their DNA. Already, insurers and employers have begun to discriminate against people based on their genotype.[42]

Schneider shows how individuals' own psychological well-being can be affected by their genetic status. Although he was healthy, he was worried about being at genetic risk of cancer. Analysis provided him with relief. But, if it had come out the other way, he might have become one of the "worried well" or "asymptomatic ill"—a healthy individual who is at increased genetic risk of later illness. Some women who learn they have a genetic propensity to breast cancer, for example, say that they feel like a time bomb is ticking away inside them.[43]

With the possibility for self-stigmatization and discrimination based on one's genes, the ability to prevent unwanted genetic testing of one's DNA—or control who has access to the results of DNA testing—becomes crucial. An essay in the *Garden of Delights* catalogue noted that genetic profiles could become the basis of future caste systems based on scientific rather than cultural constructs of human difference.[44] A critic observed that just as a Ovalle obtained a DNA sample surreptitiously as a birthday surprise, so too samples could be obtained as evidence in a paternity suit.[45] The samples—or the genetic blow-ups created from them—could also be used as a source of information that could threaten a person's ability to obtain insurance. Manglano-Ovalle's subjects were not given the same information about the risks of genetic discrimination that they would have gotten in a clinical setting when given a DNA test. But what about their privacy? It might be possible to diagnose someone as having a disease or mental health risk based on their genetic portraits.

Artist as Creator

Beyond analyzing living DNA for a work, artists have begun creating it. The current Alice in Wonderland world of biotechnology is unregulated, available to anyone. At one Web site, I can order up genetic tests to see if I have genes associated with breast cancer or Alzheimers' disease, among other conditions. A handheld genetic sequencer is available that would allow me—à la the movie *Gattaca*—to test the DNA of my dates. From various biotechnology companies, I can buy the building blocks of life to design human genes.

In fact, when I served on a national commission advising the Human Genome Project, a geneticist testified there should be *no* regulation of human genetics. He argued that geneticists should be able to tinker in their garages, just like the computer innovators did. But the geneticists in many cases will be tinkering with human life.

The Pasadena boutique installation I mentioned is part of a new art trend in which genes are used as a source of inspiration. But while that work was a commentary upon people's hubris in attempting to remake themselves and their children with genetic tools, other artists demonstrate how easy it would be to do so. Artists are actually creating genes, shaping the clay of life itself. A genetics laboratory at the Massachusetts Institute of Technology has an artist in residence, Joe Davis, who is putting secret messages into actual DNA. Paul Perry, in his *Good and Evil on the Long Voyage*, fused his own white blood cells with a cancer cell from a mouse producing a new type of cell, a hybridoma.[46] The cancerous genes cause the new cell to remain in the mitotic cycle, while the white blood cell genes produce antibodies, which can be used in treatment. The cancer genes are seen as the "messenger of death" and are considered evil, while the antibodies from the white cells are the "warriors of the immune system" and represent the good. Perry's success rate in creating these fusions is low, succeeding a couple of times in about ten million attempts.

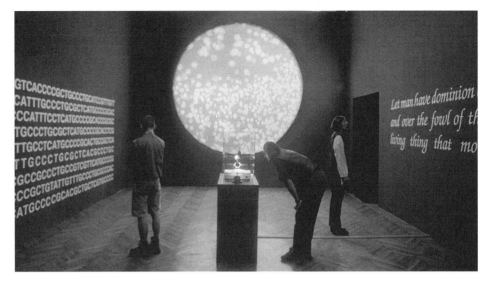

Figure 8.1
Eduardo Kac, *Genesis*, 1999. Transgenic net installation (detail), dimensions variable.

Artist Eduardo Kac created the Genesis gene. He started the work with a single sentence from Genesis in the Bible: "Let man have dominion over the fish of the sea, and over the fowl of the air, and over every living thing that moves upon the earth."[47] He then translated the Biblical sentence into genetic code. He needed to go from the twenty-six-letter English alphabet to the four-letter alphabet of the genetic code, which contains only G, A, T, and C (the chemical bases guanine, adenine, thymine, and cytosine, which are the building blocks of life). The intermediate step, Morse code, allowed him to use the following conversion principle: the dot in Morse code becomes a C; the line, a T; the word space, an A; the letter space, a G. He created the formula for a gene out of a sentence in the Bible. He then gave the gene sequence to Buck Strom, then Director of Medical Genetics and the DNA Laboratory at Illinois Masonic Hospital, who arranged for a biotechnology company to make the new gene, which was inserted into bacteria in a petri dish. People can log on the Internet and, with a click of their mouse, cause the bacteria to reproduce, making the new gene propagate and mutate (figure 8.1).

Kac next had a researcher genetically engineer a rabbit, *GFP Bunny*, to express the green fluorescent gene that is carried by the Pacific Northwest jellyfish. He named his creation Alba, a rabbit that glows green under certain special light.[48]

The techniques that Kac used on the rabbit could very well be used on people. Researchers in Atlanta removed a gene from a prairie vole, an affectionate, monogamous rodent that spends half its time cuddling.[49] They transferred the gene to a closely related

species, the mountain vole, which lives a promiscuous lifestyle. The recipient rodents did not become monogamous, but their brains developed to look like those of prairie voles and they became more cuddly and affectionate. Science writers began to speculate on the potential applications to humans. In the wedding of the future, would we not only promise to love, honor, cherish, and obey—but also to have a prairie vole gene implant?

Viewing one of Kac's exhibits, theorist and curator Arlindo Machado of the University of São Paulo wondered whether, in the future, our inherited genes would mean less than our artificial additions. "Will we still be black, white, mulatto, Indian, Brazilian, Polish, Jewish, female, male, or will we buy some of these traces at a shopping mall?" he asks. "In this case, will it make sense to speak of family, race, nationality? Will we have a past, a history, an 'identity' to be preserved?"[50]

"Memory and identity were once understood as inextricably interconnected, and skin, face, and body were imprinted with experiences and memories," wrote Whitney Museum of American Art curator Christiane Paul in response to Kac's work. "Now plastic surgery and bioengineering have turned the body into a modifiable sculpture."[51]

The Impact of Genetic Manipulation

As technology evolves, parents-to-be will have even more control over the traits of their offspring. In a Louis Harris poll sponsored by the March of Dimes, 42 percent of potential parents surveyed said they would use genetic engineering on their children to make them smarter; 43 percent, to upgrade them physically.[52] Another survey found that over a third of people wanted to tweak their children genetically to make sure they had an appropriate sexual orientation.[53] With around four million births per year in the United States, that's a market for prebirth genetic enhancement almost as large as that for Prozac or Viagra.

Scientists have put firefly genes in tobacco plants, causing them to glow in the dark, and human cancer in mice. Now genetic engineering is being proposed for human embryos. It has been suggested that people's vision be expanded from the near ultraviolet to the near infrared and that genes be added so that people's urine changes colors when they begin to get sick so that they can be diagnosed early.

Art, of course, is already dealing with this possibility. Eva Sutton has a CD-ROM that lets you choose parts of creatures to mix and match.[54] Daniel Lee created photographic chimeras that marry the facial characteristics of humans and animal.[55] Bradley Rubenstein's portraits, in which he doctored children's portraits to have the eyes of dogs, present a disturbing look at the coming trend.[56]

Susan Robb uses both sculpture and photography to express the recent developments in the fields of biotechnology and genetic engineering.[57] In her *Bunny Test*, she created a series of grafted chocolate Easter bunnies to show the possible frightening consequences of genetic manipulation.[58]

Anthony Aziz and Sammy Cucher also ask us to envision a future where genetic engineering and cloning are rampant. Their works are motivated by the confluence of computer, bio-, and nanotechnologies which have opened up the possibility of a completely mutable universe.[59] Since their artistic union in 1990, Aziz and Cucher have been interested in "creating the visual metaphors for the increasing roles that new technologies play in our lives and how they affect us politically, socially, and psychologically."[60]

Their *Faith, Honor, and Beauty* is a satirical series.[61] In one digital photograph, a clean-shaven, chisel-jawed, nude man holds a laptop. In another, a beautiful naked woman in high heels holds a bowl of bright red apples.[62] Each of these photos seems to anticipate utopia, except for a bizarre twist: All nipples, genitals, and pubic hair have been removed because in this utopian future such bodily accoutrements will be unnecessary since children will be achieved in vitro or simply cloned.[63]

In their *Dystopia* series,[64] Aziz and Cucher present photographic portraits of men, women, and children, whose eyes, nostrils, and mouths have been digitally erased, "therefore the features that make each [person] unique are no longer present to define them."[65] However, beauty spots, wrinkles, skin unevenness, visible pores, and skin imperfections are still present.

Genetics, tissue regeneration, cloning, and other biotechnologies are being presented as offering choice to people. Artists such as Aziz and Cucher, as well as Rubenstein, are predicting that there will be a narrowing—not a widening—of human varieties. Instead of all wearing items from Nike and the Gap, we will all be wearing the same sort of genes.

Yet at the same time, artists such as Natalie Jeremijenko caution us that science and technology will not deliver on their promises. At the Exit Art exhibition, *Paradise Now*, she planted clones of trees in the gallery.[66] Even though they were tree clones—that is, their genetic makeup was identical—the environment of the gallery caused them to grow in radically different ways.

Life-science art also underscores the role in the life sciences of caring—and killing. By creating art such as tissue culture art that is living and hence requires nurturing, Oron Catts and Ionat Zurr say they create an "aesthetics of caring."[67] George Gessert, whose art includes breeding plants (figure 8.2), says, "The intensity of the medium breaks the spell cast by traditional art, in which life seems to exist freed from death. No serious breeding project can indulge this illusion, because evolution, even on the aesthetic level, cannot occur without death."[68] For example, in his 1995 *Art Life* he exhibited hundreds of plants at San Francisco's Exploratorium. As part of the exhibition, the viewers voted on their favorite plants and the rejected ones were turned into compost.[69] These works provide lessons for scientists about their nurturing responsibilities. They also make visible to the public the type of culling that takes place within science—the number of plants, products and, in some instances, human embryos that are rejected before an "acceptable" or "preferred" biological product becomes public.

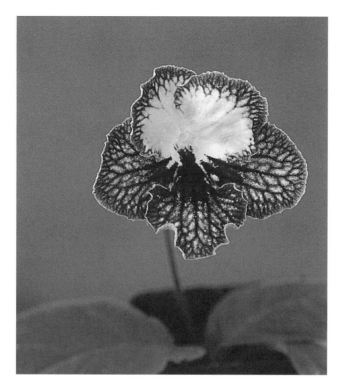

Figure 8.2

George Gessert, *Hybrid 1626*. Streptocarpus hybrid. Hybridized 2002. First bloomed 2003.

Commodification and Its Discontents

Biotechnologies have developed within an aggressive market environment, and this has profoundly changed—in my view, for the worse—the way the life sciences are conducted in the United States. Some artists focus specifically on this commodification.

Prior to the 1980s, if a university or federal researcher discovered or invented something using federal funds, that advance belonged to the public. The researchers could not personally profit. But with the passage of the Bayh-Dole Act[70] and the Stevenson-Wydler Act[71] in 1980, and the Federal Technology Transfer Act[72] in 1986, the rules changed completely.

These legal measures were enacted to encourage the commercial development of government-funded research. The Bayh-Dole Act allows universities and nonprofit institutions to apply for patents on federally funded inventions and discoveries, and provides

significant tax incentives to companies investing in academic research.[73] The Technology Transfer Act allows researchers in government facilities, including scientists at the National Institutes of Health, to patent their inventions and keep up to $150,000 of yearly royalties on top of their government salaries.[74] The law allows government researchers to enter into commercial arrangements (known as CRADAs—cooperation research and development agreements) with for-profit companies.[75]

Overnight, behavior that would have sent federally funded university researchers to the penitentiary in the 1960s and 1970s—for personally profiting from research done at taxpayers' expense—was not only legal, but encouraged.[76] But not all political leaders were convinced it was a wise move. Then-Congressman Al Gore argued that the arrangement was akin to "selling the tree of knowledge to Wall Street."[77]

Fluxus artist Larry Miller expressed his dismay at decisions like the John Moore case. Miller, struck by the questions of control and ownership of the body that were raised by the patenting of John Moore's cell line, satirized the situation. He created a Genetic Code Copyright, an elegantly drawn certificate stating: "I . . . born a natural human being . . . do hereby forever copyright my unique genetic code, however it may be scientifically determined, described or otherwise expressed."[78] He mocked the idea that a person can be treated as an object—copyrighted, commodified, and patented.

Donna Rawlinson MacLean takes it to the physiological level. She's a poet who went into the British patent office and tried to patent herself. She said, "It has taken 30 years of hard labor for me to discover and invent myself, and now I wish to protect my invention from unauthorized exploitation, genetic or otherwise."[79]

Commodification was also the theme of Chrissy Conant's art.[80] She sells Chrissy Caviar®—tins of her ovum (figure 8.3), as a commentary upon ads that actually exist soliciting egg donors for infertile couples and offering $50,000 to $100,000.[81]

The Critical Art Ensemble is a collective of five artists who combine art, technology, activism, and critical theory to create various biotech projects.[82] One project was *Flesh Machine*, a thirty-minute performance that dealt with reproductive technology.[83] Project visitors participated by taking donor screening tests and gathering information on the various methods in reproductive technology.[84] Those who passed the screening test were asked to give blood for DNA extraction and amplification, which was done at an on-site lab.[85] Cross-media profiles of the participants were constructed and the participants were able to see what their potential value was in the genetic market economy.[86]

Controversies

Artists have always found themselves in the center of controversy. Indeed that seems to be a coveted part of the artist's job description. Shaking up the status quo is what compels some people to make art in the first place. Life science art, though, raises new opportunities for social and legal constraints on artists. The controversies generated by works such as Kac's *GFP Bunny* are seen by the artists to be components of the work itself.

In 1998, the State Museum of Technology and Labor in Mannheim, Germany, displayed a striking and controversial exhibit called *Korperwelten* or *The Human Body World*,[87] consisting of two hundred preserved human corpses and body parts. The artist, Gunther von Hagens—also a physician and anatomy lecturer at the University of Heidelberg— preserved and prepared the bodies through an embalming process called plastination, which provides the body tissues and organs with firmness and fullness so they can be displayed in a true-to-life manner. Von Hagens arranged one corpse with all his organs and bones exposed, and his flayed skin draped over his arm like a robe. Other male corpses were fencing or playing chess. Another body was that of a five-months pregnant woman cut open to reveal the fetus inside of her.

The German Association of Anatomists described the show as perverse, and the deacons of Mannheim's Catholic and Evangelical churches decried the show as tasteless, immoral, and voyeuristic.[88] Prime Minister Erwin Terfel, from the Christian Democratic Union, called it "degrading to human dignity."[89]

The *Korperwelten* catalogue, filled with brilliant color photos of the figures, presents the exhibit as art. However, to deflect controversy, the Mannheim Museum employed medical students as guides to explain the anatomical features of the bodies. Despite community pressure to close the exhibit, city officials refused, saying the "scientific value" made the exhibit worthwhile.

Artist Rick Gibson did not have such an easy out. He decided to create a sculpture "to show the place of humans in society and how we treat human beings" by starting with a traditional representation of a woman's head.[90] Then he obtained two human fetuses, each of three to four months' gestation, from an anatomy professor.[91] He hung the fetuses off the sculpture as earrings. Gibson and the owner of the British gallery displaying his work were prosecuted for the common law offense of outraging public decency.[92] The defense lawyer asked that the men be charged under the Obscene Publications Act because it allows a defense for art that is in the public good.[93] The prosecution refused the request and the men were convicted by a jury. The judge said, "I accept that your motives were genuine. But in a civilized society there has to be a restraint on the freedom to act in a way that has an adverse effect on other members of society."[94] The court fined Gibson $875 and the gallery owner $612.[95]

The Gibson case presents an interesting paradigm for exploring the social regulation of life-science art. By what legal standards should such art be judged? Increasingly, regulators are involved in assessing such exhibits, particularly when the sponsor is a university with mechanisms already in place to scrutinize and regulate scientists' use of biotechnologies.

When Adam Zaretsky taught a course in life-science art, one of his students placed an order with a scientific supply house for live flies that had been genetically engineered so that they had an extra set of legs in the front of their heads instead of antennae. The student wanted to film a movie of the flies boxing. But, as he undertook the project, various of the flies escaped. This prompted a university official to call Zaretsky, concerned that

Figure 8.3

(a) Chrissy Conant, *Chrissy Caviar®*, glossy print ad, 2001–2002. Duraflex on aluminum, 30 × 40 in (76.2 × 101.6 cm), edition of 9. Courtesy of the artist. (b) Chrissy Conant, *Chrissy Caviar®*, product label detail, 2001–2002. Paper, UV laminated and water-proofed, 2.5 × 5.5 in (6.35 × 14 cm), edition of 12. Courtesy of the artist.

Lori B. Andrews

Figure 8.4

Iñigo Manglano-Ovalle, *Banks in Pink and Blue*, 2000. Cryogenic tanks, liquid nitrogen, and sperm samples. Courtesy of the artist and Max Protetch Gallery.

genetically modified organisms had been released into the atmosphere. Zaretsky communicated with scientific researchers via an e-mail to the newsgroup bionet.drosophilia and was able to assure the official that the flies were not hazardous.

Robin Held, curator of *Gene(sis): Contemporary Art Explores Human Genomics*, at the University of Washington's Henry Art Gallery, had to deal with the school's Institutional Biosafety Committee.[96] For that exhibit, Ovalle created *Banks in Pink and Blue*—which consisted of two sperm bank tanks, one in pink (including sperm sorted to be more likely to produce girls) and one in blue (to produce boys)—to provide discussion of sex selection (figure 8.4). The University of Washington requested that he destroy the samples when the project ended, but he hired lawyers to challenge that, and used the resulting contracts between the sperm providers, the university, and himself (the artist) as part of the installation.[97]

Should life science artists be held to higher, the same, lesser, or different standards entirely than scientists? Artists who undertake body art are generally held to higher standards than scientists. Artistic exploitation of the body is frowned upon, while commercial and experimental exploitation by scientists—even without the person's consent—is allowed (as it was in the Moore case). The anatomy professor who gave Gibson the fetuses, for example, was not prosecuted. And neither artist nor scientist is held accountable to the person whose tissue is used. The women whose fetuses became earrings in the Gibson case was not even mentioned in the legal opinion.[98]

A similar approach was taken in another British prosecution. Artist Anthony Noel-Kelly convinced Richard Heald of the Royal College of Surgeons to grant him access to the institution so he could sketch cadavers. Such access was in keeping with a long-standing artistic tradition; in fact, Heald introduced Noel-Kelly to his colleagues as a modern-day Leonardo.[99]

Soon, though, sketching and painting watercolors were not enough. Noel-Kelly wanted to make casts of the body parts, which would require taking them to his studio. Since that was beyond the scope of his agreement with Heald, Noel-Kelly began to take body parts surreptitiously with the help of Neil Lindsay.[100]

Once in his studio, Noel-Kelly used rubber molds, fiberglass, and plaster to make copies of the body parts and then buried the body parts in the grounds around his family's estate.[101] One of Noel-Kelly's statues for sale was a chunk of a woman's body dissected to reveal part of her womb.[102] Another was the head and torso of an old man with a hole drilled in his head; a £4,500 price tag was put on that work.[103]

Unfortunately for Noel-Kelly, his gallery exhibit of his death images also gained the attention of a police officer who realized that the pieces had been cast from dead bodies, and Noel-Kelly was charged with theft. He defended himself with an argu-ment—one also used by doctors and scientists who do research on human tissue—that the body parts had been "abandoned" in the College's basement storeroom.[104] He also argued that he was treating the corpses better than doctors or the Royal College had. "Each piece I treated with respect," said Noel-Kelly. "I did not cut them up with a saw."[105] He argued that the individuals whose bodies he used would have approved of his actions. "I felt as if the donors were looking on, I was not insulting their bodies in any way."[106]

More important, Noel-Kelly pointed out that even if he were in violation of the law, so too was the Royal College of surgeons which had kept the body parts longer than the applicable statute allowed and had failed to bury them in a timely manner. Noel-Kelly portrayed himself as a rescuer—the "route to a proper burial"[107] of human remains that were not being handled properly by the medical community.[108] His main legal argument, though, was a deceptively simple one of wide application. He argued that he could not legitimately be charged with theft because, for centuries, judges had said the human body could not be property.

In considering the Noel-Kelly case, the British judges pondered whether anyone could "own" a dead body or its parts. For centuries, the legal answer had been no. That's why the turn-of-the-century body snatchers who stole corpses were charged not with theft, but with outraging public decency.[109]

The prosecutor in Noel-Kelly's case, Mr. Campbell-Tiech, said the "no property in a body" rule had been the result of an erroneous reading of a 1614 case in which the defen-dant had disinterred corpses to steal their burial clothes. "Generations of lawyers" he said, then perpetuated the error.

Even though the legal doctrine had a "very poor legal pedigree," noted Judge Geoffrey Rivlin, he could not just reverse centuries of legal tradition. Judge Rivlin admitted it was strange that body-snatching in its heyday had not been declared a felony.[110] It was treated lightly in the nineteenth century, even though there were more than two hundred other offenses garnering the death penalty, ranging from shooting rabbits to appearing in disguise on a public road.[111]

"Why was body-snatching not made a felony?" asked Judge Rivlin in his opinion. "It is difficult to resist the thought that in not bringing the full weight of the law down upon the practice, Parliament, if not exactly turning a blind eye to it . . . winked at it in the interest of medical science." And policymakers are still winking at the interests of medical science today. The *Moore* case, for example, allowed the doctor, but not the patient, to assert a right to the patient's tissue.

Noel-Kelly tried to use this legal loophole to his advantage by claiming he couldn't be charged with theft of property when body parts were not, after all, property. The judge agreed that body parts were not property under the common law, but cited a 1908 Australian case, which established the principle that altering body parts—as the Royal College had done by putting them in formaldehyde—turned them into the Royal College's property. Noel-Kelly was convicted on April 3, 1998. He was the first British citizen to actually be prosecuted and convicted for theft of human remains.[112]

Again, there was no mention of the family members of the deceased, even though there was plenty of evidence that the Royal College was acting improperly itself by keeping body parts without burial longer than the Anatomy Act permitted.[113]

Ironically, as part of the litigation, Noel-Kelly's molds and sculptures were turned over to the Royal College of Surgeons, which could display them in its museum.[114] This underscored the fact that medical institutions are allowed to do things with body parts that other individuals and institutions are not. This unquestioned privileging of the medical sector may be as outrageous to many people as were Noel-Kelly's acts.

The approach of treating artists more harshly than scientists or doctors is suspect. For many people, art contributes more to their daily life than does science. The U.S. Constitution recognizes both the contributions of artists and scientists with its provision: "Congress shall have power . . . to promote the progress of science and useful arts by securing for limited times to authors and inventors the exclusive right to their respective writings and discoveries." In some senses, artists are more favored by the laws adopted pursuant to that provision. A researcher receives a twenty-year monopoly over his or her invention under patent law; an artist's copyright is good for the life of the author and seventy years after the author's death.[115] Moreover, under the First Amendment right of free speech, it is unconstitutional in the United States to adopt a law prohibiting art about a certain subject matter—such as a ban on paintings that parody a president. In contrast, researchers can be prohibited from undertaking certain types of research (such as research on fetuses) without such a law being seen as a violation of the researchers' First Amendment rights.[116]

Between the two extremes—harsher rules for artists versus more lenient ones—there may be an intermediate approach that takes into consideration risks created by the technologies of life-science art. If, for example, an artist decides to make not a rabbit but a human glow green, or if an artist decides to genetically profile a person without consent, the law should step in with appropriate restrictions. And, in considering when the laissez-faire approach to biotechnology may be inappropriate for artists, policymakers might also uncover deficiencies in the oversight of scientific researchers.

Art and Policy

Art can explain to us how biotechnologies work. The works created by life-science artists can emphasize the limits of these technologies and the likely social impacts. But they can also serve as a guide to public policy. By pointing out the gaps in regulation, the risks of these technologies, the inequities in access, and the way in which application of certain technologies may harm important social and cultural values, artists can encourage the social discussion that is necessary to adopt social public policies for biotechnologies.

Tissue-culture art, genetics art, and body-parts art provide us with the chance to ask: "What do we want out of our biotechnology?" It's time to go beyond thinking "Gee Whiz! Isn't it amazing they can do that?" We can use life-science art to think about the ways in which people can control the technology, rather than the technology controlling the people.

Notes

1. The shop was staffed by two bespectacled intellectuals, Tran T. Kim-Trang and Karl S. Mihail, both wearing white laboratory jackets.

2. *Moore v. Regents of the University of California*, 793 P.2d 479 (Cal. 1990).

3. Luckily, more recent cases have found that an individual or his next of kin has property rights to his tissue. *York v. Jones*, 717 F. Supp. 421, 425 (E.D. Va. 1989) (couple granted a property right to their frozen embryos); *Hecht v. Superior Court*, 16 Cal. App. 4th 836, 850, 20 Cal. Rptr.2d 275, 283 (1993) (human sperm is property); *Brotherton v. Cleveland*, 923 F.2d 477, 482 (6th Cir. 1991) (aggregate of rights existing in body tissue is similar to a property right); *Whaley v. County of Tuscola*, 58 F.3d 1111, 1117 (6th Cir. 1995) (the next of kin have a property interest in a decedent's tissue); *Newman v. Sathyavaglswaran*, 287 F.3d 786, 796 (9th Cir. 2002) (parents have "exclusive and legitimate claims of entitlement to possess, control, dispose and prevent the violation of the corneas and other parts of the bodies of their deceased children").

4. In fact, in the book we wrote, Dorothy Nelkin and I devote a chapter to artists. Lori Andrews and Dorothy Nelkin, *Body Bazaar: The Market for Human Tissue in the Biotechnology Age* (New York: Crown, 2001), 126–142.

5. Dominique Lestel, "The Artistic Manipulation of the Living," *Art Press* 276 (February 2002): 53–54.

6. "Bio(techno)logical Art," *Art Press* 276 (February 2002): 37.

7. See http://www.artbyhunter.com.

8. "Retrospective—Gallery," *Art Press* 276 (February 2002): 46.

9. See http://www.genomicart.org/kremers.htm.

10. Ibid.

11. Ibid.

12. Ibid.

13. Ibid.

14. See http://www.artbyhunter.com/.

15. Barbara Pollack, "The Genetic Esthetic," *ARTnews* 99 (April 1, 2000).

16. Jackie Stevens, "Why Are Biotech Companies Suddenly Sponsoring Art about Genes?" http://www.rtmark.com/paradise.html. Stevens points out that a public relations firm for the biotech industry contributed $500,000 to the *Paradise Now* exhibits. Other biotech companies—Affymetrix, Orchid BioScience, and Variagenics—were also sponsors. See also, Jackie Stevens, "PR for the 'Book of Life,'" *The Nation* (November 26, 2001), http://www.thenation.com/doc/20011203/stevens20011121.

17. Dominique Lestel, "The Artistic Manipulation of the Living," *Art Press* 276 (February 2002): 54. (All *Art Press* articles cited were translated by C. Penuvarden.)

18. Margalit Fox, "A Portrait in Skin and Bone," *New York Times* (November 21, 1993): 80.

19. Museum of Contemporary Art in Chicago, October 1, 1998 to February 21, 1999.

20. Brian Masters, "This Bust Was from a Decaying Corpse," *The Observer* (March 29, 1998): 5.

21. Steve Rushton, "Everything Talks with Jay Jopling," 1994, http://bak.spc.org/everything/e/hard/text/jopling.html; John McEwen, "A Weird Way to Seek Attention," *Sunday Telegraph* (April 7, 2002): 5.

22. *Incarnate*, catalogue of the exhibit at the Gagosian Gallery, Soho, New York (February 1998).

23. See http://www.susanrobb.com/Portfolio/2000/1golden.asp.

24. Ibid.

25. Ibid.

26. Personal communication, January 1999.

27. *Incarnate*, catalogue of the exhibit at the Gagosian Gallery, Soho, New York.

28. Barbara Pollack, "The Genetic Esthetic," *ARTnews* 99 (April 1, 2000): 134–137.

29. See http://www.genomicart.org/clarke.htm.

30. Ibid.

31. See http://www.genomicart.org/genome-seid.htm.

32. See http://www.genomicart.org/genome-chap5.htm.

33. Ron Platt, "Iñigo Manglano-Ovalle: The Garden of Delights," in *Iñigo Manglano-Ovalle: The Garden of Delights*, ed. Sheila Schwartz (Winston-Salem, NC: Southeastern Center for Contemporary Art, 1998), 10.

34. Iñigo Manglano-Ovalle, *The Garden of Delights* catalogue of the exhibit at the Southeastern Center of Contemporary Art, Winston-Salem, NC (July 18–September 30, 1998).

35. Alan Jones, "Kevin Clarke," *Tema Celeste* 40 (Spring 1993): 72–73.

36. See http://www.gene-sis.net/artists_vanouse.html.

37. See http://www.contrib.andrew.cmu.edu/~pv28/.

38. See http://www.gene-sis.net/artists_vanouse.html.

39. See http://www.contrib.andrew.cmu.edu/~pv28/.

40. Ibid.

41. Ibid.

42. Lori Andrews, *Future Perfect: Confronting Choices about Genetics* (New York: Columbia University Press, 2001), 141.

43. Jo Revill, "Why I Had a Mastectomy before Cancer Was Diagnosed," *Evening Standard* (December 1, 1993): 12.

44. Platt, "Iñigo Manglano-Ovalle," 15.

45. Ibid., 19.

46. See http://www.recirca.com/backissues/c90/18.shtml.

47. See http://www.ekac.org/geninfo2.html.

48. See http://www.ekac.org/gfpbunny.html.

49. Larry J. Young, Roger Nilsen, Katrina G. Waymire, Grant R. MacGregor, and Thomas R. Insel, "Increased Affiliative Response to Vasopressin in Mice Expressing the $V1_a$ Receptor from a Monogamous Vole," *Nature*, no. 400 (August 19, 1999): 766–768.

50. Arlindo Machado, "A Microchip Inside the Body," http://www.ekac.org/microinside.html.

51. Christiane Paul, "Time Capsule," *Intelligent Agent*, no. 2 (1998): 4–13.

52. *Harper's* magazine press release, November 12, 1997.

53. "Results of Public Survey on Human Genetics Released," *Cancer Weekly* (December 21, 1992): 9. See also Richard Liebmann-Smith, "It's a (Blond-Haired, Blue-Eyed, Even-Tempered, Ivy-Bound) Boy!" *New York Times* (February 7, 1993): sec. 6, p. 21.

54. See http://genomicart.org/sutton.htm.

55. See http://www.daniellee.com.

56. See http://www.genomicart.org/rubenstein.htm.

57. See http://web.archive.org/web/20050209081116/www.gene-sis.net/artists_robb.html.

58. Ibid.

59. See http://www.azizcucher.net/home.php.

60. See http://www.genomicart.org/aziz%20+%20cucher.htm.

61. Helen A. Harrison, "Art; Foibles and Terrors of Contemporary Life," *The New York Times* (December 26, 1993): 13LI.

62. Ibid.

63. Ibid.

64. Thyzr Nichols Goodeve, "These Are the Forms that We Live With" (1999), http://www.azizcucher.net/interview.php.

65. Aziz + Cucher: "Less Is Often More," Kemper Museum of Contemporary Art, Kansas City, MO, http://www.kemperart.org/acliom.htm.

66. Ron Bailey, "Pink Mice and Petri Dishes," *Reasononline* (December 2000), http://reason.com/0012/cr.rb.pink.shtml.

67. Annick Bureaud, "The Ethics and Aesthetics of Biological Art," *Art Press* 276 (February 2002): 39.

68. George Gessert, "Plants and the Art of Evolution," *Art Press* 276 (February 2002): 41.

69. Ibid., 44.

70. 35 U.S.C. §§ 200–2001.

71. This was 15 U.S.C. §§ 3701–3714.

72. This amended the Stevenson-Wydler Act. 15 U.S.C. §§ 3701–3714.

73. 35 U.S.C. §§ 200–211.

74. 15 U.S.C. §3710c(a)(3).

75. 15 U.S.C. §§ 3701–3714.

76. Leonard Hayflick, "Novel Techniques for Transforming the Theft of Mortal Human Cells into Praiseworthy Federal Policy," *Experimental Gerontology*, no. 33 (1998): 191–207.

77. Seth Shulman, *Owning the Future* (New York: Houghton Mifflin Company, 1999), 114.

78. Miller's work appeared at the Horodner Romley Gallery, New York, February 1993.

79. "Of Her Own Making," *New York Times* (March 12, 2000): 4.

80. http://www.chrissycaviar.com.

81. Her work is reminiscent of that of Piero Manzoni, who sold cans of his feces by weight, for the going rate of gold. He created a series of ninety such cans in 1961. Although he died at age

twenty-nine in 1963, the Tate Gallery recently paid £22,300 ($52,000) for a can of thirty grams of excrement "Tate Gallery Buys Canned Crap," CBC, ArtsCanada (July 8, 2002), http://www.cbc.ca/ artsCanada/stories/canned_crap020702. That was a hundred times the going rate for gold. Manzoni's creations led to an interesting lawsuit, in which an art collector loaned his can to a museum gallery for an exhibit and the temperature in the gallery was not maintained properly. The can exploded, diminishing the value of the "artwork" (Catherine Milner, "The Tate Values Excrement More Highly Than Gold," *Telegraph (London)* [June 30, 2002]: 13).

82. See http://www.critical-art.net/.

83. Ibid.

84. Ibid.

85. Ibid.

86. Ibid.

87. *Korperwelten* catalogue of the exhibit at the Mannheim Museum of Technology and Work, October 30, 1997 to February 1, 1998.

88. Jordan Bonfante, "The Anatomy of Death," *Time* (December 15, 1997): 62.

89. Ibid.

90. "Two Face Charges in Britain for Showing Human Foetus Earrings," *The Reuter Library Report* (January 31, 1989).

91. Gibson claims that an anatomy professor gave him the fetuses and told him that they were more than twenty-five years old. "Foetus Earrings Made to Promote Debate Says Artist," *The Daily Telegraph (London)* (February 8, 1989): 3.

92. The offense carries a maximum penalty of life imprisonment ("Two Face Charges in Britain for Showing Human Foetus Earrings").

93. Section 4 of the Obscene Publications Act of 1959 provides that "a person shall not be convicted of an offense against section two of this Act . . . if it is proved that publication of the article in question is justified as being for the public good on the ground that it is in the interests of science, literature, art or learning, or of other objects of general concern."

94. John Weeks, "Art Pair Fined over Foetus Earrings," *The Daily Telegraph (London)* (February 10, 1989): 3.

95. "British Jury Finds Fetus-Skull Earrings an Outrage," *Reuters* (February 9, 1989). Gibson appealed on the grounds that section 2(4) of the Obscene Publications Act of 1959 precluded a prosecution for outraging public decency. That section provides: "A person publishing an article shall not be proceeded against for an offense of common law consisting of the publication of any matter contained or embodied in the article where it is of the essence of the offense that the matter is obscene." The Court of Appeals upheld the conviction. *Regina v. Gibson and Another*, 1 All ER 439 (Court of Appeal, Criminal Division, 1990). It ruled that because "obscene" under the Obscene Publications Act (Section 1 of the Act provides: "For the purposes of this Act an article shall be deemed to be obscene if its effect . . . is, if taken as a whole, such as to tend to deprave and corrupt

persons who are likely, having regard to all relevant circumstances, to...see...the matter contained or embodied in it....") means corruption of public morals, it only stops prosecution under the common law for actions that corrupt public morals, but does not stop every offense that falls under an outrage to public decency charge. Thus, Gibson could be convicted under the common law offense of outraging public decency; he did not have to be tried under the Obscene Publications Act. The Court of Appeals also held that the prosecution did not have to prove intent to outrage public morals or reckless, it just had to prove that the intentional publication took place. Furthermore, the artist or gallery owner did not have to try to draw people in to look at the exhibit, it was sufficient for conviction that the mannequin was displayed.

96. Steven Henry Madoff, "The Wonders of Genetics Breed a New Art," *New York Times* (May 26, 2002): sec. 2, pp. 1, 30. Madoff points out that Robin Held also had to deal with the university "sanitarian—a wonderful *Brave New World*-ish job title—who tracks potential health issues on campus."

97. Barbara Pollack, "The Genetic Esthetic," *ARTnews* 99 (April 1, 2000), 134–137.

98. The consent issue permeates the field of body art. To obtain his bodies for plastination, von Hagens obtains consent from volunteers. He has received over one thousand donations. Donors know what they will be used for, defining it as a kind of "body liberation." Von Hagens does not accept the bodies of dead infants donated by their parents since the infants themselves can not give consent. Rather, he obtains infant bodies—some who died at the turn of the century—from hospitals and medical schools that have preserved them for research and educational purposes. Edmund L. Andrews, "Anatomy on Display and It's All Too Human," *New York Times* (January 7, 1998): A1.

99. "A Leonardo Preoccupied with Death," *Birmingham Post* (April 4, 1998): 2.

100. The judge gave Neil Lindsay less jail time because he was younger than twenty-one when the thefts began. The judge also recognized Noel-Kelly's strong personality and influence over Lindsay.

101. Alastair Dalton, "Sculptor Jailed for Theft of Body Parts," *The Scotsman* (April 4, 1998): 1.

102. "Jury Sees Body Sculptures," *The Guardian* (March 27, 1998): 7.

103. Noel-Kelly said that the sculptures were a way of "demystifying death" ("A Leonardo Preoccupied with Death"). "I find beauty in death...these rotting bodies," said Noel-Kelly. "You look at them and remind yourself, this is how we all end up." John Windsor, "Death is No Sleeping Beauty," *The Independent* (April 5, 1998): 5. His work struck a responsive chord in people, gaining the admiration, for example, of Prince Charles. Tony Ellin, "Burke and Heir," *Daily Record* (April 4, 1998): 4.

104. Melvyn Howe, "Body Parts Taken on London Tube to Artist's Studio," *Press Associated Newsfile* (March 31, 1998).

105. Paul Cheston, "I've No Qualms About Going into a Morgue, I Find Beauty in Death," *The Evening Standard* (April 3, 1998).

106. "Dismembered Corpse on the London Tube," *Belfast News Letter* (April 1, 1998): 7. Noel-Kelly claims that he always had respect for the body parts; however, in his diary, he referred to one severed leg stored in his attic as "Hopalong" and he did not bury the parts in any type of

container. Melvyn Howe, "Judge Jails Sculptor for 'Revolting' Thefts," *Belfast News Letter* (April 4, 1998): 3.

107. Melvyn Howe, "Body Parts Taken on London Tube to Artist's Studio," *Press Associated Newsfile* (March 31, 1998).

108. *Regina v. Noel-Kelly and Another*, 3 All ER 741 (Court of Appeals, Criminal Division, 1998).

109. Melvyn Howe, "How One Can Steal What Cannot Be Owned," *Press Association Newsfile* (April 3, 1998).

110. Ibid.

111. Ibid.

112. "Body Parts Sculptor is Freed From Jail on Appeal," *The Evening Standard* (May 15, 1998): 21. Previous body-snatchers had been charged with a lesser offense—outraging public decency. Melvyn Howe, "Judge Jails Sculptor for 'Revolting' Thefts," *Belfast News Letter* (April 4, 1998): 3. Noel-Kelly and Lindsay appealed, arguing that the trial judge erred in ruling that body parts were property. The Court of Appeals, Criminal Division, upheld the conviction: "In our judgment parts of a corpse are capable of being property within section four of the Theft Act, if they have acquired different attributes by virtue of the application of skill, such as dissection or preservation techniques for teaching or display purposes" (*Regina v. Noel-Kelly and Another*, 3 All ER 741 [Court of Appeal, Criminal Division 1998]). However, the appellate court reduced Noel-Kelly's nine-month sentence to three months. "Body Parts Sculptor is Freed from Jail on Appeal," *The Evening Standard* (May 15, 1998): 21. Noel-Kelly was released on May 15, 1998, after he had served half of the sentence. Lindsay's sentence was reduced to two months, rather than six months, and was suspended for two years. The justices considered the facts that both defendants were supposedly not motivated by malice or greed (although Lindsay was paid for his help in stealing the bodies, and the sculptures that Noel-Kelly made were offered for sale at 10 times the price that Noel-Kelly paid Lindsay), that they had never been in trouble before, and that Noel-Kelly was motivated by "artistic reasons." Cathy Gordon and Jan Colley, "Bodysnatching Artist Has Sentence Reduced," *Press Association Newsfile* (May 14, 1998): Home News Section. However, the justices were concerned that the theft could have a "dissuading effect" on someone who was thinking about donating his body for research. In addition they thought that the many people would view the acts "with repugnance." "We accept that however questionable the historical origins of the principle," said the court, "it has now been the common law for 150 years at least that neither a corpse nor parts of a corpse are in themselves, and without more, capable of being property protected by rights.... If that principle is now to be changed it must be by Parliament" (*Regina v. Noel-Kelly and Another*, 3 ALL ER 741 [Court of Appeal, Criminal Division]). See also Cathy Gordon and Jan Colley, "Bodysnatching Artist Has Sentence Reduced," *Press Association Newsfile* (May 14, 1998).

113. The lawyers for Noel-Kelly and Lindsay argued that, even if taking the body parts might be considered theft in some instances, it couldn't be a crime here because the Royal College of Surgeons was not the owner of the parts. The Anatomy Act of 1832 made it legal for anatomists and certain others to possess body parts and corpses. Among other things, the Anatomy Act requires a person or institution to have a license to legally possess a body. Noel-Kelly and Lindsay said since the College was violating the Anatomy Act by keeping body specimens longer than its license

permitted, it did not legally possess the body parts and the defendants were not stealing the parts because they did not belong to someone else. Section 5(1) of the Theft Act says: "Property shall be regarded as belonging to any person having possession or control of it, or having in it any proprietary right or interest." Legally, samples could only be retained for three years and then had to be disposed of, yet some of the samples were over twenty years old, and were not being used by the college. The court held that the Royal College could not prove it was in lawful possession of the corpses, it only had to show that it had possession when the body parts were taken for the defendants to be guilty of theft.

114. Melvyn Howe, "Artist Jailed for 'Revolting' Theft of Human Parts," *Press Association Newsfile* (April 3, 1998).

115. 17 U.S.C. § 302(a).

116. *Margaret S. I*, 488 F. Supp. 181, 220–221 (E.D. La. 1980). See also *Margaret S. v. Treen*, 597 F. Supp. 636 (E.D. La. 1984), *aff'd sub nom.*, *Margaret S. v. Edwards*, 794 F.2d 994 (5th Cir. 1986); *Wynn v. Scott*, 449 F. Supp. 1302, 1322 (N.D. Ill. 1978), *aff'd sub nom.*, *Wynn v. Carey*, 599 F.2d 193 (7th Cir. 1979). However, such a law might be declared unconstitutional based on other grounds, such as its interference with a couple's right of privacy to make reproductive decisions. *Lifchez v. Hartigan*, 735 F. Supp. 1361 (N.D. Ill.), *aff'd without opinion, sub nom.*, *Scholberg v. Lifchez*, 914 F.2d 260 (7th Cir. 1990), *cert. denied*, 498 U.S. 1069 (1991).

Liberating Life from Itself: Bioethics and Aesthetics of Animality

Dominique Lestel

Three major evolutionary events mark the twentieth century. They represent the most radical changes in evolution since the invention of agriculture and the domestication of animals in the Neolithic age. Since 1945, we have known that a species can destroy all other species on earth, including itself. Yuri Gagarin's feat in 1961 marked the first time that species have been able to leave earth. Mammals have been artificially cloned since 1997. The development of species used to follow a trajectory of a long natural history; bodies and behaviors were fashioned in response to the challenges they faced in their adopted environments. According to Darwinian evolution, species' development consisted of haphazard mutations that were selected according to instrumental criteria that could be summarized in a simple yet accurate formula: eat or be eaten, reproduce or disappear.

Humans have always manipulated living organisms to their advantage, ever since domestication and hybridization—techniques that seek to control reproduction. And their manipulations of the living were not exclusively instrumental; humans have always transformed the living for aesthetic, affective, or symbolic reasons.

Pets bred essentially for their masters' well-being are not a recent invention. With the rise of bio- and cognitive technologies, the coupling man/animal/technique did away with the importance of the notion of *species* from an evolutionary standpoint. These technological advances potentially render *all* interspecific boundaries completely permeable. Homo sapiens has therefore acquired unprecedented powers for manipulating life, both for his or her own species and for others. The question is no longer what humans can do (potentially, they can do anything), but what humans are authorized to do. Herein lies the ethical question. While the reasons for transforming living organisms for the benefit of humans are sometimes questioned, the instrumental justifications brought to these practices have rendered them acceptable. But artistic manipulations belong to a different category. Can animals be transformed (in appearance or bodily function, behavior or subjective state) in fundamentally noninstrumental contexts, that is, for example, in aesthetic contexts

connected to subjective appreciation? This chapter will address the latter question in some detail.

Humans Are Fundamentally Blind Even to Their Most Complex Actions

It is quite common to hear that within what is commonly called the "animal kingdom," humans have unparalleled capabilities to act. This statement is incontestably true, but leaves unsaid an important point: This human capability to act is a product of human history as much as a product of human capabilities. And it is often overlooked that humans possess another characteristic that results precisely from these concurrent genealogies: Humans are incapable of adequate representations of their actions. Most often they tend to overestimate their scope or underestimate their effects. Human rationality is not only limited, as Herbert Simon[1] has affirmed, but its beliefs, anticipations, fears, and hopes render it biased. Unreliable representations often accompany human actions, whereas other animals generally lack elaborate representations of their actions. Some animals, like chimpanzees, are exceptions since their representations are most often commensurate with their capabilities to act. Homo sapiens can transform the world or alter him or herself by resorting to representations that, although more complex than those of other species, are often inadequate.[2] The matter does not end here. Humans are not satisfied by merely acting and establishing acceptable representations of their actions: They feel obliged to grant meaning to them. Humans are not satisfied with action for the sake of action. Every action needs to be evaluated according to a set of values: It must be true or false, good or bad. Hence the necessity of resorting to an ethical standard. Homo sapiens has to choose not only between what it can or cannot do, but also between what it *ought* or ought not to do. The fundamental problem lies in the distance separating humans' capacities of action from their capacities to evaluate those actions correctly. Human relations with life in general, and animals in particular, reveal a great deal about this issue.

Manipulating Life

Since the Neolithic revolution, humans have consciously sought to modify life, and not only for material reasons but also for visual pleasure (designing the most beautiful animals), emotional needs (designing the most affectionate animals), and symbolic space (designing animals who are carriers of meaning for humans) account for most of these modifications. Human experiments on animals are therefore anatomic, behavioral, and cognitive, and are evaluated by means of complex symbolic representations. Humans are not only consumers of domestic and wild animals, but they are also literal consumers of domestication and hunting as such. The result is a fundamental "poly-predation" between humans and living organisms in general, and humans and animals in particular, which has been virtually ignored until now. Since the end of the twentieth century these transforma-

tions have been directly genetic ones. This raises two important questions: When applied to animals, do biotechnologies constitute a break in the creation and transformation of animals, or can they be said to refer back to already existing operations (hybridity, selection, taming, mutilation)? To what extent do humans have the right to alter living organisms according to their fancy, interests, or desires? In this chapter, I will limit myself to what may seem, prima facie, to be the most scandalous question, but also the most appropriate for the present volume: *To what extent is it ethical for humans to manipulate animals for aesthetic reasons?* Do humans have the right to manipulate an animal's body and behavior for aesthetic or purely intellectual reasons? Or, put differently, does the aesthetic approach still constitute a polymorphic predatory activity on the part of humans, or is it substantially different?

Artistic Manipulations of Animals in the Twentieth Century

This is hardly a new issue. H. G. Wells focused on this very issue in *The Island of Dr. Moreau*, through which he expressed his disapproval of the practices of vivisection of his times. One often forgets that Dr. Moreau's justification for conducting vivisections on animals in order to create proto-humans is, in fact, *artistic* in nature. Today, most people consider Dr. Moreau's activity inadmissible: The pain inflicted on the animals during the manipulations is unjustifiable, and the symbolic transgression of humanizing of the animal is worrisome since it calls into question the line separating humans from animals. Is this because the English scientist practices "gory" vivisections, or because he manipulates animals' skills? The question raised by H. G. Wells is especially relevant today. Since the 1980s, animal manipulation has become more common currency in artistic performances: Peter Gerwin Hoffman describes domestic animals as works of art, Czech philosopher Vilém Glusser sees artistic potential in budding biotechnologies, painter George Gessert exhibits iris seeds in his *Iris Project* (1985). Some of the most impressive examples are Alan Sonfist's "ecological art" *paintings*, arrangements of micro-organisms between two plates of glass (1970s); davidkremers's use of genetically modified bacteria to produce different colors; and Eduardo Kac's interactive transgenic installation *Genesis*.

Aesthetic manipulation of living organisms is not limited to micro-organisms or plants. Among the foregoing artists, Kremers exhibited sculptures of genetically modified zebra fish and Kac built installations with bats and a transgenic rabbit (*GFP Bunny*). Joseph Beuys's performance piece *Coyote: I Like America and America Likes Me,* where the German artist locked himself in a glass cage with a coyote for a week in New York in 1974, is now considered a classical reference in the field. However, it was not the first. In 1969 at the Attico Gallery in Rome, Jannis Kounellis included twelve horses in his performance, *Horses*. The field does not necessarily privilege large animals: Hubert Duprat manipulated insects, larva from Caddis flies, from 1980 to 1999 in order to transform their solid production into stunning jewels.

Evolution and Human Manipulations of Animals

Objections raised by those who feel humans do not have the right to manipulate animals for noninstrumental ends (i.e., for sensory pleasure or for research purposes to ultimately receive material benefits) are based on arguments that seem impressive from afar, but lose their strength when studied in detail, even if one agrees (as I do) with the basic desire to minimize animal suffering. For the purposes of this article, let us comment on both the strong and weak versions of this argument. The weak version advocates the respect of the *natural life* of the animal, which humans have no right to disturb. The strong and more audacious version claims the animal should be considered a person with rights, specifically with the right to be left in peace. Neither position is entirely tenable. Furthermore, these positions are also counterproductive, since they implicitly supply their adversaries with counterarguments.

The weak position claims a naturalist point of view, in which nature constitutes a sort of norm that we should be forced to follow in our behaviors. In this sense, the poly-predatory activity of humans is an unjustifiable intrusion into the animal's life. This approach is segregationist since it strives to preserve animals in "protected" spaces where they could live as they wish, naturally, without being manipulated by humans for human needs. Two difficulties are inherent in this position. First, the notion that animal life should not be disturbed by anything, and least of all by humans is problematic for anybody interested in the evolution of life. Nature is constantly, and intrinsically, transformed and manipulated; in other words, this segregationist attitude is anything but natural. A growing number of people have begun to worry about the animal condition and to feel responsible for other animals, but this attitude is not natural, and is simply the result of humans' long *cultural* history. This does not diminish the relevance of their concern, but one must be careful about claiming to have a naturalist or protectionist attitude toward nature. The second objection against aesthetic manipulation of animals (i.e., that the animal has the right not to be manipulated) is also problematic, because it essentially excludes humans from nature by granting them a special status within the world of the living, and by considering, more or less implicitly, humans' natural needs (such as manipulating other living beings to their advantage) to be less important than the needs of animals *not* to be manipulated.

The strong position is not tenable either. To consider that an animal is a "person" and therefore should not be manipulated by humans under any circumstances presupposes, without ever proving it, that the status of a "person" is a natural status and not a cultural artifact that can be applied to humans and animals alike. I have shown in detail that the notion of a "person" can only be understood in a larger context in which the mechanisms of natural evolution and cultural history give rise to individuals.[3] Determining whether an animal is a person is not an exclusively neurobiological question with physiological correlations. It is possible to maintain that a person's chief characteristic is to develop such a

status as personhood, and that this can take place by interacting with humans (for multiple reasons) rather than avoiding them. Fundamentally, we become a "person" in our relations with humans, and animals do not constitute an exception to this rule. Canadian philosopher Charles Taylor showed that Western notions of "person" and identity are not natural, but are the result of a long process of humans' auto-transformation throughout their history.[4]

The major problem of resorting to an evolutionary norm is that the evolutionary process is far from homogenized, thus it can be examined on many different levels. Limiting ourselves to National Geographic Society or BBC films, though edifying, would hardly constitute a rigorous method. Good will can make us want to set nature free, but we need to know what it is being set free from. A "Faustian" reading of the evolution of life proposes that the evolutionary process constitutes a fundamental condition for living organisms, and that living organisms should undergo transformation, either by themselves or by others, whoever those "others" may be. The story of the "Red Queen," from Lewis Carroll's *Alice in Wonderland*, widely used in evolutionary theory, is a metaphor for this: One has to run in order to stand still. In evolutionary terms, immobility is a form of passive suicide. According to biologists, Darwinian adaptive self-transformation among living organisms constitutes a necessary condition for the survival of a species. Therefore, the manipulation of the living by the living can be considered a "naturalist" norm and not a segregationist attitude, as some have claimed. From this perspective, not only is it ethical to manipulate life—whether the manipulations be biotechnological or not—but *it is unethical to prevent these manipulations from taking place.* Far from being opposed to ancestral evolution, humans pursue its dynamic. The fact that humans form an integral part of the animal environment and offer animals opportunities to develop and change has been the case for millions of years. Therefore, it is deeply unethical (a) to freeze life in its archaic or antiquated form; (b) to want to "protect" life instead of providing an opportunity for transformation; and (c) to refuse opportunities for self-renewal provided by humans to living organisms. The objection that this analysis would be true if humans avoided new techniques such as genetic manipulation in evolution simply demonstrates ignorance of biology of living organisms: Plants were transgenic long before humans ever manipulated them. For example, a vegetal tumor[5] is unleashed by a bacteria, whose process can be described as a natural form of genetic engineering. One can say this is obvious. However, this approach refers to instrumental adaptations: The question remains whether *aesthetic* manipulations of the living can be justified.

Aesthetic Manipulation of Life as an Intrinsic Property of Life

The conviction that evolutionary mechanisms are purely instrumental ignores the multiplicity of phenomena of life that can be characterized as forms of expressive rationality rather than forms of instrumental rationality sensu stricto. In other words, aesthetic

manipulation of the living, far from being a specifically human behavior (even if the practical modalities often are), is a basic tendency of the evolution of living organisms. Instead of being a perverse cultural invention, artistic manipulation of life is located *within* the world of the living. Multiple examples of this exist.[6] Many species of spider crabs adopt surprising behavior: They select elements from their environment (especially small animals: algae, sponges, byozans, or ascidians) to make garlands that they then attach to different parts of their shell. Many species of decorator crabs exist.[7] Their shells are not covered in small organisms that cling to them haphazardly, but by elements that are fixed to their shell after elaborated and repeated manipulations. Most of these crabs decorate themselves in this manner throughout their entire lives, and the decorative styles vary from one species to the next. Although the decorations sometimes serve as camouflage, this is not always the case, and some decorations even attract attention. These manipulations of the living are extremely diverse. They can be tactile (cleaner fish[8] on the Great Barrier Reef tickle their "clients" in order to attract them), synaesthetic (Arabian babblers are birds from the Negev desert who organize real dances at dusk[9]), or auditory (bird songs[10] are a goldmine for those interested in aesthetic animal behavior). Are these aesthetic animal behaviors or functional behaviors which humans interpret as being aesthetic? An initial response to this question is to ask oneself why a human's aesthetic interpretation would not shed light on what *other animals* deem aesthetic. A second response calls into question the opposition between utility and aesthetics—an opposition that is not entirely self-explanatory. For example, the fastest cars have the most aesthetic shapes. An aesthetic behavior is a behavior whose perception arouses *a particular* pleasure—not just a form of general pleasure—in whoever interacts with it. Aesthetic behavior takes place when behaviors or feelings of the other are manipulated, and pleasure is aroused. In this light, we could say that *only* co-evolutionary phenomena, such as that which connects certain wasps and certain orchids, are intrinsically aesthetic.

If the forms of these manipulations in humans are cultural, their guiding principle is not. In order to be properly understood, these human practices ought to be put in a phylogenetic context. This is not to say that artistic animals exist, but rather to recognize that artistic practices in humans are founded upon a playful relationship with the environment and the self, which predates behaviors that could be considered genuinely artistic in the Homo sapiens. I have suggested that the history of life can be seen as parallel to the development of two types of rationalities: an *instrumental rationality* (mobilizing the means in hopes of a particular end) on the one hand, and an *expressive rationality* (mobilizing the means in hopes of self-expression) on the other hand.[11] Although there are many ethology and comparative psychology studies devoted to instrumental rationality, relatively little work has been done on expressive rationality. Sociological and theoretical considerations explain this discrepancy. Most researchers are wary of taking part in studies that deviate from mainstream positions, which is difficult to reproach in light of academic valuation criteria. However, it would be short-sighted to stop at this explanation. Authentic concep-

tual difficulties also explain why expressive rationality has been neglected. Evolutionary theories remain primarily functionalist and utilitarian. Rather than improving matters, sociobiological or behavioral ecological trends that replaced aggressive behaviorism only made matters worse. Taking an interest in useless matters—at least where species survival is concerned—is a true act of academic gallantry and, one must admit, a somewhat suicidal endeavor. Play behaviors represent an instance of these difficulties. A given behavior is identified as play the minute it is deemed useless (otherwise it would be catalogued as hunting, combat, fleeing, or some other behavior). It is therefore a defined behavior *by default*, and thus considered different from all the other animal behaviors. Herein lies the puzzle: According to Darwinian logic, the ethologist needs to figure out the purpose behind a useless behavior. The proposed explanation is ingenious: A behavior that seems useless at a particular moment in time actually serves to perfect that behavior for a later moment in time. If children play a hunting play, they do it in order to become good hunters. Brilliant! However, this remains wishful thinking: No empirical or experimental data has ever rigorously confirmed this hypothesis. Another vague reasoning used to neglect or ignore expressive rationality in animals is a reasoning that I call *falsely exclusivist*, which is often found in explanations of mimetism or sexual selection. In mimetism, the animal conceals himself from the eyes of his predators by adopting characteristics of his environment. In sexual selection, the male dons a gleaming attire, a stunning voice, or decorates his nest tastefully in order to seduce females. As has been demonstrated, these functionalist reasons are fruitful beyond a doubt. The ruses of evolution are well worth those of history. But why limit ourselves to them? Why exclude another dimension of these behaviors, linked precisely to the search for self-expression and the pleasure that ensues? Denying this sometimes goes so far as to become absurd. Why do many male birds continue singing even when there are no females present, or once reproduction season is over? Those who believe that the male continues to sing mechanically or that he has realized the uselessness of his efforts are perhaps satisfied with their explanations—but is either really the case? It is more convincing to accept a hypothesis that the practice of these activities produces true ecstasy in the animal, and leads him to repeat it as often as possible, even when no adaptive advantage is expected, just as a rat can excite its neurological center of pleasure by manipulating a lever, and will continue to do so even in the absence of gratification.

Toward a Third Type of Existentialism

Objections raised to biotechnologies are political objections that try to pass as ethical or unfounded metaphysical objections. The question is not *whether* we should manipulate living organisms, but *who* is authorized to do so, and under what democratically controlled conditions. This radically changes the nature of the question. What is at stake is not the transgression of a norm external to humans, but rather the search for a consensus that

could determine what humans are as such. The existence of GMOs (already invented by nature millions of years ago) is less problematic than the privatization of living organisms, accomplished by means of patents owned by a select number of multinational companies. The role of artists is crucial in this context because they can experiment with manipulations of living organisms that need no justification from an instrumental point of view. They then can attempt to make sense of these experiments within a larger context. This enables artists to speak more freely than scientists, and to be more creative about the transformation of living organisms. *Social experiments*, for example, enable them to establish the fundamental continuity among all living beings, manipulated or not, and the importance of shared meanings, interests, and affects among human/animal hybrid communities.[12] It also gives them an opportunity to critique the exclusively and excessively utilitarian position held by biologists or bio-engineers who manipulate living organisms. Artists remind us of two essential factors: first, that a manipulated living organism remains living and should never be assimilated with an object or a machine, and second, that the manipulation of living organisms is never a *cold technique* but remains inhabited by fantastical representations that are intrinsically part of the creative process itself; creativity disappears altogether without representations that rely on the cultural and personal imagination of the innovator.

It is now time to link the ideas I have upheld thus far in this paper to a more general philosophical position—*a third type of existentialism*. Existentialism, simplified, is the philosophy according to which humans control their existence, and do with it what they wish. Another way of putting this is existence precedes essence. But classical European philosophies uphold the opposite: Humans live and act according to who they are from the outset. From this perspective, existentialism is an impressive philosophy of freedom, and it was quickly understood as such. Two types of existentialism have existed until now. *Christian existentialism* finds its sources in the work of Søren Kierkegaard, who inspired such twentieth-century thinkers as Karl Jaspers in Germany and Emmanuel Mounier and Gabriel Marcel in France. *Atheist existentialism* was originally developed by philosophers such as Martin Heidegger and Jean-Paul Sartre. Unlike Christian existentialism, atheist existentialism ignores the existence of a God as well as the comfort that follows from this resolution. Since, for Sartre, there is no God, humans cannot be defined by such a concept, and must therefore be defined by the sum of their actions. Human nature does not exist since God does not exist to create it. However, deep anguish results from the fact that without God, existence is fundamentally absurd. The third type of existentialism I would like to propose—let us call it "evolutionary existentialism"—is just as atheistic as Sartre's. However, compared to the latter, the third type of existentialism is evolutionary, technological, and transspecific. It is *evolutionary* because its sphere encompasses not only that of the individual or of the group, but also that of the species itself. It is *technological* because it emphasizes a mastery of the self by means of new technologies that offer a host of novel actions and opportunities (whose consequences can be either positive or negative).

What I do depends on techniques that enable me to accomplish an action, and who I am depends on the representations that I draw from that. This existentialism is *transspecific* because it considers that each living being determines who he or she is (existentialism extends to non-human species as well) and that the self-determination of humans takes biological or behavioral transformations of animals into account (the sphere of existentialist action of humans also applies to non-human species). The idea that there could be a "natural norm" that would be unthinkable to transgress is fundamentally foreign to this type of existentialism. For the third type of existentialism, nature exists only in a contingent manner. It does not have a preexisting essence and that would have to be maintained and protected simply *because it is nature*. I can wish to protect whales, but not because they are endangered species that need to be saved because they exist, but rather because the whale is of a value (emotional or symbolic) for me, and because I prefer to live (for a number of reasons that are not necessarily clear) in a world with whales rather than in a world without them. For this very reason, I can defend the idea that the quality of my relationship with the whale will improve if, for aesthetic reasons, I manipulate certain whales and alter their natural acoustic capacities so that they may sing differently. Similarly, neither Christopher Boesch nor Jane Goodall hesitated vaccinating their *wild* chimpanzees in order to prevent their extinction.

Conclusion

In light of this evolutionary existentialism, humans should take their fate, and that of living organisms in general, into their own hands. This fate is forged, and not imposed from the outside by more or less hostile Gods. The idea that humanity should be free to act as it chooses does not mean that every human should choose his or her destiny individually. Humans need to *liberate life from itself*. The skeptic will ask: Why not leave animals in peace? Because this precise alternative does not exist today. In the age of budding biotechnologies, it is difficult to see that the alternative no longer lies between leaving the animal in peace vs. manipulating it, but between wholly instrumentalizing the living versus inventing practices that resist this radical instrumentalization. In this context, *creating an existential value of the living* is an approach that has a chance of succeeding, given the prevailing sentiments in Western countries. Herein lie the bioethical stakes of aesthetic manipulations of living organisms. It is my belief that greater awareness of these issues ought to be raised by artists and philosophers. Bioethics is a heated topic of debate and should not become a tool in the hands of obscurantists and fundamentalists. The personalization of animals—a consequence of cognitive manipulations by humans—requires us to redefine a new status for them and, afterward, for all living organisms. Duties of respect and responsibility do not imply, a priori, any superfluous legalism. The role of the artist vis-à-vis the living is first and foremost to demonstrate that bio- or cognitive technologies generate meaning. These technologies should not be conceived of as purely

utilitarian. It is therefore essential not to entrust the monopoly on legitimate discourse about living organisms to biologists, computer scientists, or bio-ethicists, whose positions are often excessively reductive and limiting.

Notes

1. American economist Herbert Simon gained critical acclaim for his concept of "limited rationality" (a rational decision is made according to gathered information, but it is more rational to make a decision quickly that relies on incomplete information rather than waiting to have complete information). He was also one of the "founding fathers" of artificial intelligence and received the Nobel Prize in Economics in 1976.

2. Human representations are also about other representations. This is not the case in most animals, where this representation ability was experimentally tested.

3. Dominique Lestel, *L'animal singulier* (Paris: Seuil, 2004).

4. Charles Taylor, *Sources of the Self* (Cambridge, MA: Harvard University Press, 1989).

5. This does not have any pejorative connotations. Tumors are part of *normal* development of living organisms and must be considered as such. Whether we prefer to avoid them is another matter which should not be confused with the first one.

6. Semiotician Thomas Seboek provides the best account of animal art in his "Prefiguration of Art," *Semiotica* 27 (1979): 3–73.

7. M. Wickten, "Decorator Crabs," *Scientific American* (February 1980): 146–172.

8. R. Bshary, "The Cleaner Fish Market," in *Economics in Nature: Social Dilemmas, Mate Choice and Biological Markets*, ed. R. Noë, J. van Hooff, and P. Hammerstein (New York: Cambridge University Press, 2001): 146–172.

9. For further information about these bird dances and their evolutionary explanation, see A. Zahavi, "Reliability in Communication Systems and the Evolution of Altruism," in *Evolutionary Ecology*, ed. B. Stonehouse and C. Perrin (London: MacMillan, 1977): 253–359. A French-speaking reader could also read the excellent study by Belgian philosopher Vinciane Despret, *Naissance d'une théorie éthologique: La danse du cratérope écaillé* (Paris: Synthélabo, 1996).

10. The best book about the expressiveness and creativity in bird songs remains: Charles Hartshorne, *Born to Sing: An Interpretation and World Survey of Bird Song* (Bloomington, IN: Indiana University Press, 1973). A French-speaking reader should consult François-Bernard Mâche, *Musique au Singulier* (Paris: O. Jacob, 2001). The author, both a musician and musicologist, has studied bird songs in detail for his musical compositions, and is a former student of Olivier Messiaen.

11. Dominique Lestel, *Les origines animales de la culture* (Paris: Flammarion, 2001), chapter 4.

12. The notion of human/animal community is discussed in Dominique Lestel, *L'animalité: Essai sur le statut de l'animal* (Paris: Hatier, 1995).

III

Bio Art

Life Transformation—Art Mutation

Eduardo Kac

For over two decades my work has explored the boundaries between humans, animals, and robots.[1] Thus, transgenic art can be seen as a natural development of my previous work. In my telepresence art, developed since 1986, humans coexist with other humans and non-human animals through telerobotic bodies. In my biotelematic art, developed since 1994, biology and networking are no longer co-present but coupled so as to produce a hybrid of the living and the telematic. With transgenic art, developed since 1998, the animate and the technological can no longer be distinguished. The implications of this ongoing work have particular social ramifications, crossing several disciplines and providing material for further reflection and dialogue.

The presence of biotechnology will increasingly change from agricultural and pharmaceutical practices to a larger role in popular culture, just as the perception of the computer changed historically from an industrial device and military weapon to a communication, entertainment, and education tool. Terms formerly perceived as "technical," such as *megabytes* and *RAM*, for example, have entered the vernacular. Likewise, jargon that today may seem out of place in ordinary discourse, such as *marker* and *protein*, for example, will simply be incorporated into the larger verbal landscape of everyday language. This is supported by the fact that high school students in the United States already create transgenic bacteria routinely in school labs through affordable kits. The popularization of aspects of technical discourse inevitably brings with it the risk of dissemination of a reductive and instrumental ideological view of the world. Without ever relinquishing its right to formal experimentation and subjective inventiveness, art can, and should, contribute to the development of alternative views of the world that resist dominant ideologies. As both utopian and dystopian artists such as Moholy-Nagy and Tinguely have done before, in my work I appropriate and subvert contemporary technologies—not to make detached comments on social change, but to *enact* critical views, to make present in the physical world invented

new entities (artworks that include transgenic organisms) which seek to open a new space for both emotional and intellectual aesthetic experience.

I have been employing the phrase "bio art" since 1997, in reference to my own works that involved biological agency (as opposed to biological objecthood), such as "Time Capsule"[2] and "A-positive,"[3] both presented in 1997. The difference between biological agency and biological objecthood is that the first involves an active principle while the second implies material self-containment. In 1998 I introduced the phrase "transgenic art" in a paper-manifesto with the same title[4] and proposed the creation (and social integration) of a dog expressing green fluorescent protein. This protein is commonly used as a biomarker in genetic research; however, my goal was to use it primarily for its visual properties as a symbolic gesture, a social marker. The initial public response to the paper was curiosity laced with incredulity. The proposal was and is perfectly viable, but it seemed that few believed the project could or would be realized. While I struggled to find venues that could assist me in creating the aforementioned project, entitled "GFP K-9," I too realized that canine reproductive technology was not developed enough at the time to enable me to create a dog expressing green fluorescent protein.[5] In the meantime, I started to develop a new transgenic art work, entitled "Genesis," which premiered at Ars Electronica '99.[6]

Genesis

Genesis (figure 10.1) is a transgenic artwork that explores the intricate relationship between biology, belief systems, information technology, dialogical interaction, ethics, and the Internet. The key element of the work is an "artist's gene," a synthetic gene that was created by translating a sentence from the biblical Book of Genesis into Morse code, and converting the Morse code into DNA base pairs according to a conversion principle I specially developed for this work. The sentence reads: "Let man have dominion over the fish of the sea, and over the fowl of the air and over every living thing that moves upon the earth." It was chosen for what it implies about the dubious notion—divinely sanctioned—of humanity's supremacy over nature. Morse code was chosen because, as the first example of the use of radiotelegraphy, it represents the dawn of the information age—the genesis of global communication. The Genesis gene was incorporated into bacteria, which were shown in the gallery. Participants on the Web could turn on an ultraviolet light in the gallery, causing real, biological mutations in the bacteria. This changed the biblical sentence in the bacteria. After the show, the DNA of the bacteria was translated back into Morse code, and then back into English. The mutation that took place in the DNA had changed the original sentence from the Bible. The mutated sentence was posted on the *Genesis* Web site. In the context of the work, the ability to change the sentence is a symbolic gesture: It means that we do not accept its meaning in the form we inherited it, and that new meanings emerge as we seek to change it.

While presenting *Genesis*, I also gave a public lecture in the context of the symposium "Life Science," presented by Ars Electronica '99. My lecture focused on the "GFP K-9" proposal. To contextualize my presentation, I reviewed the long history of human-dog domestication and partnership, and pointed out the direct and strong human influence on the evolution of the dog up to the present day. Emphasizing that there are no packs of poodles and Chihuahuas running in the wild, and that the creation of the dog out of the wolf was a technology—a fact that we seemed to have lost sight of—I proceeded to point out the complex relationship between dogs and humans throughout their long history together, which goes back at least 14,000 years, according to archeological records. While some showed support and appreciation for the work, others reacted against the project and voiced their position. The stage was set for a very productive dialogue, which was one of my original intentions. As I see it, the debate must go beyond official policy-making and academic research to encompass the general public, including artists. "GFP K-9" was discussed in art magazines and books and science journals. Daily papers and general magazines also discussed the work in progress. While specialized publications showed greater appreciation for "GFP K-9," the response in the general media covered the whole gamut, from forthright rejection to consideration of multiple implications to unmistakable support. The shock generated by the proposal curiously caused one critic to declare "the end of art."[7] As I see it, there's no reason to see the beginning of a new art as the end of anything.

GFP Bunny

This pattern of response repeated itself, at a truly global scale, when I announced in 2000 the realization of my second transgenic work. Entitled *GFP Bunny* (figure 10.2) the work comprises the creation of a green fluorescent rabbit (Alba), the public dialogue generated by the project, and the social integration of the rabbit. This work was realized with the assistance of Louis Bec and Louis-Marie Houdebine. Louis Bec worked as the producer, coordinating the activities in France. Bec and I met at Ars Electronica (September 1999) and soon afterward he contacted Houdebine on my behalf, for the first time, to propose the project. Months later, in 2000, Alba was born, a gentle and healthy rabbit. As I stated in my paper entitled "GFP Bunny,"[8] "transgenic art is a new art form based on the use of genetic engineering to create unique living beings. This must be done with great care, with acknowledgment of the complex issues thus raised and, above all, with a commitment to respect, nurture, and love the life thus created."

GFP Bunny attracted local media in the south of France in June 2000 when the former director of the French institute where Alba was born used his authority to overrule the scientists who worked on the project and refused to let Alba go to Avignon and then come to my family in Chicago. This arbitrary decision was made privately by one individual (the former director of the French institute where Alba was born). He never explained

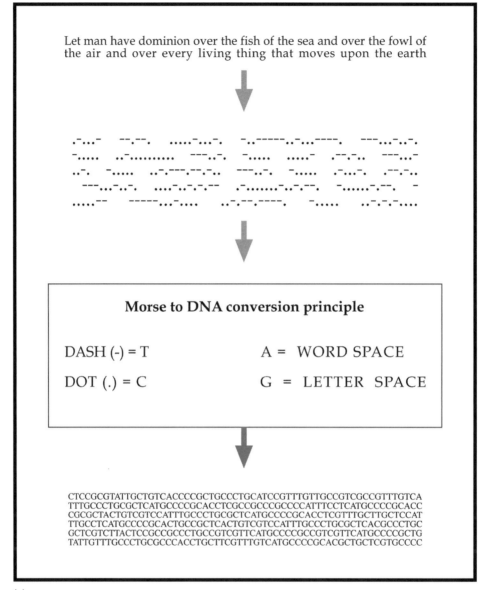

Figure 10.1

Eduardo Kac, *Genesis*, 1999. (a) The *Genesis* code. (b) *Genesis*. Transgenic net installation, general view, dimensions variable. (c) *Genesis* Web interface.

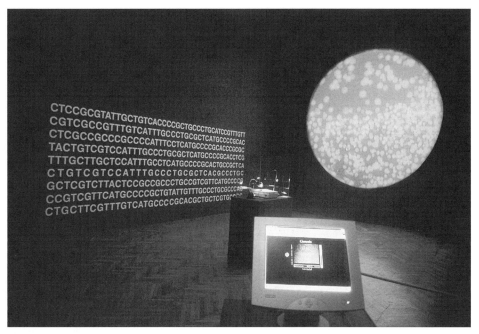

(b)

(c)

Figure 10.1

(*continued*)

Life Transformation—Art Mutation

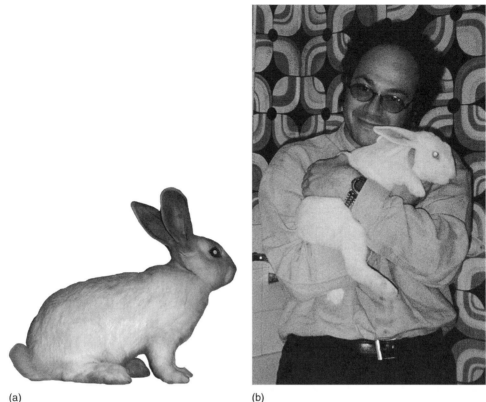

(a) (b)

Figure 10.2
Eduardo Kac, *GFP Bunny*, 2000. (a) Alba, the fluorescent bunny. (b) Eduardo Kac and Alba. (c) "Free Alba!" (*Boston Globe*), 2001. Color photograph mounted on aluminum with Plexiglas, 36 × 46.5 in (91.5 × 118 cm), edition of 5.

his reason for the refusal, so it remains unknown to this day. Bec and I denounced the censorship through the Internet and through interviews to the press.[9] If the objective was to silence the media, the result backfired. "GFP Bunny" became a global media scandal after a front-page article appeared in the *Boston Globe*,[10] sharing headlines with articles about the 2000 Olympics and US presidential debates. Articles about Alba were published in all major countries, with wire services further spreading the news worldwide.[11] Alba was also on the cover of *Le Monde*, the *San Francisco Chronicle*, and *L'Espresso*, among others. *Der Spiegel* and the *Chicago Tribune* dedicated full pages to *GFP Bunny*. She also appeared on the front page of the Arts section of the *New York Times*. Broadcasts by ABC TV, BBC Radio, and Radio France also took the Alba story to the whole planet. Since 2000 the relentless response to *GFP Bunny* has been equally intense and fascinating,

(c)

Figure 10.2
(*continued*)

Life Transformation—Art Mutation

with fruitful debate and both strong opposition and strong support. From 2000 to 2004 the "Alba Guestbook" collected general opinions about the work and expressions of support to bring Alba home.[12] Through lectures and symposia, Internet postings, and e-mail correspondence, the debate intensified and became richer, more subtle and nuanced, as I had hoped. The response to *GFP Bunny* constitutes extremely rich material, which I hope to revisit in the near future.

As part of my intercontinental custody battle to obtain Alba's release, between December 3 and December 13, 2000, I staged a public campaign in Paris, which included lectures, broadcasts, public and private meetings, and the public placement of a series of seven posters. I placed individual posters in several areas, including Le Marais, Quartier Latin, Saint Germain, Champs de Mars, Bastille, Montparnasse, and Montmartre. The posters reflect some of the readings afforded by *GFP Bunny*. They show the same image of Alba and me together, each topped by a different French word: Art, Médias, Science, Éthique, Religion, Nature, Famille.[13] Between December 3 and December 13, 2000, concurrent with radio (Radio France and Radio France Internationale), print (*Le Monde*, *Libération*, *Transfert*, *Ça M'intéresse*, *Nova*), and television (Canal+, Paris Première) interviews and debates, I posted these images on the streets in an effort to intervene in the context of French public opinion and gather support for my cause to bring Alba home. I also engaged the public directly through a series of lectures (Sorbonne, École Normale Superior, École Superior des Beaux Arts, Forum des Images) and through face-to-face conversations on the street sparked by the public's interest. In total, I reached approximately 1.5 million people (about half of the population of Paris). This was an important step, as it allowed me to address the Parisian public directly. In 2001 I created "The Alba Flag," a white flag with the green rabbit silhouette, and started to fly it in front of my Chicago-area house. The flag not only publically signals the green bunny home, but most importantly stands as a social marker, a beacon of her absence.

Continuing my efforts to raise awareness about Alba's plight and to obtain her freedom, in 2002 I presented a solo exhibition entitled *Free Alba!*[14] at Julia Friedman Gallery in Chicago (May 3–June 15, 2002). *Free Alba!* included a large body of new work comprised of large-scale color photographs, drawings, prints, Alba flags, and Alba t-shirts. Seen together for the first time were the posters from my public interventions in Paris (2000), an Alba flag flying outside the gallery (2001), photographs that reclaim green bunny narratives circulated by global media (2001–2002), drawings that reflect on our closeness to the "animal other" (2001–2002), and Alba t-shirts that extend Alba's cause beyond gallery walls (2002). Through the leitmotif of the green bunny, this exhibition explored the poetics of life and evolution. The story of *GFP Bunny* was adapted and customized by news organizations worldwide, often generating new narratives that, both intentionally and unintentionally, reinstated or overlooked the facts. My *Free Alba!* exhibition featured photographs in which I reappropriated and recontextualized this vast coverage, exhibiting the productive tension that is generated when contemporary art enters the realm of daily

news. The photographs in this series dramatize the fact that the reception of *GFP Bunny* was complex, taking place across cultures and in diverse locations. I will continue to develop new strategies to make Alba's case public and to pursue her liberation.

Parallel to this effort, transgenic art evolves. One new direction involves the creation of nanoscale three-dimensional structures built of amino acids. This "proteic art," or "protein art," can be experienced in many forms, including in vivo, in vitro, and expanded into other settings, such as rapid-prototype models and online navigational spaces. All of these forms, and many others, can be combined through new bio-interfaces. A prominent aspect of this path is the fact that these three-dimensional structures are assembled according to combinatory rules that follow strict biological principles (otherwise it is not possible to produce them), even if one invents and synthesizes a new protein. This constraint imposes a biomorphology that offers a new and fascinating creative challenge. A second new direction involves complex interactive transgenic environments with multiple organisms and biobots, biological robots partially regulated by internal transgenic microorganisms. In what follows I offer a discussion of these developments, both of which I explored in 2001.

Sculpting New Proteins

While the first phase of *Genesis* focused on the creation and the mutation of a synthetic gene through Web participation, the second phase, carried out in 2000–2001, focused on the protein produced by the synthetic gene, the Genesis protein,[15] and on new works that examine the cultural implications of proteins as fetish objects. The Genesis protein is another step in the translation of the original Biblical text, this time from the Genesis gene (itself encoding the English sentence) to a three-dimensional form made up of discrete parts (amino acids). The transmogrification of a verbal text into a sculptural form is laden with intersemiotic resonances that contribute to expand the historically rich intertextuality between word, image, and spatial form. The process of biological mutation extends it into time.

A critical stance is manifested throughout the *Genesis* project by following scientifically accurate methods in the real production and visualization of a gene and a protein that I have invented and which have absolutely no function or value in biology. Rather than explicating or illustrating scientific principles, the *Genesis* project complicates and obfuscates the extreme simplification and reduction of standard molecular biology descriptions of life processes, reinstating social and historical contextualization at the core of the debate. I appropriate the techniques of biotechnology to critique the language of science and its inherent ideologies, while developing transgenic art as an alternative means for individual expression. In its genomic and proteomic manifestations, the *Genesis* project continues to reveal new readings and possibilities.

Protein production is a fundamental aspect of life. Multiple research centers around the world are currently focusing their initiatives on sequencing, organizing, and analyzing the

genomes of both simple and complex organisms, from bacteria to human beings. After genomics (the study of genes and their functions) comes proteomics (the study of proteins and their functions). Proteomics, the dominant research agenda in molecular biology in the post-genomic world, focuses on the visualization of the three-dimensional structure of proteins produced by sequenced genes.[16] It is also concerned with the study of the structure and functionality of these proteins, among many other important aspects, such as similarity among proteins found in different organisms. The second phase of *Genesis* critically investigates the logic, the methods, and the symbolism of proteomics, as well as its potential as a domain of artmaking.

In order to arrive at the visualization of the Genesis protein, I first explored aspects of its two-dimensional structure[17] The next step was to compare the predicted folding pattern of the Genesis protein to another known protein to which it is similar: chorion. With the goal of producing a tangible rendition of the nanostructure of the Genesis protein, I researched protein fold homology using the Protein Data Bank, operated by the Research Collaboratory for Structural Bioinformatics (RCSB). I then produced a digital visualization of the Genesis protein's three-dimensional structure.[18] This three-dimensional dataset was used to produce both digital and physical versions of the protein. The digital version is a fully navigable Web object rendered both as VRML (Virtual Reality Modeling Language) and PDB (Protein Data Bank) formats, to enable up-close inspection of its complex volumetric structure. The physical rendition is a small solid object produced via rapid prototyping, to convey in tangible form the fragility of this molecular object.[19] This object was used as a mold for casting the final form of the protein used in the creation of the *Transcription Jewels*.

Transcription Jewels (figure 10.3) is a set of two objects encased in a custom-made round wooden box. The word "transcription" is the term employed in biology to name the process during which the genetic information is "transcribed" from DNA into RNA.[20] One "jewel" is a two-inch genie bottle in clear glass with gold ornaments and 65 mg of purified Genesis DNA inside. "Purified DNA" means that countless copies of the DNA have been isolated from the bacteria in which they were produced and accumulated and filtrated in a vial. The gene is seen here out of the context of the body, its meaning intentionally reduced to a formal entity to reveal that without acknowledgment of the vital roles played by organism and environment, the "priceless" gene can become "worthless." The other "jewel" is an equally small gold cast of the three-dimensional structure of the "Genesis" protein. By displaying the emblematic elements of the biotech revolution (the gene and the protein) as coveted valuables, "Transcription Jewels" makes an ironic commentary on the process of commodification of the most minute aspects of life. Neither the purified gene in *Transcription Jewels* nor its protein were derived from a natural organism, but rather were created specifically for the artwork *Genesis*. Instead of a "genie" inside the bottle, one finds the new panacea, the gene. No wishes of immortality, beauty, or intelligence are granted by the inert and isolated gene sealed inside the miniature bottle. As a

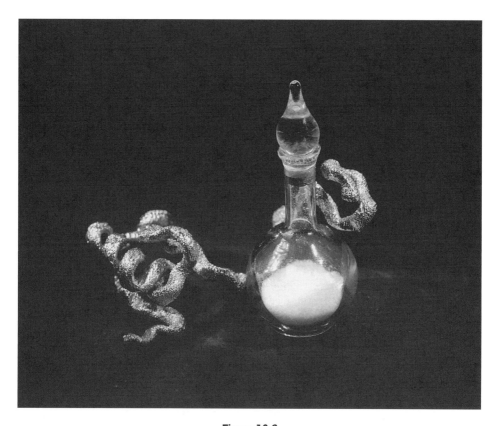

Figure 10.3

Eduardo Kac, *Transcription Jewels* (from the *Genesis* series), 2001. Glass, purified *Genesis* DNA, gold, wood, approximately 2 in (5 cm) each.

result, the irony gains a critical and humorous twist by the fact that the "precious commodity" is devoid of any real, practical application in biology.

All pieces described and discussed earlier, including the Internet installation with live bacteria, were presented together in my solo exhibition *Genesis*, realized at Julia Friedman Gallery in Chicago from May 4 to June 2, 2001. The multiple mutations experienced biologically by the bacteria and graphically in the images, texts, and systems that compose the exhibition reveal that the alleged supremacy of the so-called master molecule must be questioned. The *Genesis* series (including the installation, *Transcription Jewels*, and other works) challenges genetic hype and opposes the dominant biodeterministic interpretation in stating that we must continue to consider life to be a complex system at the crossroads between belief systems, economic principles, legal parameters, political directives, scientific laws, and cultural constructs.

(a)

Figure 10.4

Eduardo Kac, *The Eighth Day*, 2001. Transgenic work, dimensions variable. (a) The piece brings together living transgenic life forms and a biological robot (biobot), thus making visible what it would be like if these creatures would in fact coexist in the world at large. (b) The transgenic amoebae, fish, plants, and mice glow green when illuminated with blue light.

(b)

Figure 10.4

(*continued*)

The Eighth Day

The Eighth Day (figure 10.4) is a transgenic artwork that investigates the new ecology of fluorescent creatures that is evolving worldwide. It was shown from October 25 to November 2, 2001, at the Institute for Studies in the Arts, Arizona State University, Tempe.[21] While fluorescent creatures are being developed in isolation in laboratories, seen collectively in this work for the first time they form the nucleus of a new and emerging synthetic bioluminescent ecosystem. The piece brings together living transgenic life forms and a biological robot (biobot) in an environment enclosed under a clear Plexiglas dome, thus making visible what it would be like if these creatures would in fact coexist in the world at large.

As the viewer walks into the gallery, he or she first sees a blue-glowing semisphere against a dark background. This semisphere is the four-foot dome, aglow with its internal blue light. He or she also hears the recurring sounds of water washing ashore. This evokes the image of the Earth as seen from space. The water sounds both function as a metaphor for life on Earth (reinforced by the spherical blue image) and resonate with the video of

moving water projected on the floor. In order to see *The Eighth Day*, the viewer is invited to "walk on water."

In the gallery, visitors are able to see the terrarium with transgenic creatures both from inside and outside the dome. As they stand outside the dome looking in, someone on-line sees the space from the perspective of the biobot looking out, perceiving the transgenic environment as well as faces or bodies of local viewers. An online computer in the gallery also gives local visitors an exact sense of what the experience is like remotely on the Internet.

Local viewers may temporarily believe that their gaze is the only human gaze contemplating the organisms in the dome. However, once they navigate the Web interface they realize that remote viewers can also experience the environment from a bird's eye point of view, looking down through a camera mounted above the dome. They can pan, tilt, and zoom, seeing humans, mice, plants, fish and the biobot up close. Thus, from the point of view of the online participant, local viewers become part of the ecology of living creatures featured in the work, as if enclosed in a websphere.

The Eighth Day presents an expansion of biodiversity beyond wildtype life forms. As a self-contained artificial ecology it resonates with the words in the title, which add one day to the period of creation of the world as narrated in the Judeo-Christian Scriptures. All of the transgenic creatures in "The Eighth Day" are created with the same gene I used previously in "GFP Bunny" to create Alba, a gene that allows all creatures to glow green under harmless blue light. The transgenic creatures in *The Eighth Day* are GFP plants, GFP amoeba, GFP fish, and GFP mice. Selective breeding and mutation are two key evolutionary forces. *The Eighth Day* literally raises the question of transgenic evolution, since all organisms in the piece are mutations of their respective wildtype species and all were selected and bred for their GFP mutations.

The Eighth Day also includes a biological robot, or biobot. A biobot is a robot with an active biological element within its body, which is responsible for aspects of its behavior. The biobot created for *The Eighth Day* has a colony of GFP amoeba called Dyctiostelium discoideum as its "brain cells." These "brain cells" form a network within a bioreactor that constitutes the "brain structure" of the biobot. When amoebas divide, the biobot exhibits dynamic behavior inside the enclosed environment. Changes in the amoebal colony (the "brain cells") of the biobot are monitored by it, and cause it to move about throughout the exhibition. The biobot also functions as the avatar of Web participants inside the environment. Independent of the ascent and descent of the biobot, Web participants are able to control its audiovisual system with a pan-tilt actuator. The autonomous motion, which often causes the biobot to lean forward in different directions, provides Web participants with new perspectives of the environment.

The biobot's "amoebal brain" is visible through the transparent bioreactor body. In the gallery, visitors are able to see the terrarium with transgenic creatures from outside and

inside the dome, as a computer in the gallery gives local visitors an exact sense of what the experience is like on the Internet. By enabling participants to experience the environment inside the dome from the point of view of the biobot, *The Eighth Day* creates a context in which participants can reflect on the meaning of a transgenic ecology from a first-person perspective.

Move 36

Move 36[22] (figure 10.5) makes reference to the dramatic move made by the computer called Deep Blue against chess world champion Gary Kasparov in 1997. This competition can be characterized as a match between the greatest chess player who ever lived and the greatest chess player who never lived. The installation sheds light on the limits of the human mind and the increasing capabilities developed by computers and robots, inanimate beings whose actions often acquire a force comparable to subjective human agency.

According to Kasparov, Deep Blue's quintessential moment in game two came at move 36. Rather than making a move that was expected by viewers and commentators alike—a sound move that would have afforded immediate gratification—it made a move that was subtle and conceptual and, in the long run, better. Kasparov could not believe that a machine had made such a keen move. The game, in his mind, was lost.

The installation presents a chessboard made of earth (dark squares) and white sand (light squares) in the middle of the room. There are no chess pieces on the board. Positioned exactly where Deep Blue made its move 36 is a plant whose genome incorporates a new gene that I created specifically for this work. The gene uses ASCII (the universal computer code for representing binary numbers as roman characters, on- and off-line) to translate to the four bases of genetics Descartes' statement: "Cogito ergo sum" (I think therefore I am).

Through genetic modification, the leaves of the plants curl. In the wild these leaves would be flat. The "Cartesian gene" was coupled with a gene that causes this sculptural mutation in the plant, so that the public can see with the naked eye that the Cartesian gene is expressed precisely where the curls develop and twist.

The Cartesian gene was produced according to a new code I created especially for the work. In eight-bit ASCII, the letter C, for example, is 01000011. Thus, the gene is created by the following association between genetic bases and binary digits:

A = 00
C = 01
G = 10
T = 11

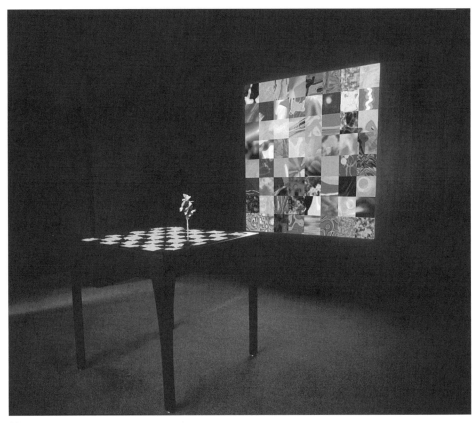

(a)

Figure 10.5

Eduardo Kac, *Move 36*, 2002/2004. Transgenic installation with looped digital video, dimensions variable. (a) Partial view. (b) Plant close-up.

The result is the following gene with fifty-two bases:

CAATCATTCACTCAGCCCCACATTCACCCCAGCACTCATTCCATCCCCCATC

The creation of this gene is a critical and ironic gesture, since Descartes considered the human mind a "ghost in the machine" (for him the body was a "machine"). His rationalist philosophy gave new impetus both to the mind-body split (Cartesian dualism) and to the mathematical foundations of current computer technology.

The presence of this Cartesian gene in the plant, rooted precisely where the human lost to the machine, reveals the tenuous border between humanity, inanimate objects en-

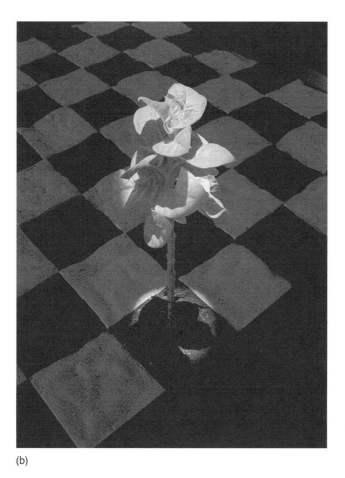

(b)

Figure 10.5
(*continued*)

dowed with lifelike qualities, and living organisms that encode digital information. A single parallel light beam shines delicately over the plant. Silent square video projections on two opposing walls contextualize the work, evoking two chess opponents in absentia. Each video projection is composed of a grid of small squares, resembling a chessboard. Each square shows short animated loops cycling at different intervals, thus creating a complex and carefully choreographed thread of movements. The cognitive engagement of the viewer with the multiple visual possibilities presented on both projected boards subtly emulates the mapping of multiple paths on the board involved in a chess match.

A game for phantasmic players, a philosophical statement uttered by a plant, and a sculptural process that explores the poetics of real life and evolution, this installation gives continuity to my ongoing interventions at the boundaries between the living (human, non-human animals) and the nonliving (machines, networks). Checkmating traditional notions, nature is revealed as an arena for the production of ideological conflict, and the physical sciences as a locus for the creation of science fictions.

Conclusion

Quite clearly, genetic engineering will continue to have profound consequences in art as well as in the social, medical, political, and economic spheres of life. As an artist I am interested in reflecting on the multiple social implications of genetics, from unacceptable abuse to its hopeful promises, from the notion of "code" to the question of translation, from the synthesis of genes to the process of mutation, from the metaphors employed by biotechnology to the fetishization of genes and proteins, from simple reductive narratives to complex views that account for environmental influences. The urgent task is to unpack the implicit meanings of the biotechnology revolution and contribute to the creation of alternative views, thus changing genetics into a critically aware new art medium.

The tangible and symbolic coexistence of the human and the transgenic, which I developed in several of my aforementioned works, shows that humans and other species are evolving in new ways. It dramatizes the urgent need to develop new models with which to understand this change, and calls for the interrogation of difference taking into account clones, transgenics, and chimeras.

The Human Genome Project (HGP) has made it clear that all humans have in their genome sequences that came from viruses,[23] acquired through a long evolutionary history. This means that we have in our bodies DNA from organisms other than human. Thus we too are transgenic. Before deciding that all transgenics are "monstrous," humans must look inside and come to terms with their own "monstrosity," namely, with their own transgenic condition.

The common perception that transgenics are not "natural" is incorrect. It is important to understand that the process of moving genes from one species to another is part of wild life (without human participation). The most common example is the bacterium called "agrobacterium," which enters the root of plants and communicates its genes to it. Agrobacterium has the ability to transfer DNA into plant cells and integrate that DNA into the plant chromosome.[24]

Transgenic art suggests that romantic notions of what is "natural" have to be questioned and that the human role in the evolutionary history of other species (and vice versa) has to be acknowledged, while at the same time respectfully and humbly marveling at this amazing phenomenon we call "life."

Notes

1. Peter Tomaz Dobrila and Aleksandra Kostic, eds., *Eduardo Kac: Telepresence, Biotelematics, Transgenic Art* (Maribor, Slovenia: KIBLA, 2000). See also http://www.ekac.org.

2. Robert Atkins, "State of the (On-Line) Art," *Art in America* (April 1999): 89–95; Mario Cesar Carvalho, "Artista Implanta hoje Chip no Corpo," *Folha de São Paulo, Cotidiano* (November 11, 1997): 3; Michel Cohen, "The Artificial Horizon: Notes Towards a Digital Aesthetics," in *Luna's Flow: The Second International Media Art Biennale*, ed. Wonil Rhee (Seoul, Korea: Seoul Museum of Art, 2002), 20 and 32–33; Patricia Decia, "Bioarte: Eduardo Kac tem Obra Polêmica Vetada no ICI," *Folha de São Paulo, Ilustrada* (October 10, 1997): 13; Steve Dietz, "Memory_Archive _Database," *Switch*, vol. 5, no. 3 (2000), http://switch.sjsu.edu; Steve Dietz, "Hotlist," *Artforum* (October 2000): 41; Luis Esnal, "Un Hombre Llamado 026109532," *La Nacion*, Section 5 (December 15, 1997): 8; Eduardo Kac, "Time Capsule," *InterCommunication* 26 (Autumn 1998): 13–15; Eduardo Kac, "Time Capsule," in *Database Aesthetics*, eds. Victoria Vesna, Karamjit S. Gill, and (David Smith, special issue of *AI & Society*, vol. 14, no. 2 (2000): 243–249; Eduardo Kac, "Art at the Biological Frontier," in *Reframing Consciousness: Art, Mind and Technology*, ed. Roy Ascott (Exeter, UK: Intellect, 1999), 90–94; Eduardo Kac, "Capsule Temporelle," in *L'Archivage Comme Activité Artistique/Archiving as Art*, ed. Karen O'Rourke (Paris: University of Paris 1, 2000), n.p.; Arlindo Machado, "A Microchip Inside the Body," *Performance Research*, vol. 4, no. 2, "On Line" special issue (London, 1999): 8–12; Christiane Paul, "Time Capsule," *Intelligent Agent*, vol. 2, no. 2 (1998): 4–13; Julia Scheeres, "New Body Art: Chip Implants," *Wired News* (March 11, 2002); Maureen P. Sherlock, "Either/Or/Neither/Nor," in *Future Perspectives*, ed. Marina Grzinic (Umag, Croatia: Marino Cettina Gallery, 2001), 130–135; Kristine Stiles, "Time Capsule," in *Uncorrupted Joy: Art Actions, Art History, and Social Value* (Berkeley: University of California Press, forthcoming); Stephanie Strickland, "Dalí Clocks: Time Dimensions of Hypermedia," *Electronic Book Review* 11 (2000); Steve Tomasula, "Time Capsule: Self-Capsule," *CIRCA* 89 (Autumn 1999): 23–25.

3. Gisele Beiguelman, "Artista discute o pós-humano," *Folha de São Paulo* (October 10, 1997); Patricia Decia, "Artista Põe a Vida em Risco" and "Bioarte," *Folha de São Paulo* (October 10, 1997); James Geary, *The Body Electric: An Anatomy Of The New Bionic Senses* (New Brunswick, NJ: Rutgers, 2002), 181–185; Eduardo Kac, "A-Positive," in *ISEA '97: The Eighth International Symposium on Electronic Art*, September 22–September 27, 1997 (Chicago: The School of the Art Institute of Chicago, 1997), 62; Eduardo Kac, "A-Positive: Art at the Biobotic Frontier," flyer distributed on the occasion of *ISEA '97: The Eighth International Symposium on Electronic Art*, September 22–September 27, 1997 (Chicago: The School of the Art Institute of Chicago, 1997); Eduardo Kac, "Art at the Biologic Frontier," in *Reframing Consciousness*, ed. Roy Ascott (Exeter, UK: Intellect, 1999), 90–94; Arlindo Machado, "Expanded Bodies and Minds," in *Eduardo Kac: Teleporting An Unknown State*, ed. Peter Tomaz Dobrila and Aleksandra Kostic (Maribor, Slovenia: Kibla, 1998), 39–63; Matthew Mirapaul, "An Electronic Artist and His Body of Work," *The New York Times* (October 2, 1997); Simone Osthoff, "From Stable Object to Participating Subject: Content, Meaning, and Social Context at ISEA '97," *New Art Examiner* (February 1998): 18–23.

4. Eduardo Kac, "Transgenic Art," *Leonardo Electronic Almanac*, vol. 6, no. 11 (1998). Also see http://www.ekac.org/transgenic.html. Republished in *Ars Electronica '99: Life Science*, ed. Gerfried Stocker and Christine Schopf (Vienna and New York: Springer, 1999), 289–296.

5. At the time of writing, February 2003, canine reproductive technology is still not developed enough to enable the creation of a transgenic or cloned dog. However, research is underway to both map the dog genome and to developed canine IVF. Clearly, "GFP K-9" will be possible in the near future.

6. Eduardo Kac, "Genesis," in *Ars Electronica '99: Life Science*, ed. Gerfried Stocker and Christine Schopf (Vienna, NY: Springer, 1999), 310–313. Also see http://www.ekac.org/geninfo.html. "Genesis" was carried out with the assistance of Dr. Charles Strom, formerly Director of Medical Genetics, Illinois Masonic Medical Center, Chicago. Dr. Strom is now Medical Director, Biochemical and Molecular Genetics Laboratories, Nichols Institute/Quest Diagnostics, San Juan Capistrano, CA. Original DNA music for "Genesis" was composed by Peter Gena.

7. Charles Mudede, "The End of Art," *The Stranger*, vol. 9, no. 15 (December 30, 1999).

8. Eduardo Kac, "GFP Bunny," in *Eduardo Kac: Telepresence, Biotelematics, and Transgenic Art*, ed. Peter Tomaz Dobrila and Aleksandra Kostic (Maribor, Slovenia: KIBLA, 2000), 101–131. Also see http://www.ekac.org/gfpbunny.html.

9. I had proposed to live for one week with Alba in the Grenier à Sel, in Avignon, where Louis Bec directed the art festival "Avignon Numérique." In an e-mail broadcast in Europe on June 16, 2000, Bec wrote: "Contre notre volonté, le programme concernant 'Artransgénique', qui devait se dérouler du 19 au 25 juin, se trouve modifié. Une décision injustifiable nous prive de la présence de Bunny GFP, le lapin transgénique fluorescent que nous comptions présenter aux Avignonnais et à l'ensemble des personnes intéressées par les évolutions actuelles des pratiques artistiques. Malgré cette censure déguisée, l'artiste Eduardo Kac, auteur de ce projet, sera parmi nous et présentera sa démarche ainsi que l'ensemble de ses travaux. Un débat public permettra d'ouvrir une large réflexion sur les transformations du vivant opérées par les biotechnologies, tant dans les domaines artistiques et juridiques, qu'éthiques et économiques. Nous nous élevons de toute évidence contre le fait qu'il soit interdit aux citoyens d'avoir accès aux développements scientifiques et culturels qui les concernent si directement."

10. Gareth Cook, "Cross Hare: Hop and Glow," *Boston Globe* (September 17, 2000): A01.

11. For a bibliography on transgenic art, see http://www.ekac.org/transartbiblio.html.

12. http://www.ekac.org/bunnybook.2000_2004.html.

13. These posters have also been shown in gallery exhibitions: *Dystopia + Identity in the Age of Global Communications*, curated by Cristine Wang, Tribes Gallery, New York, 2000; *Under the Skin*, curated by Söke Dinkla, Renate Heidt Heller, and Cornelia Brueninghaus-Knubel, Wilhelm Lehmbruck Museum, Duisburg, 2001; *International Container Art Festival*, Kaohsiung Museum of Fine Arts, Taiwan (December 8, 2001–January 6, 2002); *Portão 2*, Galeria Nara Roesler, São Paulo, Brazil (March 21–April 27, 2002); *Free Alba!*, Julia Friedman Gallery, Chicago (May 3–June 15, 2002); *Eurovision: I Biennale d'Arte: DNArt: Transiti: Metamorfosi: Permanenze*, Kunsthaus Merano Arte, Merano, Italy (June 15–August 15, 2002); *Gene(sis): Contemporary Art Explores Human*

Genomics, Henry Art Gallery, Seattle (April 6–August 25, 2002). See also the following catalogues: *Under the Skin* (Ostfilden-Ruit, Germany: Hatje Cantz Verlag, 2001), 60–63; *Eurovision: I Biennale d'Arte: DNArt: Transiti: Metamorfosi: Permanenze* (Milano: Rizzoli, 2002), 104–105; *International Container Art Festival* (Kaohsiung: Kaohsiung Museum of Fine Arts, 2002), 86–87.

14. Lisa Stein, "New Kac Show Takes a Look at Ethics, Rabbit," *Chicago Tribune* (May 10, 2002): 21.

15. In actuality, genes do not "produce" proteins. As Richard Lewontin clearly explains: "The DNA sequence does not specify protein, but only the amino acid sequence. The protein is one of a number of minimum free-energy foldings of the same amino acid chain, and the cellular milieu together with the translation process influences which of these foldings occurs." See R. C. Lewontin, "In the Beginning Was the Word," *Science* 291 (February 16, 2001): 1264.

16. In 1985 I purchased an issue of a magazine entitled *High Technology* whose cover headline read "Protein Engineering: Molecular Creations for Industry and Medicine." Clearly, the desire to "design" new molecular forms has been evolving for approximately two decades. See Jonathan B. Tucker, "Proteins to Order: Computer Graphics and Gene Splicing are Helping Researchers Create New Molecules for Industry and Medicine," *High Technology*, vol. 5, no. 12 (December 1985): 26–34.

17. Special thanks to Dr. Murray Robinson, Head of Cancer Program, Amgen, Thousand Oaks, CA. Currently Vice President of Oncology at Aveo Pharmaceuticals.

18. Protein visualization was carried out with the assistance of Charles Kazilek and Laura Eggink, BioImaging Laboratory, Arizona State University, Tempe, AZ.

19. Rapid prototyping was developed with the assistance of Dan Collins and James Stewart, Prism Lab, Arizona State University, Tempe, AZ.

20. Terms like "transcription," as well as "code," "translation," and many others commonly employed in molecular biology, betray an ideological stance, a conflation of linguistic metaphors and biological entities, whose rhetorical goal is to instrumentalize processes of life. In the words of Lily E. Kay, this merger integrates "the notion of the genetic code as relation with that of a DNA code as thing." See Lily E. Kay, *Who Wrote the Book of Life: A History of the Genetic Code* (Stanford, CA: Stanford University Press, 2000), 309. For a thorough critique of the rhetorical strategies of molecular biology, see Richard Doyle, *On Beyond Living: Rhetorical Transformations of the Life Sciences* (Stanford, CA: Stanford University Press, 1997).

21. *The Eighth Day* team: Richard Loveless, Dan Collins, Sheilah Britton, Jeffery (Alan) Rawls, Jean Wilson-Rawls, Barbara Eschbach, Julia Friedman, Isa Gordon, Charles Kazilek, Ozzie Kidane, George Pawl, Kelly Phillips, David Lorig, Frances Salas, and James Stewart. Additional thanks to Andras Nagy, Samuel Lunenfeld Research Institute, Toronto; Richard Firtel, University of California, San Diego; Chi-Bin Chien, University of Utah, Salt Lake City; and Neal Stewart, University of North Carolina at Greensboro. I developed *The Eighth Day* through a two-year residency at the Institute of Studies in the Arts, Arizona State University, Tempe, AZ. The exhibition dates were October 25–November 2, 2001. Exhibition location was Computer Commons Gallery, Arizona State University, Tempe, AZ (with the support of the Institute of Studies in the Arts). Documentation can be found at http://www.ekac.org/8thday.html.

22. *Move 36* was made possible, in part, by the Creative Capital Foundation, New York. *Move 36* was exhibited at the following venues: The Exploratorium, San Francisco (February 26–May 31, 2004); Gwangju Biennale, Korea (September 10–November 13 2004); Bienal de São Paulo, Brazil (September 25–December 19, 2004); Centro Cultural Conde Duque, Madrid (January 18– February 20, 2005); Galerie Biche de Bere/Numeriscausa, Paris (September 27–October 30, 2005).

23. See T. A. Brown, *Genomes* (Oxford, UK: Bios Scientific Publishers, 1999), 138; and David Baltimore, "Our Genome Unveiled," *Nature* 409 (February 15, 2001): 814–816. In private e-mail correspondence (January 28, 2002), and as a follow-up to our previous conversation on the topic, Dr. Jens Reich, Division of Genomic Informatics of the Max Delbruck Center in Berlin-Buch, stated: "The explanation for these massive [viral] inserts into our genome (which, incidentally, looks like a garbage bin anyway) is usually that these elements were acquired into germ cells by retrovirus infection and subsequent dispersion over the genome some 10 to 40 million years ago (as we still were early apes)." The HGP also suggests that humans have hundreds of bacterial genes in the genome. See International Human Genome Sequencing Consortium, "Initial Sequencing and Analysis of the Human Genome," *Nature* 409, no. 6822 (February, 15, 2001): 860–921. Of the 223 genes coding for proteins that are also present in bacteria and in vertebrates, 113 cases are believed to be confirmed. See p. 903 of the same issue. In the same private correspondence mentioned earlier, Dr. Reich concluded: "It appears that it is not man, but all vertebrates who are transgenic in the sense that they acquired a gene from a microorganism."

24. This natural ability has made a genetically engineered version of the agrobacterium a favorite tool of molecular biology. See L. Herrera-Estrella, "Transfer and Expression of Foreign Genes in Plants" (Ph.D. thesis, Laboratory of Genetics, Gent University, Belgium, 1983); P. J. J. Hooykaas and R. A. Shilperoort, "Agrobacterium and Plant Genetic Engineering," *Plant Molecular Biology* 19 (1992): 15–38; J. R. Zupan and P. C. Zambryski "Transfer of T-DNA from Agrobacterium to the Plant Cell," *Plant Physiology* 107 (1995): 1041–1047.

Why I Breed Plants

George Gessert

1

My earliest memories are of plants: my mother's iris border in full bloom, and a Christmas cactus in our housekeeper's room. She was a farmgirl who came to live with us after my mother slipped a disk and could no longer care for my sister and me. At the time the cure for a slipped disk was to wear a plaster cast from neck to hips. Whenever my mother held me I cried—at least, so I was told. I don't remember. All that I know for sure is that I have always sought companionship and comfort in the nonhuman world. I can't say that I am happier with plants than I am with people, but I am more at peace with plants, and on the whole feel freer with them. How much this is due to innate predisposition, and how much to beginning life as a little monkey in an accidental experiment I can only guess.

We lived on a farm about forty miles from Milwaukee. My father commuted to the city, where he sold jukeboxes and pinball machines, but his passion was for art. He had a keen eye for bargains, and during the 1950s, when Tiffany was out of fashion, he built up a large collection of vases, lamps, and metalwork that he found in secondhand stores and dusty antique shops. He told me once that he never paid more than $25 for a vase. He also had Whistler and Pennell prints, and for a while there was a greasy-looking Bouguereau of a doe-eyed peasant girl in our attic. But my father was especially interested in Japanese and Chinese art. He concentrated on porcelains, sculptures, and cloisonnés. Some of these objects were quite magical. There was an ivory bear, beautifully detailed right down to the pads on its feet. There was black magic, too, in the form of a rhinoceros horn libation cup. It was a densely carved, inverted brown cone. Like many evil things it seemed inconsequential, although my father kept it in a locked glass case. I didn't understand the

cup until the summer I was seven, when one night I dreamed that I woke up. It was very late at night, but there were lights on downstairs. At first I wondered if my parents were having a party, then realized that the house was absolutely silent. I left my bedroom and walked down the stairs. The rhinoceros cup was out of its case, and lay on the dining room floor at the bottom of the stairs in a blaze of electric light. I knew instantly that no one could protect me from what was there, and I woke in terror.

Chinese and Japanese art focuses on landscapes, plants, insects, animals, and birds. These images accommodated what was around me on the farm, and helped explain the world to me. They confirmed what I already knew, that the splendor of the world was largely nonhuman. I remember realizing with sorrow that I could never fly south with the wild geese that passed overhead. However, I could draw them, and someday I might even be able to draw ones as magical as the birds and dragons on my father's cloisonnés.

Cultural dislocation begins at home. Although I was a Westerner by birth and up-bringing, I grew up seeing the world through Japanese and Chinese art. My exposure to Western visual culture was limited to works in my father's collection, and to what I gathered from newspapers, magazines, and trips to town. We did not have a television. I followed the comics in the daily paper, and I studied advertisements and photographs of movie stars. However, I saw only one movie before I was twelve. It was *Snow White*, the Disney version. Snow White was a goody goody, afraid of forests. The real heroine was the evil queen, who was imperfect, knew spells, and could make green smoke shape itself into a skull.

When I was nine I visited a museum in Milwaukee with an aunt, and saw a marble statue that was uncircumcised. It bewildered me because I didn't know what a foreskin was. Years later I learned that most Midwestern males of my generation had been circumcised without anesthesia soon after birth. The psychological effects of male circumcision are largely unstudied and unknown, but perhaps that introduction to the human world also predisposed me to the non-human.

When I was twelve my family moved to San Francisco. During the next few years I was exposed to a broad range of Western art. I remember searching portraits and historical paintings for signs of art, and occasionally finding hints of it in background landscapes, or in still lifes of overworked cut flowers. Even today I find most painting from the Renaissance to the middle of the nineteenth century somewhat foreign, much too anthropocentric and illusionistic. From a traditional Chinese point of view, realism is a trick to impress the ignorant.

Modern painting, which I first became aware of when I saw Van Gogh's *Potato Eaters* and a Mondrian painting at the DeYoung Museum when I was 13, initially repelled and bewildered me. However, modern art had the fascination of extremity, and seemed to accommodate the disjunctions of puberty. By the time I was in high school I sought out

modern art, especially kinds inspired by China and Japan. Still, at seventeen my favorite artist was Chi Pai Shih.

2

My parents wanted me to study medicine, science, or economics, and for a while I tried to please them. However, I was drawn to art and, eventually, with encouragement from friends and a semester's full financial support from my parents, I took the plunge. As an art student at the University of Wisconsin, Madison, in the 1960s, I met no artists interested in any kind of Asian art except for Japanese ceramics and prints. I learned to draw the figure, paint in oils and acrylics, make serigraphs, and pay attention to what was happening in New York. I also learned not to paint or draw flowers. They were not explicitly forbidden, but no one did them, because they were associated with effeminate homosexuals and women, and, worst of all, with amateurs. My professors all seemed to agree that to be a "Sunday painter" was the ultimate failure. So I made serigraphs of broken flags and nuclear explosions. The Vietnam war was at its height, and I also became enthusiastic about nonrepresentational art, which seemed to offer a way back to nonhuman nature.

I was determined to be up to date, and fell under the spell of one artist after another: Frank Stella, Andy Warhol, Jackson Pollock, Mark Rothko, Robert Morris, Ad Reinhardt. Even after I got my master's degree and moved to New York my student mindset persisted. I worked with fluorescent lights like Dan Flavin did, poured paint like Morris Louis did, was captivated by Islamic art, Northwest Coast Indian sculptures, African textiles, Hans Haacke, and Robert Smithson. From each I learned something, and yet I could not create work that was my own until I reconnected with the nonhuman world and with East Asian art. Every new discovery only delayed a reckoning. I told myself that Chinese literati artists often did not begin to paint seriously until they were in their fifties, but I wondered if in fact I was a hopelessly slow learner, not suited for art.

I married, tried studying horticulture, then took a job as a graphic artist at the University of Oregon in Eugene. In 1981, after my second child was born, I finally decided to give up art once and for all. My responsibilities as a father seemed to demand it, and besides, exploration had brought me to a dead end. I decided to settle the matter by destroying my art materials. I emptied ink onto sheets of Japanese paper that I had never quite figured out how to use. They were unsized, and as ink spread through them it assumed shapes like clouds, or breadmold colonies in a time-lapse movie. Watching these stains grow, I suddenly realized how irrelevant I was to the creative process. I had learned in school that artists created art, but actually creative energy was everywhere: in paper, ink, in every aspect of being. All I had to do was step back and let it happen.

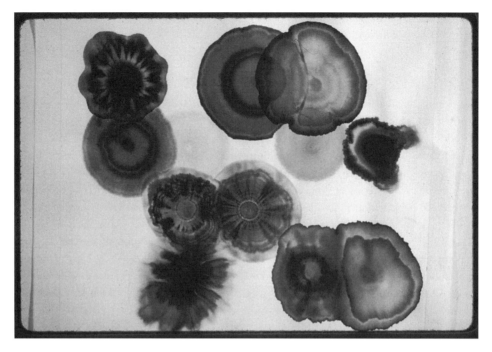

Figure 11.1
George Gessert, Untitled, 1981. Ink on Hosho paper, 13 × 15 in (33 × 38 cm).

After that, the paintings—I can hardly call them "my" paintings—painted themselves. For the next three years I served as intermediary between ink and paper as spots and stains assumed their own shapes largely independent of me (figure 11.1). Spots generated by ink and paper were my bridge between East and West. They also brought me back to plants.

3

There are connections between plant breeding and love, child-rearing, money, politics, and spirituality, and these deserve close attention, but for now I can only offer a bare outline of my work with plants. In 1985, I began exploring hybridization as an extension of painting. I had dabbled in plant breeding since high school, so I knew basic techniques. I was drawn to Pacifica irises because they are one of the most showy wildflowers in the part of western Oregon where I lived. The southern Willamette Valley has two species, *Iris tenax*, which has purple flowers up to six inches across, and *Iris chrysophylla*, which has creamy white flowers. Interspecific hybrids occur naturally. They are usually pinkish or

pale greyish-violet. Farther south there are about ten other species. They come in all colors except true red. I crossed various species, and raised seedlings to bloom. Some looked like one parent or the other, others were blends, and still others had colors and patterns quite different from either parent.

In the 1980s, I developed an annual ritual. Every April and May during iris bloom season I drove logging roads looking for irises. I was especially interested in unusual kinds, and sought them out in places that I would not otherwise have visited. I became alert to the sorts of places that irises favored, to light conditions, soils, and plant communities. Iris hunts focused my attention on the land in a new way, and in the process the Northwest became my home.

No plant breeder can improve on irises in the wild. They light up roadsides and forest trails. And yet in gardens these same irises look like little more than souvenirs of wildness. The problem is that they cannot stand up to visual competition from domesticated ornamentals, many of which are large, colorful, and extravagantly formed. The challenge of breeding Pacificas is to adapt them to the visual environments of gardens, but without destroying their most distinctive qualities.

In ancient Greece, Iris was the goddess of the rainbow, and carried messages from the deities to humankind. People make flowers into emblems, symbols, and myths. However, flowers ultimately represent nothing except themselves. Plants, including domesticated ones, are beings that live beyond our stories and projections, so plant breeding is an art that lends itself to celebration of pure materials. Yet plant breeding is not quite the paradise of anti-illusionism that the minimalists sought. The serpent in the garden is not storytelling or our need for symbols, but that most flowers can be bred to resemble other flowers.

Over the last sixty years, many plant breeders have selected irises for "ruffled" flower parts that de-emphasize distinctive form, and produce full, blousy-looking blooms vaguely evocative of orchids or hibiscuses.[1] Plants as dissimilar as pansies, daylilies, sweet peas, poppies, begonias, and African violets have been bred for this same look. What drives this is the commodification of life. Consumer culture demands ornamental plants for national markets; to sell, hybrids have to look at once familiar and new, luxurious and affordable, exotic and tame. Ruffles, all dazzle and contradiction, fit the bill. Ruffles celebrate nature while they trivialize it. They mix degradation and superabundance, sensuality and cynicism. They are genetic television.

I select irises for clean, unruffled parts, and for strong vein and signal patterns, all of which I associate with these flowers (figure 11.2). Clear forms bridge past and present. Some of my most vivid childhood memories involve a little marsh near our farmhouse. In the spring this marsh swarmed with pollywogs, always a draw for me. There were dragonflies and water striders and countless smaller creatures including miniscule red mites that swam in corkscrew patterns, legs waving. Offshore a clump of pale blue irises grew

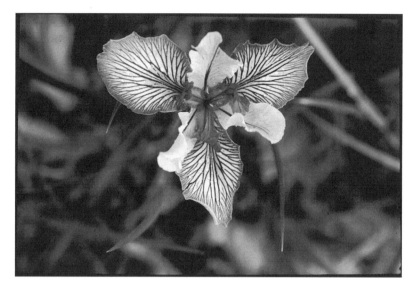

Figure 11.2
George Gessert, '*Robert Smithson*', Pacifica iris. Hybridized 1986, first bloom 1988.
Flower 3.75 in (9.5 cm). Registered with the American Iris Society, 1999.

on a hummock. The flowers seemed to float above the water like scraps of sky, dematerialized, and yet the plant was more a part of the place than I could ever be. That iris gave me an image of perfection that has stayed with me ever since.

The pale blue water iris, I know now, was *Iris versicolor*. Versicolor belongs to a breeding complex quite distinct from Pacificas, and yet an image of blue marsh irises affects my choices in breeding even today. This is mostly unconscious, an aesthetic undertow toward absolute clarity. Yet if a goal of plant breeding is to create plants that resemble nothing except themselves, how can I justify taking versicolor as a model for breeding Pacificas? Is this any better than selecting for ruffles? In versicolor's favor I can say that it is wild.

Versicolor is not native to the Pacific Northwest and rare in gardens, so for many years I did not see it. When I finally did, it did not match my memory. Although the flowers had beautifully spare forms, the color was pale, almost washed out, and the standards disappointingly small. Like everything else, memory flows, and the blue iris in my mind had drifted away from the one in the little marsh. My image had become more like a Pacifica than like versicolor. Still, inaccurate memories bring me back to old problems of minimalism. The most difficult thing in art is to create something that looks entirely like itself.

In plant breeding I focus on color, form, pattern, value, and texture—aesthetic considerations. However, other concerns are unavoidable, for example, death. At first I tried to find a home for every iris that I hybridized, including rejects. I sold them, I gave them to friends, acquaintances, strangers, anyone who would accept them, but still there were plants left over. Many of my giveaways were weak and aesthetically inferior, yet I trusted that circumstance would salvage them. There are many ways of playing God, and I did it by ignoring the obvious, that irises are adapted to produce far more progeny than can survive. Plants accumulated until I ran out of space. Eventually I composted a few of the more miserable specimens. Composting brought me back to my materials and to earth. In plant breeding, death is in the wings of every aesthetic decision. Over the years I have come to understand that the same is true of painting and essay writing, but with them death is at a remove and easy to deny.

4

Paul Shepard criticized domesticated animals, and by implication domesticated plants, as "goofies," that is, as grotesque cartoons of wild creatures. According to him the problem with domestication is that it destroys what he calls the DNA harmonic, the infinitely complex, infinitely subtle genetic tuning that takes place in ecological systems over geological time. In mature ecosystems the complete genetic information of a system intricately cross references relationships until everything registers in everything else, and the shape of a leaf is not separate from the curve of a claw.

I agree with Shepard that no degree of consciousness can match the refinement of ecosystems or their evolutionary power. Humility is essential. Nevertheless here we are, hunter-gatherers wandering among wreckage of our own making, and evolved to play with evolution. No creature has reached this particular place before, although we should remember that domestication is not a human invention. Millions of years before we began to co-evolve with dogs and reindeer, ants domesticated fungi. The history of domestication, human and nonhuman, offers perspective, but only a little. As we bring consciousness to bear on evolution, most of what we do is strictly experimental.

Most experiments fail, but I believe that art can increase our chances of success, as well as warn us away from the worst kinds of failure. Very few recognized artists have bred plants or animals, or used the tools of advanced biotechnology, and yet art is better positioned than any other discipline to explore what it means to bring human consciousness to evolution. Art involves a full range of emotional, intellectual, social, and ethical energies, and utilizes every kind of awareness, including dreams as they shade off into oceanic unconsciousness. Other disciplines deliberately downplay or ignore much of what constitutes awareness. Science, for example, necessarily distances itself from pure emotion. Art works in full view of the public, and is widely recognized as everyone's business. Evo-

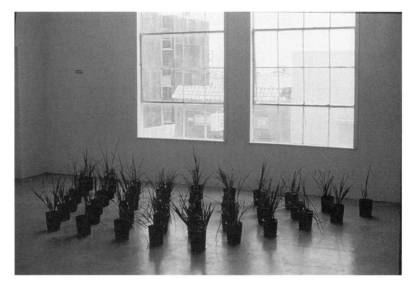

Figure 11.3
George Gessert, *Iris Project*, 1988. Installation, 15 × 8 × 1.5 ft (4.5 × 2.4 × 0.4 m).
Pacifica iris hybrids in pots. New Langton Arts, San Francisco.

lution is also everyone's business. The more artists explore genetics and evolution the better.

5

In 1988, Renny Pritikin and Nayland Blake included some of my hybrid irises in the *Post Nature* show at New Langton Arts in San Francisco (figure 11.3). At about the same time I began corresponding with Vilém Flusser, and in 1989 I received an invitation through him from Philippe Henry to talk about my work in São Paulo. With these successes, I decided to branch out.

Poppies appealed to me because they include some of the most highly domesticated plants and are extremely rich in cultural associations. Also, they come in true red, the color missing from irises. My first experiments were with oriental poppies and opium poppies. Luther Burbank crossed the two and reported that second-generation plants (F2) were more various than any other F2 hybrids he had seen. My first generation plants were all perennials with hairy leaves and orange flowers like oriental poppies. Most were sterile, but a few produced seed or fertile pollen. I crossed these and got second generation plants that were extremely various, just as Burbank said. Some plants were outstanding (figure 11.4). However, I did not take things further. The drug wars had heated up.

Figure 11.4
George Gessert, Unnamed F2 hybrid, 1989. *Papaver somniferum × P. orientale.*

Although I was not growing poppies for opium, and I had obtained seeds legally from a well-known seed company, by germinating the seed I had committed a crime potentially as serious as possessing heroin. Not only could I go to prison, police could confiscate my family's home. The laws were absurd, but given the political climate, I had to ask: Was my poppy breeding program worth the risk, or even the worry? I uprooted my opium poppies and discontinued the breeding program.

I next turned my attention to California poppies. They belong to a breeding complex that, to the best of my knowledge, consists of a single species, *Eschscholzia californica*, which is widespread in California and Oregon. From seed to flower takes only a few months, unlike the hybrids of oriental and opium poppies, which take a year or two, or Pacifica irises, which take two to four years. However, I soon found that California poppies had so little variability that there wasn't much I could do with them. Their color range is fairly limited, restricted to yellows, orange, orange-red, rose, and white. There are no true purples, no blues, greens, browns, or blacks. Some cultivated flowers have faint tesselation on the outsides of petals, but I have yet to see picotees, stripes, strongly pigmented veins, or spots. Breeders are slowly expanding the palette of colors and patterns, but unless genetic engineering accelerates the process, many human generations must pass before California

poppies have accumulated the kind of variability that artists are likely to find interesting. I continue to select California poppies, but I do not expect to come up with anything I can exhibit.

6

When I began exhibiting hybrid irises in the late 1980s, I did not know that Edward Steichen had exhibited delphiniums at the Museum of Modern Art in 1936. Nor did I know that Joe Davis, Alexis Rockman, Dennis Ashbaugh, Kevin Clarke, and Larry Miller were reintroducing genetics into art. I knew only what I learned from the media, that ecology and biotechnology were in the air. In the early 1990s, I received grants from New Langton Arts and the Oregon Arts Commission to produce genetic art works. In 1995, I was artist-in-residence at the Exploratorium for the exhibition *Diving into the Gene Pool*. In 1996, Roger Malina asked me to be editorial advisor for art and biology for *Leonardo* magazine, which brought me into contact with many artists working with living things, including artists who were exploring genetic engineering. Eduardo Kac contacted me and we discovered that we had many of the same concerns about working with living creatures as art.

During this time I continued to breed Pacificas, and experimented with corn poppies and tall bearded irises. By 1995 I had used up all available space in my garden, and the only place I could begin another breeding project was indoors. I considered several different kinds of houseplants, and eventually settled on streptocarpuses (figure 11.5). They turned out to be completely unlike any other plant I had worked with.

In Latin, the word streptocarpus means "twisted fruit," which describes the spiral-shaped seed capsules that are characteristic of the genus. However, in English, the word sounds like a disease, and tells us nothing about the plants except that they are too new to cultivation to have acquired a good name.[2] There are about 130 described species in the genus, all native to Africa and Madagascar. A few South African species were brought to England at the beginning of the nineteenth century, and hybridization began soon after. However, to date, less than half a dozen species have been extensively hybridized, and the genus remains largely unexplored by breeders.

The streptocarpuses in cultivation are not difficult to grow. In seven years I have had few problems with diseases or pests. Flowers are one to four inches across, big enough to be showy and make pollination easy on the eyes. Plants bloom abundantly from March to October, and sporadically into December, so it is possible to make crosses throughout the year except during the darkest months, when plants need a rest. Seeds germinate easily. From sowing to bloom usually takes nine to eighteen months. Leaf cuttings readily produce new plants, so hybrids can be propagated.

Plants are like languages, striking deepest in childhood. I did not become acquainted with streptocarpuses until I was an adult, and so I began my work with them without a

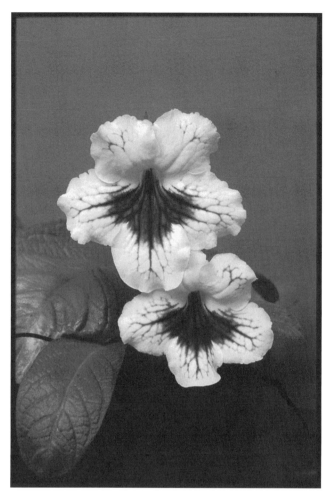

Figure 11.5

George Gessert, '*Edward Steichen*', streptocarpus. Hybridized 1998, first bloom 2000. Flowers to 2.5 in (6.3 cm). Registered with the American Gesneriad Society, 2001.

feel for the medium. Making selections, I had no sense of what was appropriate, or how to relate patterns, colors, and forms. I began with nothing more than bumbling curiosity, and within a year, almost without noticing, I slipped into doing what I had criticized other breeders for: I borrowed aesthetic goals from another breeding complex. I selected streptocarpuses for vein patterns like those in irises.

It took me two more years, three streptocarpus generations, and several hundred plants to understand how inadequate irises are as a model for streptocarpuses. Streptocarpus vein patterns tend to be heavier than those in irises. When fine patterns occur, they are usually rather faint. Iris vein patterns sometimes break up into dots and dashes, but in streptocarpuses dots and dashes are restricted to the throat. I was drawn to the deep blue-purples that are common in cultivated streptocarpuses. Powdery blue, grape-purple, burgundy, brown, rust red, and amethyst are rare, and for me have the appeal of the unusual. At the same time, I began to recognize certain signal patterns as unique to streptocarpuses. As I became conscious of these things, I developed breeding goals specific to these plants.

Identifying the distinguishing characteristics of a breeding complex is one thing, appreciating those characteristics is another. I still find certain things about streptocarpus characteristics weird, for example, the way leaves grow from the base for months after first appearance, and the way flower stalks arise one after the other in rows in leaf axils. In some species, such as S. *dunnii*, these characteristics have evolved to such an extreme that plants have only single leaves. Throughout the lifetime of a plant its one leaf grows, eventually becoming more than two feet long. Then, scores or even hundreds of flowers appear in a burst of bloom, and the plant dies. After eight years I am still trying to figure out just what streptocarpuses are. This is one reason that I still hybridize them. Plant breeding is a way of getting to know other beings. It is a way back into the community of life.

7

Plant breeding is the slowest art. Like Chinese landscape painting, which some artists continue to practice in ways not radically different from those of a thousand years ago, plant breeding involves repetition, variations on themes, and incremental change. The slow arts survey the scheme of things, and celebrate how little we understand or control. The slowest art opens into vistas of evolutionary time.

Today genetics largely serves the commodification of life, but art presents other possibilities. Plant breeding could create a world far wilder and freer than our own. Since plant breeding is a hunt for life that does not yet exist, it suggests the possibility of modified ecosystems, or even new ones. Beyond familiar agro-ecosystems may be blends with wildness where distinctions between domesticated and undomesticated blur or disappear. Plant breeding favors such dreams, and yet is also their corrective, because plants are literally unimaginable. No one could dream up a wild iris. As for highly domesticated

plants, even today with more than a quarter of a century of genetic engineering behind us, they shape our minds more than we shape them. At least I like to think so. I trust their power more than I trust ours.

Notes

1. Breeding for ruffles in irises did not begin until after the introduction of "Snow Flurry" in 1939. "Snow Flurry" was a tetraploid tall bearded iris that passed ruffles on to progeny in many different colors. By 1960, most tall bearded introductions were ruffled.

Tall bearded irises cannot exchange genetic information with most other kinds of irises, including Pacificas. Ruffling had to be created separately in each iris breeding complex.

Tall bearded irises provided the model and led the way because they had been cultivated much longer than any other kind of iris, and are the most popular kind in the West. Today the only iris introductions with reliably clean forms are those that belong to complexes that rarely produce inheritable ruffling.

2. By "new to cultivation," I mean first cultivated after 1500. A few centuries in cultivation is too little time for most plants to significantly affect art or literature, or to influence popular imagination. There are exceptions, of course. Some recently domesticated plants look enough like existing ornamentals to borrow their associations. Pacifica irises, for example, which were not cultivated until 1825, borrow the associations of tall bearded irises. Among the very few newly cultivated plants that have acquired rich associations entirely on their own are cattleya orchids. They came into cultivation only in 1818, but quickly become emblematic of wealth, luxury, decadence, the tropics, and seduction. Streptocarpuses, however, are typical of the unassimilated majority of newly cultivated ornamentals. If these newcomers disappeared from cultivation, most people would never notice.

Chlorophyll Apparitions

Heather Ackroyd and Dan Harvey

Senescence is a word that has been firmly transplanted into our vocabulary. With its intimations of senility, aging, and mortality in humans, the scientific application of this word describes the process of leaf death and chlorophyll loss in plants.

It is difficult to overstate the crucial role that chlorophyll plays in the greater scheme of things. It is the green pigment responsible for initiating the beautifully orchestrated sequence of events leading to photosynthesis. The term *photosynthesis* literally means building up or assembling by light, and it could be regarded as the basic alchemy of all life—the gold of the sun transmuting into the green of life. There is poetry and mystery in describing the chemical embrace of light and chlorophyll. Photons of light pierce through the outer layer of the epidermis and enter into the heart of the palisade cells. Drawn irresistibly by the magnesium at the heart of the tiny chlorophyll molecules, the light gives up its energy, and in the process a water molecule is split into hydrogen and oxygen. The plant releases the oxygen, and the hydrogen, with carbon dioxide, is converted into sugar to build new plant tissue. How the chlorophyll molecule achieves this remarkable act of division of the water molecule is still a biochemical mystery.[1]

The beginning of our artistic collaboration in 1990 was catalyzed by grass, a material we had both been working with individually before we met. At this time, our perceptions of this growing, living agent were inspired more by the philosophy of the arcane arts than the rigors of scientific investigation. Seven years later we embarked on intensive research into a specialized new breed of grass at the Institute of Grassland and Environmental Research in Wales. Grass may be the material of our investigation but chlorophyll is the primary medium that binds us.

Early in 1997, we approached scientists Howard Thomas and Helen Ougham[2] at IGER in response to an article in the *New Scientist*[3] journal describing their pioneering work into a strain of grass. This strain did not senesce in the usual way and lose its green color when

under stress. The color green is volatile and the chlorophyll molecule even more, so this "stay-green" grass held promise to an inquiry that we had been pursuing for some years in our artistic work.

Grass grown from seed on vertical surfaces has an extraordinary capacity to record either simple shadows or complex photographic images through the production of chlorophyll. In a sense we have adapted the photographic art of producing pictures on a sensitive film to the light sensitivity of emergent blades of young grass; the equivalent tonal range of black-and-white photographic paper is created within the grass in shades of yellow and green. Each germinating blade of grass produces a concentration of chlorophyll molecules depending on the amount of projected light available to it, and the strength of green produced is determined by the intensity of light received. In complete darkness, the seedling grass grows but no chlorophyll is produced; other, light-independent pigments give the grass a yellow color. But once exposed to light in a gallery environment, the grass in the yellow regions quickly seizes the available light and gradually, over hours, changes color, greening up. Kept in very low light levels in a living state, the green grass begins to dismantle its chlorophyll and, taking on a quality akin to an old tapestry, the image slowly fades away.

The haunting presence of the emergent organic image was and still is a revelation to us. In the greater body of our artwork we play with many materials exploring processes of growth, transformation, and decay, and while we embrace the transience and ephemeral nature of our materials, somehow the fragility of these chlorophyll apparitions urges us to make moves to preserve them for longer. We cannot recall the exact moment when we first articulated this desire to hold the image, although conceptually we can rationalize the move to preserve it for longer by saying that it follows through the established process of photography of exposing, developing, and then fixing the image. To talk about "fixing" an image refers directly to the photographic process of stabilizing the emergent picture. It is a word used as much now as nearly 200 years ago by the early pioneers of photography.

According to historian Malcolm Andrews the widespread use of the word "fix" at this time indicates "a predatory, acquisitive instinct," a "figurative sense of appropriation" that "leads in one direction to landscape as a commodity." At the same time, he suggests, such terms represent a prevailing need to give "stability to new experiences."[4]

We recognize these thoughts—a desire to hold onto something, an attachment to visibility, a reluctance to allow an extraordinary elusive presence to depart too soon, a need to stabilize or slow the process of change, allowing more people to witness the works for longer periods of time.

William Henry Fox Talbot, the English pioneer of photography, received a letter from his sister-in-law in 1834: She wrote, "Thank you very much for sending me such beautiful shadows. . . . I grieved over the gradual disappearance of those you gave me in the summer."[5] Talbot made his first photographs by placing an object on paper sensitized with silver salts and putting both in the sun. When the object was removed, the exposed paper

retained the silhouette of the object. The frustration of capturing and then losing the image led Talbot to find ingenious ways to fix the image, and through a seminal art and science collaboration, Talbot's friendship and working relationship with the eminent scientist John Herschel eventually led to the discovery of hypo, the chemical fixative, in the 1840s.

We were first introduced to Fox Talbot's extraordinary photographic work, *The Pencil of Nature*,[6] in 1995, four years after our first experiment of capturing an image in grass. We were both astonished and drawn by his subject material, and one picture in particular sent a shiver of recognition through our spines—a photograph of a ladder leaning against a haystack.[7]

Under the title of *The Other Side*, we presented our first collaborative artwork in 1990 in the village of Bussana Vecchia in Northern Italy. Here, a vaulted ceiling interior room became the site for an interaction that involved quantities of germinating seeds, volumes of mud and water, and, significantly, a ladder. The space literally became a living chamber, as seed implanted in a clay base and spread over the walls sprouted and grew into a vibrant skin of fresh grass. As part of the installation the ladder was placed leaning against the far wall of growing grass. One day, upon moving the ladder we noticed its faint yellow shadow cast in the grass. To be honest, we were unclear exactly what we were witnessing, terms such as "chlorophyll" and "photosynthesis" were not tripping off our tongues and it would be some time before we would draw the analogy of leaving a deck chair on the lawn and seeing the yellow imprint days later when it was removed. Quite simply, the seed of an idea was sown, and in 1991 we experimented in growing our first living grass photograph.

A "pencil of nature" seems such an apt description of the single living blade of grass present by the thousands in our living photography. In a contemporary echoing of the pioneering work of the proto-photographers, it became apparent to us that should a potential solution exist for arresting the chlorophyll image, it lay within the field of science.

Our earliest forays into science took us superficially into the world of embalming plants. A Swedish company, Evergreen, indicated that the immature root hairs of our seedling grass would be too tiny to absorb the relatively large molecules of their liquid embalming feed. In pursuit of longevity of the grass photograph, we went one step further, beyond notions of embalming living plant material into the horticulturally dubious area of rapidly killing it off.

The syndrome of senescence is part of the plant's natural life cycle and survival strategy in the face of stress. As applied to plants, it can only occur if the tissue is fully viable. That is, green leaves and other organs will not senesce properly if they cannot vigorously accomplish all the essential life processes such as gene expression, energy generation, and maintenance of cell integrity. Plants are tough and adaptable, but even the hardiest plant needs to have a way of resisting or running away from a hostile environment. When a plant is subjected to environmental pressures such as heat, drought, and pollution, the plant selectively kills off bits of itself until it becomes a near-impregnable residual structure. What is

seen as yellowing, withering, and death is part of the plant's survival kit. The disappearance of green color is the visible symptom of a plant under stress.

In 1969, a meadow fescue plant was identified in field tests at IGER, which subsequently led to years of scientific investigation. The favored story goes that a crop of grass plants were plucked from the neighboring hills and brought into the greenhouses at the research station for study. A particularly hot weekend combined with an absent employee resulted in the transplanted plants struggling in a drought-ridden environment. Most succumbed to the state of senescence described above, relinquishing their green and fading into a pallid version of their former selves. But one plant, to all intents and purposes, remained looking green and healthy. Termed a "stay-green" the mutation was at first treated as a scientific curio. Under the observant eye of Howard Thomas and his team, however, the mutant has come to play a critical role in establishing current understanding of the cellular pathway of chlorophyll breakdown and the mechanism by which photosynthetic structures in green cells are taken apart.

To understand the process pursued by Howard Thomas, it is necessary to ask a fundamental question: "Why is chlorophyll green?" The answer to this lies in the structure of the chlorophyll molecule. It is one of a class of compounds known as tetrapyrroles, of which the best known is haem. Haem, as part of the protein haemoglobin, gives blood its red color, and is responsible for blood's ability to carry oxygen around the body. Although chlorophyll and haemoglobin have evolved separately for hundreds of millions of years, and fulfill very different functions, their structures are remarkable similar. The chemical structures of both haem and chlorophyll, like many other tetrapyrroles, are such that they selectively absorb light in certain parts of the visible spectrum, reflecting the rest back. The chlorophyll molecule absorbs red and blue light and reflects—or rejects—the green light; this is why plants appear green. Absorbing red and blue light is fundamental to the function of chlorophyll, which is to capture light energy from the sun so that it can be used to turn water and carbon dioxide into sugars and oxygen. This is the process of photosynthesis, which directly or indirectly supports almost all life on earth.

Yet chlorophyll's ability to absorb light is a mixed blessing. When plant leaves are under stress, or simply at the ends of their lives, chlorophyll becomes potentially very dangerous, because light energy that can no longer be used for photosynthesis may instead be diverted to generating reactive oxygen species (free radicals). These are potentially as dangerous to plants as they are to humans, because they can damage membranes, DNA, and other structures in the plant cell. Although plants have a built-in antioxidant system, it is not always sufficient in times of stress. So they have evolved a method of removing unwanted chlorophyll. This in some ways resembles the way they handle toxic compounds from their environment, and the detoxification process is the reason why plants lose their chlorophyll.

Until relatively recently, it was unknown what chemical changes happened to chlorophyll as it disappeared from leaves during senescence. Stay-green grass was the key to

unlocking this mystery. Philippe Matile, Professor of Plant Biology at the University of Zürich, had long shared the IGER team's interest in the fate of chlorophyll. During a sabbatical visit to IGER in the mid-1980s, he and Howard Thomas found some chemical constituents of yellowing grass leaves that were absent from the stay-green. After further exchanges, and some state-of-the-art chemistry in Zürich, it was confirmed that these products are indeed the elusive colorless residues left when chlorophyll is broken down. Subsequently many of the intermediate steps in the sequence—the enzymes that bring about the changes, the cellular organization of the process, and some of the genes that specify chlorophyll breakdown—have been discovered. Thomas and Matile learned that one of the steps in the pathway is blocked in stay-green grass because, as the consequence of a defective gene, the corresponding protein[8] is missing. (A deficiency in the same enzyme is responsible for the difference between green and yellow pea seeds, first described by Gregor Mendel just a few years after Talbot and Herschel had conceived the infant era of photography.[9])

Searching for stay-greens is in one sense easy, as it requires nothing more complicated than a keen eye. Creating a stay-green in a precisely targeted way is more difficult, but it has been done.

One way of creating a stay-green is to disable pigment degradation. Most of the known mutants of this kind have a genetic lesion that interferes with the same step of chlorophyll breakdown. Since the stay-green trait was first discovered, grass geneticists and breeders have been crossing the gene into different lines. Initially crosses were confined to meadow fescue, the species in which the stay-green character was originally found. For many purposes, festuca is less useful and versatile than other grass species, notably ryegrass, and stay-green ryegrass has been produced by hybridization with perennial ryegrass. Modern breeding methods use genetic maps of species, such as the grasses, allowing individual traits to be tagged with DNA markers and efficiently traced during a breeding program.

Stay-green perennial ryegrass[10] was the seed in research available to us to experiment with in our photosynthetic photographs. With the support of a Wellcome Trust Sci-Art[11] research award, we set ourselves up in temporary residence at IGER in the summer of 1997. A series of comparative studies between the regular ryegrass and the stay-green ryegrass were made from which it emerged that the stay-green permitted rapid drying of the grass canvas with no loss of the green chlorophyll, in contrast to the regular grass in which many of the green blades senesced. Significantly, it was at this time that we first considered drying the grass photographs as a way of preserving them, and we became aware of the possibility of growing, drying, and framing the photographs in a studio environment and then freighting them off to exhibitions. Independence had been conferred to the photographs through this collaboration; we also had the ability to show these pieces for much longer periods of time. In one respect the work had "come of age."

However, we had not quite taken into consideration just how influential light would be on the long-term preservation of the images. The ephemeral nature of our creations had

Figure 12.1

Heather Ackroyd and Dan Harvey, *Mother and Child*, 1998. Photographic photosynthesis, dried stay-green grass, clay, 72 in × 48 in (183 cm × 122 cm), "Out of Sight." Santa Barbara Museum of Art, California. Photo: The artists.

Figure 12.2

Heather Ackroyd and Dan Harvey, *Testament* (with inset showing fading of image after 4 weeks), 1998. Photographic photosynthesis, rye-grass, clay, water, 26 × 26 ft (8 m × 8 m), Photo 98 and Hull Time Based Arts, The Ice House, Hull, UK. Photo: The artists.

been tempered somewhat using the stay-green, so the fading of the work was no longer occurring along the physiological but along the pathological route.

It is a task of museum conservators to anticipate and avoid direct exposure of precious paintings, photographs, textiles, and tapestries to light. The shorter wavelengths present in light are potentially destructive to sensitive pigments and, given the opportunity, will bleach them away. This became the subject of the 2001 exhibition *Presence* at the Isabella Stewart Gardner Museum in Boston. Alongside the new artworks created in response to the museum's collection, the first ever *Mother and Child* grass photograph was brought out of storage and exhibited within view of a freshly grown piece.

Mother and Child was the first artwork presented publicly using the stay-green seed (figure 12.1). It was developed, grown, and dried in 1998 in response to a California exhibition at the Santa Barbara Museum of Art *Out of Sight: Imaging/Imagining Science*. Displayed behind plexiglas, the grass photograph received direct light over the course of the six-week exhibition, resulting in fading in areas of the image subjected to the most intense light. It became apparent that to conserve the image in the long term, it would

Figure 12.3

Heather Ackroyd and Dan Harvey, *Cherie*, 2000. Photographic photosynthesis, stay-green grass, clay, 72 in × 48 in (183 cm × 122 cm), Institute of Grassland and Environmental Research, Aberystwyth, Wales, UK. Photo: The artists.

Figure 12.4
Heather Ackroyd and Dan Harvey, *Script*, 2001. Photographic photosynthesis, dried stay-green grass, clay, wood, 7.8 × 6.8 ft (2.4 m × 2.1 m), "Presence." Courtesy of Isabella Stewart Gardner Museum, Boston. Photo: The artists.

be necessary to display the work in a non-direct, subdued light. Helen Ougham and Howard Thomas believe that under the correct conservation conditions, the grass image should retain visibility for many, many years. A grass photograph has been taken into the collection at IGER and, under the watchful eye of such chlorophyll experts, the correct lighting conditions can be determined to inhibit the corruption of the image.

It has been argued at times that artists gain more from crossing the cultural divide between art and science than scientists do, yet Helen Ougham has said that some of the new directions for IGER research would never have been undertaken without our artistic presence. The subtlety and range of tonal color captured in the grass photographs (figures 12.2–12.5) made a deep impression on our science colleagues and, in a remarkable shift in perception, they realized that observations of plant material could occur in very different circumstances than the established investigative paths. Grinding up leaves and subjecting them to various kinds of separation was the conventional scientific way to analyze

Figure 12.5

Heather Ackroyd and Dan Harvey, *Sunbathers*, 2000. Photographic photosynthesis, dried stay-green grass, clay, 10 ft × 7.6 ft (3.2 m × 2.3 m), "Paradise Now." Exit Art, New York. Photo: The artists.

the molecular makeup of plant material. The irony of observing processes of life through dead material had been an accepted collusion of established method and material.

The potential to investigate molecular indices of leaf death through a noninvasive high-resolution imaging technique was recognized in 1999 with the help of a Pioneer Art and Science award from the National Endowment of Science, Technology and Art.[12] Using digital cameras able to resolve minute differences on a grey scale at many orders of magnitude greater than the human eye, the IGER team pioneered a technique for searching out and recording the hidden information that emerges when the color spectrum of light reflected from plants is examined. This approach draws on tools used in remote satellite sensing, producing *hyperspectral*[13] images of color, which influence, in turn, the artistic vision of a grass photograph.

Research at IGER into hyperspectral imaging is now part of ongoing studies being funded by the British government, the European Union, and industry, involving a range of applications of the technique including studies of flower petals, plant diseases, crop genetic variation, and the composition of complex plant communities.

Seductions of time and visibility are at the heart of our artistic work with photosynthesis. A grass photograph has the power to elicit strong emotional responses in the viewer, and it is undeniable that the beauty of the freshly grown grass canvas suggests all that is fertile and life-enhancing. Our desire to alleviate the process of decay has encouraged us to journey into the world of science and genetics, and has opened our work to a greater number of people throughout the world. There seems little doubt that that which survives turning to dust or fading is potentially conferred prestige.

We cannot at this time truly say how long our chlorophyll apparitions will be visible, but we can suggest how best to conserve them, and, as further inspiration, refer interested parties to Sigmund Freud's thought-provoking paper "On Transience": "Nor can I understand any better why the beauty and perfection of a work of art or of an intellectual achievement should lose its worth because of its temporal limitation."[14]

Notes

1. Maria Burke, "Green Miracle," *New Scientist*, no. 2199 (August 14, 1999): 26–30.

2. Howard Thomas and Helen Ougham are scientists working at the Institute of Grassland and Environmental Research, a leading agricultural research institute based in Aberystwyth, Wales, UK. Howard "Sid" Thomas is Strategic Development Director and Member of the Executive of IGER. His specialization is investigation and modification of cellular and biochemical mechanisms of plant senescence and death, with particular emphasis on pigment and protein metabolism, cloning, mapping and exploiting genes determining senescence, late-season and post-harvest deterioration, food and feed quality, and consumer perception in a range of crop and amenity species. He is the author of over one hundred refereed publications, numerous conference proceedings including International Botanical Congress, Gordon Research Conference, United Engineering Foundation, and Wellcome Sci-Art, and has published abstracts and other written contributions. Helen Ougham is Principal Research Scientist and head of IGER's informatics program, specializing in gene expression during leaf senescence and growth, interaction between chlorophyll synthesis and catabolism, regulation of plant development, bio-informatics and the biological applications of computing methodologies, the art-science interface, and science in society. She is also the author of numerous refereed papers.

3. Andy Coghlan, "Why the Grass Grows Greener in Wales," *New Scientist*, no. 2063 (January 4, 1997): 21.

4. Cited in Geoffrey Batchen, *Burning with Desire: The Conception of Photography* (Cambridge, MA: MIT Press, 1997), 94.

5. Maria Hambourg et al., cited in *The Waking Dream: Photography's First Century* (New York: The Metropolitan Museum of Art, 1993), 3.

6. *The Pencil of Nature* by William Henry Fox Talbot was published between 1844 and 1846.

7. *The Haystack*, Plate 10 from William Henry Fox Talbot, *The Pencil of Nature* (Lacock Abbey, England: The National Trust, Fox Talbot Museum, 1843).

8. The protein is essential for the correct function of the chlorophyll-degrading enzyme. The stay-green gene has recently been isolated and sequenced: *New Phytologist* 172, no. 4 (December 2006): 592–597.

9. *Science* 315, no. 5808 (January 5, 2007): 73.

10. The stay-green Lolium perenne (perennial ryegrass) for turf has been developed at IGER by plant breeder Dr. Danny Thorogood supported by the seed company Germinal Holdings. The variety AberNile is now available worldwide in the lawn seed mix So-Green.

11. The Wellcome Trust SCI-ART initiative was set up in 1997 to engage collaborative work between artists and scientists.

12. The National Endowment of Science, Technology and the Arts was set up by an act of British Parliament in 1998. Its aims are "to seek out creative people and innovative ideas that can bring social, economic and cultural benefits to society."

13. Hyperspectral imaging enables extraction of high-resolution color and texture information from leaves. IGER scientists do this by fitting a liquid crystal tunable filter to a cooled, CCD camera. The system's 400–720 nm range tracks the interplay among the dozens of pigments in living grass, including carotenoids (responsible for yellows, oranges, and some reds) and anthocyanins (reds and purples), as well as chlorophyll.

14. "On Transience" essay by Sigmund Freud written in 1915. In James Strachey, ed., *The Standard Edition of the Complete Psychological Works of Sigmund Freud (SE)*, vol. 14 (New York: W. W. Norton, 2000), 306.

Good and Evil on the Long Voyage

Paul Perry

Good and Evil on the Long Voyage (1997) (figures 13.1–13.4) is the title of a work produced in collaboration with Dr. Frans Ramaekers and Mr. Wiel Debie from the Department of Molecular Cell Biology and Genetics, University of Maastricht, for the exhibition *Preservations*, which took place December 13, 1997 to February 1, 1998, in the former Bonnefanten Museum, in Maastricht, Netherlands.

For the work a "new cell" called a hybridoma was created by fusing one of my own white blood cells (lymphocytes) with a cancer cell (myeloma) of a mouse. The success rate for such cross-species transgene fusions is very low—in our case there were only a couple of successful fusions out of approximately ten million attempts. Only when the researchers showed surprise that it worked at all did I realize exactly how unique our fusions were.

Why did I do it? To begin with, I'm very interested in the discussion around immortality and radical life-extension. The hybridoma culture we created is, in principle, immortal. Thanks to the cancerous nature of the specific mouse cell-line we used, some of my own genetic material will continue to live and divide forever (in a cell culture) and will not succumb to cell death (apoptosis).

Of course not all of my genes made it into the hybridoma—the surviving germ plasm is part man and part mouse, a mixture of white blood cell and cancer. *Good and Evil on the Long Voyage* is a hybrid: It was curiosity about hybrids that started me on the path to this project in the first place.

The project began with a desire to identify and elaborate the "genesis barrier," the form that maintains difference, the wall that differentiates species.

I found the barrier (initially) in the zona pellucida that surrounds the female egg. As an empirical experiment and proof, I had planned to explore (and transgress) a "foreign zona" using a technique called ICSI (Inter Cytoplasmic Sperm Injection). Unfortunately, using

Figure 13.1

Paul Perry, *Good and Evil on the Long Voyage*, 1997. Wiel Debie taking a blood sample
in order to isolate Perry's lymphocytes.

the technique would have jeopardized the existence of the laboratory where we planned
to do the work, as ICSI is currently under considerable fire, both for ethical as well as
safety reasons. However our creation of a hybridoma turned out to be a less controversial
(but probably much more radical) method to "do some art" addressing convergence and
divergence.

What was there to see? Throughout my period in the laboratory I was struck by how
invisible molecular biology actually is. All events are marked, mirrored, and scaled up in a
variety of ways in order to be measured by the observer.

I like to think about "ideal or conceptual" art and biology in terms of genotype and
phenotype. A cell or organism's genetic constitution or genotype is much more concrete
than an image in the imagination, as the genes can be read, measured, and re-recorded
precisely. In some ways, however, genotype and art concept are similar: Both depend on
a corresponding phenotype or genetic expression to get passed on to the next generation.
The phenotype is the expression of the genes and art concept made physical in the world
as body, entity, or art work.

Figure 13.2
Paul Perry, *Good and Evil on the Long Voyage*, 1997. The (clustered) hybridoma cells as photographed under a microscope.

Figure 13.3
Paul Perry, *Good and Evil on the Long Voyage*, 1997. The bioreactor in the canoe. The culture is in the center flask.

Figure 13.4

Paul Perry, *Good and Evil on the Long Voyage*, 1997, dimensions variable. The complete work on display in the former Bonnefanten Museum, Maastricht, The Netherlands.

For the exhibition, I insisted on the hybridoma being physically present (no pictures—I wanted the real thing). A cell culture is usually maintained in an intensive care unit called a bio-reactor—a very expensive device. For the exhibition I was able to borrow a bio-reactor from the company New Brunswick Scientific. The bio-reactor with the hybridoma culture was placed in an aluminum canoe that was raised several meters above the floor in a scaffold. In order to see the bioreactor, a mirror was suspended above the canoe.

Art: in vivo and in vitro

Marta de Menezes

The use of biology as an art medium is not a recent phenomenon. It is likely that ever since early humans started domestication, animals and plants have been selected, and consequently modified, based on aesthetic values. Modern biology made possible the modification of life in an extremely controlled way, but also offered access to many other techniques: from protein structure analysis to direct visualization of neurons in the living brain.

Biotechnology was born to explore these new tools for the benefit of humankind. It is becoming possible to develop new therapies for incurable diseases, but, at the same time, the public fears misuse of this powerful technology. As society becomes aware of biotechnology, with all its hopes and fears, artists have started to include references to biotechnology in their works. Modern biology and biotechnology offer the opportunity to create art using biology as a new medium. We are witnessing the birth of a new form of art: art created in test tubes, using laboratories as art studios.

Biological Art

Creativity is a major feature of human nature. The evolution of our species has been characterized by a remarkable capacity to adapt to very different ecosystems, from the cold tundra to the hot equatorial savannah. In most cases, adaptation and survival were only possible through the development of tools and survival strategies based on human creativity. Some of these strategies were directed not only to the modification of inanimate objects, but also to the modification of live organisms, as domestication of plants and animals begun. The history of agriculture and animal domestication is a remarkable achievement in modifying the characteristics of other live organisms in order to adapt them to human needs.[1] It is even more remarkable that such modifications were achieved without

any knowledge on the mechanisms governing them. Only in the last 150 years have the principles of natural selection, evolution, and heredity been described.[2] With crude methods of selective breeding human beings created genetically modified organisms a long time before the existence of genes was even suspected. It is important to note that evolution never stops, and human beings have also changed in these last thousands of years. We now have come to depend, for our own survival, on the live organisms we have shaped.

However, human beings have not restricted their creativity to solving practical problems. Artworks created by our early ancestors have been discovered in multiple locations. It is likely that aesthetics motivated not only the creation of objects, but also the selection of animal and plant characteristics. It has been suggested that early efforts to domesticate plants and animals were not associated with an increased demand for products for human consumption, but rather with the production of plants and animals for special occasions frequently of a religious nature. The different breeds of cats and dogs that exist today are living evidence that animal selection has frequently been based on aesthetic characteristics.

Darwin's description of the evolution theory and natural selection, although a groundbreaking conceptual advance, did not immediately change the human ability to interfere with the characteristics of live organisms. Similarly, Mendel's laws of heredity, and even the discovery of the structure of DNA by Crick and Watson in 1953, did not lead to practical advances in the modification of life.[3] However, the combination of all these discoveries paved the way to the development of technologies that offered the possibility of directly manipulating the DNA content of live organisms in a powerful way: The use of restriction enzymes to cut DNA at specific locations, methods to separate DNA fragments, amplification of the number of copies of a specific DNA fragment, insertion of DNA in bacterial plasmids, introduction of DNA in mammalian genomes, and even the replacement of specific genes in animals and plants.[4]

These advances have allowed the modification of life in an extremely controlled way. Nature is now reinvented every day in research laboratories: fruit flies (*Drosophila*) with limbs replacing antennae;[5] worms (*Caenorhabditis elegans*) with twice the normal life span;[6] chickens in which extra wings or legs are induced;[7] and thousands of mice with different genes added or deleted, simulating human diseases, fluorescing green, or apparently being normal.[8] This kind of experiment has been crucial for a better understanding of what we are, and biotechnology was born to explore these new tools for the benefit of humankind.

Cloning, stem cells, transgenesis, and *genomics* are a few examples of words that are now commonly found in the mass media. These words, the meanings of which are unclear to most people, are special in the sense that they represent both hope and fear for the contemporary society. The fruits of biotechnology are frequently seen as solutions for many problems of today, ranging from medical conditions to environmental issues. But, at the same time, there is widespread concern that biotechnology can be misused, creating seri-

Marta de Menezes

ous problems ranging from environmental and health issues to possible loss of personal identity. In this respect, biotechnology, with its clones and transgenics, has been replacing electronics, with its computers and robotics, in becoming a central concern today. Robots no longer fight humans for their survival in the movies; instead it is "clones" that have begun to attack.[9]

As society has become aware of biotechnology, artists have started to include references to and use of this new technology in their works.[10] Moreover, in the same way previous technical advances resulted in opportunities for artistic exploration, biology and biotechnology now offer similar prospects. I believe biology is similar to photography, video, and computers in that it can be successfully adapted by artists for use as an art medium. It is a fact that the use of biology as a new art medium has some associated hurdles that can still deter wide artistic use. Unlike photography or video, biological equipment is not readily available outside research facilities. As a consequence, artists willing to explore the use of biology as an art medium still have to collaborate with scientific laboratories. Equally, much biological material and equipment may raise bio-safety concerns: Research laboratories have to comply with safety guidelines regarding, for example, the containment of live organisms according to their characteristics; scientists are trained in the use of laboratory equipment and biological material in order to protect themselves and the environment. As a consequence of these safety issues, it is likely artists will have to continue to use the laboratory as an art studio, rather than converting their studios into laboratories.[11]

However, there are currently a number of artists using biology as an art medium who follow different strategies. Some of these artists have been demonstrating, through their work, that it is possible to use biology as an art medium without working in a research laboratory. George Gessert has been pursuing selective breeding of ornamental plants to generate plants with novel characteristics.[12] His approach is similar to the one adopted by our ancestors, who selected the species and breeds of animals and plants that we now find on farms and in pet shops. Ultimately, genetically modified organisms that are generated as interesting mutants can be selected to breed. Joe Davis and Eduardo Kac have been creating genetically modified organisms in a more direct way, by direct introduction of DNA into the genomes of organisms using technology developed over the past thirty years.[13] Biological art is not even restricted to works with whole organisms. Oron Catts, Ionat Zurr, Guy Ben-Ary, and their colleagues have been demonstrating the use of live cells and tissue culture techniques to create semi-living sculptures: objects in which a nonliving scaffold is colonized by live cells.[14] These artists in collaboration with scientists at the University of Western Australia have founded SymbioticA, an unique institution promoting hands-on collaborative projects between artists and biologists.[15] So far, artists have only begun to explore biology as an art medium. With the preceding examples, together with my own work described here, I aim to illustrate the variety of options available.

It is still, however, uncommon for artists to have a significant academic education in scientific subjects, including biology. Such deficiency in biology training may deter some artists from exploring the opportunities for creating biological art. Furthermore, many of the scientific communications are unintelligible to outsiders to the field. Unfortunately, this includes some books and events intended to make science understandable to the general public. It is likely that an artist willing to use biology as an art medium would have to learn the basics about the experimental systems she or he is considering using. Personally, I do not see this as a major hurdle: Quite a few artistic techniques require extensive training. The use of information technologies as a new art medium, for example, is only possible when the artist acquires skills in a field that is not by nature "artistic." Biology may not be very different from informatics, except that there is greater availability of computers compared to availability of biological equipment.

My work has been focused on the possibilities that modern biology offers to artists. I have been trying not only to portray the recent advances of biological sciences, but to incorporate biological material as new art media: DNA, proteins, cells, and organisms offer an opportunity to explore novel methods of representation and communication. Consequently, although lacking formal scientific training, my recent artistic activity has been conducted in research laboratories.

Art with a Life Span

Contrary to popular belief, it is not necessary to modify the genes of an organism in order to change its phenotype (i.e., appearance). It is possible to achieve a change in the phenotype by external interference with cell communication, or by changing the levels of certain proteins. Such interferences can be so powerful as to induce the formation of extra limbs.[16] In such cases the new phenotype is not transmitted to the offspring, as the information of the gametes is left unchanged.

In 1998 I started a collaboration with the laboratory of Professor Paul Brakefield at the University of Leiden, the Netherlands. Brakefield's team studies the evolution and development of butterfly wing patterns. They are trying to address two problems: How is the wing pattern formed during butterfly development, and what is the evolutionary significance of developmental variation around this process? To investigate how the wing pattern is formed, they interfere with the normal development of the butterfly, in order to identify what factors affect wing appearance. As a consequence they have found ways to modify the wing pattern by simply interfering with the normal development of the wing, without changing the genes that pass on to the next generation through the egg or sperm cells.[17]

During my residency in Brakefield's laboratory I developed *nature?*, a project that explored not only the boundaries between art and science, but also between the natural and the artificial.[18] In *nature?* I created live butterflies with wing patterns modified for

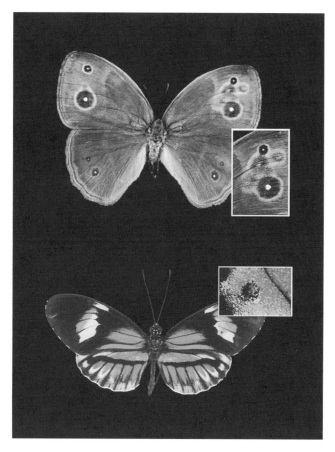

Figure 14.1

Marta de Menezes, *nature?* 1999. Butterflies with modified wing patterns. The left wings of the *Bicyclus* (top) and *Heliconius* (bottom) butterflies have the natural design. The pattern on the right wings have been modified. The inset shows the area of the intervention at higher magnification.

artistic purposes. This was achieved by interfering with the normal developmental mechanisms of the butterflies, leading to a new wing pattern never before seen in nature. The butterfly wings are made of normal live cells, without artificial pigments or scars, but designed by an artist. This is an example of something simultaneously entirely natural, but resulting from human intervention (figure 14.1).

For *nature?* I modified the pattern of one wing of *Bicyclus* and *Heliconius* butterflies. As a consequence, all of these butterflies had one wing with the natural design—fruit of years of evolution—and another one with my design. Through this asymmetry, I tried to

Figure 14.2
Marta de Menezes, *nature?* installation at Ars Electronica 2000, Linz, Austria. The visitors could enter the enclosure to observe the live butterflies directly.

emphasize the similarities and differences between the unmanipulated and manipulated, between the natural and the novel natural.

In the butterfly wings I expressed concepts that deal with our perception of shapes. By adding, changing, or deleting eyespots and color patches, it became possible for our imaginations to identify shapes and rhythms familiar to our senses. Another approach included highlighting particular aspects of the natural wing—for example, the removal of the outer rings of an eyespot to show only the white center of it. My intention was not to enhance nature's design. Nor did I intend to make something already beautiful even more beautiful. I simply wished to explore the possibilities and constraints of the biological system, creating (within what is possible) different patterns that are not the result of an evolutionary process[19] (figure 14.2).

It was also my intention to create unique butterflies. As the germ line was not affected by any of my changes, the induced patterns were not transmitted to the offspring. Each modified butterfly was different from any other. The new patterns were never before seen

in nature, and quickly disappeared from nature not to be seen again. This form of art has a life span—the life span of a butterfly. It is a form of art that literally lives and dies. It is simultaneously art and life. Art and biology.

Protein Sculptures

In recent years, genes and genetics have become the most prominent topic of biology in our society. But biology and biotechnology do not deal exclusively with genes. In spite of all the recent hype concerning the sequencing of the human genome, the development of transgenic organisms, or the use of powerful genetic screening methods, biological research is making important advances in other areas. It is even likely that other areas of biological research will become more exposed to the public in the near future. Proteins are perhaps the best example. The proteome—the identification of all proteins from an organism—is likely to replace the effort that was made to sequence the genome of several species, including our own. The general consensus is that characterization of the proteome of a species is more daunting than sequencing its genome: A recent meeting on proteomics was entitled "Human Proteome Project: 'Genes were easy.'" Many biotechnology companies have been formed to explore the economic possibilities of proteomics, marking the beginning of the post-genomic era. As an example, last December Oxford GlycoSciences alone filed patent applications for approximately 4,000 human proteins.

Concerning the opportunities proteins offer to artists, I would like to encourage the exploration of databases of protein structure.[20] Certainly the three-dimensional shapes of proteins will not leave anyone feeling indifferent. Proteins are frequently as beautiful as contemporary sculptures. Exploring a computer database of protein structures using software and hardware allowing three-dimensional visualization is like exploring an art gallery. Therefore I believe it is possible to use proteins as a medium for the creation of sculptures.

In *Proteic Portrait* I decided to take advantage of the visual opportunities offered by structural biology in order to create a self-portrait using proteins as an art medium.[21]

Proteins are made of twenty different amino acids; each one can be represented by a letter (one-letter code).[22] Using that convention, it is possible to design a protein whose amino-acid sequence corresponds to a name. However, interesting three-dimensional conformations are only apparent when the protein is over a given length: Very short peptides adopt linear structures that are relatively uninteresting. As a consequence, my professional name—Marta de Menezes—would be too short for an interesting conformation. Fortunately, as Portuguese people tend to have very long family names I was able to design a protein with my full name, the *marta* protein:

MARTAISAVELRIVEIRDEMENESESDASILVAGRACA

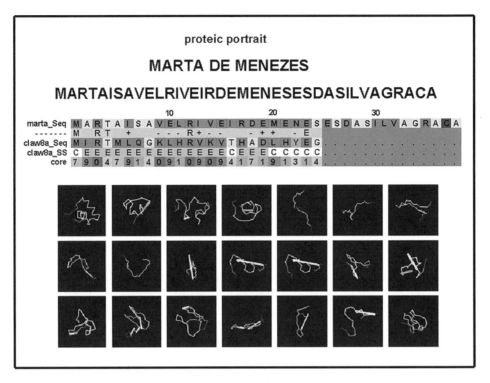

Figure 14.3

Marta de Menezes, *Proteic Portrait (study)*, 2002. Printed canvas, 51 × 37.4 in (130 × 95 cm). The picture shows the sequence of *marta* protein, compared with the most similar protein so far described: *claw_8a*. The diagrams represent possible three-dimensional conformations of *marta* as computer-predicted by comparing the sequence of *marta* with sequences of proteins with known structures.

Using computer databases it is possible to confirm that there is no known protein in nature with this amino-acid sequence. In fact, it is even possible to identify the natural proteins most similar to *marta*. Computer modeling also creates several possible conformations for *marta*, based on the structure of similar amino-acid sequences in known proteins. However, the exact conformation of *marta* can only be determined experimentally by solving its structure using nuclear magnetic resonance (NMR) or crystallography. The *Proteic Portrait* will only be finished when the true structure of *marta* is uncovered (figure 14.3).

Although proteins are not living structures, this project requires the use of live organisms. In order to solve the structure of *marta* by crystallography or NMR, it is necessary to produce a large number of copies of *marta*. Such production can be achieved by designing

the gene encoding the information of *marta*'s sequence, and introducing this gene into bacteria, yeast, or even human cells. Such cells will then produce millions of copies of the protein. This is a standard method for the production of synthetic proteins.

Scientists have organized databases in which information from all known proteins is stored. Not only can proteins from all different life organisms be found in such databases, but also synthetic proteins designed to be used, for example, as drugs. In July 2002, I submitted *marta* protein details to GeneBank, one of such databases.[23] As it was not my intention to mislead any scientist using the database as a research tool, I carefully annotated *marta* as a synthetic protein, without known biological function, and created as a molecular sculpture. The inclusion of *marta* in the database was declined because the protein did not have a biological function. I understand the scientists' wish to exclude irrelevant information from the database, as the primary function of the database is to be a tool for biological research. However, I was disappointed to find that the database will not contain all existing proteins. Even proteins designed by artists and devoid of any biological function do become part of nature.

Putting the Mind into the Picture

For years artists have attempted to illustrate not only people's appearances, but also their essential nature. The personality of a model can be conveyed by, for instance, the depiction of the pose and the setting, as well as by the style of rendering used by the artist.

Science has developed powerful tools to image the interior of the body. Since Roentgen's discovery of X-rays, we have begun to be able to see what is hidden behind the skin. Today, new imaging technology allows better visualization of both biological morphology and function.

The technique of functional Magnetic Resonance Imaging (fMRI) has recently been developed to determine which regions of the brain are activated while a subject performs a given task. This form of "brain mapping" is achieved by setting up an advanced MRI scanner in such a way that the increased blood flow to the activated areas of the brain can be detected. The image intensity observed in MR images is determined by various biochemical properties of the tissues, some of which are sensitive to hemodynamic changes. In particular, the elevation in blood flow induced by cerebral activation causes the image intensity to increase locally. Statistical comparison of images collected during active and rest periods therefore enables the detection of the brain regions that are involved in the task under study.[24]

I have been creating *Functional Portraits* by imaging the brain function of the model while she or he performs a task that characterizes her or himself. I use fMRI equipment more powerful than that used for medical diagnosis in order to achieve better images. Among the first portraits I produced was *Patricia Playing the Piano*, in which Patricia's

Figure 14.4

Functional Portrait: Martin Kemp Analyzing a Painting, 2002. Digital image printed on canvas, 37.4 × 51 in (95 × 130 cm). The painting incorporates Martin Kemp's brain activity while analyzing a painting from the Renaissance from inside the MRI scanner.

physical appearance was combined with images of her brain activity while she was playing the piano inside the fMRI machine, as well as a self-portrait of my own brain function while drawing[25] (figure 14.4).

Painting with DNA

I have also been exploring the use of genes, DNA, and chromosomes as a new art medium. In spite of my assertions that biology is more than genes and DNA, the importance of genetics in present society is beyond doubt.

In *nucleArt* I used DNA probes labeled with fluorochromes to paint the nuclei of human cells, adapting cell biology techniques to the production of art. I combined my knowledge of the relative position of the chromosomes with the capacity to use DNA to paint each one of the chromosomes specifically. The technique is known as Fluorescence In-Situ Hybridisation (or FISH), and can also be used to visualize segments of chromosomes or even single genes.[26] Groups of chromosomes can be equally stained with the same color. In this way, it is possible to create relatively controlled images in which one or many chromosomes are painted, with or without portions of them in other colors. The resulting artworks, the stained cells, require the use of a confocal laser scanning microscope in order to be seen, and are displayed at a visible scale using computer projections in order to convey the three-dimensional structure of the human nucleus.

The position of the chromosomes in the interphase cell nucleus is determined in part by certain rules. For example, certain chromosomes tend to stay at the periphery of the nucleus while others are more commonly found toward the center. With this information, it is possible to predict, to a certain extent, where chromosomes are likely to appear, and to paint them accordingly. However, there are still many uncertainties concerning the position of chromosomes in the cell nucleus. In fact, one of the topics being researched in Dr. Ana Pombo's laboratory, where the project is being developed, is how different human chromosomes interact with each other.[27]

In Pombo's laboratory I have been using DNA probes that bind to specific human chromosomes or human genes in order to generate aesthetically interesting microsculptures (figure 14.5). The artworks (the painted cell nuclei) have been displayed in installations that far exceed the almost immaterial size of the art object. These sculptures have been shown as large three-dimensional video projections, resulting in a visual and tactile environment.[28] In fact, I personally prefer not to have the actual artworks (the painted cells) in the gallery.

The Two Cultures?

The experience of working as an artist alongside scientists in a research laboratory has been an integral part of my recent activity. As I do not have any specific background in biology, I continually have to learn the techniques and scientific problems that biologists are addressing. This also serves my intention to demonstrate that interactions between artists and scientists can be fruitful for all the parties involved.

It is a central feature of my work not only to take advantage of scientific techniques, adapting them to the production of artworks, but also to try to contribute to the scientific research of the laboratory. Although my work is not based in scientifically designed experiments, occasionally my artistic experiments produce unexpected results. Such results are frequently a consequence of attempts to use the technology in new ways.

Figure 14.5

Marta de Menezes, *NucleArt*, 2002. Installation at the Perth Institute for Contemporary Art, Perth, Australia, August 2002, dimensions variable. The DNA-painted human cells were reconstructed at a visible scale by video projection onto parallel translucent screens.

In the case of *nature?* I attempted several procedures that had never been previously tested, such as transplanting cells between the two different species of butterflies. The motivation to pursue these experiments was to create eyespots in a butterfly species in which they never appear. Such experiments were a failure from my artistic perspective, since I was unable to induce eyespots in the "resistant" butterfly species. However, some of these "artistic experiments" led to unexpected observations and raised scientific questions that require further scientific research in order to be explained.

Similarly, all the human brains that I experiment with, and all the cells whose nuclei I paint with DNA, have been analyzed by scientists. I believe that any experimental procedure, providing it is adequately recorded, can be potentially useful for science. However, when I work in a laboratory I am not making science: My aim is not the advancement of knowledge. Motivations and strategies are significantly different between artists and scientists, even those working in the same laboratories.[29] Nevertheless, and perhaps as a

consequence of those differences, it is likely that mutual benefits can result out of such collaborations, leading to advances in both art and science.

Acknowledgments

The works mentioned were developed with the help of the following scientists, artists and institutions: P. Brakefield, A. Monteiro, P. Beldade, R. Kooi, and K. Koops at the University of Leiden, the Netherlands (*nature?*); A. Pombo at the MRC—Clinical Sciences Centre, Imperial College London, and M. Higgbottom, at Vivid, Birmingham (*NucleArt*); P. Figueiredo at the University of Oxford, J. Waldmann and M. Higgbottom (*Functional Portraits*); R. Alves and S. Filipe (*Proteic Protein*).

Notes

1. C. Darwin, *Variation of Animals and Plants Under Domestication* (London: John Murray, 1868); C. O. Sawer, *Agricultural Origins and Dispersals: The Domestication of Animals and* Foodstuffs (Cambridge, MA: MIT Press, 1970); R. A. Caras, *A Perfect Harmony: The Intertwining Lives of Animals and Humans Throughout History* (New York: Simon and Schuster, 1996).

2. C. Darwin, *On the Origin of Species* (London: John Murray, 1859); G. Mendel, "Versuche über Pflanzen-Hybriden," *Verhandlungen des naturforschenden Vereines in Brünn VIII für das* (Jahr 1869): 26–31; C. Correns, "G. Mendels Regel über das Verhalten der Nachkommenschaft der Rassenbastarde," *Berichte der Deutschen Botanischen Gesellschaft* 18 (1900): 158–168; H. De Vries, "La loi de disjonction des hybrides," *Comptes Rendus de l'Academie des Sciences* (Paris) 130 (1900): 845–847; T. H. Morgan, A. H. Sturtevant, H. J. Muller, and C. B. Bridges, *The Mechanism of Mendelian Heredity* (New York: Henry Holt and Company, 1915). English translations of the above articles are available at http://www.esp.org/foundations/genetics/classical/.

3. Ibid and J. D. Watson, and F. H. Crick, "Molecular Structure of Nucleic Acids: A Structure for Deoxyribose Nucleic Acid," *Nature* 171 (1953): 737–738.

4. For an account of the history of these advances see H. F. Judson, *The Eighth Day of Creation* (London: Jonathan Cape, 1979); and B. Alberts, A. Johnson, J. Lewis, M. Raff, K. Roberts, and P. Walter, *Molecular Biology of the Cell* (New York: Garland Science, 2002).

5. P. A. Lawrence, *The Making of a Fly* (Oxford: Blackwell Scientific, 1992).

6. C. Kenyon, J. Chang, E. Gensch, A. Rudner, and R. Tabtiang, "A C. Elegans Mutant that Lives Twice as Long as Wild Type," *Nature* 366 (1993): 461–464.

7. M. J. Cohn, J. C. Izpisua-Belmonte, H. Abud, J. K. Heath, and C. Tickle, "Fibroblast Growth Factors Induce Additional Limb Development from the Flank of Chick Embryos," *Cell* 80 (1995): 739–746.

8. M. Okabe, M. Ikawa, K. Kominami, T. Nakanishi, and Y. Nishimune, "Green Mice as a Source of Ubiquitous Green Cells," *FEBS Letters* 407 (1997): 313–319; L. Graca, "Targeting the Immune

System: Techniques and Applications of Gene Targeting to Immunology," *Revista da Sociedade Portuguesa de Imunologia* 4 (1998): 25–60.

9. Compare the movies *2001: A Space Odyssey* by S. Kubrick (1968) with *Star Wars Episode 2: Attack of the Clones* by G. Lucas (2002). Even when the different Star Wars episodes are compared it is clear that biological dangers have been replacing evil robots and computers in the recent years.

10. For an account on the impact of science and biology in the visual arts see for example: S. Ede, *Strange and Charmed: Science and the Contemporary Visual Arts* (London: Calouste Gulbenkian Foundation, 2000); and M. Kemp, *Visualizations: The Nature Book of Art and Science* (Oxford: Oxford University Press, 2000).

11. M. de Menezes, "The Laboratory as an Art Studio," in *The Aesthetics of Care?*, ed. O. Catts (Perth: Symbiotica, 2002), 53–58.

12. G. Gessert, "Breeding for Wilderness," in *The Aesthetics of Care?*, ed. O. Catts (Perth: Symbiotica, 2002), 29–33.

13. J. Davis, "Microvenus," *Art Journal* (Spring): 70–74; J. Davis, "Romance, Supercodes, and the Milky Way DNA," in *Ars Electronica 2000—Next Sex*, ed. G. Stoker and C. Schopf (Wien: Springer, 2000), 217–235; E. Kac, "Transgenic Art," *Leonardo Electronic Almanac* 6, no. 11; E. Kac, "GFP Bunny," in *Eduardo Kac: Telepresence, Biotelematics, Transgenic Art*, ed. A. Kostic and P. T. Dobrila (Maribor, Slovenia: Kibla, Maribor, 2000), 101–131.

14. I. Zurr, and O. Catts, "An Emergence of the Semi-Living," in *The Aesthetics of Care?*, ed. O. Catts (Perth: Symbiotica, 2002), 63–68. G. Ben-Ary and T. DeMarse, "Meart (AKA Fish and Chips)," *Ibidem* (2002): 59–62.

15. See http://www.symbiotica.uwa.edu.au.

16. S. F. Gilbert, *Developmental Biology* (Sunderland, MA: Sinauer, 2000); E. Coen, *The Art of Genes: How Organisms Make Themselves* (Oxford: Oxford University Press, 1999).

17. P. M. Brakefield, J. Gates, D. Keys, F. Kesbeke, P. J. Wijngaarden, A. Monteiro, V. French, and S. B. Carroll, "Development, Plasticity and Evolution of Butterfly Eyespot Patterns," *Nature* 384 (1996): 236–242; P. M. Brakefield, "The Evolution-Development Interface and Advances With the Eyespot Patterns of Bicyclus Butterflies," *Heredity* 80 (1998): 265–272; V. French, and P. M. Brakefield, "Eyespot Development on Butterfly Wings: The Focal Signal," *Developmental Biology* 168 (1995): 112–123; P. M. Brakefield, and V. French, "Eyespot Development on Butterfly Wings: The Epidermal Response to Damage," *Developmental Biology* 168 (1995): 98–111; H. F. Nijhout, *The Development and Evolution of Butterfly Wing Patterns* (Washington, DC: Smithsonian Institution Press, 1991).

18. M. de Menezes, "The Artificial Natural: Modifying Butterfly Wing Patterns for Artistic Purposes," *Leonardo* 36, no. 1 (2003): 29–32.

19. This project was first exhibited in Ars Electronica 2000, Linz, Austria, where an enclosure containing the live butterflies was installed inside the Brucknerhaus Gallery. See M. de Menezes, "Nature?" in *Ars Electronica 2000: Next Sex*, ed. G. Stoker and C. Schopf (Wien: Springer, 2000), 258–261.

20. For example, Molecular Modelling DataBase, from the National Center for Biotechnology Information (NCBI): http://www.ncbi.nlm.nih.gov/Structure/MMDB/mmdb.shtml.

21. *Proteic Protein* was presented for the first time at the 19th International Sculpture Conference, Pittsburgh, PA, June 2001.

22. For more information, see note 4.

23. GenBank belongs to the National Institute of Health: http://www.ncbi.nlm.nih.gov/Genbank/.

24. P. Jezzard, S. M. Smith, P. M. Matthews, *Functional Magnetic Resonance Imaging: An Introduction to Methods* (Oxford: Oxford University Press, 2001); R. Turner, A. Howseman, G. E. Rees, O. Josephs, and K. Friston, "Functional Magnetic Resonance Imaging of the Human Brain: Data Acquisition and Analysis," *Experimental Brain Research* 123 (1998): 5–12.

25. An installation consisting of the video-projection of "Patricia Playing the Piano," in which her brain activity could be seen as the piano music was heard, was exhibited for the first time in "Bio-Feel" curated by O. Catts and integrated in the Biennale of Electronic Arts Perth (BEAP), Perth, Australia, August 2002.

26. For more information, see note 4.

27. A. Pombo, P. Cuello, W. Schul, J.-B. Yoon, R. G. Roeder, P. R. Cook, and S. Murphy, "Regional and Temporal Specialization in the Nucleus: A Transcriptionally-Active Nuclear Domain Rich in PTF, Oct1 and PIKA Antigens Associates with Specific Chromosomes Early in the Cell Cycle," *EMBO Journal* 17 (1998): 1768–1778; http://www.csc.mrc.ac.uk/ResearchGroups/NuclearOrganisation/NuclearOrganisationResearch.html.

28. The *NucleArt* installation was exhibited in Lugar Comum, Lisbon, Portugal (May–June 2002) and Perth Institute of Contemporary Art, Perth, Australia (August 2002).

29. See C. P. Snow, *The Two Cultures* (Cambridge: Cambridge University Press, 1993); L. Wolpert, *The Unnatural Nature of Science* (London: Faber and Faber, 1992); and the references in note 10.

Semi-Living Art

Oron Catts and Ionat Zurr

What Makes a Blob Alive?

The resolution in which we think we know the world ranges from the subatomic to the universe. We perceive the world as a relatively large organism[1] that harbors a thing called consciousness and a concept of self. Many humans feel uneasy and even threatened when exposed to objects that might question their perceived realities. Parts of bodies of complex organisms have been cultured since 1910.[2] The "production of a new surprising form of life, cellular life in vitro,"[3] presented a tangible challenge to our concept of self as well as the concept of death. Initially, the existence of the semi-living, a part of a complex living being sustained alive outside and independent from that being, was rarely discussed, mainly due to its confinement to a scientific context. The semi-livings are now out of the laboratories and into an artistic context. This opens up new discourses about the different relationships we might form with these new entities and sheds a different light on our perception of life.

The timing is not accidental. We humans have generated enough knowledge to manipulate different levels of life to an extent that requires us to reevaluate our understanding of the concept of life. Back in 1905 in the light of experiments in surgery and embryology, H. G. Wells wrote: "We overlook only too often the fact that a living being may also be regarded as raw material, as something plastic, something that may be shaped and altered."[4] He then went on to write the *Island of Dr. Moreau*, fictionally exploring this concept at the level of the whole organism. The appropriation of parts of complex organisms, sustained and grown outside of the body as "plastic raw material" to be "shaped and altered" seems like a more palatable version of this concept. In reality it seems that there were more epistemological barriers to the use of living parts of complex organisms then

that of the whole. The sustenance and manipulation of parts seems to be more disturbing and confronting because it puts into question rooted perception of the inseparable whole living being. If we can sustain parts of the body alive, manipulate, modify, and utilize them for different purposes, what does it say about our perceptions of our bodies, our wholeness and our selves? As mentioned previously, the developments of tissue culture techniques started at the turn of the twentieth century, but the realization that functional utilitarian tissue constructs can be engineered is still a controversial one. It might not be surprising to realize that the main examples of this can be found in the U.S. military[5] and in the new area of wet biology art practice. The first is not concerned with the broader epistemological and ethical implications, while the second attempts to confront them. The form and the application of our newly acquired knowledge will be determined by the prevailing ideologies that develop and control the technology. When the manipulation of life takes place in an atmosphere of conflict and profit-driven competition, the long-term results might be disquieting. One role that art can play is to suggest scenarios of "worlds under construction" and subvert technologies for the purpose of creating contestable objects. This role of art makes the emergence of the semi-livings and the multileveled exploration of its use so relevant.

The Tissue Culture & Art Project

Wet biology art practices are engaged in the manipulation of living systems. The Tissue Culture & Art Project (TC&A)[6] is exploring the manipulation of living tissues as a medium for artistic expression; it looks at the level above the cell and below the whole organism. We use tissue engineering and stem cell technologies to create semi-living entities. The semi-livings are made of living tissues from complex organisms grown over/into three-dimensional constructed substrates. Our semi-living entities grow in artificial conditions, which imitate body conditions, in bioreactors. This new palate of manipulation, at least at this stage, is significantly linked to ethical concerns and to emerging philosophical issues.

The TC&A is introducing a new class of object/being in the continuum of life: the semi-livings are constructed of living and nonliving materials, and are new subautonomous entities located at the fuzzy border between the living/nonliving, grown/constructed, born/manufactured, and object/subject. While the semi-livings rely on the vet/mechanic, the farmer/artist, or the nurturer/constructor to care for them, they are not human imitations and do not attempt to be human replacements. Rather they are a new class of object/being that is both similar to and different from other human artifacts (humans' extended phenotype) such as constructed objects and selectively bred domestic plants and animals. These entities consist of living biological systems that are artificially designed and need human and/or technological intervention for their construction and maintenance.

Oron Catts and Ionat Zurr

This chapter will describe some of our semi-living artworks and discuss the different levels of relations and interactions that we explored with these new entities. When we started back in 1996, we were looking at the production of visual objects covered with living skin. We then explored the construction of different tissue types and substrates. We began to shy away from aspects of beauty for a deeper exploration of the ethical and epistemological issues and concerns about the life-science industry in general. By exploring different tissue types we also looked at the different levels of interaction and feedback that some tissue types can generate. In a sense, when we started to look at what we could get these tissue constructs *to do*, we emulated humans' path of interaction with fellow living beings. We started looking for a mode of manipulation to exploit our newly developed semi-livings. Looking at the form of the ultimate exploitation, that of consumption, of eating, we observe that this form of relationship is the most problematic but also the most primal, and brings us back to the basic interaction humans have with their fellow living beings. Consumption is also an issue our modern society is trying to conceal, and one we are attempting to expose. This discussion will raise issues in regard to society's hypocrisies toward living systems (let alone semi-living systems) and to the "other" in general. Our semi-livings are "evocative objects"[7] that raise emotional and intellectual reactions and suggest alternative scenarios for a future.

Semi-Living Sculptures

The TC&A project began by the exploring tissue-engineering technologies to create semi-living sculptures. Tissue engineering deals with constructing artificial support systems (with the use of biomaterials) to direct and control the three-dimensional growth of tissue into desired shapes in order to replace or support the function of defective or injured body parts. "In essence, new and functional living tissue is fabricated using living cells, which are usually associated in one way or another with a matrix or scaffolding to guide tissue development."[8] In the mid-nineties the "poster boy" of tissue engineering—the mouse with the ear on its back—was released to the public eye. The Vacanti brothers,[9] pioneers in the field of tissue engineering, grew an ear-shaped construct, which was seeded with a patient's own cells. They used a nude mouse (an engineered mouse stripped of part of its immune system) as a natural bioreactor. The image of this new chimera triggered many responses worldwide. For artists, it presented the possibility of sculpting with living tissues (not without feeling concern regarding the use of a living sentient mouse as a tool for such an endeavor). Around that time Oron Catts was writing his thesis in product design suggesting the creation of a product called Costume Grown Living Surface as a point of future interaction between design and biotechnology. The exploration into this new semi-living product stemmed from ecological concerns, a search for sustainable modes of

production as well as the perception of design as only "skin deep." The use of naturally occurring processes, engineered and manipulated by humans, can be seen as a way of overcoming some of the problems associated with current modes of production. Changing the culture of production from manufacturing to growing was in the core of Oron's research. However, the research also indicated that some very profound ethical and epistemological issues require further investigation. It became apparent to us that in order to explore these issues, we needed to develop tangible examples of the semi-living and expose their visceral existence in public spaces. Looking at the prevailing ideologies behind the biotech industry, we decided that the only way to further explore this idea should be to approach it as an artistic project. Creating real semi-living sculptures would enable us to suggest, explore, critique, and provoke the public, and to create a space in which we could explore the reactions, emotions, and attitudes toward them.

By way of a lucky coincidence, we learned about a professor of anatomy, Professor Miranda D. Grounds, at the University of Western Australia, who was interested in working with artists.[10] We approached her with our idea of exploring the use of tissue culture as a medium for artistic expression. To our surprise, she invited us to work in her labs and introduced us to a polymer scientist (Professor Traian Chirila) who was developing polymers for biomedical research. The openness and courage of these two scientists (joined shortly after by one of our collaborators, neuroscientist Dr. Stuart Bunt) encouraged us to get our hands wet and explore, in what can be described as a phenomenological experience, working with living biological materials using the tools of modern biology. With a small grant from the Perth Institute of Contemporary Arts, we were able to pay for the materials and other consumables we used as part of the initial research, and could learn tissue culture techniques and basic concepts regarding biomaterials. Following this initial grant we received more funds from the New Media Arts Fund of the Australian Council for the Arts.

We begun by culturing cells over glass (figures 15.1–15.2). We "wrapped" glass with a monolayer of epidermal and connective tissue. Figurines were suspended in the tissue culture flask hung with a sterile string. We designed the glass figurines in shapes of technological artifacts (such as cogwheels, bombs, etc.). The cells were harvested from rabbit eyes. We would like to emphasize that all of our tissues, with one exception,[11] were scavenged from leftovers of animals that were killed for scientific research or food consumption. The idea of scavenging is of importance to us for ethical reasons (to reduce animal suffering) and from a philosophical perspective (to enhance the idea of tissue culturing as an extension of life). Some of the cells we cultured were taken from animals killed more than twenty-four hours prior to any treatment we gave them (obviously, the meat was kept in a cool environment). Using tissue culture, we have successfully extended the life of parts of organisms for up to nine months.[12] In the words of Landecker, "animals apparently could also live without themselves."[13]

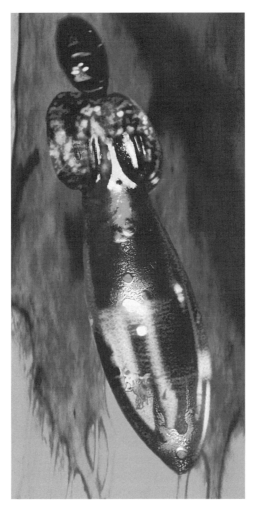

Figure 15.1

Oron Catts and Ionat Zurr, *B(W)omb*, 1998. Digital montage, 68.8 × 33.8 in (175 × 86 cm). The montage depicts epidermal and connective tissue grown over a glass figurine in a shape of a bomb. © Oron Catts and Ionat Zurr. Photo © Ionat Zurr.

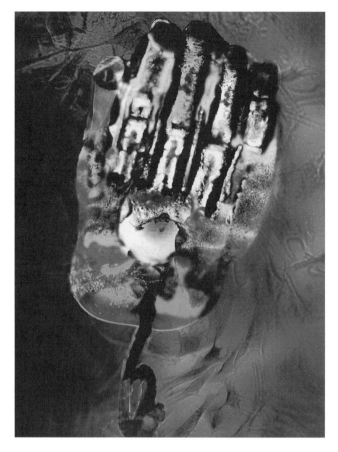

Figure 15.2
Oron Catts and Ionat Zurr, *Hamsa*, 1998. Digital montage, 68.8 × 33.8 in (175 × 86 cm). The montage depicts skeletal muscle tissue grown over a found glass amulet that supposes to protect from the evil eye. © Oron Catts and Ionat Zurr. Photo © Ionat Zurr.

Stone Age Biology, 1998–1999

This stage of our project, initially known as "Force and Intelligence on Plastic," could be seen as a conceptual turning point in our practice. Here, for the first time, we were directly addressing the epistemological consequences of new developments in the application of newly acquired knowledge in the fields of biology and biomedical research.

We grew skeletal muscle ("force") and neuron cells ("intelligence") over three-dimensional miniature replicas of stone tools made of biocompatible polymers p(HEMA). Creating semi-living prehistorical stone tools was a tangible metaphor for the mental shift

humanity has to go through when treating living nature (including ourselves) as a resource for new biological tools that will be part of our manufactured environment. A similar mental shift happened when early humans realized that stones could be chipped to form functional tools. Only the humans that could build a mental three-dimensional representation of a finished tool, and who had the cognitive ability to plan ahead and manually construct the tools, could survive the game of natural selection. For them, nature became a resource for raw materials for tool production. This mental shift separated humans from nature for the first time, and transformed our species into a technology-based organism.

Our looking at semi-livings as tools would be the starting point of our attempts to explore issues of utilitarian exploitation of living systems: issues that were further developed in our subsequent practice.

The Feeding Ritual: *The Tissue Culture & Art(ifical) Wombs* (2000)

During the early years of our practice we could not present the living semi-living sculptures outside of the confines of the laboratory. Besides the reluctance of galleries to present living/moist art, and the regulations involved in receiving permission to present live tissue constructs in a public domain, there are also the practicalities involved in setting up the basic requirements for the survival of semi-living sculptures outside of the lab. The semi-living sculptures need to be kept in sterile conditions, immersed in nutrient media and kept at a temperature which suits their needs (mammalian tissue in 37 degrees Fahrenheit, fish and amphibians can be left at room temperature). Our first exhibitions presented images of the sculptures or the sculptures themselves already fixed in formaldehyde. The importance of exposing the living visceral sculptures was obvious.

In 2000, while working as Research Fellows at the Tissue Engineering and Organ Fabrication Laboratory, Massachusetts General Hospital, Harvard Medical School, we were invited to present our living sculptures for the first time as part of *The Tissue Culture & Art(ifical) Wombs* installation at the Ars Electronica festival. For this we constructed a tissue culture laboratory in situ (in the gallery) that enabled us to show the living semi-living sculptures and feed them daily. The Feeding Ritual is now an integral part of our installations, in which we invite the public to view the procedure through peep holes in the laboratory we have constructed in the gallery. The Feeding Ritual attempts not only to demystify some of the processes involved in creating semi-living entities but also to emphasize the notion that life that we have created needs care for its survival and is wholly dependent on us to feed and nurture it.

In *The Tissue Culture & Art(ifical) Wombs* installation, we have handcrafted biodegradable/bioabsorbable polymers (PGA, PLGA, and P4HB) and surgical sutures to create an iconic semi-living entity of a worry doll. The audiences were encouraged to tell the semi-living worry dolls their worries (figure 15.3).[14]

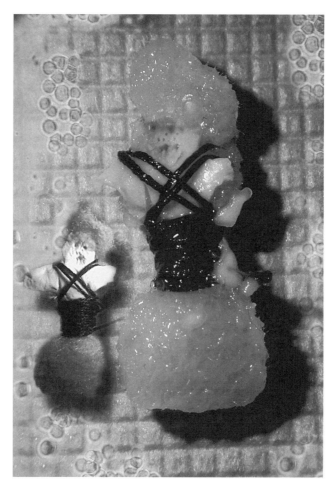

Figure 15.3
Oron Catts, Ionat Zurr, and Guy Ben-Ary, *Semi-Living Worry Doll*, 2000. Biodegradable/bioabsorbable polymers, surgical sutures, and McCoy Cell Line, $0.5 \times 0.3 \times 0.1$ in ($15 \times 10 \times 5$ mm). © Oron Catts, Ionat Zurr, and Guy Ben-Ary. Photo © Ionat Zurr.

The Killing Ritual: *Pig Wings* (2001)

In the *Pig Wings* project we differentiated bone marrow stem cells to grow pig bone tissue in the shape of the three solutions for flight in vertebrates. Winged bodies (both animal and human) have been used in most cultures throughout history. Usually, the kind of wings represented the creatures (chimeras) as either good/angelic (bird-wing) or evil/satanic (bat-wing). There is a third solution to flight in vertebrates which seems to be mostly free of cultural values—that of the pterosaurs. In this work we were referring to the often less than realistic propositions coming from the mass media and public relations statement from research institutes dealing with new biological technologies. The rhetoric surrounding the human genome project and xenotransplantation made us wonder if pigs would fly one day and, if they would, what shape their wings would take? The original lab-grown pig wings were cultured for around nine months; we then fixed them and coated them with gold. For the first public exhibition of the *Pig Wings* project (figure 15.4),[15] we cultured another set of wings for five months prior to the show. We then transferred the living wings to the gallery where we maintained them alive for the first ten days of the show. As we had to go back to Perth and there was no one who could care for the living wings, we devised yet another ritual (which we used for subsequent shows as well) of the killing of the sculptures.

At the end of every installation we faced the ultimate challenge of an artist—we have to kill our creation. Transferring living material across borders is difficult and not always possible, and as there is usually no one who is willing to "adopt" the semi-living entities and feed them (under sterile conditions) daily, therefore we have to kill them. The killing is done by taking the semi-living sculptures out of their containment and letting the audience touch (and be touched by) the sculptures. The fungi and bacteria which exist in the air and on our hands are much more potent than the cells. As a result, the cells get contaminated and die (some instantly, and some over time). The Killing Ritual (figure 15.5) also enhances the idea of the temporality of living art and the responsibility which lies on us (humans as creators) to decide upon their fate.

Is It Sentient? Can It Learn? A Semi-Living Artist

One very important aspect of our practice is to try to identify trends in scientific research relating to the concept of the semi-living. In mid-2000 we learned about research concerning the use of living neuronal assemblies for computational and machine-operating purposes. A robot operated by eel neurons and leech neuron calculators[16] are just two examples of such research. At the time we were in Boston, and we brought these stories to the attention of Guy Ben-Ary and Phil Gamblen in Perth. Together we decided to develop a project proposing a system based on similar concepts that would attempt to display qualities we tend to only observe in fellow humans. This ongoing research project

Figure 15.4

Oron Catts, Ionat Zurr, and Guy Ben-Ary, *Pig Wings*, 2000–2002. Pig bone marrow stem cells, differentiated into bone tissue, approx. 1.5 × 0.3 × 0.1 in (40 × 10 × 4 mm) each set. Medium: Bone tissue and degradable polymer scaffold. Cultured and grown for nine months in shapes of wings: The Chiropteran, Aves, and Pterosaurs versions. © Oron Catts, Ionat Zurr, and Guy Ben-Ary.

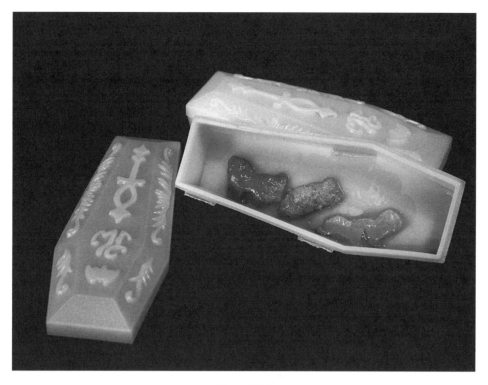

Figure 15.5

Oron Catts, Ionat Zurr, and Guy Ben-Ary, *Pig Wings*, 2002. The Killing Ritual, 2002. Medium: Bone tissue and degradable polymer scaffold and glow in the dark plastic coffin, approx. 1.5 × 0.3 × 0.1 in (40 × 10 × 4 mm) each set. © Oron Catts, Ionat Zurr, and Guy Ben-Ary. Photo © Ionat Zurr.

originally known as "Fish and Chips" (now being referred to as "MEART") explores notions of artistry and creativity in the age of new biological technologies.

For this project we interfaced living neural assemblies to a robotic arm that produced two-dimensional marks. We were exploring different modes of feedback loops and attempting to make some kind of sense of the streams of data received from these neural assemblies. The first public outing of this project was at the 2001 Ars Electronica Festival. That was the first generation of the project, where we picked up activity from goldfish neural assemblies, both prefabricated (i.e., bits of brain) and cultured over silicon and Pyrex wafers. We used a single electrode to pick up the activity and a single electrical stimulator to provide the feedback. We developed two computer programs to drive a robotic arm (software created by Ian Sweetman) and manipulate a musical score (composed

by Gil Weinberg). We used a sound-sensitive switch to control the audio output as a source of electrical stimulation feedback to the neurons.

The second generation of this project was presented as part of the *BioFeel* exhibition in August 2002 at the Perth Institute of Contemporary Arts. In this stage we were collaborating with Steve M. Potter, a neuroscientist from the Laboratory for Neuroengineering, Georgia Institute of Technology. We introduced more complexity into the project by growing the neurons over a multi-electrode array (sixty channels of activity) and the introduction of telepresence. In this case, embryonic rat cortical neurons were cultured over the multi-array "MEA" in a laboratory at Georgia Tech (the brain of MEART), and the data received from the neural activity was processed both in Atlanta and Perth to control the drawing arm (body of MEART) in real time. We closed the feedback loop by sending the stimulations to the neurons (multi-stimulations) in Georgia. The stimulation blueprint was based on images that were captured in the gallery in Perth. We were interested to find out if there would be any change in the neural activity that resulted from the stimulations.

Semi-Living Food: *Disembodied Cuisine*

Another way of interacting with living systems is to consume them as food. Throughout history, most humans have practiced some kind of division among living entities, categorizing them as food or others (such as pets, ornaments, work, etc.). These divisions are not always clear, and we must practice some kind of hypocrisy in order to be able to love and respect living things as well as to eat them. Dogs are an example of such confusion; in some cultures they are "man's best friend" (pets), in others they are ornaments and are selectively bred for aesthetic qualities. Dogs in other cultures are being eaten. Peter Singer refers to such division as "Speciesism in Practice—Animals as Food."[17]

Our project, entitled *Disembodied Cuisine* (figure 15.6) was shown at an international biological art exhibition, *L'art biotech*, in Nantes, France, in March 2003. In *Disembodied Cuisine* we grew frog skeletal muscle over biopolymer for potential food consumption. A biopsy was taken from an animal that continued to live and was displayed in the gallery alongside the growing "steak."[18] This installation culminated in a "feast." We also culture plant tissue in which we marinated the "steak."

The idea and research into this project began at Harvard in 2000. The first steak we grew was made out of prenatal sheep cells (skeletal muscle). We used cells harvested as part of research into tissue engineering techniques in utero. The steak was grown from an animal that was not yet born.

Disembodied Cuisine deals with one of the most common zones of interaction between humans and other living systems, and probes the apparent uneasiness people feel when someone "messes" with their food. Here the relationships with the semi-living are that of consumption and exploitation; however, it is important to note that it is about "victimless" meat consumption. As the cells from the biopsy proliferate, the in vitro steak contin-

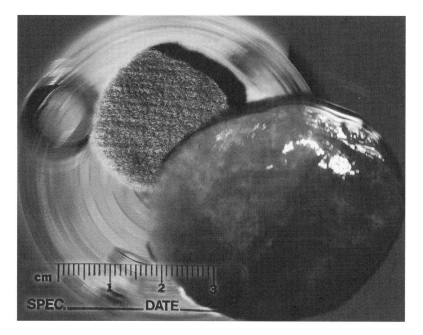

Figure 15.6

Oron Catts, Ionat Zurr, and Guy Ben-Ary, *Tissue Engineered Steak No. 1*, 2000. A study for *Disembodied Cuisine*. Prenatal sheep skeletal muscle, cultured and grown for four months, over PGA scaffold. Medium: Prenatal sheep skeletal muscle and degradable PGA polymer scaffold, $1.1 \times 0.7 \times 0.1$ in $(30 \times 20 \times 5$ mm$)$. This was the first attempt to use tissue engineering for meat production without the need to slaughter animals © Oron Catts, Ionat Zurr, and Guy Ben-Ary. Photo © Ionat Zurr and Oron Catts.

ues to grow and expand, while the source, the animal from which the cells were taken, is healing. Potentially this work presents a future in which there will be meat (or protein-rich food) for vegetarians and the killing and suffering of animals destined for food consumption will be reduced. Furthermore, ecological and economical problems associated with the food industry can be reduced dramatically. However, by making our food a new class of object/being—a semi-living—we risk making the semi-living the new class for exploitation. One should also remember that currently tissue culture nutrients consist of serum that is an animal-derived product.

Where from Here?

Looking at communities of cells as entities, one can see the vast gradients of life's complexity. Lynn Margulis suggested that a eukaryotic cell is a result of the evolutionary symbiosis

relations between two prokaryotic bacteria.[19] Margulis presented a revolutionary perception not by looking at life as collections of entities but by presenting symbiotic relations as a source of evolutionary leap.

Collections of cells cooperating/competing with each other for some sort of coherence that will enable survival are now being manipulated/exploited by us. As there is more that we do not know, we must work in a dialogue with these communities of cells. As early as 1952, Etienne Wolff had warned that through the "illogical abuse of language, one often applies the term 'tissue culture' to anarchic proliferations of cells that do not reflect either the structure or cohesion of the tissue from which they are taken."[20] But as the field of tissue engineering develops and more understanding of cell communications is attained, one realizes that the semi-livings are more than "anarchic proliferations of cells." This realization enables us to view cancer cells (cell lines) in a positive light as "better" raw material for the creation of semi-living sculptures outside the body. These cells grow faster and are more resilient to the dangers of the external environment.

Perceiving a body as a collective of cell communities might challenge long-held value systems, such as the idea of reincarnation of a whole body even if parts of the body are still alive, spread in different geographical locations, and might have even greater bio mass than the original body they derived from. Ideas about hierarchy in the animal kingdom can be dissected when a body is dissected, since there is so much in common in all mammalian cells whether they are human or not. These cells show similar behaviors when adjusting to their new in vitro "body," attaching to substrates and communicating among each other to form a sort of "self" which is sort of alive.

It is in this context that Jeremy Bentham's question becomes important—the question is not whether they can reason, nor whether they can talk, but whether they can suffer.[21]

Learning from our experiences of growing semi-living entities over the past ten years, we are pursuing a better dialogue with our entities as well as encouraging the audience to become an integral part of the discussion. Taking the living semi-living entities outside of the scientific laboratory into a lab in a public space is not trivial but of enormous importance to us.[22] As the time and scale of cells is different that that of a whole organism, when the cells are looked at in real time they seem still, and one has to make a leap of faith to actually believe that they are alive. Creating time lapse movies of the growth enabled us to partially solve this problem. Another strategy we are exploring is the use of cultured muscle fibers to act as actuators, moving our sculptures in real time. Adding the element of movement to our sculptures will enhance the perception that what we are dealing with is actually alive. Humans have a strong tendency to perceive movement as life, and this intuitive realization that our sculptures are alive would undoubtedly confront viewers even more.

One of the most intimate interactions with other living beings involves touch. To see is to believe, but to touch is to start creating some sort of bond. At this stage of our work, touch has a fatal effect on the semi-living entities. In the future we would like to be able to

take semi-livings outside of their sterile environment to let whole organisms (including humans) physically interact and bond with them without killing them. For that we (and other tissue engineer professionals) will need to fabricate an artificial capillary system. Such a system will enable us to sustain thick cell constructs (larger ones as well) and to grow an external layer of skin, which will act as a membrane barrier to the external environment.

These evocative entities expose the gaps between our new knowledge, our ability to manipulate living systems, and our belief and value systems. These systems are not equipped to deal with the epistemological, ethical, and psychological implications raised by the emergence of the semi-living.

Our semi-livings consist of constructed elements and living parts of one or more organisms assembled and sustained alive by humans. The entities we create might become our "natural-ish" companions, invading and replacing our constructed and manufactured environments with growing, moving, soft, moist, and care-needing things. One area in which the semi-living is seriously discussed is architecture; in 1996 we suggested the creation of living walls as a way of making urban environments more hospitable. Ted Krueger suggests that "Through the use of scaffolds, biologically-based components may be configured to architectural requirements,"[23] and Geoffrey Miles describes a future in which genetically modified bacterial towers dominate city skylines.[24] This emergence of a new class of object/being may become increasingly visible as our abilities to manipulate life increase. As these creations will contain different degrees of life and sentience, new relationships will be formed with our environment, and with the concept of life itself. Parts of our own bodies can be sustained apart from us as independent autonomous entities (currently, only small fragments such as skin cultures). What kinds of relationships are we going to form with these entities? Will we care for them or abuse them? Where will semi-living objects be positioned in the continuum of life and how will this affect our value systems with regard to living systems, including our own bodies, human or otherwise?

Notes

1. The best estimate is around fifty million. This is an estimate as some cells, such as blood cells, continue to divide and regenerate in response to different factors (though some cells, like neurons and, to a large extent, striated muscle, do not divide in the normal human adult). Therefore there is not a static cell count within any one person. Size differences between individuals also dictate that different numbers of cells must be present in the organs of different people (http://www.sciencenet .org.uk/database/Biology/Cell_Biology/b00307c.html).

2. The technique was invented by 1903 by J. M. J. Jolly, but was perfected by Alexis Carrel in 1910, who actually coined the term, "tissue culture." Cited in *A Vital Rationalist: Selected Writings from Georges Canguilhem*, ed. Francois Delaporte (New York: Zone Books, 1994), 300.

3. Hannah Landecker, "New Times for Biology: Nerve Cultures and the Advent of Cellular Life in Vitro," *Studies in History and Philosophy of Biological and Biomedical Sciences* 33 (2002): 567–760.

4. H. G. Wells, "The Limits of Individual Plasticity," in *H. G. Wells: Early Writings in Science and Science Fiction*, ed. R. M. Philmus and D. Y. Hughes (Berkeley: University of California Press, 1975), 36–39.

5. See http://www.darpa.mil/dso/TextOnly/thrust/sp/engcontissue.html.

6. Oron Catts initiated the Tissue Culture & Art Project in 1996.

7. The term "Evocative Object" was coined by Professor Sherry Turkle, originally in regard to computers and other E-toys. For more see Sherry Turkle, *The Second Self: Computers and the Human Spirit* (London: Granada, 1984).

8. Robert P. Lanza, Robert Langar, and Joseph Vacanti, *Principles of Tissue Engineering*, 2nd ed. (San Diego, CA: Academic Press, 1997), 4.

9. The Vacanti brothers and, especially, Dr. Joseph P. Vacanti are considered to be the pioneers in the tissue-engineering field.

10. We have worked as artists in residence in the School of Anatomy and Human Biology, University of Western Australia, for four years. This mode of collaboration was later developed to form and build a dedicated laboratory for artists dealing with life: SymbioticA—The Art and Science Collaborative Research Laboratory (established in 2000 by Professor Miranda G. Grounds and Dr. Stuart Bunt [Directors] and by Oron Catts [Artistic Director]). For more information see http://www.symbiotica.uwa.edu.au.

11. For the *Fish and Chips* project we used goldfish CNS (central nervous system). This work involved long and heated ethical discussions. At one point we were proposing to construct a "Fish and Chips" restaurant in the gallery while using the fish's CNS for neural recordings, cooking its body, and serving it (together with fried chips) to the audience.

12. It is possible to continue to grow the cells forever by transforming them into a cell line. Cell lines are cells that have been transformed by using viruses that ultimately cause the cells to grow indefinitely in culture. Primary cells are explanted directly from a donor organism. They have a finite number of divisions in culture and, given the right conditions, can survive for some time.

13. Landecker, "New Times for Biology."

14. As we developed our projects in the laboratories alongside our scientist colleagues, we found the interactions with them and their reactions and critiques of our work extremely stimulating. We believe that some of our best art works/performances were never shown in public—they happened (and are happening) in the lab. You can read some of the worries, and add your own, on our Web site, http://www.symbiotica.uwa.edu.au.

15. See http://www.adelaidebiennial.com/.

16. BBC News, June 2, 1999. Sci/Tech News, http://news.bbc.co.uk/hi/english/sci/tech/newsid_358000/358822.stm.

17. Peter Singer, *Practical Ethics* (New York: Cambridge University Press, 1993), 62.

18. It is interesting that the first restriction on eating parts of animals while they are still alive can be found in Genesis 9:3–4: "Every moving thing that lives shall be food for you; even as the green herb have I given you all things. But flesh with its life, which is its blood, you shall not eat."

19. Lynn Margulis, *Symbiosis in Cell Evolution* (San Francisco: W. H. Freeman and Company, 1981).

20. Etienne Wolff, cited in Francois Delaporte, ed., *A Vital Rationalist: Selected Writings from Georges Canguilhem* (New York: Zone Books, 1994), 301.

21. Jeremy Bentham, cited in Peter Singer, *Practical Ethics* (New York: Cambridge University Press, 1993), 57.

22. We are now considering constructing a mobile lab that will enable us to take the semi-living entities to remote places and enable interaction with different people through a service window in the van.

23. Ted Krueger, "Heterotic Architecture," in *Reframing Consciousness: Art, Mind and Technology*, ed. Roy Ascott (Portland, OR, and Exeter, UK: Intellect Books, 1999), 234.

24. From a lecture by Geoffrey Miles at the symposium "Tissue Culture, Art, and Architecture," organized by Eduardo Kac and Anders Nereim, at The School of the Art Institute of Chicago, October 19, 2001.

Cases for Genetic Art

Joe Davis

Recent History

Treatments of various topics of naturalism in the history of art and the coincidental rise of agriculture and genetic manipulation are undertaken elsewhere in this book. Instead, I will concentrate on the current philosophical and technological bases and motivations which have played a greater role in my own involvement in art and genetics.

In 1970, Morton Mandel and Akiko Higa (at the University of Hawaii School of Medicine) discovered that by treating cells with calcium salts, the cells could be encouraged to take up viral DNA. The first recombinant phage DNA was created by Paul Berg in 1971. The first successful recombinant bacteria were created by Herbert Boyer, Stanley Cohen, and Annie Chang in 1974. Technology for convenient synthesis and assembly of DNA molecules became widely available in the early 1980s. The first work of art made with synthetic DNA and genetically modified bacteria was created in 1986. The first completely functional synthetic genome (a synthetic polio virus) was created in 2002 (Couzin 2002).

In the short space of these three decades, human beings have learned how to animate heretofore inanimate materials. It is by no means an oversimplification to say that we have, in at least in a few first, cautious steps, learned how to bring ideas to life.

Aliens

Perhaps the most profound example of this "transanimation" is the serious scientific search for extraterrestrial intelligence, because we hope that by merely asking a question, we can bring the whole universe to life. Here human imagination has been moved to repeat earlier

themes. Popular hysteria about alien abductions are replete with sexual complications. There is both fear and anticipation.

While attitudes about alien-initiated sexual encounters are decidedly phobic, attitudes about human-initiated encounters have been quite the contrary. Consider the 1960s *Star Trek* episodes where starship captain James Kirk had romantic encounters with members of other species (extraterrestrials). Perhaps that is less frightening than recently published statistics suggesting that at least one out of eight Americans has had sex with (terrestrial) animals. It should be pointed out that William Shattner, who portrays James Kirk, is actually Canadian.

Monstrosities

An intriguing aspect of the transanimation stories is that they are almost always about horrible monsters that have romantic or sexual interactions with human beings. Yet, just as classical monstrosities all correspond to what we now understand to be examples of clinical pathology, it turns out that in one way or another, all of our monsters are versions of ourselves.

Artists invented chimeras at least in the classical, if not the modern, scientific sense. Composite, part human/part animal figures of the ancient pantheons all seem to have anticipated the spectre of interspecies monstrosity that haunts the antigenetics lobby and activists concerned with genetically modified food. Yet these chimeric "monsters" already exist in many, perhaps unsuspecting, forms.

Homo sapiens share many essential genes with the rest of terrestrial biology. We human beings, no matter how unique and gifted we imagine ourselves to be, have an approximate 70 percent genetic homology with tomatoes. Homo sapiens' genetic homology with chimpanzees and the great apes is closer to 99 percent.

Imaginary or not, monsters have undergone their own special form of evolution. They seem to have improved over time. These days, they are up-to-date creatures with access to the latest scientific and technical advancements. The business of transanimation by divine intervention has been switched to the more contemporary agencies of nuclear radiation and biotechnology. Dragons have given way to the more paleontologically correct dinosaurs while Washington Irving's "headless horseman" has become the new "acephalus," a (so far) mythical headless human clone created explicitly for organ harvest.

Over the last hundred years or so, genetically adjusted "monsters" have completely overrun the planet and currently occupy more territory than human beings themselves do. Like aliens in *Men in Black*, our monsters are numerous, ubiquitous, and incognito, and most of them have something to do with food.

Let's again take the tomato as an example, one that has been obtained say, at an "organic," "natural foods" grocery store. It has never been directly treated with chemical pesticides or fertilizers. Yet even this purest of tomatoes is a monster by dictionary definition.

Tomatoes are fat and luscious because they have many more copies of their chromosomes than their raisin-sized ancestor's normal complement.

The extra DNA in today's tomatoes means that many genes are translated over and over again, which has had the effect of giantizing the original fruit. Once upon a time we made giant tomatoes. It makes little difference whether or not this modification of tomatoes was carried out with conventional horticultural techniques, use of mutagenic agents, or the recombinant techniques of molecular biology. The result is the same. Tomatoes are monsters. Most people just don't know.

An early icon of the movement against genetically modified food was the "Flavr Savr" tomato, a genetically modified variety that stays fresher longer on grocery store shelves than "ordinary" tomatoes do. In this case, no extra chromosomes were created. No extra gene was added to the tomato genome. In fact, Flavr Savrs have a little less DNA than other tomatoes. In Flavr Savrs, one of the genes that cause tomatoes to "rot" (coding for an enzyme that digests tomatoes from the inside) has been removed. Otherwise, Flavr Savrs are identical to other tomatoes.

A rose is a Frankenstein too, of course, because it is comprised of pieces and parts of the genomic makeup of many other subspecies of roses.

Over time, human beings have not only been the creators of monstrosity, they have become the phages and/or consumers of the monstrosities they have created. In so doing, they have indirectly modified themselves. If modern Homo sapiens had to survive on the ancestors of species that make up its current food supply, genetic "retrofits" would be called for. We would have to resupply ourselves with the phenotypes of earlier homonids simply to manage the collection and digestion of those materials.

Not only have we been historically confused about who the monsters are, we expect everybody else (aliens) to be just as confused as we are.

The Search

Whether or not it was our original intention, we have sent strangely incorrect pictures off into the cosmos explicitly to impersonate our species. These were rocketed out of the solar system on gold-plated message plaques with NASA Pioneer and Voyager interplanetary probes. They are reputed to be the first serious scientific attempts to communicate with alien species.

Launched in the early and mid-1970s, NASA's Pioneer and Voyager spacecraft achieved enough velocity to escape the solar system with the assistance of the Jovian gravitational field. They are the fastest ballistic objects ever created by human beings and are now traveling at about 1/20,000th light speed—many, many times faster than a speeding bullet.

Pioneer message plaques contain a collage of visual information including a rudimentary map of the solar system and the spacecraft's trajectory, a chart of quasi-stellar objects

called "pulsars" (which was intended to guide curious extraterrestrials back to the vicinity of our solar system), an image of the Pioneer probe itself, and two line drawings intended to represent average male and female Homo sapiens. The figures are of well groomed Caucasians without facial or body hair. The male figure has a mysterious raised arm and open hand, and "appropriately" represented genitals. The genital structures of the smaller female figure are conspicuously missing.

NASA decided to completely eliminate all attempted representations of nude human beings from messages accompanying the two Voyager probes, the next spacecraft to leave the solar system. Clearly, such censorship was not undertaken for the benefit of aliens.

Obviously, we know very little about aliens. It is probably a highly self-centered view to assume that our attempt to communicate should necessarily target alien "animals." An openminded investigator would assume that we might attempt to communicate with an intelligent plant, for instance, or something like a plant. Like our own cells, plant cells are eukaryotic (having nuclei) as distinguished from less complicated cells (including bacteria) that characterize the kingdom of prokaryotes. Yet, even this view would very likely also be a short-sighted one.

Whatever the reasons for the great Precambrian Extinction, whole phyla were wiped out in that relatively brief moment. Those strange life forms would otherwise have evolved into a modern terrestrial biology drastically different from the present one. The implication is that even plants would turn out to be closer to our expectations (and easier to communicate with) than the alien life forms we may ultimately detect.

It may be just as short-sighted to decide that knowledge of mathematics is a prerequisite for an intelligent species (Wittgenstein and others suggest as much). For that matter, there is no reason to assume that "intelligence" as we understand it is central to any other entity in the universe save Homo sapiens itself.

Still, if "intelligence" exists anywhere else in biological form, there is one thing we can be nearly certain of: that intelligent entity is very likely to be a sexual one because organisms must exchange genetic material in order to evolve. Joshua Lederberg was awarded the Nobel Prize in 1958 for his discovery that even bacteria have sex. They exchange genetic material and they evolve. In fact, since they are thought to have been among the Earth's first living inhabitants and since they can produce a generation every twenty minutes or so (in the case of E. coli), they are technically much more highly evolved than we are.

Advertently or inadvertently, we have managed to send several messages into space that could be interpreted as speaking very strongly about our own intolerance. Our communications suggest that aliens aren't entitled to know what we look like. Perhaps we should not be so skeptical about reports that aliens are abducting people to experiment with their sex organs.

In 1974, astronomers sent their first light-speed message into space in an attempt to communicate with extraterrestrials. As it turns out, even though the Pioneer and Voyager

spacecraft are the fastest artificial ballistic objects in history, at 1/20,000th light speed, it would take about 100,000 years for one of them to reach the nearest star. Unfortunately (or perhaps, fortunately), the Pioneer and Voyager probes are not headed for the nearest star and are not expected to enter the planetary environment of any star for at least a billion years.

Astronomers Frank Drake and Carl Sagan decided to use the million-watt radar transmitter at Arecibo, Puerto Rico, to beam a three-minute, light-speed message to the constellation *Hercules* in 1974.

Because of its inherent simplicity, Drake and Sagan reasoned that binary mathematics would be the most universally acceptable form of quantization. Futhermore, the two astronomers decided that if aliens knew about mathematics, they would also know about prime numbers and numbers mathematicians call, "Zormelo numbers." These are a family of numbers, like the number 35, that can only be divided by itself, 1, and the two prime factors (in this case, 5 and 7). Drake and Sagan used the Arecibo radar to transmit a signal consisting of 1679 "ons" and "offs"(zeros and ones). 1679 is a Zormelo number that can only be factored by itself, 1 and the prime numbers 23 and 73. Thus, intelligent aliens would deduce that the stream of 1679 bits must be compiled into a 23 by 73 rastar grid. If the "zeros" and "ones" are assigned contrasting values (e.g., "light" and "dark"), then in one of several possible 23 by 73 compilations, the intended image appears. Finally, with one more leap of faith, the alien interprets intended information from the assembled graphic.

Like the Pioneer plaques, the correctly interpreted Arecibo radar message contained a picture of its vehicle (the Arecibo radar dish); a rudimentary map of the solar system; and a crude representation of human beings (a single stick figure). The Arecibo message also contained a representation of the right-handed DNA helix, the atomic weights of its five constituent chemical elements, the approximate number of DNA bases in the human genome, and a 1974 world population estimate.

Message in Many Bottles

In 1989, I installed one of my several artworks inspired by the Arecibo message at the Hayden Library at MIT. The artwork, entitled *Message in Many Bottles*, consisted of 1,679 generic, "Boston Round" sixteen-ounce glass bottles with phenolic caps mounted in large partitioned racks. "Ones" were water-filled bottles; "Zeros" were empty. The installation occupied eighteen aisles of library space in the basement "stacks" of the library. Hayden is one of MIT's largest libraries. It contains all of the information the message refers to; all of the information needed to decode the message; and supposedly better-than-average terrestrial intelligence frequently visit the library.

No one decoded the message. There was some concern about whether or not the racks of bottles installed in the library aisles constituted a nuisance to scholars and, of course,

there was ample discussion about whether the installation was actually art or not. Evidently, at least some of the problems inherent in extraterrestrial communications are not unlike problems we encounter when trying to communicate with each other.

Messages human beings compose for the purpose of communication with extraterrestrial intelligence are vast in context and yet they must be somehow self-revealing. Aristotle realized that we must first reveal ourselves to ourselves before we can reveal ourselves to others. In "Poetics," his theory of art, Aristotle considered this problem of self-revelation to be an essential element of the poetics of tragedy. He called it the principle of "recognition and reversal" and, indeed, this is a theme that reverberates throughout the history of art and literature: I go all the way to the ends of the Earth in search of the Holy Grail. On the way, I kill my mother, engage in terrible adversity, unspeakable suffering and harsh travails. In the end, I finally arrive only to discover that the Grail has been in my back pocket the whole time.

It is the story of *Jekyll and Hyde*, *Moby Dick*, *Oedipus*, *The Return of Martin Guerre*, *Fitzcarraldo*, and *The Wizard of Oz*.

The "other," like the "monster," invariably resides within. Everywhere else we go and in everything else we see, no matter how distant or remote from the world, there we find only reflections. In the Aristotelian view, we finally arrive at the edge of the universe and discover that the cerebral cortex is imprinted on the wall there and we suddenly pop out on top of our own heads.

Scientists who take the search for extraterrestrial intelligence seriously continue to construct elaborate and, for practical purposes, unintellible digital messages for interstellar radar transmissions; but the universality of binary language is questionable on several grounds.

First, we are bilaterally symmetrical creatures in a world rife with other possible symmetries. We are immersed in traditions of cognitive dichotomy: right and left, positive and negative, true and false, good and evil. If we were instead radially symmetrical, we might consider some other form of mathematical expression to be the most likely "universal" one.

Zero wasn't invented on our own planet until about a thousand years ago. Presumably intelligent creatures who built the Parthenon, the aquaducts of Rome, and the pyramids of Egypt, and those who first mapped the stars and calculated the Earth's circumference did so without the use of zero.

Another problematical preconception is that scientists' dependency on visual information for interstellar communications, whether in the form of rastered pixel arrays or engravings on message plaques, presumes that alien visual sensory organs will be available to view those messages. On our own planet, Kent Cullers, now at the SETI Institute in California, and who for many years was one of NASA's principal investigators devoted to the search for extraterrestrial intelligence, is a blind man.

Joe Davis

Poetica Vaginal

In 1986, I organized an artistic project to transmit vaginal contractions into space to communicate with extraterrestrial intelligence. The project, called *Poetica Vaginal*, involved artists, mechanical and electrical engineers, biologists, astronomers, professional dancers, architects, linguists, and philosophers.

A "vaginal detector" was built in a mechanical engineering laboratory and consisted of a water-filled polyallomer centrifuge tube mounted on a hard nylon base that contained a very sensitive pressure transducer. Dancers and other female volunteers (unsolicited) hygienically invaginated the detector in order to characterize vaginal contractions (the fastest was clocked at 0.8 Hz). The embedded pressure transducer was sensitive enough to detect voice, heartbeat, and respiration as well as voluntary and involuntary vaginal contractions.

Electronic music software was used to generate real-time harmonics of vaginal contractions until that frequency matched one of the frequencies in the set of unique frequencies of English speech.

A collaborating linguist bit-mapped those speech sounds (called "phonemes") so that they could be generated in real time corresponding to vaginal "inputs." A digital map of the analog detector output was also made in real time. In this way, three forms of the message were simultaneously generated: (1) an analog signal directly generated by vaginal contractions, (2) a digital map of the contractions, and (3) voice (English phoenetic maps of vaginal contractions).

Collaborating electrical engineers built gating circuits so that *Poetica Vaginal* signals could be transmitted from MIT's million-watt Millstone Radar transmitter at Haystack Observatory in Groton/Westford, Massachusetts.

Artists, architects, and mechanical engineers collaborated in the construction of a "Vaginal Excursion Module" to contain electronics and human operators at the transmission site. A folding structure made of steel, cable, wood, and thatch materials, the Vaginal Excursion Module looked rather like a Native American "sweat lodge" mounted on a Mars lander.

Astronomers and astrophysicists collaborated in the selection of four nearby sunlike stars: Epsilon Eridani, Tau Ceti, and two unnamed sunlike (G-type) stars with RGO (Royal Greenwich Observatory) catalogue numbers. These stars are from ten to forty light years away. Their positions (right ascension and declination) were calculated so that radar signals could be targeted. The Vaginal Excursion Module was assembled at Haystack and preliminary test transmissions of vaginal signals were undertaken with sample vaginal signals recorded on audio tape. Then, on the eve of the planned live broadcast, the Millstone project Group Leader, a United States Air Force Colonel (Millstone Radar had been contracted to the Air Force by MIT) suddenly terminated the project.

Slow Boats and Other Problems

Like spacecraft-based experiments, radar transmission experiments in interstellar communications also have significant problems to overcome. There are no powerful radar transmitters in space, so transmissions must be sent through the relatively dirty window of atmosphere. This effectively narrows the range of frequencies that can be transmitted.

Millstone Radar was a convenient choice of transmission instruments for the *Poetica Vaginal* project not only because it is an MIT facility (a number of the *Poetica Vaginal* collaborators were affiliated with MIT), but also because it is one of the few radar transmitters that can generate powerful signals at frequencies at which sunlike stars make only relatively weak signals of their own. A million-watt radar signal between one and ten gigahertz is "bright" enough to outshine the sun. That is, a megawatt signal is enough to make the sun appear to be "brighter" at those particular frequencies than any other G-type star.

One problem with this strategy is that it only works when the receiving entity happens to be located precisely in the center of the transmitted beam of radio photons (i.e., at the center of the columnated radar signal). Because radar waves are photons and photons diverge (according to the "inverse square law")—like the focused beam of photons from an automobile headlight or a hand-held flashlight diverge—the radiated signal incident on a receiver drops off dramatically with distance from the center of the beam. Over interstellar distances, targeting must be extremely precise.

There are from 200 to 400 billion stars in our local galaxy, and a significant percentage of these are G-type (sunlike) stars. Owing to technical limitations, radar transmissions can only be made to one star at a time. To put this in perspective, there are many more stars in the Milky Way than there are fish in the ocean. One day we decide to go fishing for only three minutes. We hope that we are successful, but we are only equipped to catch one particular fish in an ocean full of fish. Our chances for success are extremely slim.

The biggest problem with high-speed messages for extraterrestrial intelligence is that at cosmic scales, even light-speed messages are very slow "boats." The Milky Way galaxy is approximately light years in diameter. A transit from one side to the other and back again equals a 200,000-year round trip at the speed of light. The "mitochondrial Eve" (from which all living human beings are said to be decended) lived approximately 200,000 years ago.

If the mitochondrial Eve had somehow obtained the facilities needed to transmit a signal at the right frequency and with enough power to the other side of our own galaxy, and that signal was received at the right moment 100,000 years ago by an alien intelligence who immediately beamed a corresponding message back in our direction, that message might not have arrived yet. Meanwhile, Eve evolves into another species. The mitochondrial Eve was probably not Homo sapiens as we know it.

The radar dish at Arecibo is not highly maneuverable because it is built into the hemispherical depression of an extinct volcanic crater. Signals transmitted from there can therefore only be aimed through a limited window. Sagan and Drake had to choose from stars appearing in that window at the time they transmitted their interstellar message. As a result, the light-speed message transmitted from Arecibo was beamed to a group of stars in the constellation Hercules that lie about 25,000 light years away. So, here we are, waiting in the chapel with fresh flowers for the spouse for 50,000 years: nude descending and descending and descending the staircase, bachelors waiting and waiting and waiting to strip the bride bare. It is tragic indeed.

Aside from any problems having to do with message content, three basic technical problems remain that surface in all experimental interstellar communications projects: First, billions of message copies are needed for billions of possible receivers. Second, the message carrier must be robust enough to survive harsh extremes of the space environment including thermal extremes, radiation, and vacuum. Third, for practical purposes, the integrity of the message carrier must remain intact indefinitely (at least for periods of time that are equivalent to periods we call "geologic time"). These are the problems that stitch together the immeasureable scale of the macrocosmos with the infinitesimal minutae of the microcosm. They inspired my first artistic projects in molecular biology.

It so happens that bacteria, especially sporulating bacteria, can cope with the criteria of these three problems very well. They have been shown to survive the space environment for extended periods of time and can probably do so indefinitely. Many billions of exact copies of a single bacterium can be conveniently and inexpensively produced overnight.

Microvenus

In 1986, two of the *Poetica Vaginal* collaborators (myself and Dana Boyd, a Harvard geneticist and molecular biologist) decided to create a model bacterial carrier of human intellectual information. This work, called *Microvenus*, became the first work of art to be created with the recombinant tools of molecular biology and the first artwork to be created directly in the form of DNA (Davis 1996). *Microvenus* consists of a graphic icon (like a "Y" and an "I" superimposed) that was coded into a sequence of DNA nucleotides. The sequence was synthesized with Martin Bottfield at Harvard. The resulting synthetic oligonucleotides were purified at UC Berkeley with Dana Boyd and later transformed at Harvard with laboratory strains of E. coli by single-strand, blunt-end ligation with pUC19 and pSK-M13+ plasmid vectors.

Microvenus was the first of several artworks that employ increasingly complex strategies to artificially encode human knowledge into DNA. We assigned a set of phase values to the four DNA bases (C = x; T = xx; A = xxx; G = xxxx) in order to code the *Microvenus* icon. This strategy was combined with the Zormelo raster-mapping technique used by

Drake and Sagan to compose the Arecibo message. *Microvenus* was coded into a 35-bit (7-bit by 5-bit) Zormelo raster containing the icon:

10101
01110
00100
00100
00100
00100
00100

Using phase value assignments for the four DNA bases, the number comprising this binary raster can be expressed as "CCCCCCAACGCGCGCGCT." The first binary digit on the upper left (top row) can be expressed as "C" because that number has a single phase, that is, it is not immediately repeated. It remains in the same state ("1") a single time before switching to the other binary digit. The second, third, and fourth digits in the second row can be expressed as a single "A" because that number ("1") repeats three times before switching to the other binary digit. The next four binary digits can be expressed as "G." In this way, the 35-bit *Microvenus* raster is coded into 18 DNA bases. In addition, a short sequence, "CTTAAAGGGG," was added as a decoding clue (referring to the DNA base-to-phase value assignments). The combined 28-mer *Microvenus* DNA sequence reads "CTTAAAGGGGCCCCCCAACGCGCGCGCT."

The *Microvenus* icon is both an ancient Germanic rune for the female Earth and a graphic representation of genitalia heretofore censored from messages to extraterrestrial intelligence. No provision was ever made to disseminate *Microvenus* bacteria into space and so to risk contamination of extraterrestrial environments with terrestrial bacteria. But *Microvenus* bacteria, perhaps as Bacillus spores, would have significant advantages over radar and spacecraft as carriers of messages for extraterrestrial intelligence.

The Riddle of Life

In the early 1990s, I discovered that some scientists had thought about writing messages into DNA some thirty years before the *Microvenus* organism was made. I found two books that made minor references to this little-known episode in the history of science (Fischer and Lipson 1988; Beadle and Beadle 1966). The events took place in the year 1958.

Watson and Crick (with the help of Rosalin Franklin) had resolved the structure of DNA some five years earlier, but nearly another decade would elapse before scientists resolved the working details of the genetic code. The triplet-codon operational aspects of

DELBRÜCK *RIDDLE OF LIFE* RNA CODE (ABCD=UCAG)

FIRST PLACE↴	URACIL	CYTOSINE	ADENINE	GUANINE	↲THIRD PLACE
URACIL	UUU-PHE UUC-PHE UUA-LEU UUG-LEU	UCU-SER UCC-SER UCA-SER UCG-SER	UAU-TYR - **S** UAC-TYR - **T** UAA-STP UAG-STP	UGU-CYS - **A** UGC-CYS - **D** UGA-STP - **E** UGG-TRP	URACIL CYTOSINE ADENINE GUANINE
CYTOSINE	CUU-LEU CUC-LEU CUA-LEU CUG-LEU	CCU-PRO - * CCC-PRO CCA-PRO CCG-PRO	CAU-HIS - **U** CAC-HIS - **W** CAA-GLN CAG-GLN	CGU-ARG - **F** CGC-ARG -**H** CGA-ARG - **I** CGG-ARG	URACIL CYTOSINE ADENINE GUANINE
ADENINE	AUU-ILEU AUC-ILEU AUA-ILEU AUG-MET	ACU-THR ACC-THR ACA-THR ACG-THR	AAU-ASN - **Y** AAC-ASN AAA-LYS AAG-LYS	AGU-SER - **K** AGC-SER - **L** AGA-ARG -**M** AGG-ARG	URACIL CYTOSINE ADENINE GUANINE
GUANINE	GUU-VAL GUC-VAL GUA-VAL GUG-VAL	GCU-ALA GCC-ALA GCA-ALA GCG-ALA	GAU-ASP GAC-ASP GAA-GLU GAG-GLU	GGU-GLY - **N** GGC-GLY - **O** GGA-GLY - **R** GGG-GLY	URACIL CYTOSINE ADENINE GUANINE

Figure 16.1

DNA were known, but the distribution of the twenty amino acids according to their representations by the sixty-four possible nucleotide triplets was not resolved until 1967. In the interim, biologists realized that the operation of the genetic code was in many ways similar to the operation of natural language. A given triplet codon has as much to do with the amino acid it represents as, say, the word *red* has to do with the phenomenon or perception of the color red. In this way, the genetic code works like language in the formal, linguistic sense and when scientists discovered this, they waxed just a little bit poetic. For a few years there were even arguments in the halls of biology about whether or not there were "spaces" between the "words." Biologists designated these competing views as "comma-" and "comma-free" codes. Once again, science had reached the limits of understanding and found its own language reflected there.

On the occasion of the 1958 Nobel Prize ceremonies in Stockholm, two scientists exchanged several encrypted messages based on the linguistic operations of the genetic code. Max Delbrück and George Beadle sent a series of messages to each other in which letters of the English alphabet were substituted for the positions of amino acids in the 64-place code (Fischer and Lipson 1988) (figure 16.1). Delbrück's messages contained "commas" or "space" codons. Beadle's were "comma-free."

The final message in this exchange was a DNA model constructed of 174 toothpicks in four different colors. Delbrück had shipped the model to Stockholm and Beadle decoded it at the podium in a formal lecture that followed his Nobel Prize award. The model contained the message, "I am the riddle of life know me and you will know yourself."

Delbrück's riddle was the "Riddle of the Sphinx." "Know Thyself" was the edict of Apollo at the temple of Delphi and the doctrine of its famous oracles. It was the reason

Socrates went running around Athens trying to prove that he knew nothing at all (which evidently contributed to his demise).

In 1995, I was inspired by all of this to organize an exhibition at Harvard's Boylston Hall and Harvard Yard called *The Riddle of Life*. That exhibition featured the participation of both artists and scientists (Nadis 1995).

Professor Al Wunderlich, then head of the Painting department at the Rhode Island School of Design (RISD), contributed a rack of 174 test tubes containing four different light-emitting phosphors. RISD students contributed a 174-picket fence (installed in Harvard Yard) stenciled with the images of four different animals. Rob Stupay, an MIT graduate student in architecture contributed a computer-manipulated graphic of 174 one-, two-, three-, and four-story houses on a street in Somerville, Massachusetts. We made models with 174 toothpicks; 174 broomsticks; ladders with 174 rungs; and four strands of knotted rope with 174 knots. All of these artworks contained the message, "I am the riddle of life know me and you will know yourself." My own most significant contribution was the 174-mer Riddle of Life DNA.

Delbrück and Beadle could not synthesize actual DNA in 1958. In fact, DNA could not be conveniently synthesized until the mid-1980s and a molecule as large as the 174-mer Riddle of Life DNA could not be conveniently synthesized before the advent of PCR (polymerase chain reaction)—assisted synthesis which was not widely available to biologists until the early 1990s.

In the winter of 1993–1994, I arranged for the synthesis and purification of Riddle of Life DNA at Burkhardt Wittig's laboratory at Free University in Berlin. Later (1994), I assembled and cloned the Riddle of Life oligonucleotides into E. coli with Stefan Wölfl at Alexander Rich's laboratory at MIT.

Permission was obtained from Harvard's Biosafety Committee and the Cambridge (Massachusetts) Biosafety Committee to install the Riddle of Life E. coli in a locking, double-glass fronted refrigerator that was obtained for that purpose and installed in Harvard's Boylston Hall.

The journal *Nature* published a page-long article about the Harvard Riddle of Life exhibition that suggested that we had built a "bridge between two cultures" of science and art. Unfortunately however, we didn't quite make it all the way across the bridge.

Regulatory Issues: Production, Exhibition, and Public Display of Genetic Art

In a last-minute "clarification," Harvard's Biosafety Committee reversed its initial permission to install Riddle of Life E. coli in the refrigerator in Boylston Hall. This finding was made in spite of the fact that *Scientific American* had recently nationally published a do-it-yourself "Amateur Scientist" column instructing hobbyists about how to create their own recombinant E. coli at home in an aquarium with a light bulb incubator.

Five years later, Riddle of Life organisms were finally displayed publically in special enclosures at Ars Electronica 2000 in Linz, Austria (Nadis 2000). Arrangements for physical and biological containment were made with full authorization and oversight of Austrian biosafety officials.

Genetic artists who choose to manipulate the DNA of living organisms must obviously confront significant technical, architectural, climate control, and biosafety issues connected with public display of recombinat organisms. The same is, of course, true for curators who choose to mount such exhibitions in publically accessible venues. Gallery and museum operators have often found themselves unable or unwilling to undertake the challenges that are required for the handling and display of genetic (genetically modified) art. Daunting security and liability issues must be overcome. Curators are also concerned with founded and/or unfounded public hysteria about genetic manipulation in general and the attitude of the press.

In the laboratory, organisms are relegated to increasing levels of containment based on how dangerous they are perceived to be to other organisms (including human beings). Organisms like E. coli (the human intestinal bacterium) were chosen to become the workhorses of biology because they normally coexist with human beings without any attending pathology. Although they comfortably coexist with human beings, E. coli make bacteriotoxins which are harmful to other bacteria. This accounts for their overwhelming majority among bacterial populations of the human intestinal tract. In fact, E. coli are crawling all over us most of the time. They are found inside and outside of human beings everywhere human beings themselves are found.

Protocols for handling these organisms in the laboratory basically specify commonsense hygiene. Genetically engineered E. coli are stored in airtight containers. Contaminated waste and used containers are routinely autoclaved prior to disposal.

Particularly dangerous organisms are handled with much more rigorous hygienic practices and more elaborate arrangements for isolation and containment. Pathogens like typhus, HIV, or anthrax are manipulated airlocked in glove boxes. Gasses, including ordinary atmosphere coming into contact with such organisms, undergo combustion on the way out of the building. Airborne pathogenic particles are thereby incinerated.

The most dangerous organism of all is handled somewhat differently. That organism, responsible for the extinction of one species every day (some say it is responsible for one species per minute) is of course, Homo sapiens. There are no protocols for containment of biologists themselves.

Occasionally, scientists will violate minor rules. There are, for instance, considerable formalities, dictated by three separate biosafety authorities, involved in the authorized transport of a single petri dish of E. coli cultures over the approximately one mile distance that separates Harvard and MIT. Some scientists consider such regulation excessive and routinely transport their cultures back and forth without attending to paperwork and interviews that constitute legally required oversight.

Whether or not scientists regularly abide by these rules, artists must carefully observe them and they can expect to encounter scientific anxiety surrounding the production of genetic artworks. There are, in fact, no protocols in place for the disposition of genetically engineered organisms that are used in the production of art. As a result, some scientific workers may feel that only other scientific workers can safely handle recombinant materials. In fact, science has no particular franchise on responsible conduct. The history of scientific misconduct and the horrors perpetrated against humanity and the environment—where science has been named as a principal excuse—now account for themselves. To date, artists have depended on collaborating scientific laboratories for the production of genetic artworks. Artists are just beginning to consider their studios as places where true genetic engineering might be undertaken for artistic purposes. An important condition of artistic collaboration in the laboratory is that artists must observe scientific protocols or they will quickly lose access to those facilities. Responsibility for all ethical (including specifically regulated) activities involving the laboratory—such as the disposition of organisms outside of a laboratory—would normally entail the culpability of the laboratory where said organisms were produced.

Genomic Art

In a relatively short period of time, artists have moved from the traditions of naturalism as mimetic representation to the direct manipulation of life itself. To date, the extent of these artistic manipulations has been work with single genes (or sets of genes) and their expression or disposition within the cells of host organisms.

In the course of time, artists will find themselves engaged in much more ambitious projects. Their involvement with the techniques of molecular genetics and molecular biology can be expected to increase as the technology itself, understandings of genetics, and, now, human genomics also advance. Soon, works of art will be created at the scale of many genes, even whole genomes.

Genomes are large reservoirs of highly organized information that have elaborate, built-in or self-generated systems for data interpretation and analysis. Since these systems are made of nucleic acids and proteins, they operate with a level of sophistication that has never been present in the kind of straightforward mathematical operations used to handle conventional databases.

Art that, in a biological sense, consists of large, randomly compiled DNA sequences cannot be automatically replicated in vivo. Large numbers of simple repeats of a single or of a few DNA base-pairs are biologically unstable. Some sequences can have properties that lead to instability and can even be toxic to host cells.

Genomic art, and even genetic art at a larger scale, must be able to encode large amounts of arbitrary information into "biologically friendly" DNA molecules. The DNA supercodes were designed for this purpose.

FIRST PLACE↓	URACIL	CYTOSINE	ADENINE	GUANINE	↓THIRD PLACE
URACIL	UUU-PHE-T UUC-PHE-E UUA-LEU-0 UUG-LEU-0	UCU-SER-2 UCC-SER-2 UCA-SER-2 UCG-SER-2	UAU-TYR-F UAC-TYR-F UAA-STP-* UAG-STP-X	UGU-CYS-G UGC-CYS-G UGA-STP-** UGG-TRP-J	URACIL CYTOSINE ADENINE GUANINE
CYTOSINE	CUU-LEU-0 CUC-LEU-0 CUA-LEU-0 CUG-LEU-0	CCU-PRO-5 CCC-PRO-C CCA-PRO-5 CCG-PRO-5	CAU-HIS-H CAC-HIS-H CAA-GLN-B CAG-GLN-B	CGU-ARG-9 CGC-ARG-9 CGA-ARG-9 CGG-ARG-9	URACIL CYTOSINE ADENINE GUANINE
ADENINE	AUU-ILEU-C AUC-ILEU-C AUA-ILEU-C AUG-MET-I	ACU-THR-7 ACC-THR-7 ACA-THR-7 ACG-THR-7	AAU-ASN-D AAC-ASN-D AAA-LYS-A AAG-LYS-8	AGU-SER-2 AGC-SER-2 AGA-ARG-9 AGG-ARG-9	URACIL CYTOSINE ADENINE GUANINE
GUANINE	GUU-VAL-6 GUC-VAL-6 GUA-VAL-6 GUG-VAL-6	GCU-ALA-3 GCC-ALA-3 GCA-ALA-3 GCG-ALA-3	GAU-ASP-A GAC-ASP-A GAA-GLU-4 GAG-GLU-4	GGU-GLY-1 GGC-GLY-1 GGA-GLY-1 GGG-GLY-G	URACIL CYTOSINE ADENINE GUANINE

Figure 16.2

Key for a base-20 degenerate DNA code.

Supercodes and the Milky Way DNA

In 1995 I created the first DNA supercode (figure 16.2) for the purpose of encoding a map of the Milky Way Galaxy into a molecule of DNA (Davis 2000).

The Milky Way Map is about a 1.1 kilobyte digital picture file containing the NASA Cosmic Background Explorer (COBE) map of the Milky Way, which can be represented as a string of binary digits.

The supercode uses most of the 64 nucleotide triplets to represent base-20 numbers that are used to code the input information (in this case, the COBE map). A second level of coding is used to solve biological problems associated with coding of arbitrary data directly into DNA. The three termination or "stop" codons (TAA, TGA, and TAG) are reserved to function as "switches" between different coding modes and to specify mononucleotide simple repeats that appear in the input data. The four mononucleotide triplets (CCC, TTT, AAA, and GGG) are used to specify corresponding DNA bases (C, T, A, and G).

The DNA supercode has three coding modes: (1) "TGA" is used to indicate biologically compatible segments of input data that are directly coded into DNA. (2) "TAA" is used to indicate mononucleotide repeats where a tripletb invoking a base-20 number precedes one of the triplets indicating a particular DNA base. (3) "TAG" is a noncoding or "delete" mode indicating that a sequence does not contain input data. TAG-specified sequences can contain recognition sites for enzymes needed for manipulation and assembly of the complete sequence, or for the insertion of essential functional genes to facilitate the stability of a completely assembled sequence in vivo.

The first step in supercoding a given database uses the TAA mode to encrypt all termination codons appearing in input data that has been directly coded into DNA. All termination codons inserted as supercode mode-switching elements are deleted in the decoding process. Codons that can initiate translation (ATC, GTG, TTG, CTG, etc.) of input data by host cell biological machinery may also be encrypted in order to prevent undesired expression in vivo.

Supercode, like the genetic code itself, is highly degenerate, so a large number of DNA sequences could be generated that would each be decoded into exactly the same input data. In the case of the Milky Way DNA, for instance, many more sequences could be generated that contain the map of the galaxy than the number of stars it actually contains.

My inspiration for creating the Milky Way DNA was a children's story about a spoiled child who could find no happiness until she met a mouse with a map of the world in its ear.

The first Milky Way DNA was synthesized in 2002 and installed at the *Biologia Como Arte* exhibition (Queiroz 2002) in Barcarena, Portugal (2002). The entire Milky Way DNA sequence comprises a 3867 bp DNA molecule that is larger than many plasmids and is the approximate size of many complete viral genomes.

Silent Code

DNA supercode solves many of the problems associated with encoding very large databases into DNA. One significant problem remains, however. An organism will tend to delete a DNA sequence that serves no significant biological purpose.

Dana Boyd and I have recently created a next-generation code called the "Silent Code" that uses the degeneracy of the genetic code to insert arbitrary information into the coding sequence of a gene without altering the biological transcript of that gene. Encoded arbitrary information will not be rearranged or deleted by a host organism as long as it resides within the coding sequence of an essential gene.

The Silent Code uses codons that represent 18 of the 20 amino acids in the genetic code (44 of 64 codons). Each of these 18 amino acids are represented by 2 to 6 triplet codons in the code. (18 codon sets corresponding to 18 of 20 amino acids). Each of these codons is assigned a binary number value in the Silent Code. Codon sets of two triplets are assigned the values "0" and "1." The codon set containing three triplets is assigned "0," "1," and "00" values. Codon sets of four triplets are assigned the values "0," "1," "10," and "11." Sets of 6 codons are assigned "0," "1," "10," "11," "00," and "01" values.

Termination codons (TAA, TGA, and TAG) and the single codon sets for methionine and tryptophan (ATG and TGG) are not used in the Silent Code (figure 16.3).

The Silent Code contains less arbitrarily encoded information per DNA base-pair than supercoded DNA, but the Silent Code is indeed very "quiet," biologically. Protein struc-

```
SILENT CODE
     amino acid     [codon = silent code
value]
     1) PHE   = [ UUU = 0, UUC = 1]
     2) LEU   = [UUA= 0, UUG = 1; CUU = 10;
CUC = 11; CUA = 00; CUG = 01]
     3) ILEU  = [AUU = 0; AUC = 1; AUA = 00]
     -) MET   = [AUG = X]
     4) VAL   = [GUU = 0; GUC = 1; GUA = 10;
GUG = 11]
     5) SER   = [AGU = 0; AGC = 1; UCU = 10;
UCC = 11; UCA = 00; UCG = 01]
     6) PRO   = [CCU = 0; CCC = 1; CCA = 10;
CCG = 11]
     7) THR   = [ACU = 0; ACC = 1; ACA = 10;
ACG = 11]
     8) ALA   = [GCU = 0; GCC = 1 GCA = 10
GCG = 11]
     9) TYR   = [UAU = 0; UAC = 1]
     -) STOP  = [UAA = X, UAG = X; UGA = X]
     10) HIS   = [CAU = 0; CAC =1]
     11) GLN  = [CAA = 0; CAG = 1]
     12) ASN  = [AAU = 0; AAC = 1]
     13) LYS  = [AAA = 0; AAG = 1]
     14) ASP   = [GAU = 0; GAC = 1]
     15) GLU  = [GAA = 0; GAG = 1]
     16) CYS  = [UGU = 0; UGC = 1]
     -) TRP   = [UGG = X]
     17) ARG  = [AGA = 0; AGG = 1; CGU = 10;
CGC = 11; CGA = 00; CGG = 01]
     18) GLY  = [GGU = 0; GGC = 1; GGA = 10;
GGG = 11]
```

Figure 16.3

tures and interactions, overall number of base-pairs, and the energy requirements of a host cell remain essentially the same with or without Silent Coded information.

Simultaneous coding of distinctly different, multiplexed (extrabiological) databases is also possible within the individual DNA sequences of naturally occurring genes. It is "silent" because it, too, can be accomplished without altering either the biological translation products of original, unencoded DNA sequences (i.e., naturally occurring amino acids, peptides, and proteins) or the number of individual nucleotides that normally comprise unaltered, natural genes (this form of Silent Code will be described elsewhere). These two kinds of DNA Silent Code constitute forms of genetic manipulation that are very

likely to be less "interfering" with host organisms and more environmentally friendly than all previous genetic modifications. These may be undertaken with negligible effect on the ecology of interactions a host organism may have with other organisms and with the environment as a whole.

Conclusion

Beyond historical notions about naturalism in art, artists are now confronted with art that truly coincides with nature itself. There are opportunities to create new kinds of genomes that contain more than just genetic instructions for biological interactions. Artists will create self-perpetuating genomes of human spirit and imagination. It is unlikely that skepticism or indifference of the scientific community will serve to prevent these developments. On the contrary, provincial scientific attitudes will probably continue to provide artists with their principal sources of inspiration. Perhaps ironically, genetic artists may ultimately behave with more environmental sensitivity than science itself has demonstrated to date.

Two projects involving the DNA Silent Code are currently under way.

Acknowledgments

The author wishes to gratefully acknowledge the contribution of Peter Seidler, who has partly supported the synthesis and assembly of the Milky Way DNA.

References

Beadle, George Wells, and Beadle, Muriel. *The Language of Life: An Introduction to the Science of Genetics*. Garden City, NY: Doubleday, 1966.

Couzin, Jennifer. "Active Polio Virus Baked From Scratch." *Science* 297 (July 12, 2002).

Davis, Joe. "Microvenus." *Art Journal* 55, no. 1 (1996): 70–74.

Davis, Joe. "Romance, Supercodes and the Milky Way DNA." In *Ars Electronica 2000: Next Sex*, edited by Gerfried Stocker and Christine Schopf, 217–235. Vienna: Springer Verlag, 2000.

Fischer, Ernst Peter, and Carol Lipson. *Thinking About Science: Max Delbrück and the Origins of Molecular Biology*. New York: Norton, 1988.

Nadis, Steve. "Genetic Art Builds Cryptic Bridge Between Two Cultures." *Nature* 378 (November 16, 1995): 229.

Nadis, Steve. "Science for Arts Sake." *Nature* 407 (October 12, 2000): 668–670.

Queiroz, I. P. "A Biologia Ao Serviço Da Arte." *A Capital* (May 19, 2002).

VivoArts

Adam Zaretsky

Four works realized between 2001 and 2002 encapsulate some of my foci questioning the techniques of modern molecular biology, scientific process itself, and the cultures they live under. My microinjection works were designed and executed at Massachusetts Institute of Technology as explorative stabs at an understanding of the transgenic production interface.[1] The *Workhorse Zoo* was an attempt to performatively botch the already impossible re-naturalization of the major workhorses of molecular biology, including humans.[2] *MMMM* was a musical massage interface between the macro and the micro aiding humans in their understanding of the erotic nuances entailed in the experiences of all living beings.[3] The *Brainus/Analolly Complex* is composed of "The Brainus," an anus made of biopolymers seeded with brain tissue, and "The Analolly," a lollipop made of biopolymers seeded with anal tissue.[4] I hope these displays will help complexify spectator preconceptualizations. I also want to aid in the age-old project of tarnishing taxonomy. The systematic and quite gymnastic categorizations we humans invent impotently order the diversity of biota only to obscure our relations with the rest of the living world.

Microsushi, Microinjection Food Science

In *MicroSushi, Microinjection Food Science* (figure 17.1) I displayed two new and exotic caviar/sushi delicacies. By using a microinjector for the creation of such delicacies, I am emphasizing the gadget-love inherent in both gastronomy and new reproductive technologies. Both include unusual practices that involve expensive, specialized, diverse, eclectic, ritualistic and even subcultural toys. The use of this specific technology for the purpose of a crossover between fertility science and food science helps emphasize the obsessive commonalities shared by all systems of expertise. Also, the application of wasabi- and

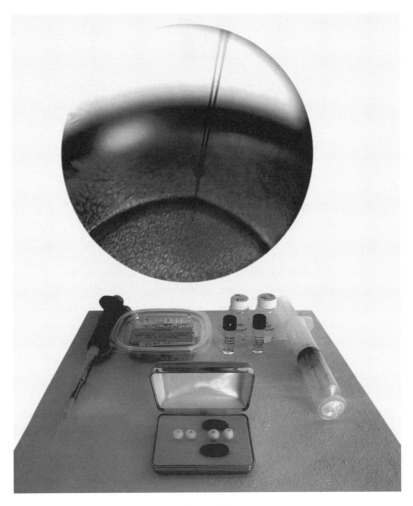

Figure 17.1

Adam Zaretsky, *MicroSushi, Microinjection Food Science*, 2001. Four Flying Fish Eggs (Tobiko), two microinjected with sterile solution of Gelman filtered Philadelphia Cream Cheese and two microinjected with sterile solution of Gelman filtered wasabi (horseradish paste). Each microinjected flying fish egg is spherical and ranges from 0.02 in (0.72 mm) to 0.05 in (1.38 mm) in diameter.

cheese-flavored microinjections into food-grade fish eggs provides more novelty excess for the discerning palettes of our progressive open markets.

For people who are not familiar with the more conventional uses of microinjection apparatus, let me explain: These gadgets are used to introduce all sorts of concoctions into the nuclei of single cells. In fact, this is one of the more popular techniques for the production of transgenic animals. The machine I used is usually reserved for molecular tagging of particular Drosophila (fly) neurons at a very early embryonic stage. These embryos are microinjected with infectious plasmids or just naked DNA in order to alter the metabolic fate of the entire organism. Other popular uses for microinjectors are nuclear transfer for cloning purposes and second molar body removal for the prenatal screening of human embryos (for defects or "not-better-enoughness"). In the case of genetic screening, the microinjector is used after in vitro fertilization and before implantation.

Microinjection can also be compared to sexual ejaculation. This is not necessarily a metaphor. The microinjection machinery is often used for the integration of novel genes into the hereditary cascade of a research organism. In biology, sex can be defined as the transfer of DNA from one or more organisms to their progeny. Within this definition, human microinjection of transgenes into embryos is sex, that is, sex between the technical and the experimental organism. This is not a symbolic gesture but a case of techno-orgasmically spurting reproductive ejaculate into the germ line of a novel entity.

The process of insertational mutagenesis implies not just ejaculation, but a type of parentage. Whoever is engineered by you is also partly your child, your responsibility. Due to the phallic architecture of the instrument, I think it appropriate to impart paternity to the technician who microinjects transgenes into viable embryos. All practitioners, irrespective of their gender, should be considered the sexually active co-fathers of these organisms. Stable insertion of new sequences into model organisms through microinjection is daddyhood.

MicroSushi was my experimental Micro-Erotic Paternalistic Embryonic Ejaculation, and the experiment ended with some recollective poesy gleaned from my personal erotic microinjectile experience:

> When my solutions were finally prepared,
> And I was on the machine,
> Twisting dials
> Until the egg was pierced,
> By a needle of the smallest bore . . .
>
> I pressed a pedal with my foot
> And out cum the tiny squirt of white cheese.
>
> Pressurized in the capillary,
> Released over and over,

In spurts of sterile solution,
Flowing like fumes into the penetrated caviar.

So delicate and obscure
Daddy squirting wasabi into the eggs
Daddy squirting cheese into the eggs
Into the source, the mystery sauce.

Workhorse Zoo

The *Workhorse Zoo* (figure 17.2) was a display of nine of the most studied industrial organisms of modern molecular biology. We lived together in an aseptic containment facility. The *Workhorse Zoo* focused primarily on introducing the public to these particular species in an installation environment. The display of these animals in a spectator arena precipitated intelligent discussion about animal research, pro or con, without the moral superiority of pat answers. These are the organisms that shoulder the brunt of scientific invasiveness. These are the organisms whose genomes have been sequenced and partially annotated. These are the evolutionary templates with whom we search for homologies to assess our own inherited pains. Much of the public has little or no idea how much the study of these select strains affects their health and potential physical future.

All of the organisms were displayed in a teeming and messy way inside a Simplex Isolation System CleanRoom. Overlapping micro-environments let us live in an imbalanced and unsustainable coexistence of natural integration. The interior architecture of the CleanRoom was designed to emulate a kitchen, a water garden, a farm, a laboratory, and a natural setting all in one. Of particular interest during the performance of the *Workhorse Zoo* were crossovers between popular conceptualizations of food, animal experimentation, pets, wildlife, and entertainment. We tried to show how taxonomies of behavior could be blurred, transgressed, confuted, and variously de-trenched for reevaluation through multifaceted display. Over this weeklong odyssey, I took on different relational personas with co-performer and life cycle specialist Julia Reodica. We tried to live through the eyes of usurped identities as follows:

Day One—Biotech Workers Day
Day Two—Do-it-yourself Punk Biotech Hobbyists Day
Day Three—Bioterrorist Day (referencing both Al Queda and fast-food poisoning)
Day Four—Medical Patient/Doctor Day
Day Five—Caveman/Anthropologist Day
Day Six—Wild Animal/Lion Tamer Day
Day Seven—Infant/Mother Day

Figure 17.2

Julia Reodica and Adam Zaretsky, *Workhorse Zoo*, 2002. Performance and installation with bacteria, yeast, plants, worms, flies, fish, frogs, mice, humans, "all badly contained and messily displayed inside of a Simplex Isolation Systems Clean Room," dimensions variable.

The *Workhorse Zoo* was an expression of love for slimy, gooey, sticky, pulsating, throbbing, jumping, flapping, living and dying, eating and having sex, everyday life. Preprocessed food was withheld for forty-eight hours during the performance. For that weekend a botchy attempt at a biosphere-esque, field-ecology-ish food chain was enacted. Local citizens of Salina joined us for taste tests of fried frogs, fish, plants and lab mice chased down with Zoo-brewed mead. After the bacchanalia, many of the animals were released.

MMMM

In *MMMM* (figure 17.3) the public, as fleshy flasks of living culture, were invited to become part of an experiment by vocally massaging cells in culture and each other's rear ends at the same time. Two ButtVibe lounge recliners were placed facing each other on opposite sides of a room. The chairs vibrated according to sound output from the vocalizations of the person in the opposite chair. Live video of volunteers was projected above and behind each chair. The audio signals were also sent to neighboring vibrating plate speakers fixed to various flasks containing E. coli K-12 and various other specimens. In real time, cells and humans were jostled by sonic experience. The conjoining of the microcosm and the human body, so often forgotten in the workaday world, was emphasized. Strangers in public livened each other's bodily experience shamelessly in a temporary suspension of moral standards. Viva tactility!

Sensual zoology can derail anthropocentrism by focusing on bounce as a form of transient existence for all life. But *MMMM* gives us the scientific ability to record a certifiable nonrepeatable effect through the bacterial bioassay of public play. Interspecies vibro-erotism may have an important metabolic function, beyond the obvious thrill of being aroused. Simple tests could show alterity of cellular metabolism due to vocal vibration, which could then be compared to morphological analysis of the human subject's involuntary facial responses. This data could be used to increase production of industrial fermentation products. It could lead to increased human health or longevity. It could even be a cure for impotence.

But *MMMM* may have some serious side effects. *MMMM* produced curious interpersonal economies outside the norms of standard nuclear family protocols. It seemed as though incest barriers, agist legalities, and even the platonic rigor of teacher-student relations were all called into question by the installation. I saw daughters, fathers, mothers, and sons vibrating each other's derrieres. Absolute strangers were allowed to nonverbally shake the lower extremities of infants. I even witnessed joyous sonic loudness produced by an entire high school class anti-authoritatively directed at their teacher's posterior. One teenager was caught with his penis out of his pants and pressed against the Freudian vibro-nub architecture of the chair. A young woman chortled to his genitalia to their mutual amusement. *MMMM* momentarily suspended culturally sanctioned norms and inhibitions in an artistic forum for the expression of animal behavior.

Adam Zaretsky

Figure 17.3

Adam Zaretsky, *MMMM*, 2002. Two custom made recliners, each with built in microphones, amps, video cameras, vibro-transducers and video projectors, dimensions variable.

Figure 17.4

Adam Zaretsky, *The Brainus/Analolly Complex*, 2002. An anus made of biopolymers seeded with brain tissue and a lollipop made of biopolymers seeded with anal tissue, each approximately 3.1 in (8 cm) high with lollipop stick.

Brainus/Analolly Complex

The Brainus is an anus made of biopolymers, which was then seeded with brain tissue. The Analolly is a lollipop made of biopolymers, which was then seeded with anal tissues. The public is invited to vote on which they would rather lick, Brainus or Analolly, and why? (figure 17.4).

The primary tissues used for these sculptures were taken from a dying eel. The eel was killed for food and the primary brain and anal tissues were isolated from the waste of culinary excess. Before using these tissues as a medium of art and science expression, I had cleared the artistic use of semi-living kitchen food preparation "waste" with Sue Lewis, Manager, Research Ethics and Animal Care, The University of Western Australia, Perth (UWA). I participated in the Program in Animal Welfare, Ethics and Science (PAWES) as a prerequisite for the use of these tissues for creative expression from within the School of Anatomy and Human Biology (ANHB).

Nonetheless, I think it is important to state clearly that the killing of the eel was not a part of my research at SymbioticA, the ANHB, or UWA. The killing of the eel was a part of my own personal gastronomic self-training as a chef. The eel was not killed for art and science expression alone. The Brainus/Analolly tissues were procured from the fresh dying flesh of a planned-to-be-dinner. The cooking began before the isolation of tissues, not vice versa. And the eel was eaten.

This was my attempt at not wasting life on art but, to some extent, I failed. The eel was butchered badly and my Do-It-Yourself shame should not be shouldered by anyone but myself. I need to learn to kill my own (animal, vegetable, bacterial, insectoid, fruit, or fungal) with more elegance. I don't think the eel wanted to be dinner or art in the first place. I owed it a more talented execution.

I cannot apologize to the eel because I doubt it would accept an apology. I can not thank it for providing me dinner or art materials, because I doubt it would say "you were welcome." I took the eel in an unskilled way and kept the waste of my meal for *The Brainus/Analolly Complex*. In the future, I can only try to sharpen my skill set and take responsibility for killing well what I plan to consume. I will also try to welcome the hunger of the living consumers of my body (animal, vegetable, bacterial, insectioid, fruit, or fungal) when they come to feast on my inevitable temporaryness, my becoming food for others.

Conclusion

These four artworks together coalesce around issues of subaltern ethics, living with other-nesses, techno-erotic nuance, and comprehensive derangement. For me, all of these issues are imbedded and entwined in the process of studying life. It may be that the fear and attraction of voyeuristic dementia are real signs of proximity to the timeless mysteries that lie beyond more copasetic conceptions of the everyday. This is the infinite approach to the mutual unknown that scientists, artists, and even most novelty-seeking organisms entertain. We poke and prod, sniff and stare, even into those areas that defy the social norm. But, because I am an artist, I am not shielded by the rhetoric of moral sanctity implicit in the public face of scientific rationalization. I am happy to simply be a "Peeping Tom" in quandary's boudoir.

Notes

1. Under the title *MicroSushi, Microinjection Food Science*, these works were presented at the Museum of Contemporary Arts, Skopje, Republic of Macedonia, June 15–June 20, 2001. Displayed: four Flying Fish Eggs (Tobiko), two Microinjected with Sterile Solution of Gelman Filtered Philadelphia Cream Cheese, two Microinjected with Sterile Solution of Gelman Filtered Wasabi (Horseradish Paste); two Microinjection Capillary Needles with Sub-Micron Tip Diameter; one Bottle of Auto-claved 1g/L Solution of Philadelphia Cream Cheese; one Bottle of Autoclaved 1g/L Solution of

Wasabi (Horseradish Paste); one Bottle of Gelman 0.2 Micrometer Sterile Acrodisk Water-Filtered Sterile 1g/L Solution of Philadelphia Cream Cheese; one Bottle of Gelman 0.2 Micrometer Sterile Acrodisk Water-Filtered Sterile 1g/L Solution of Wasabi (Horseradish Paste); 1 Gelman 0.2 Micrometer Sterile Acrodisk Water Filter with Hypo 1 20 µL Pipette with Disposable Tip; one Biohazard "Do Not Eat" Labeled Plastic Container of Previously Food Grade Flying Fish Eggs.

2. Enacted by Julia Reodica and Adam Zaretsky, as part of the group exhibition *Unmediated Vision*, realized at Salina Art Center, Salina, Kansas, January 26–March 24, 2002. The organisms displayed were bacteria (*E. coli*); yeast—C. cerevisiae; plants (*A. Thaliana*) and fresh wheat; worms (*C. elegans*); flies (*D. melanogaster*); fish (*D. rerio*); frogs (*X. laevis*); mice (*M. musculus*); and humans (*H. sapiens*). All were badly contained and messily displayed inside of a Simplex Isolation Systems Clean Room. The project was funded by the Daniel Langlois Foundation for Art, Science and Technology.

3. Exhibited in the context of the group show *BioFeel*, Biennial of Electronic Art Perth, at Perth Institute of Contemporary Art, Perth, Western Australia, July 31–August 25, 2002. On display were two custom-made ButtVibe recliners, each with built in microphones, amps, video cameras, acouve vibro transducers, and video projectors. Thanks to Adam Fiannaca for the creative metal work and surrey upholstery. The project was funded by the Daniel Langlois Foundation for Art, Science and Technology.

4. Conceived and executed by Adam Zaretsky while a Visiting Researcher at SymbioticA, the School of Anatomy and Human Biology's Art & Science Collaborative Lab in The University of Western Australia, Perth, February–September 2002.

The Relative Velocity Inscription Device

Paul Vanouse

Background: From Surface to Depth

"There is no scientific basis for race," proclaimed scientists in the summer of 2000, as the completion of the rough draft of the Human Genome Project (HGP) was announced. In fact, the scientific basis for race had been disproved as early as 1950 by an international team of UNESCO scientists, although perhaps with less fanfare.[1] The rationale for the recent statement was to allay public fears of a return to old scientific racisms that might coincide with a return to a biologically determinist framework of scientific investigation. While few imagine that culturally practiced racism will abate, a return to a massive state-sanctioned program of scientific racism now seems unlikely. For instance, the high percentage of black motorists stopped by U.S. police will probably be unaffected by the scientific proclamation, but we have likely seen the end of fanciful evolutionary models of racial development put forth by teams of scientists trying to ascertain average skull capacities of racialized groups.[2]

Racial categories were constructed based on external characteristics of groups (typically native populations in imperial colonies). The most surface characteristic of all—skin color—is the most frequent delimiter. As human genetics moves from the study of the body to the study of micro-bodies; from forms to underlying codes; varied critics have warned of subtler forms of scientific racism such as genetic or molecular racism. For instance, in family planning, the presence of parental genes for sickle-cell anemia has been used to discourage some black families from having children. As theorist Troy Duster notes, police have recently discussed using genetic databases to diagnose "potential" for aberrant behavior and, given the high proportion of blacks in the penal system, any statistical analysis of DNA may produce a self-fulfilling prophecy by implicating other black citizens. But the ultimate molecularization of racial stereotyping occurred in a recent

speech by James Watson, discoverer of the DNA double helix and principal investigator of the HGP. In a lecture at UC Berkeley in November of 2000, Watson discussed an experiment at the University of Arizona in which a group of male students were injected with melanin, the substance produced by genes that makes our skin dark. Watson claimed that the students quickly became sexually aroused—that is, they developed erections. He went on to reinvigorate old cultural stereotypes by concluding that dark-skinned people had a higher libido than fair-skinned people. We are left to assume that as the scientifically unpopular concept of race has been removed from skin color, a stigmatization and microanalysis of individual black-identified traits may follow. *Perhaps it is not the black body that is deemed prone to promiscuity, but blackness itself.* The very signifiers of race, rhetorically dislodged from their referents but still encoded within every cell in our bodies, could be personified as sexual deviants awaiting the opportunity to express themselves against our will and irrespective of environment.[3]

In order to address this tense space of contemporary genomics situated between the utopian pole of post-race and the historic racist pole of eugenics, I utilized an early publication by the American eugenicist Charles B. Davenport (and Morris Steggerda) called *Race Crossing in Jamaica*.[4] Davenport sought to disprove the theory of hybrid vigor by showing the ultimate inferiority of black/white hybrids. The study was particularly high profile because of its detailed methodology, which tabulated over one hundred examinations upon hundreds of human subjects. One of the factors that particularly intrigued me was the subject of performance, that is, tests of strength and motor control. It was obvious that these tests were the most biased by external, nongenetic factors, such as mood and occupation. Conversely, contemporary genomic studies insure a digital precision—a genetic trait is either present or absent with no ambiguities. All that would be necessary is to design the correct examination for the microbody and its value could be determined unambiguously. As my own family contains black/white hybrids of Jamaican descent, the subjects were easily selected—mother, father, sister, and brother (myself).

A Race about Race: DNA in Action

I refer to my artworks as "Operational Fictions." They are hybrid entities—simultaneously functional machines and fanciful representations—intended to resonate in the equally hyperreal context of the contemporary technologized landscape. In *The Relative Velocity Inscription Device* (*RVID*), I wanted to have genes from my own "bi-racial" family members literally compete with one another to determine the gene's fitness (figure 18.1). My goal was to build "a race about 'race'" in which (as theorist Bill Egginton adds) "the body has been erased." The multimedia installation is in fact a "real" scientific experiment, in which the entire process unfolds (live) in the space of public display.

Prior to installation of the experiment, the blood of each family member was drawn by Dr. Amos Dare. The DNA was isolated from these blood samples by Drs. Kelly Owens

Figure 18.1

Paul Vanouse, *The Relative Velocity Inscription Device*, 2002. Installation view, dimensions variable, Henry Art Gallery, Seattle, WA.

and Mary-Claire King, who then amplified specific genes understood to influence skin color, some of which varied between family members.[5] These genes were thereupon subjected to enzymes (invented by Dr. Owens) that cut the amplified genes. Whether an enzyme cuts or not depends on the presence or absence of one particular base of several hundred bases in a gene fragment. In each race these DNA fragments (one from each family member) were placed side by side in an electrophoresis gel (described later) and raced against one another in a series of twenty-three races.

The experiment employs a process called "gel electrophoresis" that allows us to discern the different rates at which fragments of the family members' DNA move through an electrically polarized gelatin. Gel electrophoresis is a scientific protocol generally used to analyze DNA fragments—the familiar representation being the "DNA fingerprint." Gel electrophoresis involves first pouring a thin (agarose) gel of about one cm and allowing this gel to set. This gel is placed flat in a container and voltage is applied across the length of the gel. DNA is placed in small holes at the negatively polarized end of the gel (figure 18.2). The gel is composed of microscopic pores, which allows the DNA to slowly diffuse

Figure 18.2

Paul Vanouse, *The Relative Velocity Inscription Device*, 2002. Every two to three days fresh DNA is inserted into the electrophoresis gel.

through the gel—however, all DNA is negatively charged and is electrically drawn toward the positive voltage at the far end of the gel. Thus, over a given time period, the DNA samples migrate toward the electrically positive pole of the gel at consistent speeds that depend upon their molecular size. The electrophoresis rig designed for *RVID* is approximately thirty inches in length—longer than typically used in laboratories. This allows each dramatic contest to last for two to three full days.

The DNA samples in the gel glow when bathed in ultraviolet light. During ultraviolet light illumination, the samples' positions in the gel are captured digitally (with a specialized video camera), analyzed by a computer, and projected upon the rear wall, in order to ascertain the progress of the race at any time. The position of all samples at the conclusion of each race is stored in a database, which can be accessed by viewers via a touchscreen monitor.[6]

Viewer Experience: The Apparatus Itself

The RVID is by definition less of a device than it is an apparatus. A narrow, stainless steel workbench holds an assortment of technologies including the gel electrophoresis chamber, power supply, power switcher, computer, fluid circulator, and fluid cooler interconnected by tubes, cables, wires, and valves. The assemblage hums—each component producing distinct oscillating drones that are amplified by hidden microphones to produce a dense, emergent soundscape.

Figure 18.3

Paul Vanouse, *The Relative Velocity Inscription Device*, 2002. A live video image of *RVID* electrophoresis gel with graphical overlays. The four bright dots are individual DNA samples from the four family members, which are glowing because of the UV light irradiation below the gel.

An image of the electrophoresis gel is captured live by a video camera and projected magnified onto the rear wall (figure 18.3). Individual lanes with the family member's names (mother, father, sister, brother) are superimposed atop the video feed. Every ten minutes, a new video frame is captured by the computer, and machine vision algorithms find the samples' current positions within it. To further underscore the metaphorical slippage between the DNA's movement through the gel and the individual family member's fitness, an animated icon of a running figure marks the position of each individual's DNA sample. This is where the viewer is confronted with a problem of analogy reminiscent of those used throughout the history of human genetics—DNA doesn't move faster or slower in the gel because it is more or less "fit," but rather because of the molecular size of the DNA figment.

On the workbench, framing the electrophoresis rig, are a book (left) and touchscreen monitor (right). The book is a first edition of the actual *Race Crossing in Jamaica* study, appropriately purchased from the collection of the anthropologist Dr. Henry Fairfield Osbourne. The text contains over five hundred pages of photographs, studies, family trees, and hypotheses about the problem of race-crossing. Key pages of the book are tagged. These pages describe (1) methodology, (2) individuals studied, (3) procedures, (4) results, and (5) conclusions. The touchscreen monitor displays a hypertext database borrowing the

previously mentioned categories to describe the *RVID* experiment. The results are updated after each race and show the exact positions and relative velocities of each family member, in each race, at the time of its completion. The entire apparatus was designed to create a tension in regard to the viewer's relationship to this "genetic horserace," in terms of his or her own sense of racial identity.

Scientific Experiment as Live Spectacle

Several aspects of the work could not be performed live, including drawing blood, extracting DNA from the blood, and amplifying DNA from selected regions of skin color genes. *However, all other phases of the process take place live in the space of public display.* Since gel electrophoresis uses DNA fragments that (when stained) are visible to the naked eye, this technology was perfect for public display in that it is performed at a scale at which viewers can actually see what is happening. It was essential that viewers witness:

1. The experimental process itself—the DNA slowly moving through the polarized gelatin.
2. Its abstraction into data—the camera periodically grabbing images of the gelatin so that computerized image-processing algorithms could find the location of each sample, and track which sample crosses the finish-line first.
3. Records of previous races—the viewer can access, via touchscreen, the results of all previous races, which are updated automatically as the experiment runs.

Each of these processes occurs live in the public arena. *The gallery is not merely an incubation chamber in which a process is occurring, nor is it merely a display space to post the results of this experiment, but an entire automated laboratory where all the phases can be viewed and evaluated.*

Technological Addendum: Integration and Automation

RVID is an assemblage of three different processes that previously have not been combined into a single apparatus in laboratory practice: gel electrophoresis, UV florescence imaging, and machine vision.

To reiterate, gel electrophoresis is a laboratory procedure for separating DNA that was re-purposed in *RVID* for racing DNA. Some of the challenges in re-purposing this technology for public display involved making the DNA visible to the viewer. Typically, a gel is "imaged" outside the electrophoresis rig in a special, opaque cabinet that contains UV light. The scientist then views the DNA bands through a camera (since the DNA glows orange when stained and bathed in UV light, the camera blocks the harmful invisible UV light from the eyes of the scientist). *RVID* is built from a combination of UV-emitting clear acrylic and UV-opaque clear acrylic to allow the UV light to make the DNA glow

as the experiment runs, while protecting the viewer from the harmful UV radiation. The computer-controlled camera periodically grabs images of the glowing DNA, and custom, machine-vision algorithms locate each glowing sample. This step was challenging to accomplish within the gallery context as background light levels change, the DNA florescence diminishes over time, and the coherence of a DNA band is reduced over long periods (two days) in the gel. The machine-vision algorithm, which corrects for varying conditions, runs as follows: first, searches the camera image for pixels containing the highest intensity orange values; second, sorts these pixels into groups of adjacent pixels; and third, evaluates which of these groups are brightest and have the requisite size, shape, and density characteristics to determine the position of each DNA sample. It is through these steps that the software is able to determine the positions of samples at all points in the race and determine the winning sample at the end of each race.

A single Macintosh computer regulates the entire apparatus. This computer controls power to all of the electrophoresis equipment via a custom electrical switcher box, turning on voltage, UV lights, cooling fans, and fluid circulation pumps. It captures camera images and evaluates DNA positions. As viewers observe, the computer updates the projected image—showing an enlarged image of the gel—and highlights the position of each sample. It also stores information from each race and makes it available to viewers via a touchscreen display. This allows viewers to grasp the relationship of the specific moment in the race to the larger scope of the *RVID* experiment.

RVID was created with funds from the New York State Council for the Arts and the Henry Art Gallery in Seattle, Washington.

Notes

1. Discussed by Evelynn M. Hammonds, "New Technologies of Race," in *Processed Lives: Gender and Technology in Everyday Life*, ed. Jennifer Terry and Melodie Calvert (New York: Routledge, 1997).

2. The term "racial groups" implies a natural essence to the designation of racial type; on the other hand, the term "racialized groups" denotes the fact that race is a cultural construction and that a given group was actively "racialized."

3. Paul Vanouse, "Race, Inter-Race and Post-Race in the Study of Human Genetics," *Afterimage* (September–October 2002).

4. Charles B. Davenport and Morris Steggerda, *Race Crossing in Jamaica* (Washington, DC: Carnegie Institute, 1929).

5. The amplification process is used to increase the amount of a small sample.

6. The fully tabulated results from the first *RVID* experiments (twenty-three races) at the Henry Art Gallery in Seattle, WA, were published in "A Race about Race," see note #3. In these races, the mother's DNA showed the highest relative velocity, followed closely by the father, sister, and brother.

Proteins

Regina Trindade

Since 1999, I have been interested in proteins as a form of expression, navigating between the realms of creation and experimentation. By appropriating techniques well known to biologists, I display these components from living creatures in a variety of colors and shapes in wet gels.

Proteins are produced from genes and are key building blocks of life. They are responsible for the maintenance of living structures and mechanisms. Proteins are the "main actors" in the process of life; that is, they are key players in the dynamics of existence itself. By accessing these components one can decompose life into a very complex array of simple molecular actions. This interpretation of life at a molecular scale opens up a new level of intimacy with the body.

By employing a protein analysis technique, SDS-PAGE (SDS-PolyAcrylamide Gel Electrophoresis), I create flexible and transparent gels prepared from a solution that is polymerized, transforming liquid into a kind of colorless jelly. In this technique, the poly-acrylamide gels behave like a sieve, which separates the proteins according to their sizes. By modifying the original technique, the polymerization and migration conditions, the gel shape and composition, I can give them a sensitive form. Selection and preparation of protein samples are key steps of my work. Subsequently, the samples are submitted to an electric field to migrate through the gel. Since proteins are generally colorless, in order to visualize them I employ specific stains which are based on their physical and chemical properties. Thus, proteins become visible, and these essential components of living creatures become exposed (figures 19.1–19.2).

With an artistic purpose, I make use of materials, methods, and techniques from biological research and perform my work in laboratories in direct collaboration with scientists. Consequently my pieces have occasionally been presented in scientific environments,

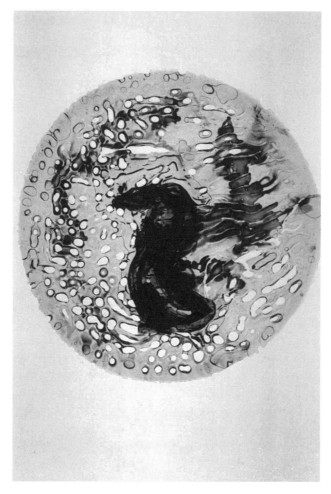

Figure 19.1

Regina Trindade, *Sobreposições* [Superpositions], 1999. Salivary and sera proteins, poly-acrylamide gel, silver nitrate staining. Diameter: 5.9 in (15 cm).

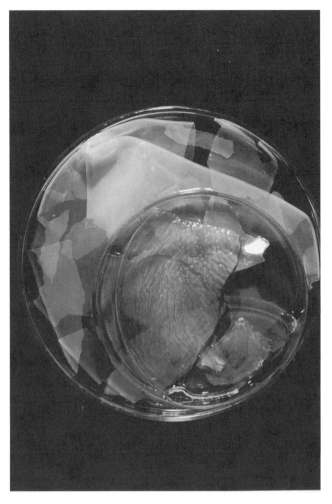

Figure 19.2

Regina Trindade, *Fracassos Azuis* [Blue Failures], 1999/2002. Salivary and sera proteins, polyacrylamide gel, copper chloride and coomassie blue staining. Diameter: 5.9 in (15 cm).

with the goal of bringing about reflections regarding the direct interference humans have on life itself as well as on the new concepts of nature, life, and human that emerge from the advances in life-science research.

In *Sequência*, a performance in collaboration with the composer Ana Lucia Fontenele, the boundaries between human and non-human were explored by presenting to the audience a mixture of sounds and organic matter. For the Brazilian Symposium on Scientific Research, Brasilia, 2000, I set up an installation composed of slide and overhead projectors as well as lab-glassware, amplifying and mixing the gels in the spaces created on 60 m^2 of white cloth. For approximately twenty minutes, I performed the last steps enabling the visualization of the proteins in the gels. As they became visible, the proteins merged with Ana Fontenele's diffusion of processed natural and artificial sounds, incidental voices, and citations from other works.

The 2000 exhibition in Brasilia entitled *SG1...406* expressed reflections of young artists on the concept of place as a combination of space and memory. For this occasion I created the work *Glissandos da memória*, which elucidated the relationship between art and science and the movements of memory. This piece was composed of an 1.80 m iron rod placed 30 cm from the floor, holding six petri dishes in lab tongs. The petri dishes contained gels for protein analysis. The proteins in the gels are visible biological information. The position and inclination of each petri dish allowed the images to blend, suggesting superposition in the memory of past experiences. During the exhibition of this work, visitors could follow the hydration (memory) and drying (the forgotten thought) of the gel. Biology and art were thus merged in order to create a dislocated place where the borders of culture and nature are fused.

For the *In Gel* exhibition (September 2002), which was presented during the process of scientific audit of the Institut de Biologie Structurale (Grenoble, France), my pieces appeared with other reflections on life-science research (figures 19.3–19.4). *SsckW, Espace d'un Instant*, and *Code*, as well as other works were presented. *SsckW* is also the name I gave to the protein sample I prepared for this series. It was a mixture of a purified protein (isolated from other cellular proteins) and a protein extract (set of proteins produced by an organism). This sample is comparable to samples produced by genetic manipulations in the production of a recombinant protein. The control in sample preparation and manipulation becomes a space of non-linearity in the gel reflecting the complexity of life's actions. I displayed the gels by immersing them in a liquid between glass plates that are fixed on a stand with lab tongs.

Historically, artists have always established a dialogue between their artistic practices and the knowledge produced at their time. Today, it is impossible to make art without perceiving the implications of a new paradigm in the conception of life.

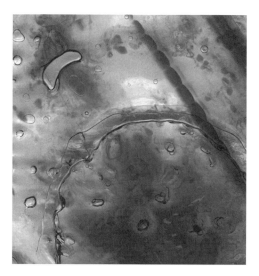

Figure 19.3

Regina Trindade, *Code*, 2002. Bacteria protein extract, polyacrylamide gel, colloidal and non-colloidal coomassie blue staining. Diameter: 5.9 in (15 cm).

Figure 19.4

Regina Trindade, *SsckW-2*, 2002. Bacteria proteins, polyacrylamide gel SDS-PAGE, Silver Nitrate staining. 6.7 × 7.8 in (17.5 × 20 cm).

Skin Culture

Object-Oriented Art
(Marion Laval-Jeantet and Benoît Mangin)

Skin Culture (1997) presents the fantasy of being able to change your skin for different skin, of being able to use standard quick plastic surgery instead of hours of tattooing. In an exhibition entitled *Live in Boston* and realized at Galerie Des Archives in 1997, we presented skin cultures originally bred from our own cells at a university lab in Boston (figure 20.1). The resulting skin cultures were tattooed with images of animals and exhibited in jars of preservative liquid.[1] The installation also included a video of an interview with a clinical doctor involved in the process, and an architectural model of a museum with various toy combinations.

With this work we offered, from our own living tissue, pieces of our own skin. We even proposed that a collector graft them on to his or her skin. We tattooed on these skin grafts the best-selling animal imagery in use in tattoo parlors in the United States: hummingbirds, tigers, panthers, eagles, butterflies, salamanders, lions, unicorns, and also the laboratory mouse that had been used to test our skin culture. These colorful tattoos lent a lively quality to the crudeness of the skin cultures. The animal image becomes like an advertising logo, as easy to put on as it is to take off. It demonstrates the liberty humans take over animals, who survive only through demiurgic human will.

People tattoo their dreams, totems that in their minds charge them with power. As experimental animals, the laboratory mice entered our dreams. Symbolically it was a metamorphosis: Their skin served us and then our skin served to represent them. We ourselves experienced this metamorphosis by getting ephemeral tattoos, which dissolved after a few months, covering our bodies with these animals. We then thought up a new project: Each time a species would become extinct, we would tattoo its image (permanently) on our bodies. This, however, was impossible, because in no time we would have been totally covered.

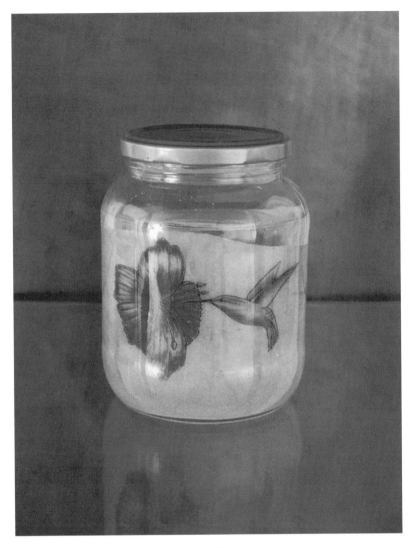

Figure 20.1
Object-Oriented Art (Marion Laval-Jeantet and Benoît Mangin), *Colibri*, 1996. Skin culture (made from the artists' own cells) grafted on pig hide, approximately 3.5 × 5 in (8.8 × 12.7 cm).

To create *Skin Culture* we became the study subjects in a cutting-edge biotechnology laboratory that was studying skin grafts. We were in the ideal context to confront the dilemmas of experimental art: Should we be involved in our work, should we or should we not produce an artistic output? By having our skin cultivated and by keeping some samples as an artistic medium, we were creating a perfect type of artwork: the result of an experience that generates an artwork, which is none other than the artist himself or herself. It was a veritable existential artwork: It exists and it refers to an existence—and it brings up a variety of ethical and political issues. After all, the reason for which we had become involved in these studies was the same utopian ideal that the anti-vivisection lobbies had advocated in the use of skin cultures: the desire to stop the use of animals for cosmetic testing.

Note

1. The grafting was performed during the tissue culture process. After a few days of culturing the skin cells, they were placed in the same bath with a pig hide in a sterile medium. The process was interrupted and the graft preserved in formaldehyde. The tattoo was produced over the final graft (human skin over pig hide). The function of the pig hide was to give the ensemble the thickness necessary for tattooing.

REPRO DUCTION

davidkremers

One of the first lessons I learned in growing living artworks was that our romantic image of the artist is 150 years out of date. Mine is no faint voice calling out from the edge of an industrial wilderness. Scientists e-mail me daily, placing me at the center of the action. Like other professionals—say surgeons or engineers—artists now have controls over natural events. What once was a role played by a god is today just somebody's job.

As our human genome becomes knowable, as we see in our similarities to the genomes of other animals, I am more overwhelmed than ever by the notion of life as something we share with each other.

I see that humans are, by our very evolution, creatures who survive by integrating and sharing. We are different from plant life, for instance, because plants can thrive in relative isolation. Humans thrive in neighborhoods. Today we live in a networked society and an artist is one node in that network. Good artists today don't paint sermons, they engage in conversations. Conversation requires more than a single voice; especially in biotechnology, healthy conversation engages voices of both sexes.

Bacteria Paintings and Clone Paintings

In 1992, using a few simple laboratory protocols, I grew a suite of paintings from single-celled organisms, E. coli bacteria (figure 21.1). I genetically altered these bacteria producing both naturally occurring colored enzymes and protein combinations that react to various colored genetic trace dyes. Fed with agar on an acrylic sheet, the works are completely transparent during painting, like painting on ice with melting snow. After a period of sixteen to eighteen hours, growth into color and form is arrested by removing

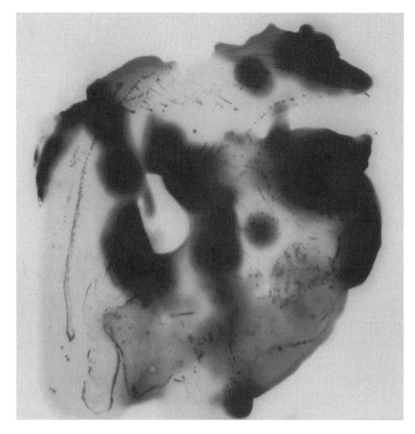

Figure 21.1

davidkremers, *Somites*, 1992. Gesso, agar, x-gal, iptg, anpicillan, coomassie blue r-250, ecoli tb-1, plasmid, synthetic resin on acrylic plate, 24 × 24 in (60.9 × 60.9 cm). Painting grown from E. coli bacteria that have been genetically altered to produce colored enzymes and protein combinations reacting with genetic trace dyes. Collection Carolyn Kremers.

moisture from the acrylic sheet. Once air is sealed out with a synthetic resin, the work enters a period of stasis, or suspended animation.

These pieces are portraits of the earliest stages in our embryonic development: gastrulation, paraxial mesoderm, visceral arches. Not only does every human appear identical at this point, but in our earliest days we look as if we could develop into whales or mice as easily as into people. These are portraits at the resolution of an entire species. But every embryo is in an environment—in our mothers. Our genetic predisposition is to become human, but the human genome is wetware designed to run in the micro environment of human mothers.

Even if you could clone a human being you wouldn't get a Frankenstein assembly of adult parts: You'd get a baby. We should be worrying about how best to provide for and raise our babies, not distracting ourselves with imaginary monsters.

In 1994 I grew a suite of diptychs in which each panel was a clone of its partner. Mounted perpendicular to the wall plane, the light passing through created a continuous chain of reflected and refracted progeny. Grown from identical genetic code, given identical initial conditions, and raised in the same environment, these clones were like monozygotic human twins. From afar they appeared to be identical, but upon closer inspection they revealed multitudes of little differing details. Grown as large-scale models of synthetic organ replacement, the idea was that if we have a piece of our DNA, plus a high resolution map of our developing organ, we should be able to slowly and carefully nurture cells into an equivalent functioning pattern. Clones aren't a photocopy. They lead their own lives. The moral discussion of genetics is still being used as an emotional substitute for genuine understanding of biotechnology.

Primitive Synthetic Life

Early organisms were composed of distinct cells which were potentially autonomous and self-sufficient. By evolving into a system of interdependence and cooperation, higher organisms can adapt to new environments without having to develop new organization.

I imagined new organisms living in our bloodstream to remove toxic waste or add vitamin C, a chemical we don't synthesize or store ourselves. These microbial automata, or nanosculptures, one-hundredth the size of a human hair, would be part carbon-based and part silicon. When I first created the concept, I expected decades to pass before anyone would bother engineering such organisms. But history moves fast now, and it turns out that such an organism could exist and be able to accurately and cheaply differentiate between anthrax and flu virus. Now that art can act in biowarfare defense, there's a group of scientists working on a first-generation prototype biosensor.

Human factories are larger than the products they manufacture, while nature's factories are smaller in size than what they produce.

Before photography, painters captured a likeness of organisms. However, the inanimate object created virtual life, in the sense that the subject lived on through the painting. Strangely enough, this is what scientists also do when they create animal models. They model reality by growing living "pictures" depicting various symptoms of a genetic mutation, for instance. These portraits of mutations (figure 21.2) can live on as scientific data long after any individual organism dies. The more data that is collected about related mutations, the more complex the portraits become. One of the goals of our vmouse (virtual mouse, 1994) as a primitive electronic organism is its ability to link these complex portraits, plus different types of data, together in way that is not possible for carbon-based organisms. There are scientists in the Caltech labs making more beautiful and significant

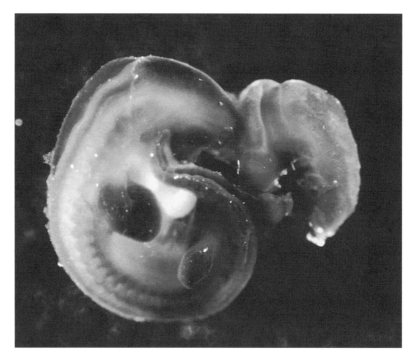

Figure 21.2
davidkremers and Kyuson Yun, *Twi mutants e32.5 2,0/90,* 1995. Dataset, dimensions variable.

artworks than you can see in the best New York galleries, just by taking pictures of their data.

ARTifacts from the Future

We already possess large-scale, high-resolution, four-dimensional maps of chemical relationships accurate to the femtosecond. We call them gardens.

Usually when anybody suggests manipulating ecosystems, voices rise up in anger. But gardening seems "natural" to humans, probably because we have been doing it for 11,000 years—long enough to forget what "nature" used to be like. Most of the flowers and fruits we grow today are nothing like their wildtype ancestors. Roses, everybody's favorite flower, are a good example. Rose breeders have been practicing the "art" of natural selection on them for centuries. They are delicate and fragrant, fragile and artificial.

Edward Steichen bred delphinium "sculptures," exhibiting them at MoMA in 1936. One important conceptual difference between this and biotechnology is the way humans

Figure 21.3

davidkremers, "A very small piece of the large scale structure of the universe," 1997. Turf maze, dimensions variable.

view "natural selection" over "genetic engineering." People today show lots of faith in "natural" but little faith in "engineering," even though every day a majority of lives depend on engineering to survive nature.

Lawns don't exist in nature although meadows do. Lawns are engineered of different grasses integrated together to achieve overall uniformity. When introducing a new type of grass into an existing lawn, it's imperative that no single variety takes over. My grass maze exhibited at the Dutch arboretum ST(*)boretum, Wageningen, in 1998 (figure 21.3), was developed with experts from the Dutch corporation Barenbrug, the world's largest producer of grass seed. Existing grass hybrids were carefully chosen to provide a contrast of both texture and color for the artwork, while adding diversity and vitality to the existing lawn after the conclusion of the exhibition. As can be seen six years later, the health of the arboretum lawns was improved by the artwork. Because grass lives mainly in its roots, spreading widely, this piece eventually disappears into the very fabric of the park. No genetic manipulation was involved in this project.

Just like DNA, a molecule that depends on many amino-acid and protein interactions with feedback from varying environmental conditions to complete an organism, my art objects are physical manifestations, often in serial iterations, of my abstract thinking. These concepts may form a type of algorithm or instruction set embodied by text. I call such texts conceptual abstracts. Like software, these conceptual abstracts and art objects are interdependent, but may both perform and simultaneously be viewed independently.

Modern monumental achievements are complex systems brought to fruition by large teams. Nuclear fission, transistors, and moonwalks are examples of such achievements. Their unanticipated cultural significance derives from by-products of scientific invention. The half life of plutonium-239 is 24,000 years. Early radio and television programs travel light years outside our solar system. Human footprints at the sea of tranquility last millions of years unless hit by chance meteorites.

My ongoing churchyard project is a new form of simultaneous historic and future preservation, whereby a number of thousand-year-old churchyards are to be protected by biosculptures lasting for the next thousand years. This came about because the Groninger Old Church Foundation, in the Netherlands, believes that the sacred nature of its sites lies *in* the fabric of its churchyards. In this case, directed evolution will be employed over the next thirty-five to fifty years while research on climate, soil conditions, plant material, economic production, and biotechnical protocols for the biosculptures will be woven into both Dutch and American scientific research programs. Simultaneous research into local historical, cultural, economic, and ritual patterns of the individual churchyard neighbors is to be woven into the metabolic fabric of the evolutionary design. An additional twenty-five years of hybridization, testing, and trial growing patterns can be expected. The outcome cannot be accurately predicted at the outset.

In a sense, perhaps our concepts of sex and procreation are beginning to expand. Look at the cemetery, traditionally a symbol for mourning, death, and decay. In this project it transmutes into a garden of expectation, birth, and growth. What once took place in the dark underground is brought up onto the grass, into the light. This singularity for a special occasion becomes an everyday event for everyone.

Life is to be lived, not merely survived.

OneTree

Natalie Jeremijenko

Cloning has made it possible to photocopy organic life and fundamentally confound the traditional understanding of individualism and authenticity. In the public sphere genetics is often reduced to "finding the gene for ... [fill in the blank]," misrepresenting the complex interactions with environmental influences. The swelling cultural debate that contrasts genetic determinism and environmental influence has consequences for understanding our own agency in the world, be it predetermined by genetic inevitability or constructed by our actions and environment. The *OneTree* project is a forum for public involvement in this debate, a shared experience with actual material consequences.

OneTree is actually one thousand trees, clones, micropropagated in culture. The clones were exhibited together as plantlets at Yerba Buena Center for the Arts, San Francisco, as part of the exhibition *Ecotopias* (November 14, 1998–January 3, 1999). This was the only time they were seen together. In the spring of 2001, the clones were planted in public sites throughout the San Francisco Bay Area including: Golden Gate Park; the public-facing sides of 220 private properties; San Francisco School District schools; BART stations; Yerba Buena Performing Arts Center; Union Square; and other sites. Friends of the Urban Forest coordinated the planting.

Because the trees are biologically identical, in the years subsequent to their planting they will render the social and environmental differences to which they are exposed. The trees' slow and consistent growth will record the experiences and contingencies that each public site provides. They will become a networked instrument that maps the micro climates of the Bay Area, not connected via the Internet, but through their biological materiality.

Each of the trees can be compared by viewers in the public places in which they are planted, to become a demonstration—a long, quiet, and persisting spectacle of the Bay Area's diverse environment.

The artificial life component of the project consists of tree growth algorithms (L-systems) that were distributed on the CD-ROM, MUTATE, with other software. The growth rate and branching patterns of the modeled trees are controlled by a CO_2 sensor (distributed with the CD-ROM) at the serial port of the local computer, puncturing the separation between virtual/digital and the actual environment. The opportunity to contrast the idealized computer models of the algorithmic trees and actual complex growth phenomena are facilitated by the *OneTree* Web site where the trees, biological and algorithmic, are assembled in an impossible geography.

Natalie Jeremijenko

The Art of Unnatural Selection

Brandon Ballengée

Our relationship to plants and other animals has evolved over thousands of generations of coexistence. Over time, domestication has allowed for the creation of human-induced or artificially selected new life-forms. This progressive understanding of inheritance and eventually genetics has allowed us to refine our living creations to artistic levels.

Nature has appeared as a dominant subject in painting and sculpture since the beginning of image making. By the late twentieth century, conceptual artists such as Jannis Kounellis, Joseph Beuys, and Hans Haake had explored using living materials in the context of their work. In 1972, Helen and Newton Harrison began to study the edible crab *Scylla serrata*. The team worked to create aquatic environments in which the crabs could be sustained while being exhibited in art galleries.[1] While conducting these experiments, the team discovered a methodology by which the crabs could be bred in captivity, something that had never been done before.

In her 1993 work *A-Z Breeding Units for Averaging 8 Breeds*, Andrea Zittel satirically employs counter-domestication strategies to generate ancestral chickens.[2] For the project, Zittel created architectural chick incubators designed to regress several domestic breeds of chickens back to a more "original" state. In theory the three-tiered sculpture contained channels that allowed eggs from the upper tiers to mingle and hatch with eggs from the middle level. Chicks from these mixed eggs would hatch and mix with others breeds to create new eggs that would be funneled down to the bottom layer. Here the process would culminate with the creation of a mixed chicken more "wild" than the initial breeds it was created from. Based more on conceptual notions of anti-utilitarianism and Rube Goldberg–like design, the "Units" looked better than they actually worked to produce chickens.

Another Zittel work, *A-Z Breeding Units for Reassigning Flight*, also was designed to create a more "wild" chicken, one with the ability to fly. Years of selective breeding have left

domestic chickens with "short stubby wings" unable to carry their large bodies more than a distance of a few feet. Working with the notion of selection based on fitness, Zittel's installation funneled eggs to varying heights. Hens would have to fly up to reach their nests. Eggs from hens unable to reach their eggs did not hatch, and thus were selected out the gene pool. Exhibited in the window of the New Museum of Art in New York City, viewers were able to watch this backward evolutionary drama being played out in front of them.

Christopher Ebener and Uli Winters collaborated to create mice capable of paralyzing computer networks.[3] The piece, entitled *BYTE*, used reward-based training methods developed by B. F. Skinner to encourage mice to destroy electronic cables. Individual mice were housed in a cage with a computer wire running through it. When the mice chewed through the cable a monitoring device automatically rewarded the destructive act by feeding them. The actions of the mice were recorded and shown on a monitor for comparison. While installed in 1998 at Ars Electronica, viewers could see the tested mice performing and analyze which animals would be the fittest for breeding. Subjects that performed well (by eating the most cables) were bred with other high-rating animals, the idea being that the offspring would have greater tendency to gnaw through wires than the previous generations.

Selectively inbreeding of species of fish can create genetic mutations that result in physical variation and often malformations. This practice is common in the North American pet industry, in which dozens of species of fish have been aesthetically "designed" to appeal to customers. In his work, *Natural Fish*, artist davidkremers is experimenting with the common pet store zebra danio fish.[4] Apparently this species is quite genetically malleable and is able to be physically transformed through selective breeding. The artist exhibits the living animals and refers to the them as "sculptures."

While an artist-in-residence at MASS MoCA, Natalie Jeremijinko documented pattern diversity in 10,000 ladybugs.[5] The piece called *The Great LadyBug Animation* involved digitally recording each animal and creating animated frames from the stills. Although members of the same species and genetically similar, each insect has distinct individual features. Jeremijinko also invited others to submit images of ladybugs to the archive via the Internet. The final animation was exhibited on a miniature LCD monitor, where viewers could see the remarkable variation. By simply contrasting the images with one another, Jeremijinko was able to show differences instead of similarities in genetics. This piece also calls into question traditional biological methods of categorizing species based on similarity.

Jeremijinko has also been observing pattern variation in monarch butterflies.[6] In this case the artist not only recorded the animals' characteristics, she raised and actually bred them. On her sixth generation, Jeremijinko documented females from each of the generations: "The frames in this animation are a daughter of a daughter of a daughter, etc. In

this way we can see that the genetic variation and phenotypic plasticity of simple but beautiful 2d variation."[7] Again presenting the frames on a miniature LCD monitor, the viewer is able to view almost lifesized brilliantly colored images of the creatures morphing from one to the next.

Also working with insects, artist Tara Galanti grew 2000 silk moths to get over her fear of them.[8] Over time, fear became devotion and Galanti began to experiment with a breeding campaign aimed at creating a fully flying adult. Silk moths have been domesticated for hundreds of years. For the silk industry, moths with the largest cocoons (with more silk) are selected out and bred. Larvae that are not chosen are boiled and eaten while their cocoons are refined to create silk works. The majority of the animals never reach adulthood, and those that do are believed to have lost their ability to fly over numerous generations of domestic care. When exhibiting her moths, Galanti creates flower-like sculptures with multileveled platforms on which she places female moths. Males, on the other hand, hatch from a central element. Fertile females release pheromones encouraging the males to fly over. Though still in the early stages of the project, the artist has recorded an individual male that flew 4.5 inches. The eggs fertilized by this individual have been kept and Galanti intends to carefully breed his offspring.

Since 1996, I have been studying the occurrence of deformities and population declines in amphibians. These studies have involved numerous ecological field surveys as well as primary biological research. A long-term experimental project I have been working on involves breeding Hymenochirus family frogs (figure 23.1). This tropical family is native to the Congo region of Africa. Hymenochirus curtipes was once a widely distributed species in the pet and laboratory specimen trade. Recent literature suggests that biodiversity in the Congo is threatened by the clearing of forests for agricultural use and increased economic demand for rain forest wood (primarily from the U.S. and European markets). Over the past forty years, the species, or perhaps the entire Hymenochirus family, may have been depleted or become extinct from their native range. Political chaos and civil turmoil in the Democratic Republic of Congo, formerly Zaire, over the past decade have severely limited biological studies. Data available on the remaining species of amphibians in the Congo is inconclusive.

Working with what I believe to be several domesticated subspecies, I am attempting to selectively breed generations backwards to produce a Hymenochirus curtipes. An investigation into historic scientific literature leads me to believe that H. curtipes is a shorter-limbed wild-type version that differs considerably from the domesticated laboratory frogs that I began with. In what Darwin referred to as regression, I have bred like with like attempting to resurface historically described physical traits. When exhibiting this project in a museum or gallery context, I have displayed documentary photographs and text explaining the progression and methods employed in this project. But more importantly, I have exhibited multiple generations of the living Hymenochirus frogs. I consider them

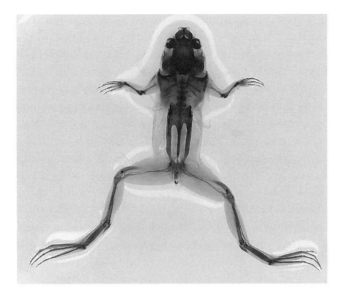

Figure 23.1

Brandon Ballengée, *Adult Cleared and Stained Hymenochirus Family Frog*, from *Species Reclamation Via a Non-Linear Genetic Timeline: An Attempted HymenochirusCurtipes Model Induced by Controlled Breeding*, 1999–2002.

to be the actual artworks. Each generation is stylistically different just as each individual animal is unique and should be viewed simultaneously as a living creature and a work of art.

One cannot deny a certain level of arrogance when it comes to selective breeding or any other kind of human-induced manipulation of nature. Concerns arise from the possibility that an experimental organism could be accidentally released into the environment. The introduction of invasive species that outcompete native ones is a major force behind global losses of biological diversity.[9] Great care should be given to assure that no non-native domestic species should be allowed to enter the wild. Although selective breeding alters the physical matrix of a given genetic line, which has had major influences on civilization, the ability of an altered breed to cross freely with its wild ancestors (resulting in regression) can produce a minor evolutionary phenomenon.[10]

In addition to selective breeding, numerous artists have experimented with transgenic manipulation of organisms as artwork. Transgenics refers to the process by which genes from one organism are transplanted into another organism, creating a new species. These artists are small in numbers, but transgenic art is certainly a field that will continue to be explored in the coming decades. Yet with transgenic manipulation, too, potentially new environmental concerns arise. Accidental release is again a major concern. In this case the

organism would not be able to regress, but instead could hybridize with native species, resulting in a kind of artificial genetic drift. Creating organisms through selective breeding or transgenic technologies involves a special kind of responsibility associated with the lifelong welfare of the organism and the surrounding environment. The care of the organism should in no way be compromised by its placement in the context of art. It is my hope that new discoveries in genetic research and artworks will help us to fully realize how connected all life-forms are. With this understanding, our role as stewards of this small, fragile planet may yet be realized.

Notes

1. Helen Mayer Harrison, and Newton Harrison, *The Lagoon Cycle* (Ithaca, NY: Office of University Publications, Cornell University, 1985).

2. "Andrea Zittel's A–Z: An Institute of Investigative Living," http://www.zittel.org/Pages/A–ZBreedingUnits.html.

3. "The Homepage of Christopher Ebener and Uli Winters," http://www.c-ebener.de/winters.html.

4. Annick Bureaud, "Art Biologique: Rétrospective-Gallery," *Art Press*, no. 276 (February 2002): 45.

5. Natalie Jeremijenko, "The Great LadyBug Animation," http://cat.nyu.edu/natalie/projectdatabase/.

6. Natalie Jeremijenko, personal conversation (September 6, 2000).

7. Natalie Jeremijenko, "Butterflies Animations Series," http://cat.nyu.edu/natalie/projectdatabase/.

8. Tara Galanti, "Moths/ecovention," e-mail correspondence (June 28, 2002).

9. Greenpeace, "Effects on the Environment," http://www.greenpeacesoutheastasia.org/en/seaissuege01.html.

10. Paul Siegel, "All Roads Lead through Animals Genetics," http://agbio.cabweb.org.

Genomic Portrait

Marc Quinn

A *Genomic Portrait: Sir John Sulston* (figure 24.1) is a work in which the sitter's own DNA was used to create an abstract image that is nevertheless an exact representation of the sitter.

The portrait, unveiled in September 2001 at London's National Portrait Gallery (NPG), was created using standard methods of DNA cloning. We extracted DNA from a sample of Sulston's sperm, which was then replicated in an agar culture, resulting in transparent colonies of bacteria, each grown from a single cell containing part of the instructions to make another John Sulston.

It is a portrait that is not just about the outside of the person but the inside as well. And although it is the first abstract image in the NPG, it's their most realistic by definition.

Sir John Sulston was awarded the 2002 Nobel Prize for Physiology or Medicine. I wanted to use the actual scientific process from John's work to make the portrait. It contains about a million pieces of genetic information, enough to show that it is John and no one else, but it's also a portrait of every one of his ancestors. And because there are only one in a thousand differences within that information, it is also a portrait of us and our relationship to John, which is why there is a mirrored frame.

I think that the whole division between arts and science is a red herring. Science, especially at John's level, uses creativity and intuition, but in a different way.

There's a whole world of DNA work to be explored and I'm very excited by this. The portrait commemorates an extraordinary moment in history; but is also a turning point for the gallery. The NPG records portraits through time and this is a new chapter. It opens up the idea of what a portrait can be. From now on, we're no longer going to be strictly bound by an essentially nineteenth-century idea of what a genealogical portrait should be.

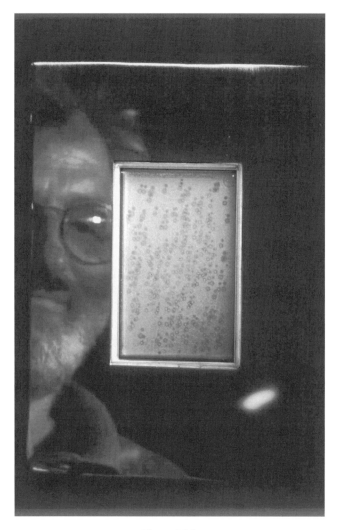

Figure 24.1
Marc Quinn, *A Genomic Portrait: Sir John Sulston*, 2001. Stainless steel, polycarbonate agar jelly, bacteria colonies, cloned human DNA, $5 \times 3\frac{3}{8}$ in (127×85 mm). Courtesy National Portrait Gallery, London.

Note

This chapter is based on excerpts from an interview published in the (London) *Wellcome News Supplement* 5 (2002).

Biology and Art History

The Origins of László Moholy-Nagy's Biocentric Constructivism

Oliver A. I. Botar

The biological, pure and simple, taken as the guide.
—László Moholy-Nagy, *The New Vision*

In January 1923, a chapter of the popular scientific writer Raoul Heinrich Francé's recent book *Die Pflanze als Erfinder* [Plants as Inventors] appeared in the Berlin art journal *Das Kunstblatt* (figure 25.1). In this text Francé discussed his *Biotechnik*, the applied science we now refer to as "bionics" or "biomimetics." Francé held that the prototypes of human technologies are to be found in nature, and that humans had much to learn from organic technology. "As Francé rightly said," wrote László Moholy-Nagy's friend, the biocentric philosopher Ernst Fuhrmann later that same year, "there is no process, even in the most complex industry, that has not been in continuous use by people, animals and plants."[1] Francé's article caused a minor sensation among members of the constructivist circle in Berlin; responses to it can be found in the writing and thinking of Moholy-Nagy (figure 25.2), Lazar El Lissitzky, Mies van der Rohe, Raoul Hausmann, and the Hungarian critic Erno Kállai. As I have argued elsewhere, this body of writing and work might be termed a "biocentric constructivist discourse."[2]

Francé's biocentrism appealed to most of these leftist intellectuals because he held that all nature—including culture—is organized into nested hierarchies of ecosystems, the tendency of which is to arrive at optimal states through symbiotic cooperation more than competition. Awareness of this led Francé to what he termed "objective philosophy," which set guidelines for living in harmony with one's environment, and which he discussed in his 1921 magnum opus *Bios: Die Gesetze der Welt* [Bios: The Laws of the World]. Two months after the appearance of the article, in March 1923, Moholy-Nagy was hired to the Bauhaus, where he taught Francé's ideas. In *Von Material zu Architektur* [From Material to Architecture], the 1929 book based on his Bauhaus teaching, Moholy-Nagy

Figure 25.1

Artist unknown, cover design for Raoul Heinrich Francé, *Die Pflanze als Erfinder* [Plants as Inventors]. Stuttgart: Kosmos, Gesellschaft der Naturfreunde, 1920. Collection of Oliver Botar.

Figure 25.2

Hazen Edward Sise, *Portrait of László Moholy-Nagy from the left, taken during CIAM IV aboard the SS Patris,* summer 1933. Modern gelatin silver print from original negative, 8.8 × 5.9 in (22.5 × 15 cm). Hazen Edward Sise Archive, Collection Centre Canadien d'Architecture/Canadian Centre for Architecture, Montreal. First publication.

discussed Francé's *Grundformen*, the seven basic forms from which, Francé claimed, all natural technologies are built up.

Moholy-Nagy's interest in technology and its creative possibilities has usually been seen as evidence that his was a purely technocentric art. He and other international constructivists have been seen as being, at best, oblivious to what (since the eighteenth century) we have referred to as "nature" or, at worst, as promoting a rapacious, exploitative approach toward it.[3] But in light of the above we may now recognize the Francéan nature of Moholy-Nagy's view of technology and art: "Technical progress is a factor of life which develops organically. It stands in reciprocal relation to the increase of human beings in number. That is its organic justification ... we can no longer think of life without such progress."[4] On the theme of art, meanwhile, just as Francé explains ecosystems to be the optimal expressions of interacting elements, Moholy-Nagy wrote that "'Art' comes into being when expression is at its optimum, i.e., when at its highest intensity it is rooted in biological law, purposeful, unambiguous, pure."[5]

In this article I will argue against the common view that Moholy-Nagy rejected nature early in his career. I will demonstrate that his thinking was rooted in and suffused by the discourse of *Biozentrik* [Biocentrism], the German term for the early twentieth-century world view, which, based on scientific trends such as Darwinism and biologism, and on a kind of materialist nature romanticism, rejected anthropocentrism, and espoused a neo-vitalist and ecological view of the world. Aspects of organicism, vitalism, monism, holism, *Lebensphilosophie* [Life philosophy], and Kropotkinian anarchism, can all be subsumed under the rubric of biocentrism.[6] I will, for the first time, place Moholy-Nagy's pre-Bauhaus German career into its proper context of the *Jugendbewegung* [Youth Movement], specifically the *Freideutsche Jugend* [Free German Youth], and its associated communes, Barkenhof and Loheland. I will suggest that while Moholy-Nagy's oeuvre drew from a wide range of intellectual and artistic sources, it was both formed and directed by a normative biocentrism inherent to the Youth Movement, especially as it was communicated to him through his first wife Lucia Schulz and her circle.

Few authors since his death have seen Moholy-Nagy as biocentric. In describing Moholy-Nagy's pedagogy as "un fonctionnalisme organique" [organic functionalism] or "fonctionalisme vitaliste" [vitalist functionalism] Alain Findeli tends in this direction.[7] This view has been expressed most clearly by German photographic historians such as Gerhard Glüher and Andreas Haus, the latter whom, as early as 1983, plainly stated that "through his propensity for the teaching of the popular biologist Raoul Francé, already in the 1920s Moholy became familiar with a—"biocentric" view of the world." But writing within the polarized context of post-1960s German politics, Haus also argues that Moholy-Nagy's biocentrism shifted from a dialectical and revolutionary one in the 1920s toward one coopted by John Dewey's concept of harmonious society after he moved to the United States in 1937.[8] Yet Moholy-Nagy had already arrived at such a view in his Bauhaus teaching during the 1920s. As he wrote in *Von Material zu Architektur*:

Oliver A. I. Botar

The revolutionist will always remain conscious that the class struggle is . . . not about capital, nor the means of production, but in actuality it concerns the right of the individual to . . . work that meets the inner needs . . . Utopia? No, but it is a task for tireless pioneers. To stake everything on the end in view [is] the supreme duty for those who have already arrived at the consciousness of an organic way of life. . . . At this point the educational problem merges into the political.[9]

Or as he later put it in *Abstract of an Artist*, "art may press for a socio-biological solution of problems just as energetically as social revolutionaries may press for political action."[10]

Jugendbewegung or Mazdaznan?

In *Experiment in Totality*, her biography of Moholy-Nagy, his second wife Sibyl Moholy-Nagy took his "vitalism," as she put it, for granted: "He was a Utopian, I a historian; he the vitalist and I the humanist."[11] She also referred to the "sacrifice" of her husband's artistic career for the sake of his commitment to teaching, as dictated by "biological law[,] because it was *bios*—the interaction of vital impulses, that stimulated man to work for his emotional fulfillment."[12] She goes on to contrast the fascination with art and technology of the late 1960s—the time she was writing the introduction to the second edition of her biography—with László's understanding of "bio-technical matters" as "the message[s] of an inexhaustible cosmic energy he tried to decode." In other words, she pitted László's biocentric, Francéan understanding of *Biotechnik* as human adaptations of naturally occurring technologies that are the resultants of what is essentially the life-force expressing itself through Francé's "law of efficiency," against the reductivist understanding of technology *apparently* at the basis of late 1960s art/technology interactions.

In attempting to describe the milieu that the newlywed Moholy-Nagys operated in, Sibyl writes, "Through [Lucia Schulz] and a circle of friends, Moholy became part of the movement for psycho-biological reform that spread through Germany after the First World War. Its program was based on the rules of the Persian Mazdaznan sect, prescribing exercises of Spartan rigor . . . and a strict vegetarianism."[13] Veit Loers has followed Sibyl's reference to this now obscure Zoroastrian-based cult popular in German bohemian circles of the time by attempting to ground Moholy-Nagy's fascination with light in Mazdaznan.[14] But while Lucia and László were no doubt exposed to the cult, I know of no evidence apart from Sibyl's text that either of them had anything to do with it during the early 1920s, and, let's face it, Sibyl wasn't there. Indeed, as is well known, László was hired to the Bauhaus partly to counteract what was seen as Johannes Itten's negative effects on the school that were *a result of* his adherence to this sect. It is highly unlikely that Gropius would have hired another Mazdaznan adherent in Itten's place! But what, then, of the "movement for psycho-biological reform?" Clearly Sibyl was attempting to denote a "movement" which she termed "psycho-biological." But "psycho-biology," a

term employed by her husband, denotes no movement recorded in history. Rather, it was used by none other than Raoul Francé to refer to the study of human consciousness as a biological phenomenon.[15] So which "movement" was Sibyl referring to? Given her mention of exercise and diet, I would propose that what Sibyl meant was that László and Lucia were part of the movement for social and cultural change known in German as *Lebensreform* [the reform of life][16] and particularly of *Lebensreform* as expressed through the biocentric wing of the *Jugendbewegung* [German Youth Movement], especially in its post-1913 form as the *Freideutsche Jugend* [Free German Youth]. There was no English word for the phenomenon she was referring to, so Sibyl seized on "psychobiology." As Lucia and László's close friend, the biocentric physician Paul Vogler put it: "It is astonishing what all came out of the *Jugendbewegung*."[17]

Freideutsche Jugend

In Germany, already the first *Wandervogel* generation of youth hiking groups was strongly affected both by Friedrich Nietzsche's anti-anthropocentrism and by the scientist Ernst Haeckel's populist nature-centric monist manifesto *Die Welträtsel* [Riddle of the World], first published in 1899, and appearing in a popular edition by 1903.[18] While the writings of Darwin, Haeckel, and other scientists produced the medium within which Nietzsche's mutating radicalism could coagulate, his powerful, poetic articulation of the consequences of positivist science's disenchantment of the world in turn affected Haeckel's thought, or at least the way in which Haeckel's "natural" morality—his opposition to religion and later to the concept of "God"; his focus on the earth and its life—were received. Some of the keener of the *Wandervogel* would then have followed the emergence of the *Monistenbund* [Monist League] in 1906, through which Haeckel and his associates attempted to provide a nature-based alternative to organized religion. In the 1910s and early 1920s, as the Youth Movement coalesced and reconfigured itself, there emerged an environmentalist consciousness out of the Nietzschean, nature-centric neo-Romanticism of the *Monistenbund* and the *Wandervogel* wave.

This consciousness formed itself as the *Freideutsche Jugend*, founded at the "First Free German Youth Day" in October 1913. It was here that the philosopher Ludwig Klages, formulator of the term *Biozentrik* and perhaps its most important philosopher, delivered his rousing environmentalist manifesto "Man and Earth": "Horrible are the effects that 'progress' has had on the aspect of settled areas," he thundered, "Torn is the connection between human creation and the earth, destroyed for centuries...is the ancient song of the landscape...The reality behind the facade of 'utility,' 'economic development' and '*Kultur*,' is the destruction of life."[19] Anna Bramwell has observed that Klages's text "contains most of the themes of today's ecologists; that matriarchy is better than patriarchy, that numberless animal species have been exterminated by man, that the fur and feather trade is wicked, that civilization and *Kultur* kills the spirit, that economics is opposed to

real values." This speech, the most resonant anticipation of today's "deep ecological" thought, had an inestimable impact on those gathered.[20]

While Klages's writings against modernity were important, Jürgen Wolschke-Bulmahn has emphasized Francé's impact on the Youth Movement's environmental awareness,[21] especially through his *Kosmos* series of popular nature books that sold hundreds of thousands of copies, *Plants as Inventors* among them. Though Francé echoed Klages's concern for the natural environment, his less pessimistic attitude of "naturalized technology" is what stirred Moholy-Nagy's and other Berlin constructivists' imaginations, rooted as they were, by their central European education, in nature romanticism, more than Klages's resolutely anti-technological attitude had done. It was Francé rather than Klages who would exercise a powerful impact on Moholy-Nagy's oeuvre after he was hired to the Bauhaus in March of 1923.[22]

Moholy-Nagy's main connection to the *Freideutsche Jugend* was his first wife Lucia Schulz (1894–1989), the cultivated, rebellious daughter of a middle-class, assimilated Jewish family from Prague. Schulz had been involved with the Bohemian Youth Movement from an early age, so it was natural that after her move to Germany she should gravitate toward the same milieu (figure 25.3). As opposed to many of his artistic colleagues in Berlin during the early 1920s, Moholy-Nagy's exposure to biocentric discourses in Germany was assured by Lucia's direct connections with this milieu. For this reason, and because this has never been done from the biocentric perspective, it is important to examine her own intellectual roots in some detail.

Lucia Schulz was both intellectual and very interested in art from an early age. She had been educated at the German University in Prague, where she remembers having studied art history, as well as science and philosophy.[23] Already as a teenager she had visited relatives in Berlin, where she prowled the museums, enthralled by what she saw. She recorded her reactions in her diaries, the precocious documents of a deep thinker. As soon as she could, she left Prague for Germany. In 1914, while working at her first job for a newspaper in Wiesbaden, near Frankfurt/Main, she read Haeckel, which imbued her thinking with monism. Her response to Rhenish religious art was ecstatically *lebensphilosophisch*: "Life, Life is their highest Art . . . Art for Life! Life for Art!"[24]

Schulz's acceptance of a job with B. G. Teubner publishers in 1918 proved to be decisive for her. As she later put it, "Leipzig was meaningful through personal contacts . . . that led to life-long friendships," including friendships with the Youth Movement activists Paul Vogler (1899–1969) and Friedrich Vorwerk (1898–1969), the latter with whom she likely had a relationship during this period (figure 25.4).[25] As early as 1917, the Kassel-born Vogler organized a *Freideutsche Jugend* rally at which the post-war realization of the goals, including Klages's environmental goals, of the 1913 "First Free German Youth Day" was discussed. With a strong interest in biology, he studied economics in Hamburg. In January 1921 he married the medical student Paula Doodt (1895–1963), and, out of a desire to reform what he saw as the capitalist/corporate nature of the medical

Figure 25.3

László Moholy-Nagy, *Lucia Moholy in the Swiss Alps*, n.d. [ca. 1927]. Gelatin silver print. Courtesy of Hattula Moholy-Nagy.

Figure 25.4

László Moholy-Nagy, *Ferenc* (Portrait of Friedrich Vorwerk), 1919 [probably 1920]. Grease crayon and pencil on paper, 20.4 × 15.1 in (52 × 38.5 cm). Collection of Hattula Moholy-Nagy. Gelatin silver print from a vintage contact negative. Courtesy of Hattula Moholy-Nagy.

(a) (b)

Figure 25.5

(a) Photographer unknown, portrait of Paul Vogler, n.d. (Schule für Physiotherapie und Massage Prof. Dr. Med. Paul Vogler, Berlin) Courtesy of Philipp Kewenig. (b) Lucia Moholy, *Portrait of Paula Vogler at the Schwarzerden Commune*, 1927. Bauhaus-Archiv, Berlin. Courtesy of Sabine Hartmann.

system, he joined her in studying medicine from 1921 to 1927 (figure 25.5a,b). Paul and Paula were adherents to what Schulz referred to as a "biological" approach to both preventive and naturopathic therapeutic health care, essentially what we would now refer to as "alternative" medicine. This Paul developed into a physiotherapeutic system of prophylaxis, deep massage, hydrotherapy, and other practices after he became a medical doctor in 1927. Later, along with the philosopher Hans-Georg Gadamer, Paul would develop what he referred to as a "biological anthropology."[26] Schulz emphasized the importance Vorwerk's and the Voglers' world views had for the development of her own, "Vorwerk through his religio-philosophical stance . . . , and Paul and Paula Vogler, through their insight into biological connections."[27] It was precisely this combination that characterized biocentrism in early twentieth-century Germany, an ecstatic nature romanticism tempered by biologism.

Oliver A. I. Botar

During the revolutionary autumn of 1918, Vorwerk became a radical leftist *Freideutsche Jugend* activist, and at some point, possibly through his contact with Ludwig Bäumer, he went to Barkenhoff, Heinrich Vogeler's Kropotkinian, biocentric anarchist commune at the Worpswede artists' colony near Bremen.[28] The Barkenhoff commune was part of what has been referred to as the second wave of the German communard movement, the one dominated by members of the *Freideutsche Jugend* from about 1918 to 1923.[29] In addition to accommodating what we could term "New Age," *Lebensreform*, and biocentric communard ideas, Barkenhoff was a center of the left wing of the *Freideutsche Jugend*.[30] After his return from the Great War in February 1918, the artist Vogeler turned his back on his comfortable, pre-war existence, transforming his late art nouveau *Reformkultur* life at Barkenhoff into one of revolutionary fervor. He established contact with the Communists of Bremen, in November 1918 he joined the Workers' Council of Worpswede, and early in 1919 he joined the newly formed *Kommunistische Partei Deutschlands*, though his thinking was more anarchist than party line at this time. He began to write about a new kind of social organization, and by late 1918 he put his ideas into practice, transforming his family home into an experimental commune,[31] though in practice, it was more a place of refuge for displaced intellectuals and revolutionaries than an organized agricultural unit.[32]

Before the end of 1918, Lucia Schulz had quit her job with Teubner to join Vorwerk at the Barkenhoff. By 1919 Vorwerk felt himself to be with "the most radical Leftist group of workers."[33] Given this and Worpswede's proximity to Bremen, there is little doubt that he took an active part in the Bremen Soviet Republic between January 10 and February 4, 1919,[34] especially since his friend Bäumer was a member of the Revolutionary Council.[35] We do know for certain that like Vorwerk and Vogeler, Schulz was a staunch anarcho-Communist at the time and she resisted the suppression of the Soviet on February 4, 1919. Vogeler recalls that Schulz and her "active Communist" friend Klara Möller assisted the wounded in the battles.[36] Vogeler also suggests that they were engaged in intelligence operations among the radical groups: "They were in the midst of the battle and they were able to shelter some threatened and many wounded comrades in the Bremen City Hall. They became hardworking Party workers."[37] Vorwerk gave a speech that April to a general meeting of the *Freideutsche Jugend* at Jena. His "religious Bolshevism,"[38] no doubt fueled by his recent experiences at Bremen and Barkenhoff, was an anarchist stance typical of Heinrich Vogeler's circle, calling for the destruction of bourgeois society: "Communism will come, whether we want it or not; there remains nothing but one thing for us to do—to go under with this world," wrote Vorwerk.[39]

Schulz also participated in the commune's intellectual life, through her contributions under the pseudonym "Ulrich Steffen" to the single issue of *Neubau*, the Barkenhoff newsletter that appeared in June 1919 (figure 25.6).[40] The motto of this journal, Nietzsche's "I beseech you my brothers, to again love the earth," was as biocentric a text as one could find in the philosopher's oeuvre.[41] Her own contributions display her radical, if naive,

Figure 25.6

Heinrich Vogeler, design and cover art for *Neubau*, vol. 1, no. 1, 1919. Photo: Staatsbibliothek, Berlin.

Figure 25.7

Photographer unknown, Ernst Fuhrmann as a young man, n.d. Silver gelatin print,
4.7 × 6.8 in (12 × 17.3 cm). Karl-Ernst Osthaus Papers, Osthaus-Museum, Hagen.

Communist beliefs, in line with Vogeler's and Vorwerk's.[42] Probably through Vorwerk's
contacts, Schulz published "Symbole" [Symbols], her only philosophical text of the
period, in the October 1919 issue of *Freideutsche Jugend*. In this ecstatic articulation of
Nietzschean antitranscendentalism, she argued for an antireligious, Haeckelian monism
in harmony with Vogeler's nature mysticism: "In the cosmos of unity, the body is no
longer the temple of the Godhead, but is, rather, its very body. Body and soul...are
one...There is no cult other than Life. All of Life is cult, or none is...God is no longer
in us. God is. We are God."[43]

Besides Schulz and Vogeler, the only author to contribute to *Neubau* was Ernst Fuhr-
mann (1886–1956), the self-described *Biosoph* and anarchist theorist of biocentrism,
whose exceptionally rich, fascinating, and little-known oeuvre awaits further research and
analysis (figure 25.7).[44] Fuhrmann, who seems to have spent time at Barkenhoff immedi-
ately after the war ended in the fall of 1918, that is, at the same time that Schulz and
Vorwerk were there,[45] was deeply affected by the thought of Klages. This is evident, for
example, in Fuhrmann's discussion of the rhythm of breath as "the highest principal of
life." Indeed, by the mid-1920s, Fuhrmann sought direct cooperation with the philoso-
pher.[46] In "Lösung" [Solution], his article dealing with the post-war political situation
published in *Neubau*, Fuhrmann gave expression to his radical organicism: "All of the

old fashioned states have collapsed and can only be rebuilt organically, from the cells up."
His views were deeply anti-anthropocentric, that is, *biocentric*: "The people of today refuse
to understand their entire higher manifestations of life in the context of the image of na-
ture and in their identity with nature...they are made up of nothing but nature
and...nothing in them supercedes nature."[47] While Francé and Klages inspired the envi-
ronmentalism of the German Youth Movement from a distance, Fuhrmann's presence at
Barkenhoff represented for Lucia and the commune a direct channel to contemporary bio-
centric thought; a letter that Vogeler sent to Fuhrmann indicates just how highly he came
to value Fuhrmann's *Biosophie*.[48]

Though Fuhrmann did not meet him through Vogeler, it was in 1919 that Vogeler's
good friend and patron, the *Reformbewegung* industrialist Karl Ernst Osthaus,[49] invited
Fuhrmann to the industrial town of Hagen to head the anthropology department of his
German Museum for Art in Trade and Industry.[50] At Hagen, Osthaus had established a
model factory, workers' housing, and a settlement for artists and intellectuals. This com-
plex, guided by what Osthaus referred to as the "Hagener Impuls" [Hagen Impulse], be-
came a magnet for members of the *Lebensreform* movement almost as important as Hellerau
near Dresden, the Mecca of *Lebensreform* itself. By the following year, Osthaus had
appointed Fuhrmann director of his "Folkwang Museum," the first museum devoted to
modern art, and in 1921 he asked Fuhrmann to head his publishing house, the
Folkwang-Verlag. After Osthaus's premature death later that same year, Fuhrmann con-
tinued to develop the publishing house as the "Folkwang-Auriga Verlag," even after mov-
ing it to that third and oldest center of *Lebensreform*, Darmstadt, south of Frankfurt/Main.
There he published a series of illustrated books in conjunction with the Folkwang-
Museum's collections whose stated purpose was to promote "organic directions for our
contemporary culture."[51] Likely at Barkenhoff, Vorwerk and Fuhrmann established a
friendship, and by early in 1922 Vorwerk was staying with Fuhrmann in Hagen. Further-
more, as an invitation sent by Vorwerk to Paul Vogler indicates, Vorwerk and Fuhrmann
were anxious to have the medical student Vogler at Hagen: "Mr. Fuhrmann is at the mo-
ment extraordinarily busy with biological things, and writes a lot on the subject. [He] and
I think that it would be very nice if you could be here...[He]...would very much like to
work with you."[52] This web of connections is suggestive of the biocentric milieu in which
Lucia Schulz operated.

Having established herself within the biocentric circles of the *Freideutsche Jugend*, from
Barkenhoff Lucia moved to the very heart of the movement's publishing endeavors in
Hamburg, where Paula and Paul Vogler were living. There, from December 1, 1919 to
March 21, 1920, she worked for the Hamburg bookstore owner and publisher Adolf
Saal.[53] As publisher of *Freideutsche Jugend* since the journal's inception soon after the move-
ment was founded in December 1914, and as director of its publishing house Freideut-
schen Jugendverlag Adolf Saal, Saal had been at the movement's core.[54] His bookstore

functioned as "a meeting place for those [students and intellectuals such as the Voglers] who loved to discuss matters."[55] That she was involved with the publishing side of things as well as the bookstore is suggested by the fact that by the middle of March, when Saal sold the store and moved his publishing business out of town,[56] she decided to quit her job, and, after a hiking trip with a friend, she continued on to Berlin where Vorwerk had taken up a position with the *Deutsche Studentenschaft* [German Student Body], a wartime student aid organization emergent from the *Jugendbewegung*.

It was at around that time, in mid-March 1920, that László Moholy-Nagy, severely ill with the flu, collapsed at the porter's lodge of St. Joseph's Hospital in the center of Berlin. Hans Harmsen, a young medical student with artistic interests quartered at the hospital, took him in his care and nursed him back to health. Harmsen—a former *Wandervogel* and a member of the student parliament—was active during 1920 in the *Bündische Jugend*, a movement that developed out of the *Freideutsche Jugend* immediately after the war.[57] It is therefore safe to assume that it was Harmsen who put Moholy-Nagy in touch with the lawyer Reinhold Schairer (1887–1971), economic director of the *Deutsche Studentenschaft*. Schairer in turn entrusted Moholy-Nagy to the care of Vorwerk, who would have been excited by the prospect of discussing the Hungarian Soviet Republic with someone who had had firsthand experience of it,[58] and he arranged for Moholy-Nagy to stay at his own boarding house. In Vorwerk's circle, among anarchists, pacifists, and members of the *Lebensreform* movement, Moholy-Nagy would have been reminded of the activist circles within which he had moved in Budapest.

Meanwhile, Schulz arrived at Vorwerk's boarding house around April 1920. By this time she was tiring of the ecstatic radicalism of the *Freideutsche Jugend* and was looking for a new direction in her life. She was impressed by what she felt to be Moholy-Nagy's level-headedness. Her arrival in Berlin forced her into a choice between Vorwerk, whom she termed a *Pathetiker* [an elevated or exalted romantic], and Moholy-Nagy, whom she characterized as a *Pragmatiker*: "Thus it became clear to me, that I had left the time of the pathetic behind me, but had not yet taken up a new attitude. And so I was thoroughly open to new impressions."[59] Moholy-Nagy and Schulz soon found a place together, and by June 1, when she began her job with the prominent Berlin publisher Ernst Rowohlt, she was able to provide for both their basic needs.[60]

Their lives began to mesh, even before they were married on January 18, 1921. László's ambition to enter Berlin's world of the fine arts introduced Lucia into a new circle, the avant-garde, which was just then—like she was—attempting to exit the "pathetic" world of expressionism, and enter a new, more pragmatic realm. This would inspire her to take up photography, and her reputation as a photographer even now continues to grow. By late 1920, through both László's Hungarian emigré connections in Berlin, and Lucia's contacts made while she was working for Rowohlt, the Moholy-Nagys came in touch with radical Berlin artistic circles, through which László befriended biocentric avant-gardists

such as Raoul Hausmann, Hannah Höch, and Adolf Behne, themselves undergoing trans-formations from the "pathetic" to the "objective."[61] Indeed all these developments paral-leled Francé's own contemporaneous attempts to change Haeckel's monism from an ersatz religion to a new "objective" *Weltanschauung*.[62]

What is most important to our current discussion is that while he continued to im-merse himself in the flourishing Berlin avant-garde art scene, through Lucia and Vorwerk, László was introduced into a world of biocentric thought that proved to be a crucial cor-ollary to his art world connections, for it helped determine the direction, as opposed to the style of his project. The crucial figures in this regard were the Vogler couple and Fuhr-mann. Fuhrmann's importance to German interwar biocentric culture is only now becom-ing apparent, and it has never been remarked that the Moholy-Nagys were his friends. Indeed, as we shall see, Fuhrmann was Moholy-Nagy's patron, purchasing his art and introducing him to the work of Albert Renger-Patzsch, the biocentric photographer who would—in part—inspire Moholy-Nagy to articulate his New Vision.[63] In turn, the Moholy-Nagys were avid readers of Fuhrmann's books,[64] and Fuhrmann visited the Moholy-Nagys at the Weimar Bauhaus on at least one occasion.[65] Paul and Paula Vogler, meanwhile, attracted the Moholy-Nagys to the life of the communes, perhaps the most important loci during the 1920s of the biocentric wing of the German Youth Movement.

"A tongue of fire to expound his happiness": Loheland and Moholy-Nagy's Biocentric Pedagogy

> From his biological being every man derives energies which he can develop into cre-ative work. *Everyone is talented....* One has to live "right" to retain the alertness of these native abilities. But only art—creation through the senses—can develop these dormant, native faculties toward creative action. Art is the grindstone of the senses, the coordinating psycho-biological factor. The teacher who has come to a full realiza-tion of the organic oneness and the harmonious sense rhythm of life should have a tongue of fire to expound his happiness.
>
> —László Moholy-Nagy, qtd. in Sibyl Moholy-Nagy, *Moholy-Nagy: Experiment in Totality*

Once they were married, Lucia arranged for the young couple to vacation at the communes in the Rhön, the central German mountain range southeast of the city of Fulda, that had their origins in the *Freideutsche Jugend*. As Lucia recalls,

> That we then took our vacation several times in the Rhön almost went without saying. Living in one of the many little granny-flat cottages with a view of meadows and mountains, where we were allowed to lead a modest summertime existence according to our own wishes, we soon came to know many other people who, in this harsh, at the time, still unfrequented region, had found . . . the rhythm of their lives.[66]

Both Moholy-Nagy and his friend Ernő Kállai mention a vacation in the mountains as the locus for Moholy-Nagy's production of the *Ackerfelderbilder* [Farm Field Pictures] during what must have been the summer of 1921, perhaps in August, after Lucia's job at Rowohlt Verlag ended.[67] Moholy-Nagy recalled "spending a holiday in the country, where from the hilltops I could see hundreds of small strips of land, I painted pictures with coloured stripes in juxtaposition and called them 'acres.'"[68] Other related works, for example *F in Feld* [F in a Field] (figure 25.8), juxtapose industrial elements such as cog-wheels, power lines, and cranes on the fields.[69] While clearly affected by the mechano-Dada style of Picabia and Schwitters, these paintings reflect Moholy-Nagy's fascination with the color rhythms of the mountainous land depicted, as well as with the agricultural equipment and power lines in it, an inscription of the "technological" on the "natural"—a synthesis of the two—atypical of post-war avant-garde art, but characteristic of the post-war biocentric constructivist perspective. That such a reading of these works is plausible is reinforced by aspects of their reception: After Hans Harmsen and Friedrich Vorwerk, Moholy-Nagy's third collector in Germany was none other than Ernst Fuhrmann.[70] He acquired Moholy-Nagy's *Schiff* [Ship] and *A Bild* [A Picture] as early as 1921. Fuhrmann arranged for Moholy-Nagy's works to be shown at the Museum Folkwang in Hagen early in 1922, his first at a German museum, an occasion on which Moholy-Nagy visited Hagen. Fuhrmann also initiated the Museum's purchase of two of Moholy-Nagy's artworks, his first by a German institution.[71]

As they did the following summer of 1922, the Moholy-Nagys may have stayed in the Rhön mountains on the *Ackerfelderbild* vacation, close to the Schule für Körperbildung Loheland [School of Body Education], an anthroposophically and holistically oriented women's commune, gymnastics and handicraft school founded near Fulda in May 1919 by the gymnast and women's education specialist Hedwig von Rohden and the anthroposophist and artist Louise Langgaard.[72] Although the summer school program had not yet begun, by the summer of 1921 Loheland was a thriving commune, with agricultural, weaving and dancing workshops. Several buildings were already in place, including a shelter for gymnastics, so the commune could have formed the focus for a vacation for the Moholy-Nagys.[73]

That the Moholy-Nagys would have been informed of this as yet new foundation, comes as no surprise. Lucia's connections and experience would have ensured such insider knowledge. She might have first met von Rohden and Langgaard on their visits to Barkenhoff.[74] She will certainly have heard of Loheland from Paul Vogler. This latter possibility is reinforced by the text "Vogler, Biologie, Loheland," which is in Lucia's autobiographical notes in connection with the Moholy-Nagys' stay there during the summer of 1922.[75] This school—early on famous for the dance performances of Eva Maria Deinhardt and other members of the commune—spawned the concept of the *Loheländerin*, a liberated and ecologically aware female type famous in Weimar Germany.[76]

Figure 25.8

László Moholy-Nagy, *F in Feld* [F in a Field], dated 1920. Gouache and collage on paper, image: 8.6 × 6.9 in (22 × 17.7 cm), sheet: 9.6 × 7.6 in (24.4 × 19.5 cm). Private collection.

The Moholy-Nagys certainly spent their vacation of July 1922 at Loheland, for Weyhers, the village in which it is known they roomed, is a mere two-to-three-kilometer walk southeast of the school. Since they were so poor at this time, they probably took advantage of the fact that Paul and Paula Vogler owned a small house at or near Weyhers, and stayed there—this was the "granny-flat cottage" to which Lucia had referred.[77] During this stay, Lucia might have participated in the first *Ferienkurse* [summer courses] at Loheland, in which somewhere between seventy and eighty women were involved.[78]

This turned out to be an important learning experience for the young married couple. Both Lucia and László Moholy-Nagy have indicated that it was here that they developed their photogram practice and formulated the ideas published as "Produktion—Reproduktion" in the September *De Stijl*.[79] Moholy-Nagy remembered that he adapted the idea of the photogram from a *Loheländerin* who was making photograms using translucent plants. This woman was Bertha Günther (1894–1975), an early member of the Loheland group who worked in its photographic laboratory on her *Crystallisation* images, and her photograms of petals, leaves, flowers, and other organic material (figure 25.9).[80] Moholy-Nagy was fascinated by the seemingly infinite range of tones that were the result of a process as simple as light modulated by organic material falling on light-sensitive paper. As he later articulated, he saw these transitions as part and parcel of the organically integrated "rhythmic" life he experienced at the Loheland commune.

The organic-functionalist core idea of "Produktion–Reproduktion"—emphasizing the development of the innate creativity and integration of each individual—was typical of *kunsterzieherisch* [art educational] and *reformpädagogisch* [reform pedagogy] ideas current at the time:[81]

> The human construct is the synthesis of all its functional apparatuses, i.e., man will be most perfect in his own time if the functional apparatuses of which he is composed—his cells as well as the most sophisticated organs—are conscious and trained to the limit of their capacity. Art effects such a training.

Moholy-Nagy's pedagogy was also affected by the ideas of the peripatetic pedagogical reformer Marie Buchhold, one of the most prominent editors of *Freideutche Jugend* in late 1919 and early 1920.[82] Buchhold was closely associated with Paul Vogler's sister, the *Freideutsche Jugend* pedagogue and dancer Elisabeth Vogler. Elisabeth, a disciple of the *Reformpedagogie* [Reform Pedagogy] leader Gustav Wyneken, had been at Loheland in 1919–1920, and the Moholy-Nagys had met with her in the Rhön by 1922.[83] Lucia in particular formed a strong friendship with Elisabeth Vogler.[84] Probably inspired by Heinrich Vogeler, Buchhold had been thinking hard about questions of communal living and education reform, and was anxious to put her ideas into action.[85] Her pedagogy indicates that she is an unrecognized pioneer of eco-feminism. Evidently affected by J. J. Bachofen's hypothesis of *Mutterrecht*—the matriarchal structure of ancient society—which circulated

Figure 25.9
Bertha Günther, plant leaves, n.d. [ca. 1921]. Photogram, 9.4 × 6.6 in (25.7 × 17 cm).
Collection of the Loheland Rudolf-Steiner Schule. Courtesy of Antje Harcken.

in the Stefan George circle of which she was a member, as well as by Klages's environmentalism, Buchhold's diary of 1924 contains passages such as: "By *Körperlehre* [body instruction]... is meant the recognition of the human organism within the organism of the world," and, "Woman requires a natural teaching that is developed from herself as a *Weltanschauung*."[86] The biocentric aspect of Buchhold's thinking is echoed in Moholy-Nagy's own pedagogical writings of the time; for example, "Man is the microcosm. Over him and in him universal laws hold sway. His entire being and accomplishment is a singular attempt to express and lend form to these laws."[87]

In the fall of 1923 Buchhold and Vogler founded a women's commune and school at Schwarzerden, 10.5 km east of Loheland.[88] Moholy-Nagy would go on to deepen his knowledge of reform pedagogy there, as he and Lucia spent vacations there after he got the Bauhaus job. As we saw at the beginning of this article, it was around this time that Moholy-Nagy discovered the writings of Francé. It was his exposure to the biocentrism of Lucia's *Freideutsche Jugend* circle, his own background in Hungarian activist circles, and his pedagogical and philosophical convictions that predisposed Moholy-Nagy to an interest in Francé's thought, particularly as it concerns technology. Just as he did to Francé, Moholy-Nagy acknowledged his debt to the *Reformschulbewegung* [Reform School Movement] and the German Youth Movement, to Wyneken and Vogeler, as well as, indirectly, to the *Freideutsche Jugend* and its communes.[89]

Coda

Moholy-Nagy's biocentrism and his interest in Francé did not diminish after he joined the Bauhaus staff in 1923. It was at the Bauhaus that Moholy-Nagy put the pedagogical ideas he learned at the communes into practice, and it was there that he developed his photographic "New Vision," a vision, as I have argued elsewhere, that was at its root biocentric.[90] Nor did his interest in biocentrism diminish after he left the Bauhaus early in 1928. If anything, it intensified, particularly after his emigration to the United States in 1937. In America, Moholy-Nagy had the opportunity to correspond with John Dewey, whose pragmatist concept of "learning by doing" inspired the same *Schulreformbewegung* Moholy-Nagy had been inspired by.[91] At his various schools in Chicago Moholy-Nagy continued to teach Francé's biotechnics, and he placed increasing stress on ergonomic design. Finally, much of Moholy-Nagy's art of his American period (1937–1946), both the two-dimensional works and the three-dimensional Plexiglas "space modulators," was both biomorphic and abstract in nature, and therefore formed part of that "bioromantic" pattern of art-making at the time, which wedded a biomorphic abstract style with biocentric content (figure 25.10).[92] His interest in the microscopic intensified during his struggle with leukemia in 1945–1946, and this interest was one of the sources, or at least one of the significant associations at play, in the production and intended reception of these works. As Sybil Moholy-Nagy wrote, "What interested Moholy in his diagnosis with

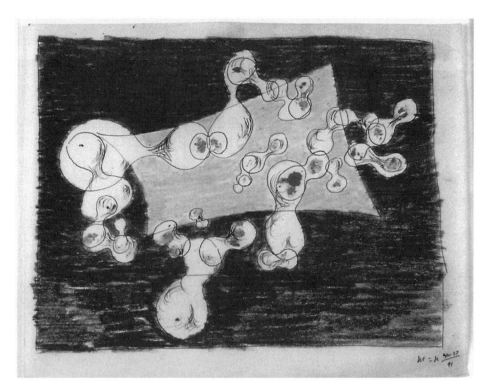

Figure 25.10

László Moholy-Nagy, *Untitled* (sketch for *Prehistoric Construction*), April 27, 1941.
Conté crayon on paper, 8.4 × 10.9 in (21.5 × 27.7 cm). Private collection.

chronic leukaemia was not the inevitable end, which he fought until his final breath, but rather the scientific side of haematology."[93] I don't see the evident visual parallels between this sketch for the space modulator *Prehistoric Construction*, and dividing cells, as a mere by-product of Moholy-Nagy's adherence to the then fashionable biomorphic abstract style. It is my view that as with Paul Klee, Wassily Kandinsky, and Hans Arp, this late style visualizes biocentrism; it is a modernist replay of artistic nature romanticism; a bioromanticism, as Erno Kállai put it.[94]

While Moholy-Nagy did not often write directly of his biocentrism or about politics, there is a telling line of argument contained in one of his most important later texts, "Space-Time and the Photographer," published in 1943. Embedded in a discussion of the new ways in which photograms articulate space ("without existing space structure[;] only by [tonal] articulation on the plane"), Moholy-Nagy's line of argument takes an unexpected turn. These "sublime gradations" make him "suddenly … aware that here starts

an invigorating investigation about the incoherent use of our rich resources. Technological ingenuity provides us with gigantic structures, factories and skyscrapers, but how we use them is shockingly anti-biological—resulting in wild city growth, elimination of vegetation, fresh air, and sunlight..." "It seems," he continues, "that the most abstract experiment of space-time [in art] may signalize [*sic*] a spatial order in which no single structural parts...will play the important part, but the relationships of neighbor units, buildings and free areas...leading towards a biologically right living most probably through a right regional planning; towards a city-land unity."[95] It was the seamless connections symbolized by the subtle, light-induced tonal gradations of photograms, the technique taught him by *Loheländerin* Bertha Günther using plants plucked on hiking trips, that served as Moholy-Nagy's model for a new, organic connection between nature and modernity. The passage is emblematic of the similarly "seamless" integration of Moholy-Nagy's biocentric world view, his art, and his politics. As Francé put it, "Harmony is the biological goal."[96]

The clearest statement of Moholy's biocentrism is in the introduction to *The New Vision*, into which he inserted a section entitled "Biological Needs," because he felt he had to explain his terminology to the American readership. "In this book the word 'biological' stands generally for laws of life which guarantee an organic development. If the meaning of 'biological' were a conscious possession, it would prevent many people from activities of damaging influence...The oncoming generation has to create a culture which...strengthens the genuine biological function."[97] This makes it clear not only that the basis for Moholy-Nagy's entire project was biocentrism, but that it was a normative and Utopian biocentrism. I would maintain that the common view of László Moholy-Nagy as a purely rational formalist naively enamored of technology is deeply flawed, and requires revision.

Notes

The research and writing of this article was carried out with the assistance of a University of Manitoba Research Leave Grant in 1999, the Resident Scholar program of the Canadian Centre for Architecture in Montreal in 2000–2001, and a University of Manitoba Social Sciences and Humanities Research Council of Canada Grant in 2002–2003. I thank all the agencies for their generous support. I also wish to thank Hattula Moholy-Nagy; Ortrud Wörner-Heil; Sabine Hartmann and Else Eckert of the Bauhaus-Archiv, Berlin; Antje Harcken of the Loheland Rudolf-Steiner Schule; Beate Arnold of the Barkenhof-Stiftung Worpswede; Bettina Heil of the Karl-Ernst Osthaus-Museum, Hagen; and the staffs of the Deutsches Literaturarchiv, Marbach and the Staatsbibliothek zu Berlin for their help in researching this article.

László Moholy-Nagy, *Von Material zu Architektur* [From Material to Architecture] (Munich: Albert Langen, 1929), 222. In English: *The New Vision: Fundamentals of Design Painting Sculpture Architecture*, trans. Daphne M. Hoffmann (New York: W. W. Norton & Co., 1938), 198.

1. Ernst Fuhrmann, *Der Sinn im Gegenstand* (Munich: Georg Müller, 1923), 29.

2. Oliver Botar, "Prolegomena to the Study of Biomorphic Modernism: Biocentrism, László Moholy-Nagy's 'New Vision,' and Erno Kállai's *Bioromantik*," Ph.D. diss., University of Toronto, 1998 (Ann Arbor, MI: UMI, 2001), chap. 4.

3. See, for example, Stephen Mansbach, "Attitudes Towards Nature in Some Early Twentieth Century Art," *The Structurist* nos. 23–24 (1983–1984): 87.

4. Moholy-Nagy, *Von Material zu Architektur*, 12. In English: *The New Vision: From Material to Architecture*, trans. Daphne M. Hoffmann (New York: Brewer, Warren & Putnam Inc., 1932), 12.

5. László Moholy-Nagy, *Painting, Photography, Film*, trans. Janet Seligman (Cambridge, MA: MIT Press, [1925; 1927] 1969), 17.

6. On biocentrism see Botar, "Prolegomena to the Study of Biomorphic Modernism," chap. 2.

7. Alain Findeli, "L'esthétique pedagogique de László Moholy-Nagy et son role dans la transplantation du Bauhaus à Chicago," typescript, 12. Published in German in an abridged version in *50 Jahre New Bauhaus*, ed. Gerhard Glüher (Berlin: Bauhaus Archiv, 1987).

8. Gerhard Glüher, "Moholy-Nagy: Photographie," in *László Moholy-Nagy: Frühe Photographien* (Berlin: Nishen, 1989); Andreas Haus, "Sinnlichkeit und Industrie," in *Avant-garde und Industrie*, ed. Stanislas von Moos (Delft: Delft University Press, 1983), 113–114.

9. Moholy-Nagy, *Von Material zu Architektur*, 16. In English: *The New Vision* (1932), 15.

10. László Moholy-Nagy, *The New Vision and Abstract of an Artist* (New York: Wittenborn, Schultz, 1949), 76.

11. Sibyl Moholy-Nagy, *Moholy-Nagy: Experiment in Totality*, 2nd ed. (Cambridge, MA: MIT Press, 1969), xi.

12. Ibid., xviii.

13. Ibid., 21.

14. Veit Loers, "Moholy-Nagys 'Raum und Gegenwart' und die Utopie vom dynamisch-konstruktiven lichtraum," in *László Moholy-Nagy*, ed. Renate Rüdiger, Monika Göbel, and Veit Loers (Stuttgart: Gerd Hatje, 1991), 41.

15. See Robert Bud, *The Uses of Life: A History of Biotechnology* (Cambridge: Cambridge University Press, 1993), 61; and Botar, "Prolegomena to the Study of Biomorphic Modernism," chap. 2.

16. On *Lebensreform* and its biocentric bases, see *Die Lebensreform: Entwürfe zur Neugestaltung von Leben und Kunst um 1900*, ed. Kai Bucholz, 2 vols. (Darmstadt: Haeusser-Media, 2001).

17. Quoted in Michael Laws, "Die Wirken des Ordinarius für Physikalische Therapie Paul Vogler am 'Institut für natürliche Heil-und Lebensweisen' der Berliner Medizinischen Fakultät," Ph.D. diss. (Berlin: Humboldt-Universität, 1993), 15. Thanks to Philipp Kewenig for sending me this dissertation.

18. On Haeckel in early twentieth-century German intellectual life, see Donald E. Gordon, *Expressionism: Art and Idea* (New Haven: Yale University Press, 1987), 9, 21–22. On the *Wandervogel*, 130.

19. Ludwig Klages, "Mensch und Erde," in *Freideutsche Jugend. Zur Jahrhundertfeier auf dem hohen Meissner 1913*, ed. Arthur Kracke (Jena, Germany: Eugen Diederichs, 1913), 89, 91.

20. Anna Bramwell, *Ecology in the 20th Century: A History* (New Haven: Yale University Press, 1989), 268, note 4. Also pp. 180–181; Janice Schall, "Rhythm and Art in Germany, 1900–1930," Ph.D. diss. (Austin: University of Texas at Austin, 1989), 34; Winfried Mogge and Jürgen Reulecke, *Hohe Meissner 1913. Der Erste Freideutsche Jugendtag in Dokumenten und Bildern* (Cologne: Verlag Wissenschaft und Politik, 1988), 39–41, 74; Ulrich Linse, *Ökopax und Anarchie: Eine Geschichte der ökologischen Bewegungen in Deutschland* (Munich: Deutscher Taschenbuch-Verlag, 1986), 60.

21. Jürgen Wolschke-Bulmahn, *Auf der Such nach Arkadien: Zur Landschaftsidealen und Formen der Naturaneignung in der Jugendbewegung und ihrer Bedeutung für die Landespflege* (Munich: Minerva, 1990), 83–91.

22. Concerning Francé's impact on Moholy-Nagy, see Botar, "Prolegomena to the Study of Biomorphic Modernism," chap. 4.

23. On Lucia Schulz, see Oliver Botar, "An Activist-Expressionist in Exile: László Moholy-Nagy 1919–21," in *László Moholy-Nagy: From Budapest to Berlin, 1914–23*, ed. Belena Chapp (Newark, NJ: University Gallery, University of Delaware, 1995), 78; Rolf Sachsse, *Lucia Moholy* (Düsseldorf: Edition Marzona, 1985), 7; Rolf Sachsse, *Lucia Moholy: Bauhaus Fotografin* (Berlin: Bauhaus-Archiv, 1995), 11.

24. Lucia Moholy, Wiesbaden diary (Lucia Moholy Papers, Bauhaus-Archiv, Berlin; Mappe 135, 1178–1167). This passage is from early 1916. For her notes on Haeckel's *Das Lebenswunder* dated March 23, 1915, see 1178–1154.

25. Lucia Moholy, "Autobiographical Notes," (Lucia Moholy papers, Bauhaus-Archiv, Berlin; mappe 4, 3 and verso; 9). On Vorwerk's *Jugendbewegung* background, see Walter Hundt, *Bei Heinrich Vogeler in Worpswede: Erinnerungen* (Worpswede: Worpsweder Verlag, 1995), 15. On Paul Vogler as a *Wandervogel* and *Freideutsche Jugend* activist, see Werner Kindt, ed., *Die Wandervogelzeit* (Düsseldorf: Eugen Diederichs Verlag, 1968), 599–600, 602, 604, 829–830.

26. Paul Vogler, "Lebenslauf. Prof. Dr. Paul Vogler," undated typescript (after 1947) (Paul Vogler papers, Bauhaus-Archiv, Berlin); Laws, "Die Wirken des Ordinarius für Physikalische Therapie Paul Vogler," 12–17; Paul Vogler and Hans-Georg Gadamer, *Neue Anthropologie*, vols. 1 and 2: *Biologische Anthropologie* (Stuttgart: Thieme, 1972).

27. Lucia Moholy, "Autobiographical Notes," 9–10.

28. On Vogeler's nature mysticism, see Bernd Stenzig's Afterword to Hundt, *Bei Heinrich Vogeler in Worpswede*, 208–210. On Kropotkin's importance at Barkenhoff, see Hundt, 67; Ulrich Linse, *Die Kommune der deutschen Jugendbewegung* (Munich: C. H. Beck'sche Verlagsbuchhandlung, 1973), 52; Bernd Stenzig, "'Von einem Auferstehenden, der nicht mehr zu beirren ist,'" in *Heinrich Vogeler: Vom Romantiker zum Revolutionär. Ölbilder, Zeichnungen, Grafik, Dokumente von 1895–1924* (Bonn: Bonner Kunstverein, 1982), 127; Siegfried Bresler, *Heinrich Vogeler* (Hamburg: Rowohlt, 1996), 65ff.; and Heinrich Wiegand Petzet, *Von Worpswede nach Moskau. Heinrich Vogeler. Ein Künstler zwischen den Zeiten* (Schauberg: DuMont Verlag, 1972), 127–128.

29. Ulrich Linse, *Zurück, o Mensch, zur Mutter Erde: Landkommunen in Deutschland 1890–1933* (Munich: DTV, 1983), 20.

30. See Walter Z. Laqueur, *Young Germany. A History of the German Youth Movement* (London: Routledge & Kegan Paul, 1962), 100–101; Dietmar Schenk, *Die Freideutsche Jugend, 1913–1919/20: Eine Jugendbewegung in Krieg, Revolution und Krise* (Münster and Hamburg: Lit Verlag, 1991), 307; and August Messer, *Die Freideutsche Jugendbewegung. Ihr Verlauf von 1913 bis 1922* (Langensalza: Hermann Beyer & Söhne, 1922).

31. Biographical information is from Rena Noltenius, *Heinrich Vogeler (1872–1942) Die Gemälde—Ein Werkkatalog* (Bonn: VG Bild-Kunst, 2000), 60–64, 304.

32. Bernd Küster, *Das Barkenhoff Buch* (Worpswede: Worpsweder Verlag, 1989), 116.

33. Schenk, *Die Freideutsche Jugend*, 117.

34. Heinrich Vogeler and other members of Barkenhoff such as Johann Kneif, for example, played active roles. On the Bremen Soviet and Vogeler's role in it, see David Erlay, *Worpswede—Bremen—Moskau. Der Weg des Heinrich Vogeler* (Bremen: Schünemann Universitätsverlag, 1972), 94–102.

35. Stenzig, "'Von einem Auferstehenden,'" 108.

36. On the fighting, see Erlay, *Worpswede—Bremen—Moskau*, 102. On Möller as part of the inner circle of the Barkenhoff commune, see Sigfried Bresler, in *Der Barkenhoff. Kinderheim der roten Hilfe 1923–1932*, Siegfried Bresler et al. (Worpswede: Worpswede Verlag, 1991), 30.

37. Vogeler, *Werden. Erinnerungen*, 230, 277.

38. Reinhard Preuss, *Verlorene Söhne des Bürgertums. Linke Strömungen in der deutschen Jugendbewegung 1913–1919* (Cologne: Wissenschaft und Politik, 1991), 210.

39. Quoted in Laqueur, *Young Germany*, 114. On this meeting, see also Schenk, *Die Freideutsche Jugend*, 112–117.

40. Sachsse in *Lucia Moholy* (1985), 8–9. Her use of this male alias is less likely because she was a woman, as Sachsse suggests, than because she was a foreign national engaging in radical activities during a period when police raids on the Barkenhoff commune were commonplace. (See David Erlay, *Worpswede—Bremen—Moskau*, 176–181.) On the complicated and contradictory status of women in the German Youth Movement, see, for example, Marion E. P. de Ras, *Körper, Eros und weibliche Kultur. Mädchen im Wandervogel und in der Bündischen Jugend, 1900–1933* (Pfaffenweiler: Centaurus-Verlagsgesellschaft, 1988).

41. Quoted in *Neubau* 1, no. 1 (1919): 3. My translation. Originally published in part III of "Zarathustra's Prologue" in *Also Sprach Zarathustra*.

42. Ulrich Steffen [Lucia Schulz], "Über den Kommunismus," *Neubau* 1, no. 1: 9–11.

43. Lucia Schulz, "Symbole," *Freideutsche Jugend. Monatschrift für das junge Deutschland* 5, no. 10 (October 1919): 406–408. See also Sachsse, *Lucia Moholy* (1985), 8.

44. On Fuhrmann as politically anarchist, see Gert Mattenklott, Vorwort in *Neue Wege, The Collected Works*, vol. 10, Ernst Fuhrmann (Hamburg: Ernst Fuhrmann Archiv, 1983), V, VIII.

45. Franz Jung, Nachwort in *Grundformen des Lebens*, Ernst Fuhrmann (Heidelberg: Lambert Schneider, 1962), 251–252.

46. Fuhrmann, *Der Sinn im Gegenstand*, 18. C.f. various texts by Klages from 1913 on, published as *Vom Wesen des Rythmus* (Kampen auf Sylt: Niels Kampmann, 1934). Fuhrmann's two letters sent to Klages during the mid-1920s offer cooperation and display intense admiration (Deutsches Literaturarchiv, Marbach, Klages Papers). For a summary of Fuhrmann's philosophy, see Volker Kahmen, "Ernst Fuhrmann—Photographs of Plants," in *Ernst Fuhrmann* (exhibit catalogue) (Rolandseck: Bahnhof Rolandseck, 1979).

47. Quoted in Volker Kahmen, "Ernst Fuhrmann—Photographs of Plants," in *Ernst Fuhrmann* (exhibit catalogue), trans. Ciarán A. Mulhern (Rolandseck: Bahnhof Rolandseck, 1979), 47.

48. Cited in Mattenklott's Vorwort in Fuhrmann, *Neue Wege*, III.

49. Osthaus had invited Vogeler to exhibit his works in the Folkwang Museum as early as 1909. (See the correspondence in the Karl-Ernst Osthaus Museum Archives, Osthaus Papers, F1/785.) Fuhrmann had met Osthaus in 1915, probably through Professor Botho Graef in Jena. Gert Mattenklott, in Fuhrmann, *Neue Wege*, V; and *Karl Ernst Osthaus: Leben und Werk* (Rechlinghausen: Verlag Aurel Bongers, 1971), 98.

50. Rainer Stamm, "'Die Brücke zum Menschen': Lebensreform und Reformkultur als Teil des Folkwang-Impulses in Hagen," in *Die Lebensreform*, vol. 1, 496.

51. Fuhrmann, *Der Sinn im Gegenstand*, 20.

52. Friedrich Vorwerk, letter to Paul Vogler (Dietershausen Post Weyhers Rhön), March 13, 1922 (Paul Vogler papers, Berlin: Bauhaus-Archiv, K-8).

53. Sachsse, *Lucia Moholy* (1985), 9; and Lucia Moholy, *Moholy-Nagy, Marginal Notes: Documentary Absurdities* (Krefeld: Scherpe Verlag, 1972), 51. For the exact term of employment with Saal, see Lucia Moholy's card file (Lucia Moholy Papers, Berlin: Bauhaus-Archiv).

54. Schenk, *Die Freideutsche Jugend*, 91; Messer, *Die Freideutsche Jugendbewegung*, 42; Werner Kindt, *Die Wandervogelzeit*, 573–574, 1065–1066.

55. Lucia Moholy, "Autobiographical Notes," n.d. [after 1974] (Lucia Moholy Papers, Berlin: Bauhaus-Archiv, mappe 4, 8 and verso).

56. Saal's Hamburg bookshop was taken over by the Deinet sisters Marie and Margarethe on March 10, 1920. See Messer, *Die freideutsche Jugendbewegung*, 99; and Reinhard Würffel, *Lexikon Deutscher Verlage* (Berlin: Verlag Grotesk, 2000), 730.

57. Botar, "An Activist-Expressionist in Exile," 74–75.

58. That Vorwerk knew of the Hungarian Soviet is indicated by the fact that Lucia Schulz wrote about it in glowing terms in her *Neubau* article.

59. Lucia Moholy, "Autobiographical Notes," 13.

60. Botar, "An Activist-Expressionist in Exile," 76.

61. Ibid., 82.

62. See Botar, "Prolegomena to the Study of Biomorphic Modernism," chap. 2.

63. On the relationship between Moholy-Nagy and Renger-Patzsch, see Fritz Kempe, "Albert Renger-Patzsch, Mensch und Werk," in *Albert Renger-Patzsch: Der Fotograf der Dinge*, ed. Otto Steinert (Essen: Ruhrland- und Heimatmuseum Essen, 1967), unpaginated. I will deal with this relationship in more detail elsewhere.

64. Moholy-Nagy's letter to Martha Kramer, secretary of the Museum Folkwang, postmarked April 8, 1922, indicates that he was expecting books that Fuhrmann promised him (Karl-Ernst Osthaus Museum Archive, Osthaus Papers, F2/155/8). That the Moholy-Nagys valued these books is indicated by the postcard from Lucia Moholy to Hannah Höch written from Dessau on June 7, 1926, asking Höch to send the "Fuhrmann-Bücher," which they had forgotten. Published in *Hannah Höch: Eine Lebenscollage*, vol. 2 (Berlin: Berlinische Galerie and Stuttgart: Gerd Hatje, 1995), 258–259.

65. See the entry in Ilse Gropius's diary of June 25, 1925 (Berlin: Bauhaus-Archiv, 1998).

66. Quoted in Sachsse, *Lucia Moholy* (1995), 108.

67. On Lucia's job ending July 31, 1921, see Sachsse, *Lucia Moholy* (1985), 9. Kállai remembers that they were produced on vacation in "Technika és konstruktiv művészet" (Technology and constructive art) *Ma* 7, nos. 5–6 (May 1, 1922): 7–9. The vacation must have taken place in 1921, the year of the *Ackerfelderbilder*.

68. Moholy-Nagy, *Abstract of an Artist*, 72. In 1921 a number of these works were in the possession of Friedrich Vorwerk (then living at Hagen). Moholy-Nagy to Dr. Otto Hover, January 25, 1922 (Osthaus Papers, Karl-Ernst Osthaus Museum Archiv, F2-155).

69. László Moholy-Nagy, *F in Feld*, watercolor and collage on paper, 22 × 17.7 cm., private collection, *Laszlo Moholy-Nagy/Laszlo Peri. Zwei Künstler der ungarischen Avantgarde in Berlin 1920–1925* (Bremen: Graphisches Kabinett Kunsthandel Wolfgang Werner, 1987), #4.

70. On Harmsen's collections, see Botar, "An Activist-Expressionist in Exile," 75.

71. See Moholy-Nagy's letter to Otto Hover, January 25, 1922; and *Museum Folkwang*, Band 1, *Moderne Kunst: Malerei Plastik Grafik*, ed. Agnes Waldstein (Essen: Museum Folkwang, 1929), 53.

72. On the Moholy-Nagys' July 1922 vacation at Weyhers, see László's letter to Theo van Doesburg of July 10, 1922, in the Appendix to Theo van Doesburg, *Grondbegrippen van de Nieuwe Beeldende Kunst* (Nijmegen: SUN, 1983), 102.

73. See the chronology of Loheland in the brochure *Loheland. Gymnastik—Landbau—Handwerk. Waldorfschule mit Internat. Ideen, werden, Taten.* (No place, publisher, or date, ca. 1988; circulated by the Loheland Foundation).

74. See Hundt, *Bei Heinrich Vogeler in Worpswede*, 104. No precise date is given for their performance, though it might have been as late as 1921.

75. Lucia Moholy, "Autobiographical Notes," 14. Lucia Moholy, "Erinnerungen von Freunden an ihre Begegnung mit Elisabeth Vogler...," in Sachsse, *Lucia Moholy* (1995), 108.

76. De Ras, *Körper, Eros und weibliche Kultur*, 163–169.

77. During 1922, Marie Buchhold and Elisabeth Vogler, the founders of the Schwarzerden commune, lived together in Paul and Paula Vogler's place in the Rhön Mountains, at Weyhers (De Ras, *Körper, Eros und weibliche Kultur*, 159). Friedrich Vorwerk's letter to Paul Vogler is addressed to "Dietershausen Post Weyhers Rhön," a hamlet that is essentially the northern extension of Weyhers (Paul Vogler Papers, Berlin: Bauhaus-Archiv, K-8).

78. Chronology in *Loheland. Gymnastik—Landbau—Handwerk* ...

79. Lucia Moholy, *Moholy-Nagy, Marginal Notes: Documentary Absurdities*, 69.

80. Moholy-Nagy, "Photoplastische Reklame," *Offset, Buch und Werbekunst* 7 (1926): 386–388. See also Loers, "Moholy-Nagys 'Raum der Gegenwart,'" 41. Günther's birthdate (June 8, 1894) and her date of death (December 24, 1975), are entered into the Loheland Register. Antje Harken of the Loheland School has been kind enough to provide me with a photocopy of the relevant page.

81. On the *Kunsterziehungsbewegung* (whose founders were Julius Langbehn and Alfred Lichtwark) and *Reformpädagogie*, see Wolfgang Scheibe, *Die Reformpädagogische Bewegung. Eine einführende Darstellung* (Weinheim: Beltz, 1978), 139–148. On creativity: 142–143.

82. Early in 1919, for example, she was book review editor of the journal. See "Schriftleiter der 'Freideutschen Jugend,'" *Freideutsche Jugend* 5, no. 1 (January 1919): inside cover.

83. On Elisabeth Vogler and Wyneken, see Linse, *Zurück o Mensch*, 160. Vogler and her students were at Loheland in 1919–1920 (the first academic year). See Linse, *Zurück o Mensch*, 159, and Marie Buchhold, "Frankenfeld, Schicksal einer Jugendsiedlung," in *Die deutsche Jugendbewegung 1920 bis 1933: Die bündische Zeit*, ed. Werner Kindt (Düsseldorf: Eugen Diederichs Verlag, 1974), 1606. Lucia remembers being at Schwarzerden in the summer of 1922, before the commune was established, but when the women were living together there. Sachsse, *Lucia Moholy* (1985), 11; Sachsse, *Lucia Moholy* (1995), 108. See also Loers, "Moholy-Nagy's 'Raum der Gegenwart,'" 50.

84. On Lucia's friendship with Elisabeth Vogler, see Lucia Moholy in Sachsse, *Lucia Moholy* (1995), 108, and Ortrud Wörner-Heil, *Von der Utopie zur Sozialreform* (Darmstadt & Marburg: Hessischen Historischen Kommission, 1996), 506.

85. See, for example, her article "Über Siedlung, Gemeinschaft und Schule: Sieben programmatische Abschnitte von Marie Buchhold," *Freideutsche Jugend* 5, no. 11 (November 1919): 475–478.

86. The first quotation is in de Ras, *Körper, Eros, und weibliche Kultur*, 162, and is from Buchhold's diary of October 11, 1924. The second is from Linse, *Zurück o Mensch*, 185. On Buchhold's and Vogler's ecological awareness, see Linse, 184–186. On Bachofen, see Bramwell, *Ecology in the 20th Century*, 27.

87. Moholy-Nagy, "Geradlinigkeit des Geistes—Umwege der Technik," *Bauhaus* 1 (1926): 363.

88. Laqueur, *Young Germany*, 120; Schenk, *Die Freideutsche Jugend*, 333; Loers, "Moholy-Nagys 'Raum der Gegenwart,'" 41.

89. Moholy-Nagy, *Von Material zu Architektur*, 17. As they only met around 1924, I will deal with the crucial influence that the music teacher Heinrich Jacoby excercised on Moholy-Nagy's pedagogical ideas ("everyone is talented") elsewhere.

90. Botar, "Prolegomena to the Study of Biomorphic Modernism," 446.

91. On this, see Alain Findeli, *Le Bauhaus de Chicago: L'Oeuvre Pédagogique de László Moholy-Nagy* (Sillery, PQ: Septentrion, 1995), 177–182. On Dewey and Germany, see Scheibe, *Die Reformpädagogische Bewegung*, 171–210. Moholy-Nagy owned a copy of Dewey's *Art as Experience*, dedicated to him by the author in 1938 (information courtesy of Hattula Moholy-Nagy).

92. On this topic, see Botar, "Prolegomena to the Study of Biomorphic Modernism."

93. Sybil Moholy-Nagy, from the Introduction to *Moholy-Nagy: Farbige Zeichnungen 1944–1946* (Munich: Galerie Klihm, 1971). The translation is mine.

94. For Moholy-Nagy's views on abstract art, see *i10* (1927): 233.

95. Moholy-Nagy, "Space-Time and the Photographer," *The American Annual of Photography*, vol. 57, ed. Frank R. Fraprie (Boston and London: American Photographic Pub. Co., 1943), 11.

96. Francé, *Bios*, vol. II: 277.

97. Moholy-Nagy, *The New Vision* (1938): 13–14.

The Growth of Microorganisms on Paper

Alexander Fleming

If a paper disc is placed on the surface of an agar plate, the nutrient material diffuses through the paper sufficiently to maintain the growth of many microorganisms implanted on the surface of the paper. At any stage, growth can be stopped by the introduction of formalin. Finally the paper disc, with the culture on its surface, can be removed, dried, and suitably mounted.

The nature of the paper makes a considerable difference to the result obtained. On filter-paper good growth takes place, but the extreme porosity of the paper makes the growth diffuse and, in the case of many moulds, the organism grows through the paper and adheres so firmly to the surface of the culture medium that the paper is torn when one attempts to remove it from the surface of the medium. For most purposes, a good stiff notepaper is suitable. The colonies remain discrete and the paper disc can be easily removed. If the colony is white a black paper disc can be used, but with chromogenic bacteria white paper is preferable.

The method is especially useful for making specimens for museum and teaching purposes. Single colonies of molds in all stages of development can be preserved dry for an indefinite period. Permanent specimens illustrating such phenomena as selective bacteriostasis, droplet infection, and so forth, can easily be prepared.

Dried cultures of chromogenic bacteria have been preserved in this way for two years, and the colors have not faded except in cases where the specimens had been exposed to light, especially bright sunlight. The color of *B. prodigiosum* was especially sensitive to light and faded very considerably in a few months when exposed to diffuse sunlight on a laboratory wall. In similar conditions there was no perceptible fading of the cultures of staphylococcus, sarcina, or *B. violaceum*.

Figure 26.1
Alexander Fleming, "Guardsman," 1933. Germ painting (pigmented bacteria on blotting paper), 4 inches in diameter. Reproduced with permission from the Alexander Fleming Laboratory Museum, London.

Note

Originally presented in 1936 at the Second International Congress for Microbiology, London. Published in *Report of Proceedings*, ed. R. St. John-Brooks (London: Harrison & Sons, 1937).

Edward Steichen's 1936 Exhibition of Delphinium Blooms: An Art of Flower Breeding

Ronald J. Gedrim

"The President and the Trustees of the Museum of Modern Art invite you to an exhibition of Steichen Delphiniums." So began the announcement of one of the most unusual and least understood exhibitions of MoMA's history. MoMA's press release described a one-man, one-week show "of remarkable new varieties of delphinium developed through twenty-six years of cross breeding and selection by Edward Steichen...his purpose is to develop the ultimate aesthetic possibilities of the delphinium."[1]

At 5:00 a.m. on Wednesday, June 24, 1936, Edward and his wife Dana loaded a refrigerated truck with hundreds of delphinium blooms at their Umpawaug Plant Breeding Farm, West Redding, Connecticut, for the three-hour drive to the museum. The first group of flowers to be exhibited were the garden hybrids of pure blue self-colors and the fog and mist shades. These were refurbished three days later and were followed on Monday, June 29, with towering datum strains. During the eight-day showing in the museum's three small ground-floor galleries, Steichen put on display between five hundred and one thousand delphinium stalks. Beaumont Newhall, MoMa's librarian, said "I helped install it. They were absolutely staggering, huge, everything big!"[2]

Pre-exhibition claims for *Steichen Delphiniums* drew flower lovers and skeptical horticulturalists to the museum. Numerous reviews and much publicity followed the opening. Horticultural writer J. W. Johnston suggested: "There must be a reasonable limit to what could be expected from the plant. To put it conservatively, our standards have been raised at least 50 per cent by the most amazing exhibit of delphiniums we have ever seen in this country."[3] "Garden notes and topics," in the *New York Times*, stated that "The giant spikes...represent what many authorities...consider decidedly the finest development in delphiniums so far attained in this country" (figure 27.1).[4]

Another writer described going through the museum door and seeing giant flowers in amazing colors:

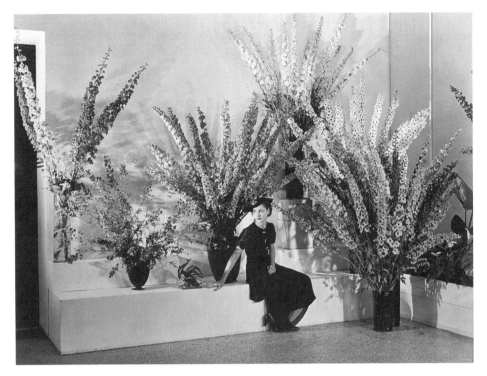

Figure 27.1
Edward Steichen, 1936. Installation view from the exhibition, *Edward Steichen's Delphiniums* (June 24–July 1, 1936). Gelatin silver print. Edward Steichen Archive, Department of Photography, The Museum of Modern Art, New York.

The show is "breath taking!" Giant spikes of brilliant dark blues, the intensity of which is amazing, against the white background of the walls. There is a plum color never before seen by the writer, also delicate pastel blues running into lavenders and pinks. Then pure whites against a deep blue background, some of them having startlingly black eyes, all standing stately and regal in their great containers.[5]

The show was covered in forty-two newspaper articles from seventeen states indicating "a reader circulation of more than ten million."[6] Steichen wrote, "The reports in the New York press were repeated by the Press across the country both in the art sections and gardening sections of the papers. The Delphinium almost overnight jumped from a position of minor gardening plant into first place in gardening talk."[7] At the same time Beaumont Newhall suggested that many people "were wondering what the hell these plants were doing in the museum!"[8]

It is difficult to ascertain what decisions led to showing Steichen's delphiniums.[9] Details of the exhibit were not brought before the annual meeting of the exhibition committee in either February of 1935 or 1936. Rather, they were probably presented to the trustees in late spring in 1936. Steichen was chair of the Museum's Advisory Committee on Photography and his influence with the Museum's trustees only increased over time.[10] In 1936 his ardent supporters included MoMA Trustee Mrs. Stanley Resor and Frank Crowninshield, a recently departed MoMA trustee.[11] Steichen's growing reputation as the "world's greatest photographer," along with his well placed friends, assured a response to his ideas. Thus, Steichen used political capital to receive approval for the exhibition, not to mention using his own money to pay for the costs of exhibition.[12]

The Museum of Modern Art had opened in November 1929, six and a half years before *Steichen Delphiniums.* Formed by a small group of devotees and collectors of contemporary art, the museum was to showcase work to a typically inhospitable public.[13] Sixteen years after the Armory Show, the public remained generally unconvinced of the merits of modern art. Although many individuals and dealers supported modern painters and sculptors, American museums, in contrast to European museums, were doing very little with modern art. MoMA's first director, Alfred Barr Jr., a young, Harvard-educated scholar, challenged the art world: "By conducting a public course in the history of the modern movement, and his blackboard was the museum . . . This was the art that so many of [his] contemporaries thought not only distasteful but a calculated insult to the reason, perpetrated by a group of dangerous Bolsheviks . . . or worse."[14]

MoMA's exhibition schedule in the period from 1934 to 1936 created precedents for *Steichen Delphiniums.* The question of whether art was utilitarian was raised in MoMA's *Machine Art* exhibition in 1934, curated by Philip Johnson, who included six categories: industrial units, household and office equipment, kitchen ware, house furnishings and accessories, scientific instruments, and laboratory glass and porcelain. Only objects in mass production and readily available for sale were featured in the exhibition. The aesthetics of the machine-made object was one curatorial concern, while another was to "serve as a practical guide to the buying public."[15] Royal Cortissoz felt it to be an "amusing aggregation of utilitarian objects," that didn't belong in a museum; he said, "It is calling the stuff 'art' that clouds the issue."[16] MoMA thus pointed to the potential utility of the modern work of art, challenging distinctions between art and craft, and between originality and the mass-produced object. If the museum could take on the role of arbiter of household fashion and utilitarian art, as in *Machine Art*, showing the art of delphinium breeding would seem to have a place.

Alfred Barr's influential MoMA exhibition, *Cubism and Abstract Art*, preceded *Steichen Delphiniums* in 1936. Occupying all four floors of the museum's gallery space it included paintings, sculptures, drawings, prints, photographs, typography, constructions, architecture, furniture, rugs, theater design, and movies. It was "the most elaborate, complex . . . and the most bewildering exhibition arranged in the career of the Museum of

Modern Art."[17] Nonetheless, nineteen European sculptures in transit to the exhibition were refused entrance by customs examiners because they did not appear to be works of art, under a Treasury Decision of 1916 that relegated sculpture to "imitations of natural objects, chiefly of the human form...in their true proportion of length, breadth and thickness."[18] Yet this was not the first difficulty MoMA had encountered with importation of art works.

In May 1935 the museum was forced to give bond on objects of art from the *African Negro Art* exhibition because it was impossible to prove that certain sculptures were not more than second replicas, or because the artist's signature could not be produced, or because no date of manufacture could be found, or because ancient bells, drums, spoons, necklaces, fans, stools, and headrests were considered by the examiners to be objects of utility and not works of art.[19]

Steichen was involved in an earlier landmark ruling on the importation of modern sculpture. On a return trip from Voulangis, France, in 1927, he brought back a Brancusi, the *Bird in Space*, which was refused duty-free entry as a work of art.[20] Custom house officials rejected Steichen's claim that Brancusi's work represented a bird, since, "no feathers were visible." Instead, they classified it under "Kitchen Utensils and Hospital Supplies," and forced Steichen to pay $600 in duty. Mrs. Harry Paine Whitney, eventual founder of the Whitney Museum of Art, believed the case set an important precedent and had her lawyers take over the case, *Brancusi v. the United States*.[21] After allowing statements by recognized authorities on art, the court ruled in Brancusi's favor and returned the assessed duties to Steichen.[22]

The precedent of *Brancusi v. the United States* was of little help to MoMA. Customs' holding of the *Cubism and Abstract Art* sculptures was based on the definition of sculpture in the Treasury Decision of 1916 and MoMA was forced to post a $100,000 bond for the release of the works. With the *African Negro Art* exhibition, MoMA was also forced to post a bond. Although the African sculpture should have been allowed under the example of *Brancusi v. the United States*, cultural biases held sway where art was defined in terms of originality and nonutility.

Steichen's delphiniums were exhibited in the context of this uphill battle to define modern art. Although living plant matter raised questions of utility, originality, and definitions of aesthetics, MoMA was no different from other museums in exhibiting and showing static works of art. Even if a vacuum cleaner or a cash register was featured in *Machine Art*, it was not operated while on display but viewed as a static object.

Flowers in the museum suggested their own particular questions. Used in a variety of social customs and as a subject for art, flowers themselves were not considered to be art. Genetics was a relatively new science and an art of breeding had not been proposed. Flowers were typically considered to be God's and not man's work. On an economic level they were decorative commodities with utilitarian purposes, even if only for the gardener's or passerby's pleasure. Although a patent defined an original strain, their propagation

allowed unlimited replication. Further, the temporal nature of plants was foreign to connoisseurship, which relied on the stasis of a perfected and determinate object. Even cut blooms were ephemeral. The questions raised by flowers in the museum were of a different nature than those posed by modernism. It is no wonder that *Steichen Delphiniums* received a cool reception from many within the museum.

Barr and Steichen had a cordial relationship but were positioned very differently. Barr the curator and Steichen the artist acted accordingly. Barr's concern with abstraction put him in constant battle with conventionalism. As curator he continually evaluated and reevaluated new work, set standards, and upheld those standards. It was not enough to bring modern art before the public; he had to usher it with persuasion and scholarship. Steichen's personal agenda had little in common with Barr's desires. Although Steichen had played a crucial role in introducing French modernism through New York's Gallery 291 before World War I, he was never entirely comfortable with abstraction. To him nature was all-inclusive and contained the abstract.[23] Despite his education, which ended at age fifteen, he had an insatiable curiosity, keen intellect, and a variety of interests. Those interests fueled his photography and his volcanic personality. As Steichen's daughter Mary Calderone said, "wherever he found himself he began doing something new and different that made sense."[24]

In this case it made sense to Steichen that the art of flower breeding should find its way into the Museum of Modern Art. Twenty years Barr's senior, he was used to being in charge, using his reputation to political advantage, and achieving his goals with characteristic flair. Steichen set the stage for his exhibition of delphiniums and, with an artist's sensibility, basked in the spectacle. Unlike Barr, he did not feel a need to explain his work and waited for questions to arise before elaborating his thoughts on delphiniums and the art of breeding. One can speculate that Barr felt that *Steichen Delphiniums* was a diversion from the pressing issues posed by modernism. Just as likely, the director's disinterest allowed him to diplomatically avoid contact and conflict with Steichen, who was determined to have things his own way.[25]

In this conflict, Steichen probably enjoyed a *Chicago News* column that chided MoMA: "What a joy this exhibition, in the halls of America's most authoritative temple of 'modern art,' will be to the 'old hats.' If sticks and stones, bits of newspapers, and other objects suggested by 'the cult of the ugly' can be passed on the canvasses of Picasso, Braque, Duchamp, and Picabia and called 'art,' why not beautiful flowers?"[26]

Whereas Barr would have appreciated June Provines's observation:

> Perhaps it is just as well that the announcement goes on to describe delphiniums, in case the Museum of Modern Art members think delphiniums are near relatives to pointillism or suprematism. And an exhibition of garden flowers at the Museum of Modern Art is as much of a shock as it would be to see Brancusi's "Bird in Space" rising out of an exhibition of prize corn at a county fair.[27]

June Provines was probably unaware that Steichen owned Brancusi's *Bird in Space* or that at various times wrapped the *Bird* in decorative floral garlands—the very flowers for which he was winning horticultural prizes.

Where Alfred Barr was the "missionary for the modern," Steichen was perceived as a curious mix of a retrograde in terms of modernism and an iconoclast calling for an art of utility.[28] Steichen was controversial through statements about the utility of art photography. Carl Sandburg gave emphasis to the subject in his 1929 biography of Steichen, where he quoted Steichen:

> All my work is commercial... There has never been a period when the best thing we had was not commercial art.... the history of painting, sculpture, architecture, tells us that most art of the past was used to sell religion to the people, or, to use their own language, to create good will and bring about good works in the cause of the Church.... the great art in any period was produced in collaboration with the particular commercialism of that period or by revolutionists who stood clear and clean outside of that commercialism and fought it tooth and nail and worked for its destruction. In the twilight zone of the "art for art's sake" school all things are stillborn.[29]

Sandburg wrote glowingly of his brother-in-law's desire to put the camera at the service of fashion, portraiture, advertising, philanthropy, product design, horticulture, and aerial reconnaissance.[30] This was not well received by the art community. In a review of Sandburg's book in January 1930, Paul Rosenfeld declared:

> Flatulence is by no means the chief offense.... It will immediately be seen that the argument is tilted to deny the spirit; to make it appear that the great artists did not work because of an impulse stronger than themselves which they dominated in their art...but rather because of the irresponsibility and jobbery that generate the main enemy of art, modern mercantile advertisement.[31]

Rosenfeld suggested that Steichen had parted company with other pioneer photographers who continued to uplift the spirit, such as Paul Strand, Charles Sheeler, Man Ray, Ralph Steiner, and Alfred Stieglitz.[32] One month later Paul Strand extended Rosenfeld's argument by suggesting that Steichen was as much to blame as Sandburg. He attacked Steichen sarcastically:

> This indeed is a startlingly revolutionary prophetic argument, a real contribution to aesthetics. At last the long sought for, much needed measuring stick: great art seeks to destroy or tie up with big business.... the passionate penetration of life gleaming on, the billboard of the young Adonis who would walk a mile for a Camel!... those profound and moving songs which celebrate the major tragedies of "B.O." or the infinite pathos of "No Sex Appeal."[33]

Steichen's argument was Bauhausian in character: "A thing is beautiful if it fulfills its purpose—if it functions. To my mind a modern icebox is a thing of beauty."[34] All objects were worthy provided they had utility. Steichen was so vehement on this issue that he often found it difficult to be with artists and arbiters of taste.

Alfred Barr Jr.'s December 1936 *Fantastic Art, Dada, and Surrealism* exhibition caused protests to erupt in the streets of New York. In legitimizing these a-logical forms of modernism, the museum became the subject of scorn both by conventional tastes as well as by radical ones. A young instructor from Princeton carried a banner that announced a group called The Transformation, and which said, "Dada and Surrealism are art that is really happening in life, not in museums."[35] Although Steichen was more conservative than Barr in regard to modernism, he found himself in the vanguard in suggesting that art was a part of everyday life. "Art for life's sake" was manifest in all aspects of life, and all forms of life and art rightfully belonged in the museum. The museum was a showcase for art, but when it was reduced to showing "art for art's sake," to Steichen it became a mausoleum.

Steichen felt that his show confirmed flower breeding as an art form: "This was the only time that living plant material had ever been shown by the Museum. By implication, flower breeding was recognized as one of the arts."[36] Steichen later clarified his views on the art of flower breeding:

> The science of heredity when applied to plant breeding, which has as its ultimate purpose the aesthetic appeal of beauty, is a creative art. Instead of words or pigment or tone, the plant breeder works and struggles with factors and forces that have been locked up within the various species of plants he may employ for tens of thousands of years. The very process of breaking up long closely inbred habits opens up the gates that release new forms, patterns and colors. . . . The delphinium and many of our garden flowers still have unexplored potentialities awaiting development that will bring us flowers beyond any of our present concepts or imaginings.[37]

He felt that the delphinium was particularly appropriate for the art of breeding in that it was "the only important garden perennial with a range of colors extending through the entire spectrum."[38]

To suggest that flower breeding was akin to poetry, Steichen named varieties of elatum delphiniums after poets. To become eligible for a namesake delphinium, a poet was to write a poem about delphiniums, as did William Carlos Williams, Archibald MacLeish, Paul Claudel, and Carl Sandburg. Sandburg's choice was a light-blue, eight-foot spike, which Steichen photographed with Sandburg standing in front of a dark backdrop in Umpawaug's delphinium fields (figure 27.2).[39]

The closing stanzas of Sandburg's "Crossed Numbers," written at Steichen's Umpawaug Plant Breeding Farm in 1933, reflect the mentality of the delphinium breeder:

One is a two is a number.
Join them and cross them
and see them be numbers
be numbers beyond numbers.

Toss them in wanton spirals.
Weave them in grave communions.
Frame them with lighted eyelashes.
Let them have opening closing lips.
The wind is a when and a how
and a giver of laughing numbers
and a thrower of crying numbers.

One delphinium by itself
is a who and a who.
A stalk of blue from a weaving earth
A sheaf of skyblue from a waltzing sun
And one is a two is a number
And a spoke of light is a why
And one yes one is a who and a who.[40]

For years Steichen had been interested in genetic mutation as a tool of the plant breeder. Influenced by the Dutch botanist Hugo de Vries, he had experimented with poppies in 1911 in an attempt to disprove the Weismann Theory, which held that acquired characteristics were not transmissible. Steichen recalled an incident from about 1911 that spurred his interest in proving the transmission of acquired characteristics:

> One of the times I was in New York, I sat next to the wife of a professor at Columbia University at a dinner at Eugene Meyer's house. . . . I made some kind of glib remark about acquired characteristics. This woman said, "Don't you know that acquired characteristics Can't be inherited?" I said, "I don't believe it." Then she told me about a German by the name of Weismann who proved that they couldn't be inherited by chopping off the tails of thirty or forty generations of mice and they still kept on growing tails. And at that I laughed and I said, "Any child could have told them of that result." Oh, it worried me, puzzled me.[41]

Genetic mutation was the radical factor in plant breeding that convinced Steichen of the art of breeding. In the early 1930s, scientists had found that the drug colchicine could double the chromosome count in plants and turn diploids into tetraploids. Coincidentally, Steichen was taking this drug for his gout. With colchicine he found that he could double the number of delphinium chromosomes and render previously sterile varieties fertile. The ability to alter radically a plant's genetic makeup was a major success. Steichen had previously written: "I like to think of nature's progress as endless flowing streams; streams in

which varied strains of heredity are ever pouring down through river beds of environment. Streams which for ages may have kept to their channels but each of which is apt at any-time to jump its banks and find a different outlet."[42]

With colchicine he forced strains of heredity to improbable outcomes. "In a few hours, mutations of plant material were produced that might not occur in nature in a thousand years."[43] In an interview in 1961, Steichen, who was holding delphinium blooms, faced an interviewer and said, "I can't believe in the Darwinian Theory. I can't imagine for in-stance, that a fish ever swam on half a fin. In breeding and cross-breeding these flowers any big change seems to happen POW, like that," whereupon Steichen smacked his right fist into the palm of his left hand, scattering delphinium petals on the ground.[44] The artist uses the sudden flash of illumination, the ruin of well laid plans, the unpredictable event to advantage. The radical factor of mutation enhanced breeding's creative potential. "The breeding of flowers is to me a creative art," he wrote, "using living materials that have been developing for thousands of years to make poetry."[45]

In addition to his arguments drawn from science, poetry, and the art of utility, Steichen suggested that the genus Delphinium's history was intimately tied to art. In *Steichen Del-phiniums* he included a small bronze sculpture of a group of dolphins sculpted by Gaston Lachaise. Steichen later explained that delphinium is a diminutive of dolphin, named by the Greeks from the form of the unopened buds. The god of the arts and music, Apollo Delphiniums, transformed himself into the dolphin. The Delphinia, an early Greek fes-tival, was marked by young girls bearing flowering branches in procession to the principal temple of Apollo at Delphi.[46] Steichen added that "dried flower(s) of the species *D. orien-tale* were found in Egypt in the tomb of King Ahmes I and . . . still possessed a trace of the blue purple color of the flower after more than three thousand years."[47]

Steichen drew clear parallels between his photography and flower breeding: "In general I've undertaken breeding delphiniums very much as I went about the study of photogra-phy years ago. . . . Systematically, I violated every rule."[48] He said an intuitive awareness of his breeding stock was essential to his crosses, just as an intuitive capacity to extend the rules of camera technique was essential to his photography. He recalled a cup and saucer exercise of 1921, in which he sought to find out "what photography is. I want to know about the chemistry of this thing—what it does and how it does it." He set up a cup and saucer on black velvet against a white background with a gray scale next to it. His aim was to accurately reproduce photographic tones. By the end of the summer he had produced over a thousand negatives for study, though he never produced a print. While on the sur-face this exercise appeared scientific in nature, Steichen found a more subtle and intuitive result: "When I was through, I probably didn't learn anything that I couldn't have gotten out of a good text-book. I didn't learn any secrets. But—the elements of the technique of photography, what photography could give me and could not give me—was part of me. I didn't have to think about that any more. I knew it."[49] Steichen suggested that "for the same fundamental reason, I grow delphiniums by the thousands rather than by

the hundreds."[50] Making a breeding selection was as intuitively demanding as making an exposure: "The most difficult thing is to pick out the good ones for breeding. Their points are indescribable. You can see it, it's just a little difference in color and texture that makes the good ones shining and luminous."[51]

Responding to questions about the art of flower breeding, genetics, the history of delphiniums, and the relation between photography and flower breeding was new to Steichen. He had worked in anonymity as a plant breeder for twenty-six years before accepting the Presidency of the American Delphinium Society in 1935. He knew that this office would publicize his breeding work and end his anonymity.

Rather than let word of his breeding program come forth gradually, with typical promotional élan he conceived of *Steichen Delphiniums.* If his delphiniums were to be exhibited, they would be spotlighted! At the same time the publicity, requests for interviews, and the stream of correspondence forced him out of his private obsession. After *Steichen Delphiniums*, his summer 1936 breeding program was almost a total loss, its progress sacrificed to writing and public appearances. One lecture in January 1937, "The Modern Delphinium," was given to the New York Horticultural Society. The demand for tickets was so great that it was necessary to use the ballroom of the Park Central Hotel, and it completely sold out.[52] From 1936 to 1959 Steichen wrote about delphinium breeding and flower gardening and took photographs for horticultural magazines and the popular press.

Asked repeatedly why his delphiniums were not for sale, he responded with this insert in the advertisement section of the 1936 *Delphinium* yearbook: "To obviate unnecessary correspondence, please note that STEICHEN DELPHINIUMS are still in the process of development. They will not be released until the standard that has been set for them in a definite breeding program has been achieved to the satisfaction of their author."[53]

Withholding the results of his breeding from sale led to questions of why he invested so much without a return. Steichen responded, "I spend my money for flowers, just as others spend for speed boats, yachts and sailboats. I get a thrill out of developing thousands of these beautiful blossoms. I simply learn a bit more about life from flowers."[54]

Questions on how to reconcile Steichen the photographer with Steichen the plant breeder required another announcement from the Museum of Modern Art about the delphinium show: "They are original varieties, as creatively produced as his photographs. To avoid confusion, it should be noted that the actual delphiniums will be shown in the museum—not paintings or photographs of them." Steichen went on to say that the flowers were making a "positively personal appearance."[55]

The day of the opening Steichen made another unusual statement about his flowers:

> I have learned more about people and human nature from raising flowers than you would believe. Flowers are just as gullible as human beings. They respond to the same stimuli.... Some of the exceptional varieties I have grown might be likened to

prima donnas. If they are not fed right or treated right they sulk. You get nothing out of them. Some varieties are just like a lot of happy-go-lucky humans; they'll go right on being themselves, neither showing any rare qualities in color or size or form nor falling down on you and failing to bloom faithfully no matter how you treat them— just like people . . . [flowers] have verified all my concepts of human behavior.[56]

On Friday, June 26, the *New York World Telegram* ran the cartoon, "Daisies Could Tell," with the caption: "NEWS ITEM: Steichen, photographer, learned about people through Delphiniums. Says flowers are just as gullible as human beings."[57]

Steichen enjoyed the incredulous responses to his personification of flowers. He was stating his manner of thinking with little elaboration and taking pleasure in notoriety. Talking to flowers was a means to understanding their behavior and to remembering their particular characteristics. More significant than this utilitarian value was communing with nature, which brought Steichen greater solace and clarity of purpose than he found with other people. His deepest promptings came through nature and, although he never stated adherence to a religious creed, pantheism is the current that underlay many of his statements. Steichen frequently alluded to nature as being identical with God, where nature was the earthly manifestation of a great, inclusive unity. It is no wonder that he brushed aside the satirical criticism of his talking with flowers. He might have responded to the controversy by saying that humans were simply displaying their egocentric character, like the narcissus.

Steichen continued to talk about delphiniums in personified terms well after the MoMA show. In 1937 he stated, "A delphinium is not alive unless it either laughs aloud when you look at it or presents so sinister an appearance that it gives you goose flesh."[58] There is a tension in this characterization of flowers that suggests an uneasiness on Steichen's part. This was a time when the news was rife with apprehension about Europe. British and French appeasement of Hitler through the Munich Pact had delivered much of Czechoslovakia to Germany. Hitler's strangulation of the arts was well documented by this time.

In 1938 Steichen went even further in saying, "Plants are pretty much like humans. They are as gullible. You can fool them just as Hitler leads his army. You can make them do almost what you will."[59] Mention of Hitler in the context of breeding and eugenics sounded a chilling note. When Steichen renewed his delphinium breeding program at Umpawaug Farm in 1929, he planted ten thousand seedlings from seed purchased from all over the world. He noted, "When they were in bloom, I plowed under the whole 10,000 with the exception of one plant. It was an ugly flower in growth, but had a quality of purple coloring that I had never seen before."[60] Steichen's breeding program did not hesitate to destroy the unfit. He saved between one and twenty-five seedlings per thousand bred; countless thousands were plowed under without any sense of remorse. The threat of undesirable secondary genetic characteristics required ruthless selection: "It's better to

run the risk of losing the perfect product through the destruction of the elements that went into it, than to issue forth to the world a lot of second bests which have in them the power of self perpetuation and multiplication . . . [to] clutter the earth with inferiority and mediocrity."[61]

The violence of Steichen's eradication of hundreds of thousands of living plants was in service of perfection. The artist strives for a perfect result and employs questionable tactics to succeed. Whether in the confines of the studio with paint, plaster, or steel, or in the breeding field with thousands of growing plants, the artist's ruthlessness is a societally sanctioned behavior. The artist is free to explore the limits of perfection and the extremes that perfection embodies. Nonetheless, a program of delphinium breeding, both personified and ruthless, was bound to suggest uncomfortable associations with the coming holocaust.

While the poetic imagination has a well-defined societal role, it is anathema in politics. Hitler's deadly poetry followed a course suggested by W. H. Auden:

> A society which was really like a good poem, embodying the aesthetic virtues of beauty, order, economy and subordination of detail to the whole, would be a nightmare of horror for, given the historical reality of actual men, such a society could only come into being through selective breeding, extermination of the physically and mentally unfit, absolute obedience to its Director, and a large slave class kept out of sight in cellars . . . Vice versa, a poem which was really like a political democracy . . . would be formless, windy, banal and utterly boring.[62]

Steichen was well aware of the breeder's god-like powers. Discussing Luther Burbank, he wrote:

> He was once invited to hear a new minister preach; was assured it was to be a sermon that would particularly interest him. He went, tried to take a seat in the rear, was ushered up in front, given a pew to himself.—The preacher [spoke] for him as one who believed he could improve after the work of God and predicted dire punishment to him unless he would leave God's plants alone.[63]

The breeder's confidence was not bridled by such parochial thinking. Steichen concluded, "and that preacher may have gone home and even if he only ate corn beef and cabbage, had tasted man's interference with nature. The beef is man bred, and the cabbage also."[64] Steichen revered the breeder's effort with a utopian's zeal: "In fact all our garden flowers are getting better each year, our fruit more luscious, our field crops more prolific, more disease resistant: a legion of skilled capable workers are working these miraculous changes all over the world."

It was at the time of *Steichen Delphiniums* that he revealed his desire to eventually leave photography. T. A. Weston reported a conversation: "Sooner or later it is his intention to

quit photography and disseminate his delphiniums under his name. The day cannot come too soon as American commerce, horticulture, 2nd prestige will be enhanced enormously when Edward Steichen photographer becomes a nurseryman."[65]

Despite his fame as a photographer, which was at its height in the mid to late-1930s, Steichen was tired of the hectic pace and competition of commercial photography. Although he never talked about competition, his directorial personality frequently put him at odds with others, especially men.[66] He was most content when he was at Umpawaug Farm among his flowers where he could pursue the art of breeding unfettered by outside influence. At one with the cosmos amidst tens of thousands of delphiniums, he was free to direct and create within nature's, and not man's, limits. As Steichen's daughter Mary stated, "Flowers were surcease from the cares of the world for him."[67]

His breeding program increasingly dominated his attention to where he employed as many as five gardeners to tend 50,000 to 100,000 delphiniums. He even attempted to reclaim twelve acres of swampland in the hope of expanding his program to include 200,000 plants.[68] Despite his demanding schedule as a commercial photographer, he reserved a month each mid-June to mid-July and four-day weekends during the summer to be at the farm. Steichen said: "The photographs I made in the country, as well as the cross-breeding and growing of delphinium and other flowering plants, kept me in contact with nature and kept my hands in contact with the soil. Without this sustenance, I don't believe I could have remained alive and interested in my professional photographic activities in New York for as long as I did."[69]

Although Steichen had made a six-figure income since the mid-1920s, he plowed that money back into his love of the delphiniums, which he, in turn, wanted to make accessible to everyone.[70] He envisioned his perfected delphinium seed being sold in five-and-dime stores, without a hint of snobbery, where the twenty-five-cent selling price would satisfy both buyer and merchant.

Steichen never placed elatum strains on the market. World War II interrupted his breeding program when, at the age of 62, he decided to join the war effort. Saving important breeding plants, he plowed under the remainder of his ten-acre field. "My last large scale planting of the tall garden hybrids came to an abrupt end with the Japanese attack on Pearl Harbor.... This became the second time a world war almost totally canceled out my work with Delphinium."[71] By the end of the war, Steichen had lost 80 percent of his prized elatum strains. With the resumption of his breeding program he decided to develop a different variety of delphinium that he had begun before the war.[72] This was an entirely new race of bush delphinium that he had created through genetic mutation. This bush-type delphinium, the "Connecticut Yankee," was perfectly suited for the casual gardener and was placed on the market in 1965. Steichen described it as "a bush covered by blue butterflies."[73] The Connecticut Yankee is still available in 2003.

In 1985 columnist Alan Lacy wrote, "I don't have any Steichen's [sic] hanging in my house. But I grow some Steichens out in my garden, which I raised from a package of

Delphinium Steichen Strain Flowers the first year from seed. Single flowers in white, blue, lilac and violet, all with contrasting bees. An improved selection of Connecticut Yankees. Long bloom period. Ht. 40-50".
BURPEE EXCLUSIVE

B-45336 Ⓐ Packet (50 seeds) **$2.95,** Two **$4.95**

BURPEE.
W. Atlee Burpee & Co., Warminster, PA 18974

45336AK

Ⓐ Packet
Net Wt. 165 mg

DELPHINIUM
Steichen Strain Mix

Elegant, long spikes of single white, shades of blue, violet and lilac flowers, many with white bees. Heat resistant, reblooms after cutting back. Perennial, zones 3-7; Annual, zones 8-11. Ht. 40-50".

START INDOORS about 8 weeks before last spring frost for bloom this year. Sow seeds ⅛" deep in seed-starting formula in a well-lighted area, and keep moist. Seedlings emerge in 21-28 days at 60-70°F. Transplant to larger containers when seedlings have at least 2 pairs of leaves. Before transfer to garden, accustom to outdoor conditions by moving to a sheltered place outside for a week.

SET PLANTS 1-2' apart in a permanent, sunny location with fertile, well-drained soil.

START OUTDOORS in midsummer for bloom next year. Sow seeds thinly in cold frame (top raised) or semi-shady seedbed. Keep evenly moist. Transplant seedlings 6-8" apart each way. Move to permanent location in late summer.

Visit Burpee on the Internet at: *www.burpee.com*

Figure 27.2

On the left, detail from *Burpee Seeds and Plants* 1999 catalogue showing the *Delphinium Steichen Strain* for sale. On the right, the actual *Delphinium Steichen Strain* seed packet, 4.5 × 3.25 in (11.3 × 8.2 cm). Collection Eduardo Kac.

seeds that cost less than a dollar. They are lovely to behold . . . fine examples of the contribution of the hybridizer's art to the American garden."[74] This statement is the exact response Steichen desired from his breeding efforts (figure 27.2). It was the same popular response that Steichen had sought for the photograph. Beaumont Newhall said, "He believed in a democratic attitude, he felt that the emphasis upon art was elitist. He liked to picture every housewife having a box camera over the sink so that while washing the dishes she could snap [photos of] the kids in the back lot at moments. It was this attitude that was really Steichen's belief; he was sincere in this."[75]

To understand Steichen the photographer, it is necessary to understand Steichen the horticulturist and plant breeder, interests rarely associated with his fine art photography. While photography was his vocation, delphinium breeding was his passion. Love of flowers was the true source of his knowledge about many things: his artist's sensibility, his patience and hard work, his exquisite eye for color and detail, his giving himself over

to the wonder and intricate beauty of the world. To understand his rapture in the natural world is to gain a view into the way he worked with a camera, whether it involved tonal landscapes, a "new objectivist" image, fashion images, portraits, metaphysical studies, or the great flower pieces he created throughout his career. Steichen is an example of an artist who must be viewed from a variety of perspectives to understand the essential nature of his art.

In the same way that Steichen's work with the flower has been overlooked as an important aspect of his art, *Steichen Delphiniums* has been neglected as an important exhibition in MoMA's history. It is fair to say that Steichen mounted an exhibition that superseded the early concerns of modernism to challenge both the role of the museum and commonly held definitions of art. His "art for life's sake" philosophy opened museum doors to the art of flower breeding as one of a myriad of possible art forms. It is ironic that the Museum of Modern Art has yet to fully embrace the challenge of *Steichen Delphiniums*.

MoMA would not include living plant matter in an exhibition again until 1969–1970 when Robert Morris created one of six installations for the exhibition *Spaces*. Jennifer Licht described the viewer's restricted approach to 144 small Norway spruce trees as contrasting "human proportions with a miniature grove of fir trees, planted in diminishing size to create impressions of distant vistas." She also said that "originally the [surrounding] air was to be imbued with negative ions, which induces feelings of euphoria, but that this aspect could not be realized."[76] Although MoMA has shown Anselm Kiefer's canvases with their symbolic use of straw and it has documented Roberto Burle Marx's art of the garden, this installation of trees was the only other living plant matter exhibited at MoMA.

Morris's elaborate and overly rationalized installation pales beside the simplicity of *Steichen Delphiniums*. Conceptual elements in the staging of *Steichen Delphiniums*, such as the overwhelming display of colorful blooms or the ephemeral quality of plant art, are overshadowed by the imprint of the artist. Steichen was a zealous breeder, one who literally worshipped fertility and adored the flower. Breeding was a ritual expression of his spirituality and nature was the boundary for that ritual. The intensity of his belief, as expressed in life-forms and exhibited in *Steichen Delphiniums*, was direct and unmediated. Everyone who entered the exhibit was able to understand flowers at some level. There was no straining to "get the message" with *Steichen Delphiniums* as with so much of today's conceptual art. This was an art born of spiritual promptings and it evoked an earnest response. It was an art of ideas but, more important, it was an art of beliefs.

Steichen was impressed with the response of viewers to the show. He stated that flowers were the most emotional of the arts, noting that some viewers of the show had actually wept. He also said that a door attendant confided that the show "took him back twenty years," and that "people had so much time. Instead of hurrying through the exhibit rooms they lingered and some people got as far as the door and then turned back and went around again."[77] *Steichen Delphiniums* provided the expert horticulturalist, the lover of

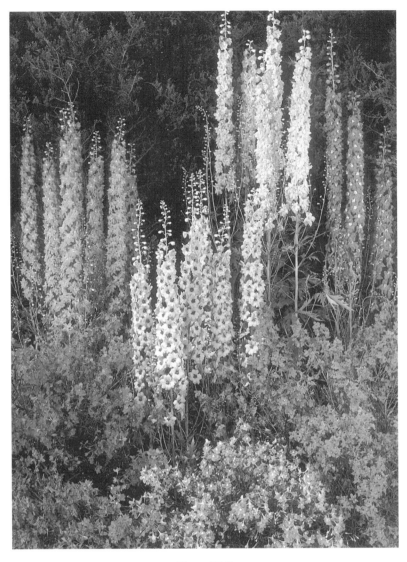

Figure 27.3
Edward Steichen, 1940. Delphinium, Umpawaug Farm. Collection Joanna Steichen.

Ronald J. Gedrim

floral paintings, the child, the neighborhood gardener, the art critic, or perhaps an unsuspecting museum goer the opportunity to experience the museum in a new way. It was a democratic subject matter and it attracted a democratic audience.

Steichen's art of flower breeding posed the question "What is the artist's role in society?" and answered it by suggesting that the artist was to be useful in meeting people's needs. This art of utility will survive both within and outside the museum, as it always has, because it helps people to live more fully (figure 27.3).

As Lucy Lippard wrote in "Gardens: Some metaphors for a public art": "It's no longer necessary to fall back on the Duchampian saw, "It's art if the artist says it is." Maybe the real question is not "Is it art?" but "What does it mean to us?" or "What do we expect from art?"[78]

With this, Steichen would have wholeheartedly agreed.

Notes

1. MoMA Press Release, "Steichen Delphiniums," June 23, 1936, Edward J. Steichen Archive, Department of Photography, The Museum of Modern Art, New York (hereafter "MoMA Steichen Archive"). The press release also stated, "One of the outstanding delphiniums to be shown in the exhibition will be a GIANT BLUE, with a spike of BLOOM FIVE FEET LONG.... According to a leading garden authority, the Steichen delphiniums to be shown at the Museum are the LARGEST and FINEST EVER GROWN IN AMERICA."

2. Interview by the author with Beaumont Newhall, August 15, 1988. From 1933 to 1937 MoMA was housed in the Rockefeller House at 11 West 53rd Street on the site of its present building. The summer 1936 exhibition schedule included *Architecture in Government Housing; Modern Exposition Architecture; Steichen's Delphiniums;* selections from the permanent collection and from a private print collection. Total attendance to these exhibitions was 17,078. There was no admission charge to *Steichen's Delphiniums* (Museum of Modern Art Archives, New York: *Executive Director's Report for the period October 1, 1935 to June 30, 1936*).

3. J. W. Johnston, "Giant Growths of Delphinium Exhibited Here," *New York Herald Tribune* (June 25, 1936).

4. "Garden Notes and Topics," *New York Times* (Sunday, June 28, 1936): sec. 9, 12X.

5. "Modern Art Museum Scene of Steichen Delphinium Exhibit," *Greenwich News and Graph* (June 27, 1936).

6. Leon H. Leonian, "Delphinium at the Museum of Modern Art," *Delphinium* (1936): 40.

7. Edward Steichen, "My Half-Century of Delphinium Breeding," *Delphinium* (1959): 12.

8. Interview by the author with Beaumont Newhall, August 15, 1988.

9. The Museum of Modern Art is a private museum, allowing only limited access to certain records and no access to other records such as Trustee Meeting Minutes.

10. This was later reflected in the behind-the-scenes politicking that resulted in Steichen, rather than Beaumont Newhall, being named the first Director of MoMA's Department of Photography in 1947. Steichen held the director's position until 1962.

11. Helen Resor had recommended Steichen to Condé Nast to replace Baron Adolf De Meyer as *Vogue*'s chief photographer. She also posed for Steichen's advertising photographs taken for the J. Walter Thompson Advertising Agency of which her husband was president. Frank Crowninshield was former editor of *Vanity Fair*, for whom Steichen had produced so many landmark portraits.

12. Steichen paid for the exhibition in its entirety, including installation costs, press releases, and the printing and mailing of 5,600 invitations, for a total sum of $5203.45. A billing memorandum to a Mr. Mabry, dated August 20, 1936 and initialed "I.U." stated, "It was my understanding that Mr. Steichen would pay the expenses of his exhibition in as much as this was added to our schedule and even added to our membership expenses. All the expenses are on the attached sheet" (Museum of Modern Art Registrar's Office: Correspondence File on Exhibition no. 50. The Correspondence File on Exhibition no. 50 primarily consists of letters from those who had been to the exhibition).

13. Mrs. John D. Rockefeller, Jr., Miss Lizzie P. Bliss, and Mrs. Cornelius J. Sullivan, patrons of contemporary art, were the "founding mothers" of MoMA. They selected A. Conger Goodyear, a hard-nosed businessman, to be the first President of MoMA, in part for his reputation as a champion of modern art. He had been voted out as President of Buffalo's Albright Art Gallery for making an unauthorized purchase of a "pink period" Picasso, *La Toilette*, for $55,000. Although public resistance was given to MoMA's early mission, it had an organizing committee of individuals committed to modern art including Professor Paul J. Sachs, Frank Crowninshield, William T. Aldrich, Stephen C. Clark, Mrs. W. Murray Crane, Frederick Clay Bartlett, Chester Dale, Samuel C. Lewison, and Duncan Phillips.

14. Russell Lynes, *Good Old Modern: An Intimate Portrait of The Museum of Modern Art* (New York: Atheneum, 1973), 141, 4.

15. "Machine art," *The Bulletin of the Museum of Modern Art 3* (November 1993): 2.

16. MoMA Archives: A. Conger Goodyear Papers, Scrapbook #27. Royal Cortissoz, "Machine Art and the Art of Some Artists," *New York Herald Tribune* (Sunday, March 11, 1934).

17. Edward Alden Jewell, "Cubist show opens with private view," *The New York Times* (March 3, 1936): L19. Alfred Barr said that the work represented in *Cubism and Abstract Art* has "become one of the many ways to paint or carve or model... It is not yet a kind of art which people like without study and some sacrifice of prejudice." Lynes, *Good Old Modern*, 139.

18. U.S. Treasury Decision of 1916, Paragraph 1807, and a corollary definition made in 1930. The most controversial of these sculptures was Boccioni's *Unique Forms of Continuity in Space*, which today would be perceived, quite simply and almost universally, as an abstracted figure.

19. "The Government Defines Art," *The Bulletin of the Museum of Modern Art 3*, no. 5 (April 1936): 3.

20. Steichen stopped leasing his chateau, the Villa l'Oiseau Bleu, in Voulangis, 30 km outside Paris, in 1924. He still owned three acres on the outskirts of the village, where he had bred delphiniums since before World War I. In 1927 Steichen's gardener François and his wife were living

in Steichen's prefabricated studio, which had been moved to the three-acre tract from the chateau's garden.

21. U.S. Treasury Department, Customs Court, 3rd Division, Protest 209109-G. *Brancusi v. U.S.*, New York, October 21, 1927–March 23, 1928; stenographic minutes (copy at the Museum of Modern Art Library, New York).

22. Chief witnesses for Brancusi were Edward Steichen, Jacob Epstein, Frank Crowninshield, Henry McBride, Forbes Watson, and William H. Fox of the Brooklyn Museum. Comments were made on the spirit of a bird and the spirit of flight, including Jacob Epstein's submission of an Egyptian stone "hawk" from 3000 BC. Government witnesses from the National Academy and the National Sculpture Society stated that the *Bird in Space* was neither sculpture nor work of art. "The Government defines art," *The Bulletin of the Museum of Modern Art* 3, no. 5 (April 1936): 5. Steichen later quipped, "Witnesses appeared before three ancient and learned judges. The gray walls of the courtroom and the dismal weather made it a somber occasion. Every time some witness said something a tug boat on the river outside gave a Bronx cheer." Linette Burton, "Steichen Discusses His Plans, Recollects Trial of *The Bird*," *Wilton (Connecticut) Bulletin* (December 5, 1962): 8.

23. One of Steichen's favorite sayings was by Auguste Rodin: *"La Nature c'est le modèle variable et infini qui contient tous les styles. Elle nous entoure mais nous ne la voyons pas."* (Nature is the infinite and variable model that contains all styles. She surrounds us, but we do not see her). Quoted in Edward Steichen, *A Life in Photography* (New York: Doubleday, 1963), chap. 5, unpaginated.

24. Interview by the author with Dr. Mary Steichen Calderone (May 1988).

25. Thomas D. Mabry, Jr., was the executive director of the Museum from 1936 to 1939 and was responsible for compiling the *Executive Director's Report*, which includes scant after-the-fact information about the exhibition. The Alfred H. Barr, Jr., Papers, Archives of American Art reels 2165 and 2166 from 1935 and 1936 do not mention the exhibition.

26. "Bulliet's Artless Comment," *Chicago News* (June 27, 1936).

27. June Provines, "Front views and profiles," *Chicago Tribune* (June 23, 1936).

28. For an in-depth portrait of Barr see Alice Goldfarb Marquis, *Alfred H. Barr, Jr.: Missionary for the Modern* (Chicago: Contemporary Books, 1989).

29. Carl Sandburg, *Steichen the Photographer* (New York: Harcourt, Brace, 1929), 51–53. Sandburg quoted Steichen as saying, "In a trip over the land of Greece, I asked myself, were Greek vases designed to go into glass cases in museums or were they originally intended as household appliances? I guessed for myself the answer was that they were manufactured, bought and sold by processes much like those of our production and commerce today. Some of these now 'precious' vases were sold perhaps at fifteen cents apiece or two for a quarter on some street corner of Athens. Men on donkeys riding through the country sold them like house to house canvassers of modern wares." Steichen was probably aware of Jay Hambidge's article, "A Simple Cooking Utensil as a Greek Masterpiece," *Diagonal* (December 1919), before his trip to Greece in 1921.

30. Carl Sandburg wrote, "The author may be allowed prejudices in writing about his wife's brother.... It is a little record and memoir of data, opinion and whim, as between friends." Sandburg, *Steichen the Photographer*, 3. Although the illustrations were beautifully printed, at $25 per

copy it was said to be "expensive even to read about Steichen." Matthew Josephson, "Commander With a Camera—II," *New Yorker* 917 (June 17, 1944): 32.

31. Paul Rosenfeld, "Carl Sandburg and photography," *The New Republic* 61, no. 790 (January 22, 1930): 251–252. In addition to Rosenfeld's invoking the myth of *Zeitgeist* against Sandburg, Steichen found himself criticized by artists within the commercial trade, some of whom labeled Steichen "the big boy with the f.64 stop." Sandburg quoted Steichen: "Practically all artists who do commercial work do it with their noses turned up. They want to earn enough money to get out of commercial art so as to take up pure art for art's sake. That viewpoint doesn't interest me; I know what is to know about it—and I'm through with it. I welcome the chance to work in commercial art." Sandburg, *Steichen the Photographer*, 55. Steichen in turn called these artists "the 'art for art's sake' boys in the trade." Edward Steichen, "The F.S.A. photographers," *U.S. Camera* (1935): 43.

32. Stieglitz characterized Steichen as a "tradesman," particularly in his work for J. Walter Thompson. He stated, "I never photograph famous people. Just old wagon horses and poor devils." Ruth Kelton, *Edward Steichen* (New York: Aperture, 1978), 9. Stieglitz felt that photographs should be made as art and have nothing to do with money. Steichen felt that Stieglitz spoke from upper class privilege of never having had a worry about money. Until 1923 Steichen was always concerned about making ends meet and later stated, "I was never ashamed of using my talents to make money." Elizabeth M. Lorenz, "Edward Steichen: Dissatisfied Genius," *Saturday Review* (December 14, 1957): 28. Their relationship became increasingly bitter, to the point where Stieglitz said, "If you'll remember that Steichen was a peasant and a frustrated actor you'll perhaps understand him." Interview by the author with Beaumont Newhall, August 1988.

33. Paul Strand, "Steichen and Commercial Art," *The New Republic* 61, no. 794 (February 19, 1930): 21.

34. Sandburg, *Steichen the Photographer*, 62.

35. Lynes, *Good Old Modern*, 147.

36. Steichen, *A Life in Photography*, chap. 13, unpaginated.

37. Edward Steichen, "Delphinium, Delphinium and More Delphinium!" *The Garden* (March 1949).

38. Edward Steichen, "Delphinium Standards," *Delphinium* (1936): 11. This was the same issue of *Delphinium* containing "Delphinium at the Museum of Modern Art," a reprint of two reviews of the exhibition and the same photograph of *Steichen Delphiniums* as illustrated in this article.

39. Edward Steichen, "Raising Seedlings in Connecticut," *Delphinium* (1937): 29. Steichen claimed that Sandburg had written "several fitting poems about the delphinium." J. W. Johnston, "Giant Growths of Delphinium," *New York Herald Tribune* (June 25, 1936). I have only been able to find "Crossed Numbers" in Sandburg's poems before 1936. Carl Sandburg. "Crossed Numbers," *The People, Yes* (1936), in *The Complete Poems of Carl Sandburg*, rev. and expanded ed. (New York: Harcourt Brace Jovanovich, 1970), 673. Hereafter referred to as *The Complete Poems*. Sandburg's "Tentative (First Model) Definitions of Poetry," no. 23 (1928), reads, "Poetry is the silence and speech between a wet struggling root of a flower and a sunlit blossom of that flower." Carl Sandburg, "Tentative (First Model) Definitions of Poetry" [definition #23], *Good Morning, America* (1928), in

The Complete Poems, 318. Another poem Sandburg wrote about delphiniums was "Out of the Rainbow End." Carl Sandburg, "Out of the Rainbow End" (For Edward Steichen), *Honey and Salt* (1963), in *The Complete Poems*, 753.

40. Carl Sandburg, "Crossed Numbers," in *The Complete Poems*, 673.

41. Interview by Wayne Miller of Edward Steichen. Typescript of *Wisdom Series* telecast, 1954, National Broadcasting Company.

42. Edward Steichen, Breeding Notes, unpaginated (handwritten notes on breeding), MoMA Steichen Archive.

43. Matthew Josephson, "Commander with a Camera—II," 40.

44. Linette Burton, "Edward Steichen's Photography and Delphiniums and Way of Life," *The Wilton (Connecticut) Bulletin* (July 26, 1961).

45. Josephson, "Commander with a Camera—II," 40.

46. Elizabeth McCausland, "Modern Museum Shows Steichen's Delphiniums" (unidentified newspaper clipping), MoMA Steichen Archive.

47. Steichen, "My Half-Century of Delphinium Breeding," 17.

48. Sterling Patterson, "Fifty Thousand Children," *Better Homes & Gardens* 16, no. 11 (July 1938): 50.

49. Steichen, *A Life in Photography*, chap. 5, unpaginated.

50. Patterson, "Fifty Thousand Children," 50.

51. "Art Museum to Hold Exhibit of Delphiniums," June 22, 1936 (unidentified newspaper clipping), MoMA Steichen Archive.

52. E. C. Vick, "Edward Steichen Delivers Lecture on Delphiniums," *New York American* (January 31, 1937).

53. Advertising section, *Delphinium* (1936). Steichen repeatedly ran this insert in the yearbook. Kate Steichen commented on her father's difficulty in releasing delphiniums to the market: "My father, all his life, in everything he did, sought the one perfect thing. And like all great artists, he was never satisfied.... That's why he held back the delphinium seeds so many years, they weren't quite good enough. He finally gives in, but he waits until he's done everything he can, or something else comes up and he doesn't have any more time for that." Kate Steichen, *WXXJ TV*, 1981.

54. Anne Whelan, "Steichen Lays Aside Camera to Become Another Burbank," *The Bridgeport Sunday Post* (October 9, 1938).

55. Ethel Beckwith, "Steichen Garden Moves to Art Museum," *Bridgeport Post* (June 23, 1936).

56. Irene Kuhn, "Steichen Roars Denunciation," *New York World Telegram* (June 24, 1936).

57. Avill B. Johnstone, "Daisies Could Tell," *New York World Telegram* (June 26, 1936).

58. "Delphinium Easy to Grow," *New York Sun* (January 16, 1937).

59. Anne Whelan, "Steichen Lays Aside Camera..."

60. Edward Steichen, "The Modern Delphinium," *Bulletin of the Horticultural Society of New York* (February 1937), 6.

61. Edward Steichen, Breeding Notes, unpaginated, MoMA Steichen Archive. Steichen was not wholly ruthless in his quest for perfection. He recognized how the mediocre flower had its place: "All delphiniums are beautiful, even the poor sorts for these have added their quota of beauty and distinction to gardens they've had the opportunity to grace." Patterson, "Fifty thousand children," 151. This statement was first made by Steichen in "Delphinium Standards," *Delphinium* (1936): 8.

62. W. H. Auden, "The Poet & the City," *The Dyer's Hand* (New York: Random House, 1948), 85.

63. Edward Steichen, Breeding Notes, unpaginated, MoMA Steichen Archive: Steichen also related a similar story of a man named Kunderd, of Goshen, Indiana, who developed ruffled petal gladiolus, and "was thrown out of the Baptist church on the charge that he was trying to improve on God's handiwork." Sandburg, *Steichen the Photographer*, 63.

64. Edward Steichen, Breeding notes, unpaginated, MoMA Steichen Archive.

65. T. A. Weston, *Florist Exchange* (June 4, 1936).

66. Interview with Rolf Petersen by the author, May 1988. Rolf Peterson suggested that Steichen was so competitive with men that he refused to acknowledge this behavior as another form of competition! He did acknowledge competition for the affection of women.

67. Interview by the author with Dr. Mary Steichen Calderone, May 1988. Steichen's neighbor, Ebba Anderson said, "The delphinium . . . was like a tonic for Steichen." Interview by the author with Ebba Anderson, May 1988.

68. Steichen said, "We have to work on an ever increasing scale to get the advantage of selection." "Art Museum to Hold Exhibit of Delphinium," *New York Times* (June 22, 1936).

69. Edward Steichen, *A Life in Photography*, chap. 11, unpaginated.

70. Steichen sank huge sums of money into his delphinium breeding over the years, employing as many as five full-time gardeners to tend one hundred thousand seedlings and the complexities of such a large breeding program. In 1961 he quipped that "We've developed over 400 species here—but it's taken what seemed to be the total budget of the United States to do it!" Burton, "Edward Steichen's photography, . . ." 2. Steichen's salary from Condé Nast started at $35,000 in 1923, the most Condé Nast had ever paid for a photographer. Working without a contract he was able to do additional work for whomever he wanted, except for Condé Nast's rival, Hearst Publications. Steichen was methodical in increasing his studio business. "I wanted to work with business like an engineer, I wanted to make photographs pay." Ruth Kelton, *Edward Steichen* (New York: Aperture, 1978), 9. By 1925, with a lucrative J. Walter Thompson account, he was making over $100,000 a year, often being paid over $1,000 for a single advertising photograph. In that same year he was approached by all of the leading New York photographic agencies and he turned down over $50,000 of work. Sandburg, *Steichen the Photographer*, 1929, 47. In the mid-1930s, Steichen attempted to dissuade people from asking for portraits by raising his price to $1,000 per portrait. As though he could not escape success, the new price only increased demand.

71. Edward Steichen, "My Half-Century of Delphinium Breeding," 19.

72. Steichen had begun his development of bush-type delphiniums in 1934 and had shown a few early varieties in *Steichen Delphiniums*. His wartime loss of Elatum strains was not the only factor in turning to bush-type delphiniums. Frank Reinelt, a Californian plant breeder developed and marketed a Pacific strain of Elatum delphiniums that Steichen described as "fixed seed strains in separate colors of magnificent delphiniums . . . the greatest single contribution by an individual to the gardens of these United States of America," Edward Steichen, "Delphinium Breeding," *Delphiniums* (1959): 14.

73. Edward Steichen, Letter to John Wailer (April 20, 1964), MoMA Steichen Archive.

74. Alan Lacy, "Photogenic Delphinium," *The Wall Street Journal* (April 24, 1985): 28.

75. Beaumont Newhall, quoted in "Steichen . . . A Century in Photography," *WXXI TV*, Rochester, NY, 1980.

76. Jennifer Licht, "Spaces," Museum of Modern Art Exhibition Catalogue no. 917B, unpaginated. Jennifer Licht, MoMA's Associate Curator of Painting and Sculpture, curated the exhibition and wrote the catalogue.

77. "Delphiniums, Photography Vie for Time" (July 10, 1936) (unidentified newspaper clipping), MoMA Steichen Archive.

78. Lucy R. Lippard, "Gardens: Some Metaphors for a Public Art," *Art in America* 69, no. 9 (November 1981): 150.

On Science

Vilém Flusser

Why is it that dogs aren't yet blue with red spots, and that horses don't yet radiate phosphorescent colors over the nocturnal meadows of the land? Why hasn't the breeding of animals, still principally an economic concern, moved into the field of aesthetics? It's as if nothing in the relationship between humanity and the biological environment had changed since the lifestyle revolutions of the Neolithic age. Yet at the same time that the farms of North America and Western Europe are today producing more food than we can consume, we also, not coincidentally, have learned techniques that ultimately make conceivable the creation of plant and animal species according to our own program. Not only do we have mountains of butter and ham, rivers of milk and wine, but we can now make artificial living beings, living artworks. If we chose, these developments could be brought together, and farming could be transferred from peasants, a class almost defunct anyway, to artists, who breed like rabbits, and don't get enough to eat.

If you could make a film of the European landscape that covered the millennia of history but compressed them into a convenient half hour for the comfort of the public, it would show the following story: first, a cold steppe, populated by large ruminant animals migrating northward in spring and southward in the fall, and followed by the beasts of prey, including humans, that hunted them. Then, an ever-denser forest, inhabited by no-longer-nomadic peoples living and working in clearings kept open by the use of stone tools and fire. Then, a basically familiar scene of fields of edible grains, and pastures of edible animals, with occasional forests surviving as sources of newsprint. And if you could project your movie camera into the immediate future, you would see a continent-sized Disneyland full of people working very short weeks because of automation, and trying desperately to amuse themselves so as not to die of boredom. The question is, Who will be the Disney of the future? He or she might, I suggest, be a molecular biologist.

All the organisms of the Earth are colored. We all secrete dyes in our skins, and these dyes have important functions: They support not only the individual (protective coloration)

but the species (sexual signals). We are now beginning to understand the chemical and physiological processes of these secretions, and to be able to formulate the laws that govern them. Molecular biologists may soon be handling skin color more or less as painters handle oils and acrylics.

Then the internal dyes of animal and vegetable biology may acquire a crucial new use: They may help the human species to survive its boredom by filling the future-as-Disneyland with multicolored fauna and flora.

Please don't think this a fanciful conceit. Instead, take scuba gear and a torch, and jump into a tropical ocean. Down deep you'll see fields and forests of plantlike creatures whose red, blue, and yellow tentacles sway with the currents, gigantic rainbow-colored snails trailing through the scenery, and swarms of silvery, gold, and violet fish overflying it. This is what our familar terra firma may someday look like. It has almost become feasible to transfer the genetic information that programs deep-sea coloring into the inhabitants of the earth's surface. You might say that this painting of the future is a kind of land art, but of a much more complex type than the one we know. Instead of wrapping rocks in fabric or shoving them around with bulldozers, we may be able to compute and compose a complex living game.

There is a kind of potato that is pollenized by a single species of butterfly, which itself feeds exclusively on that potato. The butterfly may be said to be the potato's sexual apparatus, and the potato the butterfly's digestive system, the two forming a single organism. In this particular symbiosis, the butterfly's wing is exactly the same blue as the potato flower. The wing color results from the reflection of sunlight by minuscule mirrors, that of the flower from the transformation of chlorophyll; nevertheless they match, the consequence of a complex evolutionary chain of feedbacks and adjustments. The Disney of the future should be able to program such effects at will. He or she may perhaps compose an enormous color symphony, evolving spontaneously through endless variations (mutations) in which the color of every living organism will complement the colors of every other organism, and be mirrored by them.

A gigantic living work of art, of a wealth and beauty as yet unimaginable, is definitely possible.

Today's environmentalists and ecologists, who stubbornly continue to call themselves "green," will object that a landscape transformed into a Disneyland, a work of art, will no longer be "natural." But consider: When these early peoples opened clearings in the forests, they began to make the landscape "artificial." When they planted fields, they accelerated the artifice. The future Disneyland will simply continue it.

And, anyway, why can't art inform nature? When we ask why dogs can't be blue with red spots, we're really asking about art's role in the immediate future, which is menaced not only by explosions both nuclear and demographic, but equally by the explosion of boredom.

From Genetic Perspective to Biohistory: The Ambiguities of Looking Down, Across, and Beyond

Barbara Maria Stafford

> She had always a very vague imagining of the inner spaces of her body, dark interior
> flesh, black-red, red-black, flexible and shifting, larger than she imagined herself from
> the outside, with no kind of graspable perspective, no apparent limits.... This inner
> world had its own clear landscape. It grew with precise assurance, light out of dark,
> sapphire rising in the black-red, wandering in rooted caverns, glassy blue running
> water between carved channels of basalt, and coming out into fields of flowers, light
> green stalks, airy leaves, bright flowers moving and dancing in wavering tossing lines
> to the blown grass of a cliff over a pale bright strand beyond which shone the pale
> bright sea. They have their own lights, Virgil said of his underworld, and this, too,
> however bright, with the clarity of more than a summer's day, was seen in its own
> light, knowing it was seen against dark, had risen out of dark, was in the warm dark.
> —A. S. Byatt, *The Virgin in the Garden*

A. S. Byatt, in her Elizabethan novel *The Virgin in the Garden*, evokes the convoluted stratigraphy of the pre-genetic female body: tactile, wet, colorful, cavernous. Its shadowy tunnels and nautilus-windings do not arrive at a specific site or precise origin but ripple anamorphically across a sunless somatic ocean. Today, by contrast, our attention is focused on the bioartificial—on what Roy Ascott has called "moist realities."[1] This synthetic or combinatorial product of a systems approach[2] overlaps an always already socially and culturally "tinkered" nature with an emergent technology. Bioengineering is busily constructing devices able to interact in controlled ways with minute aspects of the body.[3] Artificial intelligence (AI), artificial life (AL), robotics, and a wave of new biomaterials are further eroding the embedded geological analogies, typical of the early moderns, replacing them with contextless elementary particles, single cells, simple input patterns, a denuded space, and a discontinuous time composed of a network of isolated points and discrete steps.[4] All attempt to fabricate life processes "outside of the normal carbon settings."[5]

Plumbing the depths, or situated self-awareness, is giving way before biocomputers that interlink micromechanisms with defleshed aspects of living systems. Obeying the horizontal model of "the world as spreadsheet,"[6] biological data is routinely generated in real-time and circulates electronically in a relentlessly "now" economy. Simultaneously depersonalizing and hyper-personalizing, "biocollage"[7] draws attention to the shifting relations between individual organic and inorganic entities but not to the entities themselves. The spotlight has thus veered from the subjective probing of tangled ancestral entrails to the anonymous crisscrossing of distributed nodes in a nebulous hall of mirrors—like those deftly deployed in Olafur Eliasson's ephemeral ambient works. Conjuring with drizzle, fog, and prism-laden chandeliers activated through light projection, the artist's evanscent suspensions threaten to drown the participant in multifaceted, but elusive, information.[8]

Submersion in endlessly refracted glassy vistas and the attendant condition of disembodiment has an eerie kinship to the self-removed-from-self perspective of genetics. While claiming to unearth the buried treasures of a massively sedimented corporeal heritage, talk of programmed and programmable genes tends to flatten the carnal body into an empty prop. The conviction that information processing can adequately imitate self-developing processes and that this computer-generated self-organization *is* life has a significant formalist corollary: Life is a kind of natural information–processing system, therefore, it is *form*, not matter, that is the essence of life.[9]

The lush, fanciful, and subtly evolving ecology Byatt evoked has been replaced by a Wild West land grab. Sensors, actuators, agile software, and complex technical systems are being layered on top of, and inserted into, myriad microorganisms to exploit the bonanza of newly coded materials and electronically compressed terrains. New gene therapy procedures, DNA-based sensors, and other medical applications are foreseen which employ state-of-the art methods to initiate and control chemical reactions on DNA strands. Using specially designed nano-sized semiconductors—less than a billionth of an inch in size—"conductive linkers" are able to connect the electronic properties of semiconductors to biological or organic molecules creating novel nanoparticles.[10] It appears that medicine is flirting with genetic airbrushing, with *Gattaca*-like engineering, to the point where gene sequencing and the hunt for retouchable defects has become a riveting type of performance art.

Eugene Chan, the founder of U.S. Genomics, is developing GeneEngine, a machine he says is only several years away from being able to quickly and cheaply sequence the human genome's three billion or so letters. The show begins with isolating and preparing a blood sample, staging it on a black silicon chip—etched with nanoscopic channels—that sits on top of a glass microscope slide, and concludes with the behind-the-scenes activity of two lasers reading the data. The denouement is provided by a series of mirrors and filters directing light toward the DNA on the chip, illuminating the fluorescent tags.[11]

The curtain is also up on the industrialization of SNPs, the tiny genetic variations that account for nearly all differences in humans. This development has lead to the founding of

a new occupation. The "ancestral geneticist"[12]—a sort of science-fiction P. T. Barnum—envisions the day when genetic kits forecasting the entire range of human grandeur and misery will be sold at Wal-Mart. To add a comic note to this morbid mix: Canadian researchers have recently modified a pig to defecate environmentally friendly, phosphorus-absorbing, manure. To fashion *enviropig*, a transgene was constructed linking a small portion of the mouse gene responsible for producing a salivary protein to another gene from a nonpathogenic stain of E. coli. The new transgene was introduced into fertilized pig embryos which were then implanted into surrogate sows.[13] And—*voila!*—a pollution-reducing hybrid was born.

Such blending spectacles, produced on a daily basis by the scientific community, are putting added pressure on bioartists to transcend the 1970s melange of body art, conceptualism, activism, and performance[14] and join the future of research. Chris Burden's gory autocrucifixion or Hannah Wilke's arresting display of her diseased body to explore the ravages of physical transformation[15] unforgettably demonstrated our losing battle with evolutionary biology's concept of "fitness"—rather than just wiping it out. Conversely, Eduardo Kac's biobot—or newly minted creature—is an unevolved being, a suddenly living work of art without a discernible past. Transformed and transplanted, it remains unexplained because it has no context.

Project SymbioticA, for example, housed at the University of Western Australia's Institute for Anatomy and Human Biology, provides artists with the opportunity to work closely with researchers in the biosciences. The results of this simultaneously exciting and troubling encounter are eerily weightless and spare, as in *Fish and Chips*, a biocybernetic installation.[16] Fish neurons "raised" on silicon chips constituted the wetware. The hardware was assembled from visually and acoustically programmed software playing off of monitors. Significantly, the aim of this technopoetic project was to develop quasi-living synthetic entities. The process is quite complicated, but what is of interest here is the transformation of neuronal data into rhythm and color-sound algorithms as well as into drawings. The "half-alive" entity signals (unconsciously) how the drawing should appear on the computer monitor and how the music should sound when generated on a MIDI synthesizer.

Clearly we have moved from the populist dictum that says anyone can produce and display art to the more sweeping statement that any *thing* can. Resembling Mandelbrot's fractals or two-dimensional cellular automata, SymbioticA's equivocal, self-realizing blends hover at the intersection between physical and informational structures. Yet, like Eduardo Kac's provocatively entitled *Genesis* project[17]—mutating E. coli bacteria into *Genesis* bacteria—such fabrications also have a biblical ring. They wrest the power and the skill to originate life from the laboratory sciences by elevating the artist (and frequently, as well, an anonymous telepresent public) to the status of second Creator manipulating primal matter.

The complicated production of Kac's synthetic gene is not my concern here. What is fascinating, however, is that both the actually witnessing viewer, in tandem with the

online participant, are influential in the transformation of these fluorescent bacteria. They can control the rate of mutation and sequencing by manipulating the UV light source from afar. (The installation consists of a microscope, a UV light source, a webserver, and a larger-than-life-size video projection that makes visible the separation and interaction processes of these newly devised entities.) The resulting contextless biofictions—surfacing from the labyrinth of the Internet—are made, if not exactly by committee, by plural, nameless, and faceless interveners.

Whether one examines such procedures cybernetically, biologically, or ethically, transgenic art is equivocal through and through. On one hand, it represents a miraculous extension of what Giorgio Agamben calls "brute" or "naked" life[18]: the life of the species—or, more accurately, *some* as yet undefined species—rather than a *consciously* lived human and ethical life. On the other hand, it issues a profound challenge to Darwinian adaptionism[19] and to the upwardly mobile, tree-like pattern evolution imparted to life's history by demonstrating that much of what is now coming into biological existence seems to do so for no end-related reason. Byatt's wonder at the body's proximate microcosm, its branching grotto of common descent, has yielded to an arbitrary and processing curiosity operating either at an immense distance or at such close quarters and lower levels that it is impossible to assess. Globally linked, but disconnected, imaginings now build an array of kingdom-defying ambiguities. These densely cobbled-together microscopic systems must be scrutinized with ultrafast computers at smaller and smaller scales.

A dreamlike "hypertext rhetoric" characterizes the explanatory hypotheses devised by the growing number of physical sciences co-mingling with computer science. Just mention their names, and visions of galaxies, scattered like dust across the cosmos, leap to mind: bubble universes and inflation theory,[20] brane theory, string theory, chaos theory, complex adaptive systems (CAS), entropy, Ilya Prigogene's "dissipative structure."[21] This embrace of dark energies, randomness, self-reproduction, and apparent disorder by influential segments of the astrophysics and physics communities has been joined by microbiology's focus on the impossibly distant and primordial zones of our own strange somatic universe. Its subcellular investigations, assisted by nanocomputers, have likewise yielded an outlandish crop of world-generating virtual/physical entities more like clouds of possibility than dense three-dimensional objects.[22] The notion that genes are analogous to tiny flows of localized, yet linked, communication—invisible to the naked eyes—is dissolving a venerable body analogy likening its orderly composition to a coherent flowing narrative threading together successive subjective states.

In the era of mass individualization, the corporeal domain has become a trans-, intra-, inter-, and re-mediated patchwork of interactive functions eluding any confining or fixed volume—not unlike the weblog. Most of these textual sites are personal, full of links and commentary, that evoke the parallel domain of the genomic and the genealogical. Multidirectional hyperlinking across many sites chronicles the daily lives of hundreds of thousands of Netizens, binding their conversations and pointing to newer material that

their past conversations inspired. More specifically, the bloggers demand for (historical) "backlinks"[23]—to learn who is linking to what—is comparable to those researchers who surf the body's submerged tide, similarly dissolving it into active hubs of fluid information. In addition, there is the immense frontier of electronic literature.[24] This expanding creative metaverse stretches far beyond the humbler aspirations of the informal weblog. Post-anthropic biology appears to have a lot in common with these new aesthetic media elements. In both cases, we are confronted with an exitless maze of operations that are unpredictable, discrete, nonlinear, and ever-responsive to the back and forth clicking of multiple users. Pattern—whether on the monitor or in the petrie dish—is emergent, deriving from an elastic database[25] from which mutable excerpts or fragments are selected to interact with a limited or vast number of options.

Who can doubt, then, that we live in an era of trans-everything? Cloning, artificial life, sex reassignment, organ transplants, cosmetic surgery, and the identity shifts encouraged in cyberspace chip away at our notion of the physical body as a stable entity that defines us from birth to death. Already since the late nineteenth century, anthropometry and fingerprinting—those supposedly reliable indicators of deviant social tendencies—have mechanically translated inchoate somato-psychic experiences into exact quantitative measurements and defining inscriptions.[26] Many people expect similar revelations from molecular biology, the science behind DNA typing, and biometrics, the automated methods used for verifying or recognizing the identity of a living person, which access the buried secrets of human nature through disease markers and telltale codes.

This turn from weighty skeleton and old-style blood-and-guts physiology to diaphanous bioinformatics—processing behavior genetically, neurologically, and hormonally—emphasizes portability, assemblage, variant, and immediate screen display. What remains after this evisceration? With the ongoing evacuation of the meat of matter, many artists have embraced skin and genes. Already since the 1970s, Stelarc has been painfully piercing and stretching integument, as well as coupling his body to technological devices. But his recent *Stimulator* projects absolutely relinquish self-control, handing over his body's pleasurable or excruciating activation to anonymous, external, Net-based dataflows.

Like Kac's and Orlan's omnibus transformations, Stelarc's exaggerated investment in scar tissue, belabored features, and monstrous disability opens vistas onto the transcendental grotesque. This extreme art of multiple modalities—for representing and transmitting what we regard as the "same" thing differently—interestingly parallels the shift in focus that has occurred within biology from investigating the norm of direct, unmodified transmission[27] to reveling in transmission with modification.

If narcissism organizes the ego singlemindedly around wounded experience and the suffering of "tender organs,"[28] the new biological self-inflation is not a private resistance to reality but a generalized recrafting of it. Currently, we have the transfigurational dress of flesh: Think of Orlan, whose self-sorcery consists in tirelessly sculpting mutations of

herself and then redoubling them over the Internet. And we have the apotheosis of the decorative detail: Think of Eduardo Kac's augmented or transgenic bunny Alba—altered with a single fluorescent green protein (GFP). In either case identity is jostled, but not at the visceral level. Kac's skin-dressing art obliges us to recast Derrida's "logic of the supplement"[29]—defined as the operation by which an element that a given system tries to exclude is readmitted to that system, but only in a negated or debased form. On the contrary, Kac is a sort of genetic tattooist, enhancing an existing animal form by the subcutaneous addition of an ornamental, protein-produced aura. Far from isolating one member of the rabbit community as completely different from all the rest, this compensatory act only heightens the ambiguity of all special, or managed, existence. Similarly, Nina Levy's larger-than-life-size cast resin and painted fiberglass sculptures like *Greeter* or the *Exhibitionist*[30] are endowed with realistically rendered, but exaggerated, hands or grin. More fretful complications than deep-seated liabilities, these theatrical wearables remind viewers that we are looking not at a self-contained organism but at a canny prosthesis.

Such arabesquing works conspicuously highlight the subset. This emphasis on the compact, the insular, the discreet is a logical accompaniment of the emergence of "personalized medicine" and "consumer genetics."[31] Pharmaceutical companies are working on a field called pharmacogenomics, whose goal is to tailor drugs and vitamins to individuals based on genetic screening. Ironically, this customized delivery of particular diet ingredients and health supplements is occurring at the same time that the corporate food system still turns a profit on monocropping. The business of growing very few crop varieties on a large scale allows them to be harvested cheaply with the greatest efficiency.[32] A minimal number of genetic varieties are selected and bred for high yields. These generics subsequently become differentiated and disguised through multiple processing and seductive packaging.

Revealing parallels exist between the general public's ambivalence at eating the reshaped homogeneous stuff that is transgenic food or genetically modified organisms (GMOs) and its ambivalence at seeing the self as a composite of farmed-out, freeze-dried genes awaiting further manipulation. The question of our unease at the growing estrangement of the content of what we eat and the degradation of its quality might equally apply to our discomfort at the harvesting of genetic matter from a devalued body in which it has become merely another profitable foreign resource—much like the transplantable corneas, kidneys, livers, hearts, and other saleable organ fragments ghoulishly trafficked in by an international "body mafia."[33]

The alimentary/genetic analogy has another side as well. The witting or unwitting ingestion of bioengineered products proves that we are in no way a pure and "natural" species.[34] This insight that we are becoming voluntary or involuntary hybrids is disoriertingly encapsulated in Aziz and Cucher's photograph, *Orange-Man*, where pocked face seamlessly melds with fruit rind.

Contemplating Aziz and Cucher's series of morphed portraits of hermetically sealed boundary-beings, or the quasi-landscapes recombining data with natural features by the Cologne-based group, Knowbotic Research, or even Matthew Barney's glamorously bestial five-part *Cremaster* films (video allegories of the ascent and descent of the cremaster muscle, the rise and fall of testosterone in a transspecies culture), I am struck by how varied and pervasive the current passage of human into plant and animal forms has become. The passionate, crude, raw animality of Francis Bacon's rotting sitters[35] has turned into something equally intense, but intangible, directionless, feral. All production is co-production, the unexamined championing of the ideal of choice, alternatives. *Transfer* (that is, the transferring of human to animal and animal to human properties by the active user-spectator) sums up the notion of the user supposedly being involved in creation, rather than merely submitting to it.

This actual coexistence of humanity/animality/vegetality/minerality—without any manifest affinity or hidden correspondence[36]—has generated an abundance of hallucinatory worlds, indiscernible creatures, bizarre plasmic substances, and a surplus of strange prostheses that mutually modify one another. The generative artist's studio more and more resembles the research laboratory fabricating a machinic phylum at once disjunct and expansive. A new ambiguity—whether achieved through metamorphosis, mutation, multiplication, or decomposition—characterizes the contemporary art scene intimately touched, like the rest of us, by the coupling of information technology (IT) to the posthuman engineering of confused forms.

High-tech biology has spawned an elaborate mythology of plentiful reproduction. It has unlocked a bewildering accumulative domain comparable to globalized "Sperse," that odd distributed dimension where people are connected not by location but by e-mail. Only motion holds things together since everything is perceived as either falling or dispersing: "Things come into being from the symbiosis of collision perhaps, but there is no progress forward, no teleology, no solutions to the problems of the world."[37] Similarly, the gene purports to show content directly in its pure form; it is no longer dependent for meaning on a dialectical relationship with a greater, enduring body. Nor does the sign mimic a prototype.

Of course, this metaphysical shift occurred long ago with Duns Scotus at the close of the thirteenth century. Arguing against Thomas Aquinas, Scotus's account of signification as representation—signs, rather than being in some sense identical with the things they signify, merely represent those things—demonstrated there was no place for an analogy of being (the recognition that God and his creatures are beings in an irreducibly different sense, hence the need to forge a connection between them).[38]

As denizens of the twenty-first century, we readily comprehend what it means to study the logically possible, whatever *might* be represented, and not restrict oneself to the actually existent. What notably separates us from the ontology of the medieval thinkers, however, is the fact that the possible and the thinkable can now be turned into things without

the mediation of concepts. Perhaps this is why Matthew Barney speaks of navigating an unstable *trans*-space between genres in his work, or "a zone of ambiguous cross-reference."[39]

In this liminal domain, it is not just possible for a baby to be improbably mistaken for a handbag (as in Oscar Wilde's *The Importance of Being Earnest*)[40] but for a human being to be re-created as a flagrant biofiction. But personalization, to the *g* (*n*th) degree, is not about stylishly inverting life and art but about perfectly incorporating the natural with the artificial down to the last exquisite detail.

There is another biological lens with which to reckon, just as there are variable depths and multiple origins. Life makes more sense in light of evolution.[41] This means considering not just the genetic record, but the detailed genealogical evidence gathered by paleo-anthropologists, geologists, geochronologists, prehistoric archaeologists, and evolutionary biologists. These and other vital contributors to the life sciences locate fossil hominids and existing societies of primate species in broad evolutionary and behavioral contexts.[42] This diachronic, intraspecific modeling of animal social behavior and changing ecology points backward and forward, illuminating the reciprocal ways in which extinct and persisting organisms encountered their changing and unpredictable environments. It also avoids the two major pitfalls that bedevil attempts to find biology in culture, namely seeming either to push toward sociobiological conclusions drawing tight connections between genetic and cultural varieties and practices, or to push toward a perception of cultural change as somehow analogous to biological evolutionary processes, to talk about "memes" as if they were genes.[43]

Suzanne Anker proposed in her 1993 *Zoosemiotics (Primates: Frog, Gazelle, Fish)* installation that this intriguing interplay comes about when "life fractions." There are 234 extant species of primates of which Homo sapiens is the only one with global distribution, much to the detriment of nonhuman primates and countless other organisms struggling for survival during the past thirty thousand years.[44] Anker underscores the fragility of such vulnerable, threatened, and endangered creatures—remote from the glamorous bestiary of rarities festooning conservation posters—by sculpting a sheltering enclave. Luminous wall-hung reliefs made of hydrocal and metallic pigment impart a sensual quality to an otherwise abstract code. In this buffer zone, a panorama of silvery chromosomal projections dynamically body forth the notational understructure of living matter. These capering ciphers and dancing glyphs, in turn, are elegantly compressed and refocused for our narrowed attention within a shimmering, water-filled orb,[45] their marvelousness suspended within a biological reserve.

Morphological permutation—caused by artifice or as a consequence of optical devices—is also the leitmotif of Anker's 2001 work, *The Butterfly in the Brain*.[46] This intramedial installation exposes the deep symmetries found in art and nature revealed through high-speed scientific instruments like microscopes, telescopes, and MRI scans. Here, again,

technology used in the discovery of overall pattern works to illuminate the complexities of interindividual and intercommunity relationships.

The opulent archive displayed in Anker's *The Butterfly in the Brain* counters the naked, freshly concocted aspect of genetic mutants. With its wall-mounted, quasi-Victorian collection of flamboyant butterfly wings, dramatic blowups of Rorschach digital brain scans, and glass table vitrines—which contain an illustrated volume of natural history and an assortment of wax casts of intricate mammalian parts—this museological cabinet captures the symmetry, logic, and interconnectedness shared by all living things. Bill Viola, too, has long been plumbing such common rhythmic sequences in electronic formats that mimic the stately unfurlings of Renaissance frescoes. In his striking five-channel video mural, *Going Forth by Day* (2001), commissioned by the Deutsche Bank for the Guggenheim Berlin, he elevates the developmental aspect of biology to the level of myth. In one projection, a motley procession moves across a light-dappled forest trail. The long wavering line has no beginning or end. Both ephemeral and enduring, this mongrel parade keeps a steady pace to infinity.

Like animal language whose meaning is often generated not by the sounds themselves, but rather by the ways in which those sounds are modulated,[47] it is less the syntax of Viola's miscellany that counts than their sequence. Akin to many birds who seem to have a vocabulary of basically one call, his passersby take on different meanings based on the frequency or volume of their signals.

Viola's habit of revealing the stray or the overlooked connection between past and present joins his nuanced art to a more mundane biology concerned with commonplace occurrences taking place over long periods and with peripheral perspectives, not just those offered by the mainline victors. This awareness that the the world is complex, adaptive, and sensitive to small changes—that even the apparently irrelevant is relevant—turns people into curators of their lives. The human as catchall for inherited traits, as well as for found experiences, is a different construct from the human as detritus. Preserving a fragile ballet of randomness—made up of little routines and a swirl of minutiae—is the opposite of the genetic logic of the speck. Consonant with the ideal of beyondness valued in bioengineering, transformation, and transient expression technologies (cloning, genetic splicing), the genetic perspective interprets life as a synthetic, detachable, arbitrary, and ahistorical ordering of reshuffleable components.

No animal species are completely unrelated nor are their behaviors adaptive in an absolute sense. Those bioartist-researchers engaged in the interactive creation of autonomous novel life forms might ponder the recent discovery by ecologists that when humans alter the environment, they often cause problems more worrisome than simply the destruction of the habitat. One of the characteristics of complex adaptive systems is that they are extremely sensitive both to initial conditions and to small change. These slight modifications can be ampified disproportionally from what was in place at the beginning, causing

major unexpected outcomes[48]—as in the unintended, shortened life span of many animal clones. The term "evolutionary trap"[49] encapsulates this surprising mechanism. It vividly describes the counterintuitive fact that an alarming number of species today bypass better habitats to live in less suitable ones. Animals—ranging from the buprestid beetle to wood ducks to manatees—are led astray by illusory cues that no longer help in a setting altered by people.

Anne Wilson's elegantly damaged *Feast* (2000), a spectral banquet table on which are pinned the lacey remnants of white damask linen marred by cigarette burns and bleach stains, visualizes the deep species history drawn on the skin and secreted away inside the human body. Hers is an inferential view of human life, reconstructed from the remaining traces. A veined and spotted testimonial for downcycling (reducing the integrity of a material over time), Wilson creates an aesthetic counterpart to ecology, focused on the continual integration and disintegration of every organic and nonorganic substance.

This valiant coverlet of sooty rings incarnates a topographical analogy. Its fraying interlace alludes not to a targeting and flaw-finding genetics but to inevitable wear and tear, the physical erosion that comes from the prolonged use and abuse of one's body. Instead of revolutionary, newsbreaking events, *Feast* presents us with weak signals. Features crest and fade unobtrusively not because they lack intrinsic importance but because they are so small as to be obscured by other items or so veiled as to be deemed inconsequential. In transforming biohistory[50] into a quietist performance art, she obliges the viewer to gauge how the cumulative changes in the fabric of everyman's life—stretching over an extended period—might be summed up at a long glance. Shadowy craters, vanishing trails, and miniscule mounds—Eleanor Wilner's "fine sift of gray"[51]—chart the unclear path from whole cloth to hole that all of us tread.

Unlike the bruising armamentarium of genetic medical interventions directed at preventing or repairing disease—with its attendant fantasies of perfection and flawless restoration—Wilson carefully preserves the wounds and asks us to meditate on the certain jeopardy of mutual decay. If the past is indeed a prologue, we all face the hazard of disruption, the inevitable cut to extinction. Delicately edging the rips with human hair, she reminds us that this feathery fur and foliate fringe is our "memento mori," "our very own fossil," an evanescent fiber monument to "the towering mortality of human flesh"[52] shared with other animals and plants.

Resolutely an artist of the twenty-first century—attuned to a dazzling range of exquisite patterns from the macroscopic to the microscopic—Wilson makes us see how even the latent tears hidden in the luxuriant weave of our biological makeup can be made visible. Her tapestry further demonstrates that each individual is a complex ecology of interacting agents—heredity, selection, development, cultural practices and values—not a mere aggregate of them. Like Eva Hesse before her, she realizes that meticulous stitching and mending only make sense in light of a situated organism's daily struggle to adapt itself—by reassembly—to a complexly fracturing environment.

Barbara Maria Stafford

Notes

1. Ascott, Roy, *Telematic Embrace: Visionary Theories of Art, Technology, and Consciousness*, ed. Edward A. Shanken (Berkeley: University of California Press), 363.

2. See the essays in Agatha C. Hughes and Thomas P. Hughes, eds., *Systems, Experts, and Computers: The Systems Approach in Management and Engineering, World War II and After*, Dibner Institute Studies in the History of Science and Technology (Cambridge, MA: MIT Press, 2000), which consider the economic and social impact of systems engineering, the techniques combining mathematics, economics, computers, management, and an assortment of other areas including study of genetic codes.

3. Massimo Negrotti, "Designing the Artificial: An Interdisciplinary Study," *Design Issues* 17 (Spring 2001): 11–15.

4. See Stephen Wolfram, *A New Kind of Science* (New York: Wolfram Media, 2002), in which he argues that nature is discrete rather than continuous and functions like a cellular automaton. Also see Steven Weinberg, "Is the Universe a Computer?," *New York Review of Books* 49, no. 16 (October 24, 2002): 43–47.

5. Stephen Wilson, *Information Arts: Intersections of Art, Science and Technology* (Cambridge, MA: MIT Press, 2002), 55.

6. The phrase is John Thackara's. See his Introduction to the Doors of Perception 7 Conference: *The Design Challenge of Pervasive Computing* (Amsterdam, November 14, 2002).

7. See *Art Journal* 59 (Fall 2000), which examined the issue of "biocollage."

8. Ina Blom, "Beyond the Ambient," *Parkett* 64 (2002): 20–31. See, especially such total-surround works by Eliason as *Your Strange Certainty Still Kept* (1996), *Hall of Mirrors* (in the rococo Hall of Mirrors in Graz Castle, 1996), and *Moss Wall* (1994).

9. Claus Emmeche, *The Garden in the Machine: The Emerging Science of Artificial Life*, trans. Steven Sampson (Princeton, NJ: Princeton University Press, 1994), 4, 18.

10. Katie Williams, "Researchers Blend Biology, Semiconductors," *Argonne News* (October 14, 2002): 1–2. The team expoiting this chemistry for use in gene therapy includes Argonne Chemistry Division Director Marilyn Thurnauer and chemists Tuhaba Rajh, David Tiede, and Lin Chen in collaboration with Gayle Woloshak of Northwestern University.

11. "Demo: The Personal Genome Sequencer," *Technology Review* 105 (November 2002): 76–79.

12. David Ewing Duncan, "100% Genetically Analyzed," *Wired* 10.1 (November 2002): 181–187.

13. See the Web site for the Guelph Transgenic Pig Research Program: http://www.enviropig.uoguelph.ca.

14. Ellen K. Levy, "Responses," *Art Journal* 60 (Spring 2001): 6–7.

15. For the body-mindedness of the performance, video, and installation art produced by the feminist art movement during the 1970s, see the exhibition organized by Simon Taylor and Natalie Ng, *Personal and Political: The Women's Art Movement, 1969–1975* (East Hampton, NY: Guild Hall, 2002).

16. See http://www.symbiotica.uwa.edu.au. *Fish & Chips* was exhibited at Ars Electronica 2001. See Gerfried Stoecker and Christine Schoepf, eds., *Takeover: Who's Doing the Art of Tomorrow*, Ars Electronica 2001, exhibit catalogue (Vienna and New York: Ars Electronica, 2001).

17. See http://www.ekac.org. This installation was shown at Ars Electronica 1999, whose theme was "Life Science."

18. Cited in Nancy Schoper-Hughes, "Min(d)ing the Body: On the Trail of Organ-Stealing Rumors," in *Exotic No More: Anthropology on the Front Lines*, ed. Jeremy MacClancy (Chicago: University of Chicago Press, 2002), 47.

19. For a discussion of current alternatives and challenges to Darwinism, including Stephen J. Gould's decorative "spandrels," see Michael J. Ruse, *The Evolution Wars: A Guide* (Santa Barbara, CA: ABC-CLIO, 2000), 236–237.

20. According to inflation theory what we can see of the universe is only a tiny patch of space—30 billion light years away—on a "bubble" trillions of light-years across or more. See Dennis Overbye, "A New View of Our Universe: Only One of Many," *New York Times*, Science Times (October 29, 2002): D1, D4.

21. For Prigogine's Epicurean idea of a physical order whose stability depends on disorder elsewhere in the system, see the work of Isabelle Stengers, most recently *The Invention of Modern Science*, trans. Daniel Smith (Minneapolis: University of Minnesota Press, 2000).

22. See Bill Seaman's text, "Toward the Production of Nano-Computers and in Turn Nano-Related Emotive Virtual/Physical Environments," available at http://faculty.risd.edu/faculty/bseamanweb/texts.html.

23. David F. Gallagher, "The Web's Missing Links: A New Twist on the Hyperlink Makes Wandering the Web Twice as Interesting," *Technology Review* 105 (November 2002): 32.

24. On the new electronic literature, see N. Katherine Hayles, *Writing Machines* (Cambridge, MA: MIT Press, 2002).

25. A special issue of *AI and Society*, edited by Victoria Vesna, was devoted to database aesthetics. See http://time.arts.ucla.edu/AI Society/vesna essay.html.

26. On the nineteenth- and twentieth-century career of fingerprinting, see Simon A. Cole, *Suspect Identities: A History of Fingerprinting and Criminal Identification* (Cambridge, MA: Harvard University Press, 2001).

27. See Dan Sperber, *Explaining Culture* (London: Blackwell, 1995).

28. Tobin Siebers, "Tender Organs, Narcissism, and Identity Politics," in *Disability Studies: Enabling the Humanities*, ed. Sharon L. Snyder, Brenda Jo Brueggemann, and Rosemarie Garland-Thomson (New York: The Modern Language Association of America, 2002), 40–42.

29. The thought of early Derrida was sensitively reexamined in Geoffrey Galt Harpham, "The Hunger of Martha Nussbaum," *Representations* 77 (Winter 2002): 55.

30. For images of the exhibition, see http://www.ninalevy.com/feigen.htm.

31. Andrew Pollack, "New Era of Consumer Genetics Raises Hopes and Concern," *New York Times* (October 1, 2002): D5, D8.

32. Claire Pentecost, "What Did You Eat and When Did You Know It?," *Art Journal* 47 (Fall 2001): 48–49.

33. Schoper-Hughes, "Min(d)ing the Body," 33.

34. Carl Knappett, "Photographs, Skenomorphs and Marionettes: Some Thoughts on Mind, Agency and Object," *Journal of Material Culture* 7 (March 2002): 98.

35. Alice Cournot, "Le devenir-animal chez Gilles Deleuze," *Revue d'Esthetique* 40 (2001): 90.

36. See my *Visual Analogy: Consciousness as the Art of Connecting* (Cambridge, MA: MIT Press, 1999) for the long-lived tradition of associative thought based on kinship.

37. Paul Shepheard, "Grounds for Dispersal: Days with the New Generation," *Harvard Design Magazine*, no. 16 (Winter/Spring 2002): 50.

38. Olivier Boulnois argues that a radical shift occurred in metaphysics at the end of the thirteenth century, an innovation usually associated with Kant. See his *Être et représentation: Une généalogie de la métaphysique moderne à l'époque de Duns Scot (XIIIe–XIVe siècle)* (Paris: Presses Universitaires de France, 1999).

39. Daniel Birnbaum, "Master of Ceremony," *Art Forum* 41 (September 2002): 185.

40. See the recent film written and directed by Oliver Parker based on the 1895 play by Oscar Wilde and the review by Daniel Mendelsohn, "The Two Oscar Wildes," *New York Review of Books* 49, no. 15 (October 10, 2002): 18–20.

41. For an informative review of some classic and current ideas and controversies about human evolution see Carl C. Swisher III, Curtis H. Garniss, and Roger Lewin, *Java Man: How Two Geologists' Dramatic Discoveries Changed Our Understanding of the Evolutionary Path to Modern Humans* (New York: Scribner, 2000); and Lee R. Berger and Brett Hilton-Barber, *In the Footsteps of Eve: The Mystery of Human Origins* (Washington, DC: National Geographic, 2000).

42. Russell H. Tuttle, "Paleoanthropology Read in Tooth and Nail," *Reviews in Anthropology* 31 (London: Taylor & Francis, 2002): 118–119.

43. W. C. Wimsatt, "Genes, Memes, and Cultural Heredity," *Biology and Philosophy* 14 (April 1999): 279–310.

44. Russell H. Tuttle, "Global Primatology in a New Millennium," *International Journal of Primatology* 19, no. 1: 1.

45. Barbara Maria Stafford and Frances Terpak, exhibit catalogue, *Devices of Wonder: From the World in a Box to Images on a Screen* (Los Angeles: Getty Museum, 2001), 220–222.

46. The exhibition was held at Universal Concepts Unlimited, April 11–May 18, 2002. Also see Nancy Princenthal, "Suzanne Anker at Universal Concepts Unlimited," *Art in America* (February 2001).

47. On animal language and interspecies communication, see Douglas Heingartner, "Attention, Cows: Please Speak into the Microphone," *New York Times* (October 31, 2002): E5.

From Genetic Perspective to Biohistory

48. S. Dyer Harris and Steven Zeisler, "Weak Signals: Detecting the Next Big Thing," *The Futurist* 36 (November–December 2002): 22.

49. Lila Guterman, "Trapped by Evolution," *Chronicle of Higher Education* 49, no. 8 (October 18, 2002): A19–A20.

50. On the emergent field of biohistory, see Robert S. MCElvaine, *Eve's Seed: Biology, the Sexes, and the Course of History* (New York: McGraw-Hill, 2001).

51. Eleanor Wilner, *Reversing the Spell: New and Selected Poems* (Port Townsend, WA: Copper Canyon Press, 1998).

52. Hattie Gordon, "Anne Wilson's *Feast*" *Art Journal* 61 (Fall 2002): 23.

Art and Biotechnology

Yves Michaud

In our scientific and technical communities, biotechnology has taken a previously unprecedented position of visibility. It appears in the news with issues of therapeutic or reproductive cloning, or of genetically modified organisms giving rise to virulent and muddled controversies. In a powerful yet discrete manner, biotechnology has invaded the industrial domain (food industry, pharmaceuticals, medical engineering) and its implementation prospects continue to expand, as witnessed in the reflections on sustainable development and the call to soft techniques of environmental control within the framework of ecological engineering.

Art will never be outdone. Not only have science fiction and cinema been exploring, for quite some time, scenarios of artificial humans, the fear or dreams aroused by modified or prosthetic organisms, and the anguish in the face of other forms of life, but now visual artists are also using biotechnology, with or without scientific techniques, with or without an explicit engagement with the idea of a biotechnological art. Eduardo Kac's fluorescent creatures are no longer confined to a contemporary art gallery; they have won over the media world, as did Orlan's spectacular operations on her own body. Other practices, which have stayed more private, have involved biological processes such as implants, scarifications, piercings, tattoos, tissue cultures, and natural processes of decomposition and degradation.

Here it is a new field of acts and works that employ the materials and processes of life. This field is associated as much with artists as with those who work with the widely spread ideas related to electronic and technological art.

The questions raised by the contemporary art historian and by the philosopher who specializes in aesthetics, as well as by the ordinary citizen who is disoriented or fascinated by the culture of his or her time, are many.

First we ask what exactly this is all about. Words move about freely but the ideas often remain imprecise. We need to measure what is and what is not the novelty of these

practices: Modern art at the end of the twentieth century was rich in findings and surprises, but what appears to be novel often turns out to be a revival, repeat, or remake. We have to wonder more ambitiously and with clarity what regime of new art is being established, and with what aims. These are the three questions I will approach in this text, without expecting to find the answers but hoping at least to outline the main issues.

Since we're speaking of biotechnology and of biotech art, it would be useful to state what is meant by biotechnology. As much as we are eager to get to what appears to be the heart of the matter in debates, we find that the term is as widespread as it is little defined. Generally, the term "biotechnology" designates the use of biological instruments or tools to produce certain substances, live beings, or biological processes that will be used in technical procedures. Biotechnology is thus a technique using living organisms or parts of living organisms to fabricate or modify things: make products, improve plants or animals, develop microorganisms, or carry out acts of a biological nature.

Biotechnologies therefore cover a very wide range of procedures, from traditional and ancient to the most recent applications of biochemistry and genetics. The current prevailing tendency is to narrowly identify biotechnology and scientific biotechnology, biotechnology and genetic engineering. It's not surprising: Not only have the new biotechnologies made a considerable leap forward, but the traditional techniques have been "revisited" and scientifically redeveloped (for example, in winemaking and the food industry). This identification tends to conceal that the scope of biotechnologies has been historically wide: Humanity has, forever (or nearly), used fermentation techniques, made cheeses and alcoholic beverages, used techniques of conservation and aging, improved the ground for cultivation, domesticated and selected animals and vegetables, produced animal crossbreeds and vegetable hybrids. All of this is already part of biotechnology.

This very wide scope is, however, divided in two parts; we have gone from largely empirical biotechnologies in the past (including those that demanded a very high degree of subtlety and empirical savoir faire) such as fermentations, animal or vegetable selection, and even vaccinations, to "scientific" biotechnologies. These biotechnologies depend on the biochemical knowledge of DNA and materials from live beings, which provide the definitions of their genetic character and metabolism and inform the diagnostics and operations that can be performed on them (DNA transfers, mono and polyclone antibodies, tissue and cell cultures, transgenesis, and genetic operations).

From the point of view of epistemology and theory of knowledge, contemporary biotechnologies constitute an eminent case for technoscience, that is, of science governing the technical applications that are deeply intertwined with theoretical knowledge. Such transdisciplinary scientific knowledge—genomic, proteomic, bio-computing, robotics, nanotechnology—in turn calls upon technical knowledge, instrumental and complex practices within the framework of industrial production. I will leave this aspect of the issue to others who are more competent in epistemology and the philosophy of science.

Yves Michaud

Because we are fascinated by the feats of genetic engineering, it is important to question whether, from a historical point of view, biotechnologies have known changes as conclusive as we think.

The general definition returns to old, even ancient, human techniques. But even if we take a nonempirical view, the history of biotechnologies can hardly be said to begin with Mendel in 1866. Would it be more pertinent to make the beginning of modern biotechnology the discovery of DNA in 1953, or even the first successful production of recombined DNA in 1973? Should we talk about qualitative leaps or, rather, putting aside wonder, surprise, and fear, look at continuity of human instrumentalization?

It is clear that with the discovery of DNA and the biochemistry of life, a field that until now was subjected to empiricism and to observation has suddenly become scientific. The materials of knowledge are identified, the principles that govern their interactions known, and a priori hypotheses govern their research and exploration; thus we can use this knowledge in a systematic and organized manner to obtain derived products, therapeutic techniques, and general products. We can clone animals and obtain specific molecules with perfectly recognizable characteristics from these cloned animals, even from their milk. From a practical point of view, this progression to the scientific stage allows an engineering of production and its standardization.

However, we must not forget that the agronomic revolution of the eighteenth century, the green revolution, as empirical as it was, was of an exceptional scale and that the campaigns of purification and of vaccination at the end of the nineteenth and beginning of the twentieth centuries had immense demographic and social effects. If we surpassed one million humans at the beginning of the twentieth century to six million at the end, despite the two world wars and repeated violence, this is because of the revolutions in hygiene and health.

The most novel thing would be not the change of scale but the precision of the course of action and of control that we use, and the new methods of assessment. With the more or less enlightened consent of the population, or of the elite who are supposed to be enlightened, the politics of population and of health—that which Michel Foucault called "biopolitics"—were pursued in a largely authoritative and indiscriminate manner. Today, governments and administrations look to lead targeted and differentiated actions in the interest of small segments of the population while collecting the consent and support of its citizens in general, assisted by fuzzy reasoning and smart advertising.

The three traits that best characterize modern biotechnology would therefore be its scientific and theoretical character (no longer empirical), its field of industrial application, and its targeted method of administration (which should be and, in principle, is consensual).

If we turn now to the area between visual art and biotechnology, we notice without surprise an evolution not unlike what we have just described. We go from still empirical and implicit biotechnology practices to scientific approaches that are more explicit,

technically more complicated and targeted. Practices such as tattooing, scarification, and implants are nothing new in human history, but they have been renewed by aesthetic surgery. The art of gardens, floral production (tulips from seventeenth-century Holland), or the farming of exotic fish in the Asian tradition, continue, and, at the same time, are disrupted by genetic biotechnology. If, according to Aristotle's theory, art imitates nature or achieves what nature is powerless to achieve, then biotechnologies have for a long time been an integral part of the resources of art, but the resources and practices have considerably evolved.

These preliminary remarks cannot clarify much unless we take into account the nature of the field of art in which they intervene and form their own context. The biotech art of today is not being produced in the milieu of the modern mid-twentieth century. Since postmodernism, which, during the 1980s, marked and named the uncertain times of the end of modernist logic, we understand artistic production with much less certainty than when it obeyed "modern" principles of formal, repeated innovations. As when I most recently made a detailed diagnosis of the contemporary situation,[1] art today tends to vaporize itself. By this I mean that for certain works of art, with their formal properties and materials, the interest is shifted to the immaterial aesthetic experiences they produce, the experiences themselves, in a manner that is more and more loosely linked to the objects, but rather to the interactive and relational production systems. The dematerialization of the object, which was largely underway in the movements of the 1970s (minimalism, conceptual art, performance, installation art), has become banal. The materialness of the works even tends to become an accessory, with the accent being placed on the experience itself as an aesthetic moment, a moment of sensitivity. Art is moving to a fluid state, gaseous, ethereal—the aesthetic experience. Suddenly what is left to identify and define art—that which renders it perceptible as such—is weak and fragile. The institutional procedures of naming and identification are required. These are, by definition, conventional and thus likely to label nearly everything, no matter what, as art in confining it to what is called the "artistic zones," defined and identifiable. Autonomous, neo-anarchistic movements against globalization have taken from Hakim Bey the idea (and the practice) of TAZ, the Temporary Autonomous Zones that can be created during demonstrations or squatting. Exactly in the same way, today's artworld seems to consist of TEZ, Temporary Esthetic Zones, defined in a procedural manner; that is, artistic experiences take place in artistically consecrated settings like galleries and art centers, under conventionally defined conditions and governed by procedures, produced by actors who can define themselves as artists, mediators, or artistic designers.

The evolution in question is even more complex because it is comprised of a double movement. On the one hand, the art world defines itself by the procedural constitution of its TEZ. On the other hand, the TEZ tend, by their own fluid and ethereal nature, to go beyond the art world and spread out in culture in general. At a time when *infra-mince*

(infra-thin) experiences—to re-use the term aptly invented by Marcel Duchamp—are procedurally formed in art, the aesthetic invades society. Consider some design fads: the importance of fashion, obsession with beauty and having the "right" look, decorative cooking—concerns which result in the fashion of aesthetic surgery, of perfumes and cosmetics. Even misery aestheticizes itself, as witnessed in a 2003 runway show organized with the recycled clothing from the Emmaüs Association, a humanitarian organization which collects leftover or used goods in Europe. These new characteristics of the art world provide the context for biotech art. Not only does this context fit into and join without difficulty the general movement of the aestheticizing of life (when, for example, artists undertake to produce and direct spectacular bodily modifications with the assistance of aesthetic plastic surgery), it also encompasses the possibility of procedurally transforming a technoscientific activity into an artistic act.

Once the picture is drawn up, we can inquire into the nature of the biotechnological artistic practices themselves. Here a series of distinctions is to be made, which sometimes intersect and overlap.

We must first distinguish between metaphor and reality. It is obvious that certain posthuman or cyborgian practices are only metaphorical: They are characterized by special effects, makeup, and digitally retouched photographs. We dream of the future Eve, or of the detachable and reversible prostheses transplanted to the body, as in the productions of Matthew Barney. Certain new life creations correspond uniquely to fantastic taxonomies drafted by naturalists whose feats are circumscribed by verbal invention—for example, in the work of Louis Bec.

Other operations are, on the other hand, effective in creating physical transformations on bodies to forever remodel, scar, tattoo, pierce and/or brand them, whether with strictly artistic intentions or to be emblematic of alternative lifestyles.

In this field of practice, it is important to notice the differences, which are becoming harder to distinguish, between individual or group behavior relevant to a chosen lifestyle (or even for commercial exploitation), and these very similar behaviors in the context of an artistic project. In the 1940s and 50s the actress Rita Hayworth had her dentition redone to modify the shape of her face and notably to hollow out her cheeks.

However, I am alluding here to the difference between an artist like Orlan, who aesthetically modifies her body for art and art history, and actresses like Pamela Anderson or Ophélie Winter, who are hyper-siliconed for show business reasons (to say nothing of the actresses in the pornography industry or the fun fair monsters like Lolo Ferrari with her shocking oversize breasts on display at squalid village fairs).

What is interesting here is precisely the feature which is weakened by this difference. When the artist himself becomes the prop of his art, on the one hand, he crosses a path already explored by the practices of dandyism, but, on the other hand, he retrieves the world of village fair monsters without recognizing that it is next to impossible to tell the

difference between lifestyle and art. The sort of spontaneous dandyism appropriate for a given contemporary tribe—punk piercings or bodily modifications of bodybuilding champions—is a good illustration of this indetermination where lifestyle encounters dandyism, sometimes also with an eye toward commercialization.

Another distinction to be made, close to the preceding yet different, is between the real use of science and its staging. Certain artists like Eduardo Kac, Natalie Jeremijenko, davidkremers, and Oron Catts develop, in one way or another, projects requiring the participation of scientists to create transgenic organisms, cultivate tissues, or undertake xenografts. Others "expose" biology or botany, like Christa Sommerer or, previously, Paul-Armand Gette.

My purpose is not to make a distinction between those who would act for good and those who would play or pretend, but to point out that the engagement of art with science was already an artistic theme in the 1970s with conceptual art and in the English movement of Art and Language. Just as operations on the self by artist/performers are not entirely new—think of certain performances by Duchamp or Hausman—the transmutation of biology into art is sometimes analogous to what certain artists of the 1970s were doing with physics or mathematics.

Moreover, behind the dichotomy between real and metaphoric or staged use of science, there lies a considerable conundrum, that of the ethical problems raised by the individual approaches and the ethical framework that they engage.

As long as we stay with the metaphor or the staging of science, almost everything is permitted in the name of fiction and artistic liberty. As soon as we touch upon real approaches, things change dramatically.

We don't need to go very far beyond Faustian ventures and lab experiments. Already, despite the full responsibility of the individual to himself, attacks on oneself, and the auto-aggression of certain artists during their performances, have aroused indignation of some spectators (e.g., during some of Marina Abramovic's performances in the 1970s). Certain exhibitions and projects that used live beings received criticism for and virulent opposition to the suffering or presumed suffering of the animals. Thus the "Darwinian" installation *The World Theater* by Huang Yong Ping in the exhibition *Off Limits* at the Georges Pompidou Center in Paris in 1995, in which a variety of insects and other animals (scorpions, crickets, etc.) killed each other, became the subject of a legal proceeding demanding the banning of the exhibit by an association of animal rights advocates, who won the case.

When we come into the realm of transgenic manipulations and live operations, we find ourselves in an area where actions are eminently provocative and potentially dangerous. We don't see how we can allow artists to proceed with experiments that are forbidden to scientists, or at least closely monitored and supervised. Yet freedom of the imagination sometimes receives a surprising exemption from the social responsibility process.

Yves Michaud

The situation is further complicated by the fact that among the artistic projects, not all are inspired by the same purpose and intentions, or their purpose and intentions are not clear. Some seek to instigate reflection on the dangers of biotechnology, the weight of commercial lobbies, and the sliding risks. Ambiguity is introduced when the artist goes from theory to practice in the work. Jeremijenko's plant cloning project shows that environment and development contribute as much as the genome to determining individuals; at the same time, the artist clears cloning of suspicion and trivializes genetic manipulation. Even so, it is not the atrocity of the performance of certain aesthetic surgeons that brings about the criticism of this activity—rather, it shows fascinating potential.

In this inevitably biotechnological society, some artists—notably the emblematic Kac—put transgenic manipulations at the service of new artistic and cultural ends. Such a goal carries with it the reclamation of the artistic freedom of the demiurge tradition. This freedom actuates, albeit in a controlled manner, genetically modified organisms. It is not the least paradoxical that at the moment when militant ecologists dig up transgenic cultures in the middle of the field, in the exhibition site an artist has the right to expose transgenic animals or bacteria. Contrarily, it's not by leaving these creatures in laboratories placed under high protection while giving access (even controlled) to the public that would resolve the problem—art is adorned with the faded finery of science in calling up its contestable capacity for fascination. To see the artist, filmed in a white outfit in a research center, commenting sententiously on his or her work and his or her ideas does not give an innocent representation of either the artist or of the scientist. It not only makes the artist a "knower," "showy" in a classical representation of his or her mission (very nineteenth century, a mage and romantic prophet, cold and clean in light of pasturization and immunology), but also makes the scientist a wondermaker, largely immunized against what effectively determines most of the scientific research today—the competition between research teams and the profit of investors.

Two paths open up with their own questions. The artist might seek out the relatively insignificant, spectacular aesthetic effects, and might sooner or later rediscover the logic of spectacle and fantasy in entertainment. After the fluorescent rabbit, the artist might perhaps invent the mouse that roars; then, if possibly controllable and inoffensive, a couple of dinosaurs for Jurassic Park. Or the artist might take up truly hideous and transgressive programs with strong but dangerous aesthetic weight in their real consequences as well as in their philosophical and ideological background plan. It is on this last point that I would like to finish.

Behind a biotech art project, if we are able to escape the contemporary tyranny of the procedural, relational, and transactional, there can be a transgressive, creative radicality, not made to be inoffensive or humorous. This defines an art that is always reputable and "transgressive," but under the cosmetic conditions and limits of what is acceptable, decent, correct, and tolerated because, in conformity to its principle, it is completely

"conventional." In a certain manner the first transformative "operations" of Orlan had a provocative and subversive character. They were literally disgusting and repugnant and their result on the person of the artist herself could hardly pass for embellishment. Biotech art, especially transgenic art, goes even further in defending a program of human or animal mutation, the production of supermen, or putting monsters into circulation (starting with human clones, because, until now, they have been understood to be monstrous). Already there are intellectual groups and millennial sects defending such programs of mutation. We hardly thought that the cloning projects of the Rahelien sect proposed in this transgressive dimension could come to be seen aesthetically—under the condition that art be dissociated from its convention and rediscover its potential for monstrosity, for transgression, and even horror. This, of course, would not be correct, decent, or appropriate. It would be aesthetically unacceptable and ethically intolerable.

We mustn't forget that art can have a dark, transgressive dimension that does not imitate the world but rather produces a new world where values may be not only contrary to those accepted in the world, but simply incomparable. In many respects, the transgressive artforms of the Viennese actionism of the 1970s brought an inkling of these possibilities. Shortly after the attacks of September 11, 2001, the musician Karl-Heinz Stockhausen judged, then immediately retracted his words amid the scandal, that those acts were a complete work of art, the sublime achievement that the artist had always sought to create. The surrealists defined the surrealist act as a person going down the street with a loaded revolver and emptying it on the first passerby . . . but we have a hard time looking at serial assassins or hideous criminals as surrealists.

We can, however, conjecture that the institutional safeguards, the business sense, and the good relations that we require with the media weigh on such temptations to keep them in the state of temptation, and that biotech art will live a long time in the policed vitrine of technoscience. But whatever this pressure toward aesthetic decency, the temptation of transgression will remain, and biotech art will retain some of its adventurous and dangerous power.

Note

1. Yves Michaud, *L'art à l'état gazeux, essai sur le triomphe de l'esthétique* (Paris: Stock, 2003).

Yves Michaud

394

Contributors

Heather Ackroyd and **Dan Harvey** live in the United Kingdom and have been collaborating together since 1990 creating artworks worldwide. Much of their work is inspired by their interest in the process of change and has often been created within a collaborative arena, with artists, architects, composers, performers, scientists and writers. Nature and artifice, control and randomness often merge together in a series of interventions expressing the seductions of time and visibility at the heart of their work. They are acclaimed for their groundbreaking work with the light sensitivity of seedling grass and its ability to record complex photographic images and have been the recipients of numerous awards.

Lori B. Andrews is distinguished professor of law; director of the Institute for Science, Law and Technology; and associate vice president, Chicago-Kent College of Law, Illinois Institute of Technology. Her books include *The Clone Age: Adventures in the New World of Reproductive Technology* (2000) and *Future Perfect: Confronting Decisions about Genetics* (2001). Andrews has been an adviser on genetic and reproductive technology to Congress, the World Health Organization, the National Institutes of Health, and several other major institutions.

Bernard Andrieu is a philosopher and professor of epistemology at Institut Universitaire de Formation des Maîtres, in Lorraine, France. He is also a researcher at Archives Poincaré CNRS/Nancy University-II. His books include *La nouvelle philosophie du corps* [The New Philosophy of the Body] (2002) and *Le corps en liberté* [The Body in Freedom] (2004).

Brandon Ballengée is an artist who lives and works in New York. In 1996 Ballengée began collaborating with scientists to create hybrid environmental art/ecological research projects. Since then he has had numerous exhibitions nationally and internationally in which he presents photographs and biological samples of the creatures he collects. He is involved directly with field research and uses the visual impact of science to engage the public in a discussion of broader environmental issues. He has exhibited at venues such as the Contemporary Arts Center of Cincinnati, the Fosdick-Nelson Gallery in New York, Archibald Arts in New York, and Bronx Academy of Arts and Music in New York.

Louis Bec is an artist and a pioneer of artificial life. His work has simulated new life-forms and through them extended biological evolution. Bec describes himself as a zoosystematician. He proposes a "fabulatory epistemology" through which knowledge and imagination intertwine. He has presented his ideas in many articles and exhibitions. With the philosopher Vilém Flusser, he published the book *Vampyroteuthis infernalis* (1988), which literally translates as "vampire squid from hell." Bec is founder and director of CYPRES (Intercultural Center for the Practice and Exchange of Interdisciplinary Research) at the Academy of Fine Arts in Aix-en-Provence, France.

Oliver A. I. Botar is a Canadian art historian who has been a professor of art history at the School of Art of the University of Manitoba since 1996. He received his PhD and his MA in art history from the University of Toronto in 1998 and 1989, respectively. His dissertation and his current work focus on "biocentric" conceptions in modernist art, architecture, and design. Though he teaches mainly contemporary art history, his research centers on European and North American art of the first half of the twentieth century. He has published, lectured, and organized exhibitions on Hungarian, Canadian, and Central European art and architecture.

Oron Catts and **Ionat Zurr** are artists who live and work in Australia. Catts is co-founder and artistic director of SymbioticA—The Art & Science Collaborative Research Laboratory at the Institute for Anatomy and Human Biology at the University of Western Australia, in Perth. Zurr is artist-in-residence at SymbioticA and the academic coordinator for the MSC in Biological Arts to be offered by SymbioticA. Formerly research fellows at the Tissue Engineering and Organ Fabrication Lab, Massachusetts General Hospital, Harvard Medical School, Boston, they explore tissue culture as an art medium. Their tissue research has led them to propose "victimless" meat and leather.

davidkremers is a conceptual artist at CalTech—California Institute of Technology. He has grown paintings from genetically engineered bacteria, and his work combining living organisms and digital media has evolved into biospace station concepts for the Department of Defense and visual information systems for biotechnology research. The subject of numerous gallery and museum exhibitions in the United States and Europe, his artwork may be viewed at the permanent collections of the San Francisco Museum of Modern Art, the Denver Art Museum, the Broad Art Foundation, the Hammer Museum/Grunwald Center for the Arts at UCLA, the Panza Collection in Italy, and De Verbeelding Art Landscape Nature in the Netherlands.

Joe Davis is a research affiliate in the Department of Biology at the Massachusetts Institute of Technology, Cambridge. His teaching experience in the MIT graduate architecture program (MS in Visual Studies) and in undergraduate painting and mixed media at the Rhode Island School of Design has informed his artistic practice. He has exhibited in the United States, Canada, and Europe.

Richard Doyle is professor of rhetoric and science studies, Department of English, Pennsylvania State University. His books include *Wetwares: Experiments in Postvital Living* (2003) and *On Beyond Living: Rhetorical Transformations of the Life Sciences* (1997).

Alexander Fleming (1881–1955) received the Nobel Prize in Physiology or Medicine in 1945 for "the discovery of penicillin and its curative effect in various infectious diseases." He shared the prize with Ernst Boris Chain and Howard Walter Florey, who both (from 1939) carried Fleming's basic discovery further in the isolation, purification, testing, and quantity production of penicillin. Flem-

ing was a member of the Chelsea Arts Club, a private club for artists of all genres, founded in 1891 at the suggestion of the painter James McNeil Whistler. Fleming created "germ paintings," works on paper with pigmented bacteria, which revealed their colors after being cultured.

Vilém Flusser (1920–1991) was one of the most influential media philosophers of the twentieth century. Born in Prague, he immigrated to London in 1939 and settled in Brazil in 1940. Writing fluently in several idioms, in Brazil he developed his communication philosophy and media theory: a unique hybrid of phenomenology, information theory, and dialogical philosophy. In 1963, in Brazil, he published his first book *Língua e realidade* [Language and Reality]. His seminal book *Für eine philosophie der fotografie* (1983) was released in English as *Towards a Philosophy of Photography* (2000). The book discusses the transformation of textual into visual culture and of industrial into post-industrial society. In 1972 he returned to Europe and lived until the end of his life in the province of Robion, in southern France.

Ronald J. Gedrim obtained his MA from the University of New Mexico in 1981 with a thesis entitled "Bases of My Current Art Work." His MFA dissertation (University of New Mexico, 1990) was entitled *Edward J. Steichen's Natural World: The Flower, the Painting, and the Photograph*. He edited the anthology *Edward Steichen: Selected Texts and Bibliography* (1996). Gedrim lives in Albuquerque, NM, and works as a librarian at Mountain View Middle School, Rio Rancho, New Mexico.

George Gessert was initially a painter and printmaker. In the late 1970s he began to hybridize irises. From 1985 to the present he has been exhibiting his hybrids and focusing on the overlap between art and genetics. His exhibits often involve plants that he has hybridized, or documentation of breeding projects. He is especially interested in plant aesthetics and ways that human aesthetic preferences affect evolution. He has exhibited at venues such as New Langton Arts (San Francisco), the San Francisco Exploratorium, the Smithsonian Institution, and Exit Art (New York). His writings have appeared in many publications, and in 2005 he won a Pushcart Prize.

Natalie Jeremijenko is a design engineer and technoartist. She is director of Experimental Product Design Initiative, Department of Mechanical Engineering, Yale University, New Haven, CT. Her work has been exhibited at the Rotterdam Film Festival; the Guggenheim Museum, New York; the Museum Moderne Kunst, Frankfurt; the LUX Gallery, London; and the Whitney Biennial.

Eduardo Kac is an artist who has consistently explored the multiple ways through which *communication* transforms or becomes a work of art. Drawing from his background in philosophy and literature, Kac pioneered telecommunications and robotics in contemporary art in the eighties, and in the nineties he extended his work to the Internet and into biology. To name his new areas of investigation, he has coined several terms, including "telepresence art" and "bio art." Kac's work has been exhibited internationally at venues such as Exit Art and Ronald Feldman Fine Arts, New York; Maison Européenne de la Photographie, Paris, and Lieu Unique, Nantes, France; and Zendai Museum of Modern Art, Shanghai. Kac's work has been showcased in biennials such as Yokohama Triennial, Japan; Gwangju Biennale, Korea; and Bienal de São Paulo, Brazil. His work is part of the permanent collection of the Museum of Modern Art, New York, and the Museum of Modern Art, Rio de Janeiro, among others. The book *Telepresence and Bio Art: Networking Humans, Rabbits and Robots* (2005) collects his art writings. On the Web: http://www.ekac.org.

Dominique Lestel is a philosopher and a professor in the Department of Cognitive Sciences at the École Normale Supérieure, Paris. He is also a researcher at the Musée National d'Histoire Naturelle, in Paris, where he conducts research on human/animal communications, evolution of intelligence and comparative ecology of rationality. He is developing an "evolutionary existentialism" to make sense of the new challenges of the merging of technology and Evolution. His books, published mostly in French, include *L'animalité: Essai sur le statut de l'humain* [Animality: Essay on the Status of the Human] (1993); *Paroles de singes: L'impossible dialogue homme-primate* [Monkey Words: The Impossible Human-Primate Dialogue] (1995); *Les origines animales de la culture* [The Animal Origins of Culture] (2001); and *L'animal singulier* [The Singular Animal] (2004).

Marta de Menezes is a Portuguese artist with a degree in fine arts from the University in Lisbon, and an MSt in the history of art and visual culture from the University of Oxford. She has been exploring the interaction between art and biology, working in research laboratories demonstrating that new biological technologies, DNA, proteins, and live organisms can be used as an art medium. Her work has been presented internationally in exhibitions, articles, and lectures. She is currently artist-in-residence at the Structural Biology Department, University of Oxford. She lives and works in Lisbon.

Yves Michaud is a philosopher and professor of philosophy at the University of Paris I. His books, mostly in French, include *Changements dans la violence: Essais sur la bienveillance universelle et la peur* [Changes in Violence: Essays on Universal Benevolence and Fear] (2002); *Humain, inhumain, trop humain: Réflexions sur les biotechnologies, la vie et la conservation de soi à partir de l'oeuvre de Peter Sloterdijk* [Human, Inhuman, Too Human: Reflections on Life, Biotechnology, and Preservation of the Self through the Work of Peter Sloterdijk] (2002); and *L'art à l'état gazeux: Essai sur le triomphe de l'esthétique* [Art in the Gaseous State: Essay on the Triumph of Aesthetics] (2003).

Gunalan Nadarajan is an art theorist, curator, and writer who has written and lectured extensively on contemporary art, architecture, and cyberculture. He is also corresponding editor of *Contemporary* and contributing writer to *Flash Art* and *Moscow Art Magazine*. He has curated several major exhibitions and was contributing curator for *Documenta XI* and for *Mediacity 2002* in Seoul, Korea. Nadarajan is associate dean of Research and Graduate Studies, College of Arts and Architecture, Pennsylvania State University.

The late **Dorothy Nelkin** (1933–2003), a sociologist in the Faculty of Arts and Science, was a professor at the New York University School of Law. Her books include *Controversy: Politics of Technical Decisions* (1979); *The Animal Rights Crusade: The Growth of a Moral Protest, with James Jasper* (1992); *Dangerous Diagnostics: The Social Power of Biological Information*, with L. Tancredi (1994); *The DNA Mystique: The Gene as a Cultural Icon* (1996); and *Body Bazaar: The Market for Human Tissue in the Biotechnology Age*, with Lori Andrews (2001).

Object-Oriented Art [Art orienté objet] is a Paris-based French art duo formed in 1991 by Marion Laval-Jeantet and Benoît Mangin. Their name is derived from a computer programming methodology that decomposes problems into objects rather than procedures (as in "object-oriented code"). Their work investigates the relationship between ethics and aesthetics as well as art and science. They see themselves as "artists ethologists," concerned with how science and society manipulate life, animals, and humans.

Paul Perry is an artist whose work shows a preoccupation with the limits of the human and how these might be surpassed. Born in London, he was raised in Canada and has been living in Holland since 1982. In 2000 he directed the first episode of a multipart film on the simulation of near-death experiences *(1000 Deaths, Sortie 1)*.

Marc Quinn is a London-based artist who came to the attention of the international public with *Self* (1991), a work in which the artist's head was cast in his own frozen blood. This and other work using human bodily fluids are key to the artist's central preoccupation: the exploration of self and issues of mortality. He is often grouped with the YBAs, or Young British Artists. His work has been exhibited at venues such as the Sydney Biennale in 1992, *Young British Artists II* at the Saatchi Gallery in 1993 and *Sensation* at the Royal Academy of Arts in 1997.

Barbara Maria Stafford is William B. Ogden Distinguished Service Professor, Department of Art History, The University of Chicago. Her scholarly work crosses the domains of aesthetics, science, technology, and the fine arts. Her books published by The MIT Press include *Body Criticism: Imaging the Unseen in Enlightenment Art and Medicine* (1991); *Artful Science: Enlightenment, Entertainment and the Eclipse of Visual Education* (1994); *Good Looking: Essays on the Virtue of Images* (1996); and *Visual Analogy: Consciousness as the Art of Connecting* (1999). With Frances Terpak she co-authored *Devices of Wonder: From the World in a Box to Images on a Screen* (2001).

Eugene Thacker is assistant professor in the School of Literature, Communication, and Culture, Georgia Institute of Technology. His books include *The Global Genome: Biotechnology, Politics, and Culture* (The MIT Press, 2005) and *Biomedia* (2004).

Regina Trindade is a Brazilian artist who has carried out her research in the Laboratory of Macromolecular Engineering, Structural Biology Institute, in Grenoble, France. Her doctoral dissertation in the sociology of art is entitled "Bio Art: The Meeting of Two Worlds."

Paul Vanouse is an artist and associate professor of art, College of Arts and Sciences, University at Buffalo, State University of New York. He is also a research fellow at the Studio for Creative Inquiry, Carnegie Mellon University. He has exhibited at venues such as the Carnegie Museum of Art and the Andy Warhol Museum in Pittsburgh, the Walker Art Center in Minneapolis, the New Museum of Contemporary Art in New York, the Museo Nacional de Bellas Artes in Buenos Aires, the TePapa Museum in New Zealand, and the Louvre Museum in Paris. He has collaborated with Critical Art Ensemble and Faith Wilding in the creation of "Cult of the New Eve" (2000).

Cary Wolfe is Bruce and Elizabeth Dunlevie Professor of English at Rice University, in Houston, Texas. His books include *Animal Rites: American Culture, the Discourse of Species, and Posthumanism* (2003) and *Critical Environments: Postmodern Theory and the Pragmatics of the "Outside"* (1998). He edited the anthology *Zoontologies: The Question of the Animal* (2003).

Adam Zaretsky graduated in art studio from the University of California at Davis in 1995. He received an MFA in art and technology from the Art Institute of Chicago in 1999. From 1999 to 2001, he was a research associate at Massachusetts Institute of Technology in the Arnold Demain Laboratory for Microbiology and Industrial Fermentation. From 1993 to 1995, he was an organic farmer, working to aid subsistence farmers in such disparate climes as Guatemala, Sumatra, New York, and Hawaii. He has taught courses at several universities, most recently at Rensselaer Polytechnic Institute, Troy, NY.

Index

Animals (cont.)
laboratory experimentation and, 103–104,
112n16
language and, 108
legal issues and, 392
organ transplants and, 98
ornament and, 48–50
suffering and, 107–108, 153–154
technoteratogens and, 88–91
tissue cultures and, 234
welfare concept and, 104
Anker, Suzanne, 380–381
Anthrax, 31–32, 127, 261
Anthrax Clock (O'Reilly), 127
Anti-anthropocentrism, 320
Antitranscendentalism, 327
A-Positive (Kac), 118, 164
Apple, 40–41
Aquinas, Thomas, 5, 25n9, 379
Arabian babblers, 156
Arcimboldo, Giuseppe, 9–10
Arecibo radio transmitter, 253, 257–258
Aristotle, 4, 57, 254
Arp, Hans, 336
Ars Electronica, 164–165, 241, 261, 304
Art, 3, 38–40
biotechnology and, 387–394 (*see also*
Biotechnology)
biotelematic, 163
blood and, 115–116, 128–129
color and, 45–46
controversy and, 136–142
Dada, 353
ecological, 11–12
genetic, 125, 128–142 (*see also* Genetics)
Greco-Roman beauty and, 9
historical perspective on, 20–24
human body and, 128–129
language and, 392
materialism and, 4–5, 7
modernism and, 43–55, 351
naturalism and, 249

ornament and, 43–54
parergonal aesthetics and, 50–54
policy and, 142
postmodernism and, 390
Purism and, 45–46
science and, 4–5
telepresence, 163
transgenic, 163 (*see also* Transgenic art)
Artforum magazine, 23
Artificial intelligence (AI), 373
Artificial life (AL), 373, 377
Art Life (Gessert), 134
ARTnews, 128
Art-Oriented Object (Marion Laval-Jeantet and
Benoît Mangin), 20, 291–293
Art Press, 126, 128
Ascott, Roy, 373
Ashbaugh, Dennis, 194
Astrophysics, 376
Atheist existentialism, 158
Athena, 57, 59
Attico Gallery, 52–54, 153
Auden, W. H., 358
Augustine of Hippo, 5
Auqorea Victoria jellyfish, 75
"A very small piece of the large scale structure
of the universe" (davidkremers), 299
A-Z Breeding Units for Averaging 8 Breeds (Zittel),
303
A-Z Breeding Units for Reassigning Flight (Zittel),
303–304
Aziz, Anthony, 134, 378–379

Babies and Children's Hospital, Columbia
University, 129
Baby Adam, 67
Bachofen, J. J., 333, 335
Bacon, Francis, 379
Bacteria, 20
Genesis and, 132–133, 153–154, 164–167,
171–173, 375–376
paintings and, 295–297

Bioinformatics (cont.)
 biosystems and, 36–38
 Human Genome Project and, 31–35
 post-media issues and, 40–41
"Biological Needs" (Moholy-Nagy), 337
Bio-logics
 bioinformatics and, 33–36
 domestication and, 85–87
 life art and, 83–91
Biologism, 318
Biomimetics, 315
Biopathways Consortium, 36
Biopolitics, 389
Biopower, 2, 64, 96
Bios: The Laws of the World (Francé), 315
Biosystems, 36–38
Biotechnofacturers, 88
Biotechnology, 12, 20, 379
 animals and, 98–100
 artificial intelligence (AI) and, 373
 bio-logics and, 33–36, 83–91
 biosystems and, 36–38
 blood and, 17
 chimeras and, 57–67, 88–91
 cloning and, 2 (*see also* Cloning)
 commodification and, 135–136
 definition for, 388
 epistemological approach to, 388–389
 existentialism and, 157–159
 Flourescence In-Situ Hybridisation (FISH) and, 225
 Fuhrmann and, 327–331
 gene shopping and, 125
 genetics and, 128–142 (*see also* Genetics)
 Human Genome Project and, 31–33
 hybridoma and, 131, 211–214
 in vitro fertilization (IVF) and, 3, 9
 killer app and, 40
 life continuum and, 4–7
 ornamental, 43–55
 penicillin and, 22
 pharmacogenomics and, 378
 popular culture and, 14–15, 163–164

 property rights and, 1–2, 31, 101, 135–136, 221, 350–351
 Real Ethik and, 96
 Renger-Patzsch and, 330
 reproductive technology and, 2–3
 Saal and, 328–329
 subjectivity and, 57–67
 technoteratogens and, 88–91
 test-tube babies and, 125
 tissue cultures and, 232–242
 Vogeler and, 325–328
 Vogler and, 321, 324, 328, 330
 Vorwerk and, 328
 wetware and, 239, 241, 375
Biotelematic art, 163
Bioterrorism, 31–32, 121–122
Bird in Space (Brancusi), 350, 352
Bizzaria orange, 6
Bloggers, 376–377
Blood, 11, 17
 A-Positive and, 118
 art and, 115–116, 118, 120, 128–129
 commercialization of, 118–119
 DNA and, 117–120, 129
 economic value of, 115
 as essential substance, 116–118
 as exploitable resource, 121–122
 forensics and, 117
 HIV and, 114, 118, 128
 Human Genome Project and, 117–118, 121
 hybridoma cells and, 131, 211–214
 identity and, 117
 menstrual, 115, 118, 120
 myths of, 121
 race and, 119–120, 130
 religion and, 116
 social issues and, 115–120
 terrorism and, 121–122
 trait inheritance and, 117
Bloodlines (Seid), 129
Bloodmoney, 119
Blood transfusions, 5
Blue Failures (Trindade), 286

Frederick the Great, 5

Free Alba! (Kac), 170–171

Freud, Sigmund, 209

Frogs, 305–306

From Material to Architecture (Moholy-Nagy), 315, 318

Fruit flies, 216

Fuhrmann, Ernst, 315, 327–328, 330–331

functional Magnetic Resonance Imaging (fMRI), 223–224

Functional Portraits (Menezes), 223–224

Fuss, Diana, 109

Gadamer, Hans-Georg, 324

Gagarin, Yuri, 151

Galanti, Tara, 305

Gallerie Beaux Arts, Paris, 11

Garden of Delights (Manglano-Ovalle), 130–131

Gates, Bill, 126

Gattaca (film), 131

Gedrim, Ronald J., 20, 23, 347–369

Geep, 7

GeneEngine, 374

Gene Genies Worldwide, 125, 131

Gene shopping, 125, 131

Genesis, book of (Bible), 64

Gene(sis): Contemporary Art Explores Human Genomics exhibit, 139

Genesis (Kac), 132–133, 375–376
 bioethics and, 153–154
 mutation and, 164–167
 protein sculpting and, 171–173

Gene therapy, 2–3, 33, 38, 374

Genetically modified organisms (GMOs), 127, 158, 378

Genetic Code Copyright, 136

Genetics
 art medium and, 128–142
 chimeras and, 133
 color and, 371–372
 commodification and, 135–136
 E. coli and, 260–262, 272, 295–297, 375

economic issues and, 134

The Eighth Day and, 174–177

epistemological approach to, 388–389

food and, 250–251

Genesis and, 132–133, 153–154, 164–167, 171–173, 375–376

GFP Bunny and, 52–54, 69, 74–76, 132–133, 136, 153, 165, 168–171, 378

hybridoma and, 131, 211–214

legal issues and, 135–136

life-science art techniques and, 127–128

manipulation effects and, 133–134

Mendel and, 9, 203, 216, 389

Microvenus and, 257–258

Moore v. Regents of the University of California and, 126

Move 36 and, 177–180

patents and, 126, 221

pharmacogenomics and, 378

photosynthesis and, 126

plant breeding and, 188–210, 354–363

regulation and, 131

The Relative Velocity Inscription Device (RVID) and, 278–282

screening and, 129, 130–131

self-awareness and, 373–374

sequencers and, 131–132

SNPs and, 374–375

splicing and, 381

Steichen and, 354–355

tissue cultures and, 232–246

wearable genes and, 134

Genetic Self-Portrait (Schneider), 129

Genomic Portrait, A: Sir John Sulston (Quinn), 309–310

Geochronology, 380

Geology, 380

George, Stefan, 335

Georges Pompidou Center, 392

George V (King of England), 23

German Association of Anatomists, 137

Germ paintings, 22–23

Geryon, 57

semi-living art and, 231–246

technoteratogens and, 88–91

The Tissue Culture & Art Project (TC&A) and, 232–233

Limited, Inc. (Derrida), 95

Lindsay, Neil, 140

Lippard, Lucy, 363

Lippit, Akira Mizuta, 47–48

Lipson, Carol, 258–259

Living Paintings (Wunderlich), 127

Loers, Veit, 319

Loheland, 318, 331, 333, 335

Loos, Adolf, 43, 45

Louis, Morris, 187

Louis Harris poll, 133

Low, Sylvia, 48

Machado, Arlindo, 133

Machine Art exhibition, 349–350

McKenna, 70

Mackenzie, Adrian, 35–36

MacLean, Donna Rawlinson, 136

MacLeish, Archibald, 353

Madonna con Clone (O'Reilly), 127

Magnetic resonance imaging (MRI), 380

Magritte, 10

Malet, Leo, 11

Malthus, Thomas, 3

Man a Machine (Descartes), 5

Man a Plant (Descartes), 5

Mandel, Morton, 269

Mandelbrot, Benoit, 375

Mangin, Benoit, 20, 291–293

Manglano-Ovalle, Iñigo, 129–131, 139

Man Ray, 352

Marcel, Gabriel, 158

Marcuzzi, Max, 62

Margulis, Lynn, 3, 243–244

Marijuana. *See* Cannibas

Marta protein, 221–223

Mary (Queen of England), 23

Massachusetts Institute of Technology (MIT), 131, 253, 255–256, 260–261, 267

Materialism, 4–5, 7

Mathematics, 253–254, 256, 375

Matile, Philippe, 203

Maturana, Humberto, 19

Maupertuis, Pierre Louis Moreau de, 7

Mazdaznan sect, 319–320

MEART, 241–242

Mediatization, 86

Medusa, 57, 59

Mendel, Gregor, 9, 203, 216, 389

Mendieta, Ana, 115

Menezes, Marta de, 20, 24, 50–52, 54, 215–229

Men in Black (film), 250

Merleau-Ponty, Maurice, 66

Message in Many Bottles (Davis), 253–254

Mice, 211–214, 216, 304

Michaud, Yves, 23–24, 387–394

Michelsen, Axel, 89

Microsoft, 41

Microsushi, Microinjection Food Science (Zaretsky), 267–270

Microvenus (Davis and Boyd), 257–258

Mihail, Karl, 125

Miles, Geoffrey, 245

Milky Way, 256, 263–264

Miller, Larry, 136, 194

Millet, Jean-François, 6

Millstone Radar transmitter, 255–256

MMMM (Zaretsky), 267, 272–273

"Modern Delphinium, The" (Steichen), 356

Modernism, 351

color and, 43–46

nature and, 46–48

ornament and, 43–55

Moholy-Nagy, László, 20, 163, 317

Bauhaus and, 315, 318–319, 321, 335

Free German Youth and, 320–330

German Youth Movement and, 318–320

leukemia of, 335–336

Loheland and, 331, 333, 335

Mazdaznan sect and, 319–320

nature and, 331

photography and, 333, 336–337

Rorty, Richard, 109
Rosch, E., 66
Rosenfeld, Paul, 352
Rothko, Mark, 187
Rowohlt, Ernst, 329
Royal College of Surgeons, 140–141
Rubenstein, Bradley, 134
Rules for a Human Park (Sloterdjick), 86
Ruskin, John, 47

Saal, Adolf, 328–329
Sagan, Carl, 253, 257–258
Saint-Hilaire, Etienne Geoffroy, 9, 59
Salon des Indépendents, Paris, 11
Sandburg, Carl, 352–354
San Francisco Chronicle, 168
San Francisco Exploratorium, 134
Sartre, Jean-Paul, 158
Schairer, Reinhold, 329
Schneeman, Carolee, 11
Schneider, Gary, 129–131
Schrödinger, Erwin, 9
Schulz, Lucia. *See* Moholy-Nagy, Lucia
Science, 371–372, 376
Scientific American, 260
Scotus, Duns, 379
Script (Ackroyd and Harvey), 207
Scylla, 57, 59
Scylla serrata crab, 303
SDS-PAGE (SDS-PolyAcrylamide Gel
 Electrophoresis), 285
Second International Congress for Microbiology,
 23
Seid, Dui, 129
Selection, 3
Self (Quinn), 115, 128
Semi-living art, 231
 future avenues for, 243–245
 sculptures and, 233–236
 The Tissue Culture & Art Project (TC&A) and,
 232–243
Semi-Living Worry Doll (Catts, Zurr, and Ben-
 Ary), 238
Senescence, 199, 201–202

Sensation exhibition, 115
Sensei Seed Bank, 71
September 11, 31–32, 121, 394
Sequência (Trindade), 288
Sex
 bacteria and, 252
 bestiality and, 250
 body art and, 391
 cannabis and, 70–71, 73–74
 chimeras and, 59, 64–66, 250
 melanin and, 278
 microinjections and, 269–270
SGI . . . 406 exhibition, 288
Sheeler, Charles, 352
Shelley, Percy Bysshe, 6
Shenk, David, 96
Shepard, Paul, 191
Ship (Moholy-Nagy), 331
Short, DJ, 73–74, 77–78
"Silent Code" (Davis and Boyd), 264–266
Simon, Herbert, 152
Simplex Isolation System CleanRoom, 270
Singapore, 48–50
Singer, Peter, 98, 102, 106
Sise, Hazen Edward, 317
Skin Culture (Laval-Jeantet and Mangin), 291–
 293
Sloterdjick, Peter, 86
Smithson, Robert, 187, 190
Social issues, 163–164
 bioinformatics and, 31–41
 blood and, 115–120
 domestication and, 85–87
 genetics and, 133–134 (*see also* Genetics)
 Human Genome Project and, 31–33
 property rights and, 1–2, 101, 135–136, 221,
 350–351
 public decency and, 137–142
 reproductive technology and, 2–3 (*see also*
 Cloning)
 Temporary Esthetic Zones (TEZ) and, 390–
 391
Society of the Spectacle (Debord), 26n24
Socrates, 260